Volume 15

DIRECTORY OF
WORLD CINEMA
FRANCE

Tim Palmer and Charlie Michael

intellect Bristol, UK / Chicago, USA

First Published in the UK in 2013 by Intellect, The Mill, Parnall Road, Fishponds,
Bristol, BS16 3JG, UK

First published in the USA in 2013 by Intellect, The University of Chicago Press,
1427 E. 60th Street, Chicago, IL 60637, USA

A catalogue record for this book is available from the British Library.

Publisher: May Yao
Publishing Manager: Melanie Marshall

Cover photo: Brigette Bardot in *L'Ours et la poupée* (1969), L'parc/Marian/The Kobal Collection

Cover Design: Holly Rose
Copy Editor: Emma Rhys
Typesetting: Holly Rose

Directory of World Cinema ISSN 2040-7971
Directory of World Cinema eISSN 2040-798X

Directory of World Cinema: France ISBN 978-1-84150-563-3
Directory of World Cinema: France eISBN 978-1-84150-701-9

Printed and bound by Cambrian Printers, Aberystwyth, Wales.

DIRECTORY OF WORLD CINEMA
FRANCE

CONTENTS

To Liza and Riley – T. P.

To Subha and Jeevan – C. M.

ACKNOWLEDGEMENTS

We would like to thank very much our contributors for their work, and especially our framing essayists for sharing their research so generously. Thanks to everyone at Intellect for their support of this project, in particular Melanie and May. Thank you to Emma Rhys. Much appreciation also to: François Truffart, Guylaine Vivarat, and everyone at the 'City of Lights, City of Angels' festival. Thanks most of all to Liza and Riley, Subha and Jeevan. This book is for you.

Tim Palmer and Charlie Michael

INTRODUCTION

Directories are supposed to be life's dependable reference tools, with authoritative information at the ready. However, when it comes to discussing cinema – an art form, an entertainment industry, a political tool, a motor of commerce, a canon of cultural artefacts – things get more complicated. As the editors of this first print edition of the *Directory* of *World Cinema: France*, we found ourselves invigorated by the challenge of compiling a guide to one of the most diverse and inspiring film-making centres in the world. But we should start with a brief word about our goals and methods.

As two professors and researchers of French film, we repeatedly come up against the tradition of traditions: those master narratives of how France's cinema typically gets carved up and written up, whether in classroom textbooks, DVD catalogues, history books or coffee table anthologies. French film-making is then presented as a chronology of iconic director-auteurs and the movements they inspired, from early film pioneers (Lumière, Méliès), to classical poet-realists (Renoir, Carné), to the 'Tradition of Quality' commercialists (Clément, Autant-Lara), to New Wave mavericks (Godard, Truffaut, Chabrol), to *cinéma du look* upstarts (Beineix, Besson, Carax), and so forth.

Our approach was both to listen carefully to this standard account, while also shedding light on its blind spots. We chose eight rubrics to explore what we take as vital ongoing conversations or longstanding issues in French cinema – on Women Film-makers in France; Documentary and Realism; Avant-gardes and Counter-Cinemas; The New Wave and After; Cinema(s) of Quality; Horror; Policier; and Comedy. Each of these eight sections begins with a framing essay that maps the historical terrain in question, populated next with shorter analyses of representative films. Some of these paths are well travelled, others neglected or abandoned, but all span multiple periods in French film history, along with a range of vivid cultural and historical backdrops. Space is given here to new perspectives on well-known areas, but also to case studies unfairly or unthinkingly passed over. Our segment on the New Wave, for instance, addresses its many lives and afterlives, but we also dedicate an entire section to its alleged nemesis – the embattled 'Tradition of Quality' famously reviled by François Truffaut, which in reality was never a single tradition anyway. Likewise, three of the sections (Comedy, Horror and Policier) address popular genres that, for different reasons, have been marginalized almost entirely except when they coincide with a so-called great film or director.

In sum, perhaps the best way to learn why stubborn traditions exist is to try to think of other ways to conceptualize them. Although the essays collected here do cover a wide array of canonized classics and newcomers without reputations, as we intended, our efforts to change the roll call did leave some names out altogether. The print book is here assisted by our online repository; both will be augmented by further volumes and further materials to come. Our ultimate aim is to create an emerging new model of French cinema history, underlining its strength in depth, attending equally to its well-lit boulevards and its unknown blind alleys. As such, this first volume is both a stand-alone text and a statement of intent for things to come. We hope you enjoy this directory and, above all, find it useful in getting to know better the endlessly rewarding cinema of France.

Tim Palmer and Charlie Michael

Tomboy

FILM OF THE YEAR
TOMBOY

Tomboy

Studio/Distributor:
Hold Up Films

Director:
Céline Sciamma

Producer:
Bénédicte Couvreur

Screenwriter:
Céline Sciamma

Cinematographer:
Crystel Fournier

Composer:
Jean-Baptiste de Laubier (as Para One)

Editor:
Julien Lacheray

Duration:
82 minutes

Genre:
Drama

Cast:
Zoé Héran
Malonn Lévana
Jeanne Disson
Sophie Cattala
Mathieu Demy

Year:
2011

Synopsis

A strikingly androgynous pre-adolescent drives with her family to their new home. This is Laure, whose short-cropped hair and boyish mannerisms are warmly accepted by her mother, heavily pregnant with a male baby, her caring but busy father, and her mischievous younger sister Jeanne. Settling in, Laure introduces herself to the neighbourhood kids as a boy, Michaël, and is invited into their games: football, chase, swimming, hiking. The thoughtful yet vigorous Michaël soon catches the eye of Lisa: they hold hands, and later kiss. When Lisa visits to ask for Michaël, Jeanne discovers her sister's deception, but keeps Laure's secret in exchange for being allowed to join the group. However, Michaël then has to defend Jeanne against an aggressive older boy; s/he wins the fight but her subterfuge is exposed after the boy's mother complains to Laure's parents. Laure, wearing a dress, is forced to apologize to her new friends, who react with confusion. Finally, after Lisa visits her again, Laure re-introduces herself as a girl, and smiles.

Critique

Tomboy, Céline Sciamma's second film, opens in rhapsody. Stretching from a moving car's sunroof we see the back of a child's head – a character whose name and gender are not disclosed until nearly ten minutes into the film – and then point-of-view tracking shots exposed directly into the sun. Dazzling beams of light slice through rippling overhead tree fronds; the frame is intermittently cast into shadow and bleached into white-out. The child's hand now moves into the frame, and in shallow focus its windblown fingers arc over blurred swathes of foliage and sunshine, as if conducting a tiny organic orchestra. Birds sing, and Sciamma cuts finally to the child's face, eyes initially closed in concentration, brow furrowed, a youngster surrendering to natural rapture.

Sciamma's beautiful preface sets up *Tomboy*'s conceptual agenda: childhood as an urge towards sensorial discovery. Echoing avant-garde film-maker Stan Brakhage, Sciamma creates lyrical encounters in and around nature, immersive perceptual episodes in opposition to the banal adult world of names, objects, roles, and socialized identities. As context to her main character (Zoé Héran) diverging into two genders – the twin personae of Laure (inside, domesticated, among adults) and Michaël (outside, independent, among children) – Sciamma represents pre-adolescence as an amorphous, experientially heightened state, which ironically makes Laure/Michaël's doubled emergence all the more empowering and authentic, even logical. As such, *Tomboy* avoids polemics about the motivations of its polygendered protagonist, and instead simply revels in her/his moment-by-moment emancipations, the imaginative continuum of a childhood community. But as the parents constantly remind their daughters about summer ending and school beginning, we rarely forget that these liberties are finite, that they must end.

Often Sciamma's approach highlights the spontaneous intimacies of the two young sisters, their fierce solidarity, as they constantly play-act. When Laure disappoints Jeanne (Malonn Lévana), for instance, telling her that she has to leave but will return at six o'clock, the younger girl immediately insists that Laure draw an ink watch on her wrist to reflect the happy deadline. Similarly, when the two girls paint together, Jeanne arranges Laure before her as a model, studying her form before a canvas of paper and crayons, complaining – 'Stop moving!' – when her sister breaks the pose. Later, tenderly daubing red antiseptic lotion onto a cut on Jeanne's leg, Laure cannot help but add a little heart onto her arm; her sister smirks in delight. In essence, Laure's life extends from this unforced familial infancy with Jeanne, who is six, to the more complex, rising social peer demands of ten-to-twelve-year olds. One scene has the two girls enjoying Play-Doh, and we only gradually realize that Laure is actually sculpting a clay penis to put in her swimsuit, so as to pass for male during her swimming outing the next day. Always, though, these childhood pursuits stand in sad contrast to the diminished capacities of the adult caregivers, whose creativity extends mainly to entreaties and policing, like the (unnamed) Mother (Sophie Cattala) curtailing the girls' hour-long bath by warning them that if they do not hurry out they will die from cold, and their waterlogged fingers will stay webbed forever. Grown-up lies like these pass unchallenged, whereas Laure's casual ruses will bring the world down around her ears.

Stylistically and logistically, Sciamma's work on *Tomboy* also builds from *Water Lilies/La Naissance des pieuvres* (2007), her debut film about the coming-of-age of three teen-aged girls, nominated in 2008 for a Best First Film César (Palmer 2011: 32–40). Second time around Sciamma, a committed minimalist, streamlined things even further. She cut her budget to under 500,000 euros, went from scriptwriting to principal photography in three short months, and turned, both creatively and practically, to the Canon 7D hybrid digital film camera, typically used for stills but extremely lightweight and mobile, perfect for shooting small humans on the move, designed to capture legible images in extremes of high or low light. All of her child performers were non-professionals; the cheapness of digital video allowed Sciamma (who also designed the sets and costumes) to expose footage, frequently long takes of ten minutes or more, of them interacting and improvising, her direction sometimes limited to highlighting on camera a single pivotal movement or gesture, like when Michaël, a fledgling boy, decides to try spitting during a football game, or removes his shirt like the other boys on his team. As in *Water Lilies* Sciamma downplays dialogue: *Tomboy* has only 669 spoken lines over its 82-minute running time, averaging a (usually laconic) statement just once every 7 seconds. (The same length of film in Philippe le Guay's more typical *The Women on the Sixth Floor/Les Femmes du 6e étage* (2011) has, by contrast, 1,231 lines of dialogue.) Decisive moments – like when Lisa (Jeanne Disson) learns that her possible boyfriend is in fact a girl – are played by the young actors in silence, with unreadable static faces. Sciamma's behavioural anthropology of children is often compellingly inexpressive, latent or inert. And clearly Robert Bresson's influence looms large, traceable to Sciamma's apprenticeship at La Fémis, the illustrious Parisian film school, where she was advised by neo-Bressonian Xavier Beauvois, the head of her 2005 graduating board, to jettison the expositional elements of her scriptwriting in favour of sound cues, muted performances, and a stylized *mise-en-scène*.

Conspicuous among *Tomboy*'s achievements is this dialogue with other notable French films, past and present, as Sciamma reacts to a diverse, rich, and quite competitive national cinema ecosystem. An applied *cinéphile*, Sciamma practices her craft in part to converse with her peers. Repeatedly in interview – a vital part of the job of artistic self-elaboration in France – Sciamma spoke of the inscrutable miracle of *photogénie* (photogenesis) in Zoé Héran, her lead whose face and body and inner life *Tomboy* explores, citing explicitly the subjective poetic ideology of French Impressionist

film-makers of the 1920s. (The opening shot of Héran's hands inscribing the sky seems a direct visual reference to Dmitri Kirsanoff's 1928 *Autumn Mists/Brumes d'automne*.) *Tomboy* also strategically reworks the aesthetic of Jean Paul Civeyrac's *Through the Forest/A travers la forêt* (2005), a DV-derived chamber drama about a young woman and her possibly dead lover that refuses to distinguish diegetic reality from its protagonist's mental longings. (Civeyrac also teaches at La Fémis.) As Laure, sleepless one night, apparently contemplates Michaël, her indeterminate alter ego, like Civeyrac, Sciamma shoots her actress wandering alone through her apartment, almost invisible in sepulchral twilight, her body dividing in a mirror, a liminal space in which the fantastic becomes tangible. Lucile Hadzihalilovic's *Innocence* (2004) is another engagement: in *Tomboy*'s vivid woodland splendour, its timeless child world virtually abstracted from grown-up society, and its ambivalent organic designs that periodically supplant narrative. (Fabienne Berthaud's *Lily Sometimes/Pieds nus sur les limaces* (2010) uses similar devices to evoke a mentally disjunctive woman's retreat from adult life.) Hence when Laure is outed and abandoned by her friends, she runs into the forest, removes the blue dress she has been made to wear, then apparently vanishes into ephemeral harmony with nature – the camera wanders upwards, the customary long focal length of Sciamma's lens letting her rove freely, blissfully through the leaves of the canopy above, accompanied by piercing birdsong and ambient gusts of wind.

Exquisite in its techniques, open and non-judgmental in its materials, *Tomboy* is a film to savour, a piece of micro-cinema whose scale is deceptively small. On the strength of her two first features alone, Céline Sciamma is already a major figure in the wonderfully bustling environment of contemporary French cinema.

Tim Palmer

References

Palmer, Tim (2011) *Brutal Intimacy: Analyzing Contemporary French Cinema*, Middletown, CT: Wesleyan University Press.

Un condamné à mort s'est échappé, Gaumont.

DIRECTORS
UN STYLE DÉPOUILLÉ: ROBERT BRESSON

The story commonly told about Robert Bresson is that the difficult and unfamiliar simplicity and elegance of his films make them like no other in the history of cinema. Because of their challenging austerity, Bresson has developed (and holds to this day) the reputation of a film-maker 'apart' – apart from the storytelling traditions of the art form, from the film industry, and from French taste culture. A recurring theme in Bresson commentary and scholarship is that he is *sui generis*. Bresson is of his own kind, self-generated, an artistic singularity. He is one of few film-makers to devote his art to the expression of the ineffable. His characters do not seek to rid the world of villainy or pursue heterosexual romance. They are in a spiritual predicament; they are in search of grace. Bresson is thought to have developed his own unique language to tell their stories, his own personal system of film writing, *le cinématographe*.

This system stands apart from *le cinéma*, whose borrowings from the theatre give it a 'fraudulent realism, vulgarity, and facile psychology', as one critic explains it (Quandt 1998: 3). Bresson eschews storytelling that establishes clear character goals and linear developments in favour of an elliptical and episodic model, creating gaps and mysteries and often leaving major events and dramatic high points to be inferred by the audience. He also makes extensive use of off-screen space, reducing information redundancy about characters' actions and the spaces they occupy and replacing what is normally 'seen' in movies with what can more evocatively be 'heard'. If Bresson's economical dramaturgical approach uses sound effects to replace phenomena that a conventional film would depict visually, he is also known for stripping down the performances of his actors, which he calls 'models'. His models do not act; rather, they repeat lines and takes in order to re-emerge as their natural selves and simply *react* – to behave automatically as if there were no camera or crew present.

With such a rigorous and exacting approach to theme and storytelling, Bresson only made fourteen films in a 40-year film career. He was born on 25 September 1901, in Bromont-Lamothe (Puy-de-Dôme), Auvergne, a region in south central France that was also the birthplace of the mathematician, physicist, and religious philosopher Blaise Pascal, whom Bresson often cited.[1] He studied at the prestigious Lycée Lakanal de Sceaux, in the western suburbs of Paris. Known for its literary heritage, former students include the poet and essayist Charles Péguy and Jean Giraudoux, an acclaimed dramatist of the interwar period and *dialoguiste* for Bresson's Occupation film, *Les anges du péché/The Angels of Sin* (1943). Bresson appears to have been a painter, presumably during his twenties and thirties, although no paintings have ever been exhibited. He is reported to have married for the first time in 1926 to Leidia van der Zee, a marriage that ended in divorce (Riding 1999: C27).

His earliest documented professional activities in the 1930s were varied. Eight surviving photographs reveal that he was as a commercial and avant-garde photographer of promising talent during the early years of the decade. Bresson made his directorial debut with the *comique fou* film, *Les Affaires publique/Public Affairs* (1934), a medium-length production (Bresson, cited in Ajame 1966: 13). The sets were by Pierre Charbonnier and the film's eclectic score by Jean Wiener. Both were longtime companions of Bresson. Bresson gave his first interview in 1934 in order to promote the film. Between 1933 and 1939, he also worked as *dialoguiste* on several commercial, feature-length comedies. He was an assistant director on *La vierge folle/The Foolish Maiden* (Henri-Diamant Berger, 1938). The film, whose theme of the social constraints of love anticipates Bresson's own *Les Dames du bois de Boulogne/The Ladies of the Bois de Boulogne* (1945), recounts the ill-fated affair of a respected (and married) Parisian lawyer and a young girl.[2]

A project called 'Air pur', directed by René Clair with Robert Bresson reportedly assisting, began preproduction in January 1939 (Billard 1998: 238). A film about the challenges facing youth in urban France, it would have very few stars. The production was cut short when France declared war on Germany on 3 September 1939 (Billard 1998:

234–38). None of the footage survives.

Despite disagreement over the precise dates of his capture, few contest that Bresson was taken hostage during the earliest stages of war (Samuels 1972: 76). Once released, his career took what most regard as a marked turn. Although there is some debate about how to periodize his work, the tendency is to view his career in a three-act structure, with an early 'Bresson before Bresson' phase, a middle 'mature' period of black-and-white film-making, and a final 'colour' period characterized (for some) by its examination of the bleakness of contemporary life. For many scholars and critics, the early period consists of works completed before the Liberation: *Public Affairs* and two features produced during the German occupation of France, *The Angels of Sin* and *The Ladies of the Bois de Boulogne*. *The Angels of Sin*, was inspired by a 1938 non-fiction source, *Les dominicaines des prisons* (Lelong 1938), suggested to Bresson by the Dominican priest and public intellectual, Raymond-Léopold Bruckberger. *The Angels of Sin* received immediate praise from Roland Barthes, among others, with Giraudoux's dialogue and the authentic handling of convent life as the main traits that caught critics' eyes at the time (Barthes 1993: 37–39; Vinneuil 1943: 7). *The Ladies of the Bois de Boulogne* was adapted from the Madame de la Pommeraye episode of Diderot's *Jacques le fataliste/Jacques the Fatalist and his Master* (1796). Like *The Angels*, *The Ladies* was scored by the future St-Sulpice organist Jean-Jacques Grunenwald and shot by the esteemed cinematographer of poetic realist films, Philippe Agostini. Bresson also contracted Jean Cocteau to write dialogues, which he did, according to Bresson, for 'less than one hour, sitting on the corner of the couch' (Bresson, cited in Ajame 1966: 13).

After the Liberation in 1944, Bresson continued working with established literary, intellectual and film production figures, although he was beginning to forge a reputation of his own. In 1948, an Italian firm based in Rome, Universalia, hired him to direct 'Ignazio di Loyola', a project that never came to fruition. In the period for which he is best known, running from 1951 to 1967, he completed what some have dubbed the 'prison cycle', in which he developed his 'mature' themes of spiritual release in a sparse and exacting form of storytelling: *Journal d'un curé de campagne/Diary of a Country Priest* (1951), *Un condamné à mort s'est échappé, ou le vent souffle où il veut/A Man Escaped, or The Wind Bloweth Where It Listeth* (1956), *Pickpocket* (1959) and *Le procès de Jeanne d'Arc/The Trial of Joan of Arc* (1962).

Diary of a Country Priest is quite simply the film most responsible for establishing Bresson as an auteur. Working alongside Bresson at this stage was Léonce-Henri Burel, respected cinematographer for Abel Gance in the 1910s and 1920s. Bresson once again tapped Grunenwald and Charbonnier for his production team. Released in 1951, the film won a number of awards, including the Grand Prize of the 1951 'Venice Film Festival'. The film's reputation only grew throughout the 1950s, becoming the subject of some of the period's most widely read articles, including Bazin's 'Le Journal d'un curé de campagne et la stylistique de Robert Bresson' ('*Diary of a Country Priest* and the Robert Bresson Style') (Bazin 2009) and Truffaut's notorious *Cahiers du Cinéma* polemic, 'Une certaine tendance du cinéma français' ('A Certain Tendency of French Cinema') (Truffaut 1954: 15–29). Truffaut, writing for the fashion periodical *Elle* in 1950, reported from the set that '[i]f you don't know country life well, you'll surely find out about it in *Diary of a Country Priest*, directed by Robert Bresson in the apt setting of Pas-de-Calais, where Georges Bernanos wrote it' (Truffaut 1950: 12).

Bresson was once again called to Rome in 1963, this time to direct an episode for a project titled 'The Bible'. His episode of this omnibus film was to include Noah's Ark and cages of wild animals in pairs (lions, giraffes and hippos), but when he told the film's producer Dino de Laurentiis, 'On ne verra que des traces sur le sable' ('We will only see their footprints in the sand'), he was dismissed from the project (Bertolucci 1998: 529).

He rounded out this black-and-white period with two other masterpieces: *Au hasard*

Balthazar (1966) and *Mouchette* (1967). In his 'late' period, he adopted colour cinematography and investigated contemporary themes in stories set, for the most part, in modern Paris: *Une femme douce/A Gentle Creature* (1969), *Quatre nuits d'un rêveur/Four Nights of a Dreamer* (1971), *Lancelot du lac/Lancelot of the Lake* (1974), *Le Diable probablement/The Devil Probably* (1977), and his last film, *L'argent/Money* (1983).

During this period, he published his long-awaited collection of aphorisms about film-making, *Notes sur le cinématographe/Notes on the Cinematographer* (1975). Those themes that recur over the book's 138 pages – the film actor conceived as a *modèle*, the limits of theater vis-à-vis cinema, realism – are guided by a spirit that is wary of rigid prescriptions. Bresson writes: 'Prefer that which is suggestive to your intuition to that which you have done and redone ten times in your head' (Bresson 1975: 129).

The 82-year-old Bresson planned to make more films, but he was never able to secure financing. In his final televised interview in 1983, Bresson indicated that he wished to shoot the 'La genèse' ('Genesis') project he had been planning since the 1960s.[3] In the same interview, he also admits to having enjoyed the latest James Bond film, *For Your Eyes Only* (John Glen, 1983), with his nieces. Bresson lauds it as a rare example of *le cinématographe*, or film writing, in contemporary cinema. Beyond this, he appears to have shown interest in adapting J. M. G. Le Clézio's novella, *La grande vie/The Great Life* (1982), a road story about two girls who save money to travel to Italy, but Bresson never completed a script.

Robert Bresson passed away on 18 December 1999 in Epernon, France, southwest of Paris. He is survived by his second wife, Mylène Bresson, credited on his films under her maiden name, van der Mersch.

Bresson's legacy and reputation have continued to grow since his death. In 1999, a travelling retrospective commemorated his films. The inaugural Prix Robert Bresson was awarded in 2004 to the Dutch animator Michael Dutok de Wit. More recently, Bresson's surrealist photography, part of the permanent collection of the Centre Pompidou in Paris, was included in a 2009–10 exhibition, 'La subversion des images: surréalisme, photographie, film' ('The Subversion of Images: Surrealism, Photography, Film').[4]

Robert Bresson has for a long time been something of a puzzle. Difficult to characterize and explain, his body of work (especially after *Diary of a Country Priest*) has drawn admiration precisely for its formal and thematic inscrutability and apparent lack of sources. Throughout his career, he developed many reputations – he was a formalist or political vanguardist to some, a religious or transcendentalist visionary to others – but for all the 'Robert Bressons' that have emerged, he has above all been an individualist who expressed his personal vision through an alternative conception of cinema.

Colin Burnett

References

Ajame, Pierre (1966) 'Le cinéma selon Bresson', *Nouvelles littéraires*, 26 May.

Barthes, Roland (1993) 'Les anges du péché', *Oeuvres complètes, tome I*, Paris: Éditions du seuil, pp. 37–39.

Bazin, André (2009) '*Diary of a Country Priest* and the Robert Bresson Style', *What is Cinema?* (trans. Timothy Barnard), Montréal: Caboose, pp. 139–59.

Bertolucci, Bernardo (1998) 'Film-makers on Bresson', in James Quandt (ed.), *Robert Bresson*, Toronto: Cinematheque Ontario, pp. 529.

Billard, Pierre (1998) *Le mystère de René Clair*, Paris: Plon, pp. 234–38.

Bresson, Robert (1997) *Notes on the Cinematographer* (trans. Jonathan Griffin), Copenhagen: Green Integer.

Lelong, Michel (1938) *Les dominicaines des prisons (Béthanie)*, Paris: Éditions du cerf.

Quandt, James (1998) 'Introduction', in James Quandt (ed.), *Robert Bresson*, Toronto: Cinematheque Ontario, pp. 3.

Riding, Alan (1999) 'Robert Bresson, Film Director, Dies at 98', *New York Times*, 22 December, pp. C27.

Samuels, Charles Thomas (1972) 'Interview with Robert Bresson', *Encountering Directors*, New York: G. P. Putnam & Sons, pp. 76.

Truffaut, François (1950) Untitled, *Elle*, 264, 18 December, pp. 12.

Truffaut, François (1954) 'Une certaine tendance du cinéma français'/'A Certain Tendency of French Cinema', *Cahiers du Cinéma*, 631, January, pp. 15–29.

Vinneuil, François (1943) 'Giraudoux au couvent', *Je suis partout*, 9 July, pp. 7.

Notes

1 Cf. the following insightful essay on the affinities and citations: Mirella Jona Affron, 'Bresson and Pascal: Rhetorical Affinities' (Quandt 1998: 187).

2 This is the description of the film available on the Bibliothèque du film website (www.bifi.fr), which also lists Bresson as Assistant Director. The film does not appear to have survived. My source for this reference is Keith Reader, *Robert Bresson* (Manchester: Manchester University Press, 2000), pp. 9. His source is René Prédal, *Robert Bresson: L'aventure intérieure*, special issue of *L'avant-scène cinema* (408–09, 1992), pp. 2.

3 'Entretien avec Christian Defaye', *Spéciale Cinéma*, first broadcast in 1983 by TSR (Switzerland), *L'argent*, New Yorker DVD.

4 The exhibition ran from 23 September 2009 to 11 January 2010.

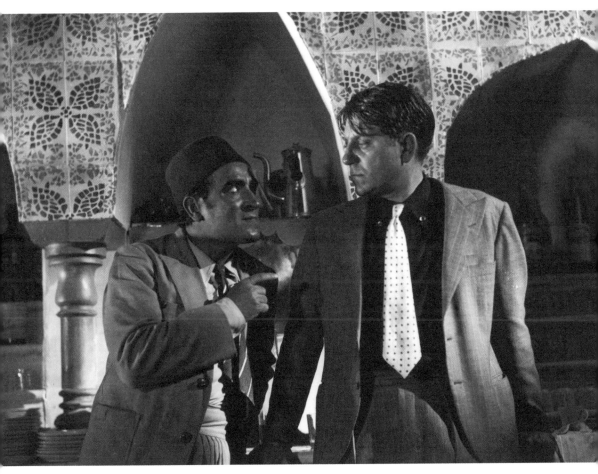

épé le Moko, Films Hakim, Paris Film.

DIRECTORS
JULIEN DUVIVIER

If I were an architect and I had to build a monument to the cinema, I would place a statue of Julien Duvivier at the entrance. (Jean Renoir, 1967)

Julien Duvivier (b.1896, d.1967) tends to sit rather uneasily alongside the other four *monstres sacrés* of French classical cinema: Jean Renoir, René Clair, Jacques Feyder and Marcel Carné. There are a number of reasons: the perceived uneven quality of his oeuvre, his tendency to remake both other films and his own work, and a critical consensus that has marginalized him because of his putative versatility and anti-auteurist posturing. David Thomson describes his style as 'spruce but seldom interesting' (Thomson 2003: 260), and Ginette Vincendeau notes that film history 'thinks of Duvivier as an excellent "craftsman" and "artisan" (or, less flatteringly, "workhorse" or "yeoman") rather than an auteur' (Vincendeau 1997: 10). On the other hand, Duvivier always maintained that a film's style was dictated by its subject, and not its director: 'Genius is just a word; film-making is a craft, a tough craft that must be learned. Personally, the more I work, the more I realise how little I know in proportion to the infinite possibilities of cinematic expressions' (Duvivier, cited in Borger 1998: 30). Jean Renoir's 1967 obituary tribute, 'Death of a Professional', focused on Duvivier's love of 'work well done' as his signature legacy.

Duvivier's working practices, their breadth, their 'invisibility', and their sureness, extended across a career of 50 years. The most recognizable visual aspects of the 'Duvivier touch' were an expressive *mise-en-scène*, highly fluid camera movements and a complex negotiation of decor, strong central performances by established stars and new actors, pessimistic narratives, and the nuanced incorporation of melodramatic elements (music, production design). Such traits coalesced to a remarkable degree in *Un Carnet de bal/Dance Program* (1937). Marie Bell, tracking down all the men on her dance card with whom she danced two decades previously, visits Pierre Blanchar's back-street abortionist in Marseilles. He is blind in one eye and the affliction is reflected in the *mise-en-scène*: camera placement is skewed, Blanchar's acting is nervy and sweaty, the sound design amplifies the creeping sense of dementia, and the entire set appears constructed on a 30° incline. Graham Greene's review of this scene focused on Duvivier's obsession with favoured themes of nostalgia, sentiment and regret, and how 'the padded and opulent emotions wither before the evil detail' (Greene: 1972: 184).

The range of genres in which Duvivier worked was testimony to his professionalism: he turned his hand to, among others, literary adaptations (from works by Emile Zola, Leo Tolstoy, Irène Némirovsky and Georges Simenon), biblical epics (*Golgotha/Behold the Man* [1935]), portmanteau films (*Dance Program, Tales of Manhattan* [1942]), comedies (the *Don Camillo* series [1952, 1953], *L'Homme à l'imperméable/The Man in the Raincoat* [1957]), the 'Hollywood' film (*Flesh and Fantasy* [1943]) and propaganda films (*Untel Père et fils/Immortal France* [1943]). Such genre fluidity exemplified the adaptability and sustained professionalism of a director whose career neatly dovetailed with profound technological, social, and artistic leaps that were taking place in France concurrently: the arrival of sound film in 1930, the development of the Poetic Realist aesthetic in the mid-to-late-1930s, the exodus to America during the German Occupation of France, working within the Hollywood studio system in the 1940s, and the return to France and a much-changed domestic film landscape in the 1950s. In each stage of his career, Duvivier's work was inflected with innovation and experimentation – from the use of double exposure in *Le Tourbillon de Paris* (1925) to express the tension between inner thought and outward appearance of Lil Dagover's tortured opera singer, to the point-of-view car crash that opens *Diaboliquement vôtre* (1967) – as well as a register that could flip to violence in the space of a single sequence, like the execution of the treacherous Regis in

Pépé le Moko (1937) that takes place with the manic noise of a mechanical piano in the background.

Duvivier's formative experiences as Assistant Director on André Antoine's *Le Coupable* (1917) and *Les Travailleurs de la mer* (1918) profoundly influenced him. Antoine's influential theories on cinematic naturalism, location shooting, and performance authenticity were absorbed and developed by Duvivier throughout his career. In 1925, he joined the production company Film d'Art, where he worked for nine years, honing his expertise by collaborating with groups of artists and technicians on a number of consecutive projects. Several of Duvivier's early 1920s films had a religious subject. The spiritual inspiration of *Credo ou la tragédie de Lourdes* (1924), *L'Abbé Constantin* (1925) and *La Vie miraculeuse de Thérèse Martin* (1929) led to Duvivier being labelled a Catholic film-maker (the latter dealt with the Carmelite saint Thérèse of Lisieux). Duvivier's output in the 1930s was dizzyingly eclectic. There are the sophisticated early sound films, like *Poil de carotte/The Red Head* (1932) and *Allo Berlin, Ici Paris!/Here's Berlin* (1932), which mix experimental, avant-garde sound techniques and gags with light-hearted sentimentality, and the noir-soaked adaptation of Simenon's *La Tête d'un homme* (1932), which laid down the template for the *policier*-procedural film. Duvivier's first 'talkie', *David Golder* (1930), marked the first time that he worked with the actor Harry Baur. The two would work seven times together throughout the decade, an enduring collaboration that epitomizes the flexible professional environment of 1930s French cinema, and the abiding teams of actors, directors, writers and technicians that helped establish many of the dominant practices of French classical cinema. *David Golder*, alongside Duvivier's two other 1930s 'Jewish' films *Golgotha* and *Le Golem/The Golem* (1935), has been labelled anti-Semitic, with objections raised over the particularly nasty interpretation of Irène Némirovsky's original novel in terms of the representation of the figure of the Jew and his daughter.

Duvivier's work in the 1930s must also be placed within the generic and aesthetic framework of Poetic Realism. His three most well-known films from this period – *La Bandera/Escape from Yesterday* (1935), *La Belle équipe/They Were Five* (1936) and *Pépé le Moko* – each combined elements of populism and melodrama with an expressionistic *mise-en-scène* and a pessimistic narrative structure. These films also starred the actor Jean Gabin: Duvivier did much to finesse Gabin's star aura, and the films deploy many of the defining Gabin traits, such as alienation, helplessness, assertive masculinity, and romanticism that seemed in tune with the pessimistic sensibility of the nation. French film practice flourished during this period, and the industry became far more artisanal. Directors with a strong personal vision assembled teams of skilled screenwriters, composers, cinematographers, and set designers who each allied themselves to a single vision. This 'can-do' climate fostered a dazzling collaborative work ethic in which abiding director-designer-writer-actor relationships emerged and thrived. Duvivier was very much part of this landscape, and working with favoured collaborators (scriptwriters Henri Jeanson and Charles Spaak, designer Jacques Krauss, and composer Maurice Jaubert) allowed the Duvivier style to fully materialize.

His technical virtuosity, coupled with the success of *Pépé le Moko*, earned Duvivier an invitation to Hollywood by MGM in 1938 to direct *The Great Waltz*. He then moved to America in 1940, and directed four films there during the Occupation period. *Lydia* (1941) was a remake of *Dance Program*, while *The Imposter* (1943), with Gabin, reworks the theme of *Escape from Yesterday*, with the setting this time in Brazzaville. On his return to France in 1945, Duvivier needed to readjust to a new film-making climate that now feted new directors like Robert Bresson, Henri-Georges Clouzot, Jacques Becker and Claude Autant-Lara, and emphasized authentic, location-filmed reality. His first post-war film was one his most accomplished – *Panique/Panic* (1946). Although some critics likened it to pre-war Poetic Realism (a style and sensibility not in vogue given the

changed artistic and political post-war landscape), *Panic* cleverly grafted the pessimism of Duvivier's 1930s films onto a new set of political and social contexts. It remains one of the high points of European noir, full of 'acutely unpleasant economic stringencies and a lack of identity' (Hayward 2005: 187). *Panic* also shed light on another problematic representation in Duvivier's oeuvre – a sense of misogyny that made women scapegoats for wartime collaboration. As a harrowing response to France's post-Liberation climate of suspicion and retribution, *Panic* has been compared to Henri-Georges Clouzot's *Le Corbeau* (1943) and Fritz Lang's *Fury* (1936), where seemingly rational individuals can be whipped up into a mob frenzy. Michel Simon's moving performance as Monsieur Hire once again highlighted Duvivier's unerring reputation as a director who could coax unexpected layers of guilt, unease, and sympathy from his actors.

The later post-war output was characterized by big-budget costume dramas (*Anna Karenina* [1948], starring Vivien Leigh), and noir-ish, more introspective melodramas, like *Voici le temps des assassins/Deadlier Than the Male* (1956). This film marked Duvivier's final collaboration with Gabin, who plays a Les Halles restaurant owner gradually duped by Danièle Delorme's pale-faced angel of death. It was critically acclaimed: *Cahiers du Cinéma*'s review called it 'faultless', with Duvivier 'bearing witness to a straightforwardness rather rare among our directors'. The 1950s were an important decade for Duvivier, both artistically and commercially. With the phenomenal success of his two *Don Camillo* films, staring the popular actor Fernandel, Duvivier's reputation as a solid, dependable craftsman was guaranteed, and his workmanlike approach to film-making meant that he was better able to negotiate the changing landscape of 1950s and 1960s film-making praxis. There was the adaptation of classic French literature (Zola's *Pot-Bouille/Lovers of Paris* [1957]), portmanteau films like *Le Diable et les dix commandements/The Devil and the Ten Commandments* (1962) and *La Fête à Henriette/Holiday for Henrietta* (1952), which would later be remade as *Paris When it Sizzles* in 1964 with William Holden and Audrey Hepburn, and films closely connected, in tone and acting style, with the New Wave, like *Sous le ciel de Paris/Under the Paris Sky* (1950), with its location shooting of Paris, or *Boulevard* (1960), Jean-Pierre Léaud's first film after Truffaut's *Les Quatre cents coups/The 400 Blows* (1959).

So, despite his anti-auteurist inclinations, Duvivier's films are consistently visually articulate and assiduously cast, designed, shot and produced. Dudley Andrew has written that 'no one speaks of Julien Duvivier without apologising' (Andrew 2012), and yet even Duvivier's so-called 'lesser' films provide a thematic and visual consistency with his earlier career that in turn raise him to the level of auteur. Duvivier requires no apology – one needs only watch the 'unhappy' ending of *They Were Five*, or his framing of Catherine Rouvel's ruthless Maria in *Chair de poule* (1963), to see that this was a director in total control of his craft.

Ben McCann

References

Andrew, Dudley (2012) 'Julien Duvivier', www.filmreference.com/Directors-Du-Fr/Duvivier-Julien.
 html. Accessed 9 February 2012.
Borger, Lenny (1998) 'Genius is a Word', *Sight and Sound*, September, pp. 28–31.
Greene, Graham (1972) 'Un Carnet de bal', *Night and Day*, 9 December 1938, repr. in John Russell
 Taylor (ed.) *The Pleasure-Dome: the collected film criticism of Graham Greene: 1935-1940*,
 London: Secker and Warburg, pp. 184.
Hayward, Susan (2005) *French National Cinema*, London: Routledge.
Thomson, David (2003) *The New Biographical Dictionary of Film*, London: Little & Brown.
Vincendeau, Ginette (1997) *Pépé Le Moko*, London: BFI.

Fauteuils d'Orchestre, Thelma Films, Studio Canal.

STAR STUDY
ALBERT DUPONTEL

In the vertiginous opening of *Irréversible/Irreversible* (Gaspar Noé, 2002), Marcus (Vincent Cassel) angrily pushes his way through the seedy hallways of a Parisian SM joint – searching, we learn later, for a man who has just brutally raped his girlfriend Alex (Monica Bellucci). Cassel, limber and ferocious as ever, commands attention in spite of the pulsating soundtrack and disorienting cinematography, while his more mild-mannered friend Pierre (Albert Dupontel) remains on the periphery, stammering fruitless attempts to calm Marcus down as they navigate the dark corridors. However, when they finally do confront their suspect, a brawl breaks out, and there is a shocking reversal. Overmatched and pinned to the floor, Marcus suffers a heinous arm fracture in front of a crowd of screaming, lascivious onlookers. Enter a reinvigorated Pierre, who suddenly lunges fully into the frame, slamming a fire extinguisher repeatedly into the head of Marcus' assailant. As the assault continues unabated, cheers of excitement turn to gasps of horror and then to a shocked silence; Pierre bashes the man's face and skull over and over, reducing his humanity to a grisly pulp. Murkily shot at a canted angle, Dupontel's eerily calm, clench-jawed descent into a murderous delirium unfolds literally before our eyes – presented in a single, excruciating take.

In many ways, *Irreversible* capitalizes on the talents of an actor already renowned for unhinged, off-kilter characters. One of the more versatile performers at-large in the French film industry today, actor-writer-director Dupontel has spent nearly two decades now shuttling between genres, minding the gaps between commercial and art house cinema like few still can. Though his cynical, high-intensity style is now a recognized part of the French star system, he also remains continually on its margins – maintaining a persona that deploys an abrasive iconoclasm that is deliberately at odds with the consensual grandeur and gloss of most mainstream entertainment. In a recent interview, Dupontel reports that the now infamous murder scene sketched above was largely a product of his own invention, the consequence of Noé's loose directorial style on-set and his own giddy improvisation (Dupontel 2010). He also apparently surprised Noé in other unscripted moments of the film, including a scene on the subway with Cassel and Bellucci, where their three characters converse while headed for the Parisian nightlife. Pierre – who also happens to be Alex's ex-lover – asks increasingly probing, inappropriate questions about her sexual experiences with Marcus. With no prior knowledge of the tragic events to come, the awkwardness here could play as comedic. But in light of what we know, the details of Pierre's behaviour – his shifty eyes, his nervous smile, his edgy tone of voice and his sheer, dogged persistence – become harbingers of the murderous capacity we know to lie just beneath the surface.

Dupontel's performance style has always exploited the ironic distance between conspicuous restraint and explosive rage. Born in St. Germain-en-Laye in 1964, the son of a doctor, he pursued his father's career as far as four years into medical school, when he abruptly changed course in the late 1980s to become an actor. While training for two years at both the Théatre National de Chaillot and the Ecole d'Ariane Mouchkine, Dupontel made several brief appearances in films, including Jacques Rivette's *La bande des quatre/The Gang of Four* (1989). But his definitive break came in 1990, when he sent a video of his stand-up comedy routine to TV host Patrick Sebastien. Impressed, Sebastien invited Dupontel on his variety show *Carnaval*, an appearance that helped the young comedian get a later opportunity to both write and act for a Canal+ sketch show called *Sales histories* (1990). Based on the repeated misadventures of two dimwitted, buffoonish young men (fellow up-and-comer Michel Vuillermoz costarred), the risqué and often violently slapstick series lasted just one season. But like many notable stars of his generation (José Garcia, Michelle Laroque, Jamel Debbouze, Jean Dujardin, Bouli Lanners and others) Dupontel profited immensely from the creative environment and name recognition provided by Canal+ in the station's early days. His momentum built from there.

While still working on television, Dupontel also kicked off a more extended stage

version of his comedy routine – a one-man show called, appropriately, *Sale spectacle*. Since its original run, which toured the Paris circuit between 1990 and 1992, several of the individual character sketches included in the show have achieved online cult afterlives. Typically clad only in jeans and a white t-shirt – the latter invariably bathed in sweat after a few minutes – Dupontel addresses his audience directly, speaking to an imaginary interlocutor. Many of his characters engage satire via their extreme mental delusions or limitations. In 'Le bac', for instance, he incarnates a teenager who is woefully ill-prepared for the philosophy portion of his college entrance exam. Cursing frantically under his breath, our would-be student scribbles notes on his palms, only to flounder when asked basic questions about Jean-Paul Sartre.

Finding an authorial voice between the juvenile and the satirical, Dupontel's directorial work creates stylized worlds befitting the mania of these earlier stage characters. Perhaps as a nod to his abandoned medical past, his first film, *Désiré* (1993), is a dystopic short about a horribly misguided obstetrics lab. However, it was with his first feature *Bernie* (1995) that Dupontel had an unexpected, low-budget, breakout hit – drawing nearly two million viewers and winning a César for a dark comedy about a mentally challenged, violence-prone simpleton who leaves an orphanage at the age of 30 to find his parents. When he eventually finds his parents, he deludes himself into thinking he must protect them, enforcing his convictions with, among other things, a very large shovel. Provocative in tone, frenetic in style, and yet still able to offer an offbeat, sentimental love story (the first of several such roles for the director's talented life partner Claude Perron), *Bernie* served notice to *cinéphiles* and critics alike that Dupontel's vision extended beyond his own histrionics to the formal properties of cinema itself, combining a slam-bang rhythm (many fans cite Tex Avery) with a cluttered *mise-en-scène* reminiscent of a Terry Gilliam or, perhaps, a less baroque Jeunet-Caro (a natural comparison since *Délicatessen* had just made waves a few years prior). Even less enthusiastic reviews of *Bernie* recognized Dupontel's ciné-literacy, as did hip culture magazine *Les Inrockuptibles*, which called the film '*Forrest Gump* spliced with *Hara Kiri*' (Anon 2005).

Since catapulting into the public consciousness as director, Dupontel has signed three other feature-length films – *Créateur/The Creator* (1998), *Enfermés Dehors/Locked Out* (2006) and *Le Vilain/The Villain* (2009) – each centred in different ways around his performance style. His follow up to *Bernie*, *The Creator*, sung an all-too-obviously reflexive tune of a playwright who cannot write effective scripts without first committing murder, and was a commercial and critical disappointment. *Locked Out*, however, offers perhaps Dupontel's most complete, ambitious vision to date. Roland, a mentally ill vagrant, finds an abandoned police uniform, and proceeds to bring his own kind of justice to the neighbourhood. On the back of this new character – who comes across as an amalgam of Bernie, Robin Williams in *The Fisher King* (Terry Gilliam, 1991) and a spastically accident-prone Buster Keaton – *Locked Out* moves along at a crisp, idiosyncratic lilt, spoofing both American blockbusters (Roland runs and jumps over cars, and rides on top of a moving bus) and socially aware French *banlieue* films in equal measure. As if to confirm the film's other aesthetic intertexts, Terry Gilliam and Terry Jones both make brief cameo appearances as part of Roland's homeless entourage, and Perron's love interest character works in a sex shop – in direct reference to her minor role in Jeunet's *Amélie* (2001), where she also plays a sex shop worker.

Despite a remarkable career path, from fringe comedian to recognized thespian, Dupontel remains in many ways uneasy about his own stardom. Notoriously surly in interviews and often outspoken about the dubious politics of commercial cinema, he has now been nominated multiple times for acting Césars, but has yet to attend the ceremony. His roles in popular French cinema now range quite widely, as his trademark intensity seems to play quite well in particular niches. Easy to see, for instance, the

links between his romantic-dramatic leads, who are often socially awkward but passionate men – the pianist in the breezy comedy *Fauteuils d'orchestre/Avenue Montaigne* (Danièle Thompson, 2006) or the shy grocer who flirts with Elise (Juliette Binoche) in *Paris* (Cédric Klapisch, 2008). Likewise, Dupontel's chiselled features and kinetic magnetism also make him a natural for action-based roles – the revenge-obsessed hero in the futuristic thriller *Chrysalis* (Julien Leclercq, 2007); the morally challenged sergeant in the war epic *L'Ennemi intime* (Florent Emilio Siri, 2007); the AWOL World War I soldier in *Un long dimanche de fiançailles/A Very Long Engagement* (Jean-Pierre Jeunet, 2004). Notable exceptions to these are films like *Le bruit des glacons/The Clink of Ice* (Bertrand Blier, 2010), where Dupontel plays the human incarnation of Jean Dujardin's unexpected cancer. Although Blier's scripted methods differ greatly from Noé's, the part cleverly draws, much like *Irreversible*, on both the vulnerable and the irascible sides of Dupontel – twin emotional states which, when combined, make him such an arrestingly human presence on both the stage and the screen.

Charlie Michael

References

Anon (1995) 'Bernie', *Les Inrockuptibles*, 11 November, www.lesinrocks.com. http://www.lesinrocks.com/cine/cinema-article/t/27977/date/1995-11-30/article/bernie/. Accessed 20 February 2012.

Dupontel, Albert (2010) 'Gaspar Noé par Albert Dupontel', interview by Romain Le Vern, 10 September, Excessif.com. http://www.excessif.com/cinema/actu-cinema/dossiers/gaspar-noe-par-albert-dupontel-et-bangalter-solondz-cassel-bellucci-5806339-760.html. Accessed 20 February 2012.

Dupontel, Albert (2011) 'Interview on "Eclectick" with Rebecca Manzoni',' France Inter, Sunday, May 22, FranceInter.fr. Accessed September 21, 2012.

Sarah's Key, Hugo Productions, Studio 37, TF1, Canal+.

INDUSTRIAL SPOTLIGHT
AN INTERVIEW WITH FRANÇOIS TRUFFART, DIRECTOR OF THE CITY OF LIGHTS, CITY OF ANGELS FRENCH FILM FESTIVAL

Since 1996, the City of Lights, City of Angels (COLCOA; www.colcoa.org) film festival has become arguably the leading Franco-American cinema event, as well as one of the highest profile sites of French film export anywhere in the world. In part an industry showcase, designed to put France's newest major films in the shop window before potential North American distributors, COLCOA is also a celebration of French film culture, its events attended by American film-making professionals and members of the public alike, including Los Angeles County school children who are bused in for the occasion. Annually screening more than fifty French films (both new releases and classics), COLCOA flies in film-makers and stars, often premiering films at the same time as – or even earlier than – Paris. In 2011 there were over 18,000 attendees, and every year COLCOA gets bigger. Tim Palmer interviewed COLCOA's director, François Truffart, to find out more about the festival's design and ambitions.

You began directing COLCOA full time in 2007. What led you to this post, and this particular career? How would you describe your job?

I started my career as a diplomat working for the promotion of French cinema in different countries, as cultural attaché, until 2001, in Hungary, Japan and in the United States, in Los Angeles. Then, after working for the Cannes Film Festival and the Marché du Film in Cannes, I was hired in 2004 by the Franco-American Cultural Fund (FACF), which had created the COLCOA festival in 1996. First I was a programmer at COLCOA, then I became director of the event in 2007. COLCOA was not a discovery for me as I'd supported the festival when working at the French Consulate from 1997 to 2001. I am now both the director of COLCOA and a programmer. It's a full-time job. As a programmer, I have to select about 35 features (including classics) and about 20 to 25 shorts and I see about 200 films (features and shorts) all year round.

COLCOA is probably the largest French film festival in North America. What, in your experience, makes the festival unique? What does it set out to do?

The festival is unique mainly because of its specificity: 74 per cent of COLCOA's audiences come from the film industry, and the competition is unique as awards for films are chosen mainly by professionals from Hollywood. Considering this audience, I would say that we follow three goals at the same time. First, a commercial goal: COLCOA is a window to promote French films and enlarge their audience in the United States, as well as internationally. As a result we work closely with US distributors, exhibitors, producers, and agents who attend COLCOA to test films with an audience, to buy rights and remake rights, and discover new talents. Along with New York, Los Angeles is our main market for distributing foreign films in the US, so in terms of visibility COLCOA has become a key platform for distributors to launch their films on the West Coast. Second, there is a cultural goal, the idea being to discover new talents (through first features, shorts, etc.), to pay tribute to classic French cinema (through our Program of COLCOA Classics) and to create opportunities for French and American film-makers to meet and exchange (with panels, cocktails, professional lunches, and so on). Third, we have an educational goal: since 2007, we have developed educational programs to create a new generation of foreign film viewers.

Sometimes but not always COLCOA prioritizes commercial cinema, or films with a potentially broader audience. Is there a formula for the programming decisions that go into your annual line-ups? What kind of qualities do you and your colleagues look for when selecting French films to get COLCOA's endorsement?

I don't think that we prioritize commercial cinema but we make sure that all kinds of films are part of our program each year. The first reason is because we believe that French cinema's strength is its diversity and we want to promote this. I am very proud to be able to program at the same time Dany Boon and Benoît Jacquot, Francis Veber and Olivier Assayas. Contrary to many who consider foreign language film as a specific genre, we prove every year that French cinema offers all kind of films for various audiences. Actually, we believe that there is not only one specific audience for French cinema in the United States. Besides, the definition of 'commercial French film' is different between France and the United States, and high box office success for a French film in France is not a selection criteria. When I select a film, I consider several criteria: the film has to be a French production (according to the Centre National du Cinéma et de l'Image Animée (CNC) rules), it has to be released in France after the last COLCOA event and to have never been shown in public in Los Angeles before us. Regarding the qualities of the film, the most important thing is the script and the directing as most of our audiences are members of the Directors Guild of America (DGA) and the Writers Guild of America (WGA). Another criteria is whether a film will be appealing and understandable for a local audience, although I do also like to surprise our audiences and show the specificities of French cinema. My personal tastes have nothing to do with my choices. Some years, my favourite films are not chosen. Finally, since COLCOA has become an important platform for US distributors to launch their films – about 30 per cent of our line-up is films about to be released in the United States – it is a priority for us to support them. If a distributor asks me to select their film, 99 per cent of the time it's a yes.

What, in your opinion, are the key challenges or obstacles to getting French cinema to reach as large an audience as possible in North America?

This is an important question. To sum up my point of view: getting past the preconception that foreign films are only auteur films for an elite, that's the first obstacle. Recently, many French films (re)formatted like American films (*The Transporter* [Louis Leterrier and Corey Yuen, 2002], *Colombiana* [Olivier Megaton, 2011], *Oceans* [Jacques Perrin and Jacques Cluzaud, 2009], *The March of the Penguins* [Luc Jacquet, 2005], etc.) have reached large audiences. Marketing is another issue: the same film released by Sony Classics, The Weinstein Company or now Music Box Films or IFC will reach a larger audience than a smaller distributor. Thanks to Michael Barker and Harvey Weinstein, some foreign films are now able to make more than $1 million at the US box office – like *Sarah's Key* (Gilles Paquet-Brenner, 2010) or *Of Gods and Men* (Xavier Beauvois, 2010). And now we are entering a new world: if the foreign film market remains a niche market, digital development will maybe change everything…

French cinema is often described as being on the brink or in the throes of a crisis, most recently perhaps from the Club des 13 and its concern about the vanishing *cinéma du milieu* (mid-range budgeted films) in France. What do you think are the main problems facing the French film industry? What, on the other hand, do you think are the reasons for its buoyancy and momentum?

French cinema has been supported by a system that gives specific sources of finance for producers, taxes on the box office, obligations for French TV channels to invest in films, etc. Like every supportive system there are some negative effects. But professionals and politicians are always working to try to improve the system and adapt it to new environments (notably digital). At the end of the day, France is still able to produce or coproduce more than 180 features every year.

COLCOA liaises among a large group of sponsoring agencies, American and French, from Unifrance to the Directors Guild of America (DGA), from the Society of Authors, Composers and Publishers of Music (SACEM) to the Motion Picture Association of America (MPAA). How are their interests represented? How do you balance all these constituents?

DGA, WGA, MPAA and SACEM are together in the Franco-American Cultural Fund which presents COLCOA. This FACF was created in 1996 to promote professional exchanges between American and French film industries and COLCOA is their main event. They work together to make COLCOA a successful festival every year for the promotion of French cinema, so they have no antagonist interests. Like the French Association des Auteurs-Réalisateurs-Producteurs (ARP) and the French Foreign Ministry, Unifrance is a supporter of the festival but not a partner. None of the partners or supporters take part in the selection of the program at any level and if sometimes some of them might suggest a film to me, it always remains only a suggestion. I am the only one to decide for the program.

What do you consider to be your main professional achievements at COLCOA? What particular projects remain your future goals and targets?

To see 3,000 American students coming in from 70 schools, watching a French film at COLCOA every year, most of them for the first time, is definitely an achievement. Another one is our ability to attract more than 18,000 people every year in Hollywood to see French films. We are also proud to have been able to use the symbol of Hollywood for the promotion of French cinema in the world, which is in a way very ironic. Another achievement is the fact that for the reasons I already mentioned, we have programmed a lot of genre movies at COLCOA since 2004, and we were probably the first to do it. Now you can see that US distributors buy and release not only art house films but also horror, action, thrillers, comedies… Most of all, the strong interest of US distributors in COLCOA to promote their films is for me the best reward I can have.

Interview conducted by Tim Palmer

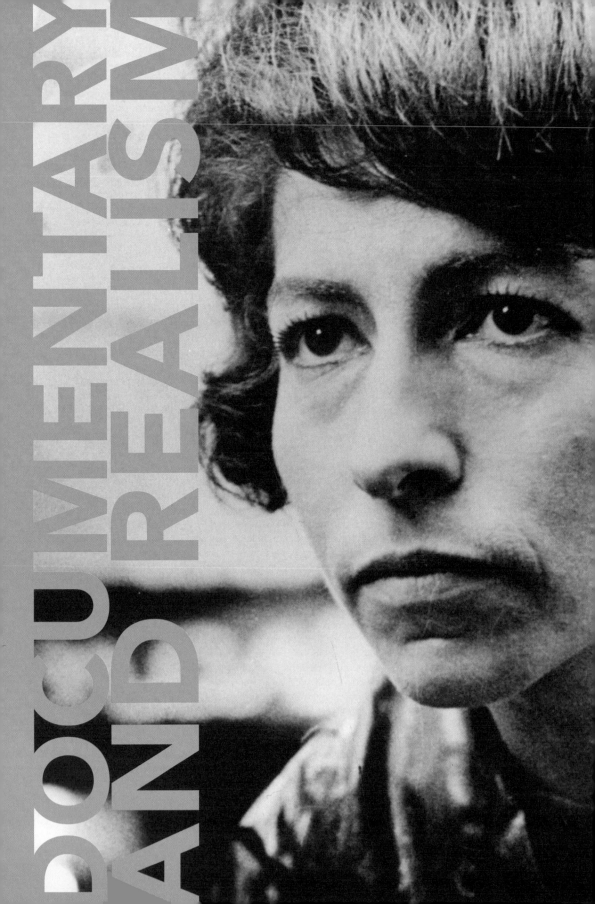

DOCUMENTARY AND REALISM

Documentary has, over the long century of film history, been notoriously difficult to define, whether as genre, style or value: a challenge all the more striking as the category is so frequently and easily used. Efforts to provide precise and useful definitions diverge in where they locate the crucial characteristics of the category. Some consider the defining moment to be that of production. In this view, it is documentary practice, the actions and intentions of film-makers and their subjects, that prescribe the categorization of the film. For others, the crucial site is the film itself. In this case, the film's appearance, aesthetics and style are the deciding factors. Yet another current would argue that what is crucial is a film's presentation to and interaction with viewers: marketing, promotion, and critical interpretation establish and, over time, determine the film's status. A more argumentatively pliant school of thought would say that it is the dynamic relationship between all of these moments that in fact make a documentary a documentary.

For the purposes of this volume, we will consider the particularity of the French case. French documentarians have worked both at the centre of various eras' hypothetically pure documentary modes as well as at the fuzzy margins between documentary and numerous other genres. Thus, the following essay recounts strong points in the history of French documentary film-making, specifically as it engages with the so-called cutting edge of documentary practice but also with the category's fuzzy boundaries. From both an aesthetic/technological as well as a production/industrial standpoint, documentary film-making has evolved in parallel to and often in dialogue with fiction film-making, particularly that of a realist mode.

The intertwined history of realist cinema and documentary is paralleled in scholarly and theoretical articulations on the same.[1] French thinkers have frequently seen in documentary a necessary companion to fiction – one that often functions as a platform from which to better understand the essential stakes of cinema itself. Thus, for Gilles Deleuze (writing in the 1980s), the early 'cinema of reality' provided an example of the constant give and take between subjectivity and objectivity at play in all cinematographic representation. In challenging fiction and turning to the real, according to Deleuze, early classic film-makers still maintained a model of truth that flowed from fiction (Deleuze 1989: 146–50). The 1960s model of documentary cinema would in turn demonstrate a self-referentiality that would displace and surpass the opposition of the real and the fictional, by offering 'real characters' who engage in self-narration (Deleuze 1989: 196). Although Deleuze implies a historical break (somewhat displaced from that of World War II against which he mapped the shift from the movement-image to the time-image), consistent across this break is the sense that fiction and non-fiction cinema are deeply implicated in each other.

The shifting place of verisimilitude has similarly shown the productive tensions between mainstream realisms and documentary. André Bazin, for instance, valued the reality present in the cinematographic image as well as the cinematographic image as reality itself: an ontological realism was his very definition of the cinema. In 1947, he praised Georges Rouquier for understanding, in *Farrebique* (1946),

that for the film industry in general 'verisimilitude had slowly taken the place of truth, that reality had slowly dissolved into realism', and moreover, for undertaking to 'rediscover reality' (Bazin 1997: 106). Thus, the documentary value of *Farrebique* displaced the centrality of verisimilitude. More recently, Jacques Rancière has suggested that the real difference between documentary and fiction 'isn't that the documentary sides with the real against the inventions of fiction, it's just that the documentary, instead of treating the real as an effect to be produced, treats it as a fact to be understood' (Rancière 2006: 158).[2] Documentary, in Rancière's view, has the freedom to disengage from the compulsion to produce verisimilitude, and the opportunity to embrace heterogeneous images within a single film.

Arguably the first French proto-documentarians were the Lumière brothers and their operators. In these fathers of French cinema, we can see the beginnings of various realist traditions (pictorial naturalism, neo-realism, etc.), where the real world and daily life is captured on-the-spot, but in carefully, dynamically, photographically composed and, indeed, often staged scenes. The Lumières' *actualités*, or 'actuality films', are also at the origins of the newsreel and current events reportage. Their *Arrivée des Congressistes à Neuville-sur-Saône/Arrival of a Congress* (1895) showcased the medium's potential gift of speed in presenting current events, as the photographers who arrived for their meeting were filmed in the morning and had that film projected for them that very afternoon. The temporal valence of *actualité* as that which is current, timely, and of the now, could not be more eloquently addressed. On a scale larger than a single stunt, speed was necessary to compete in the rapidly internationalized market for film, where cameramen were sent overseas to project a company's films in the evening, while shooting during the daytime and shipping the new footage home to nourish the domestic market. These globe-trotting cameramen evolved into the *chasseurs d'images* (literally, image hunters) of newsreel fame and anonymity, with the creation in 1908 of Pathé's newsreel division, the *journal cinématographique*.

World War I of course provided the newsreel with a nationalist mission, and indeed the French army did, during the middle of the war, create its own Photographic and Cinematographic section. By the 1930s, when Paramount opened a French actuality branch, the dashing and daring exoticism of the cameraman's adventures could be marketed to a public ever more conditioned for such attractions through World Fairs and Colonial Exhibitions (and of course the documentary and feature films of colonialism itself). Félix Mesguich, one of the Lumière brothers' earliest employees, thus similarly found a public for his 1933 memoir, *Tours de Manivelle* (literally, 'turns of the crank'). The newsreel remained a standard portion of a 'first part' of a French theatrical screening until the 1960s.

The interwar period was crucial to the international crystallization of 'documentary' as a set of practices and as a critical object. In 1922, the American Robert Flaherty made *Nanook of the North*; in 1926, the British John Grierson made the first use of the term documentary in print; in 1939, Grierson founded the National Film Board of Canada, one of the greatest producers of documentary films of the twentieth century. In France, documentary (writ large) comprised or overlapped with a number of genres and subgenres, some of which would be limited to that period, others would be precursors to later film-making.

The 1920s bore witness to a flourishing avant-garde whose city films have unarguable documentary value. These 'city symphonies' were an international phenomenon from which Paris, as a capital of modernity, could hardly be exempt. The city film exposes the deep ambivalence of high modernity with itself and its creations. René Clair's *Paris qui dort/The Crazy Ray* (1923) showed a city under the mysterious control of technology run amok, doing so by embracing the self-reflexive flourishes of freeze-frames and accelerated projection. Alberto Cavalcanti's *Rien que les heures/Nothing But the Hours* (1926)

turned a critical eye towards the politics of the proximity of rich and poor, as did Jean Vigo's *À propos de Nice* (1930), while Eugène Deslaw's *Montparnasse* (1929) celebrated both the popular and intellectual scenes of a single neighbourhood. These films were most successful in finding audiences through the ciné-clubs that were blossoming in this decade and remained active, though with less éclat, into the 1930s.

Up until the interwar period, it is probably most accurate to speak of pre-documentary non-fiction cinema. According to Guy Gauthier, the word '*documentaire*' first appeared around 1910 in Gaumont's catalogues to refer to films with scientific content (Gauthier 2004: 10).[3] Far from the public eye, the value of film for pedagogical purposes in medical schools was immediately grasped, but as a more mainstream phenomenon, 'scientific' and 'pedagogical documentary' would find one of its most prominent advocates and creative practitioners in Jean Painlevé in the 1920s–30s (Painlevé continued to make films up until the 1970s). A fellow traveller of the surrealists, Painlevé's work exposes the erotic, the violent, the cruel, but also the quirkily humorous and the breathtakingly beautiful in the natural world. Didactic voice-over soundtracks and title cards may guide and inform audience members, but the images themselves consistently escape from such overt goals, astonishing viewers with innovative microscopic and underwater camerawork.

Painlevé's axiom 'science is fiction' is not the only noteworthy complication of notions of non-fiction (fact, truth, documentary, etc.) and fiction that film history has seen. From the mid-1920s through the 1930s, the French film industry had frequent recourse to the term *documentaire romancé* (Flinn 2009). This now obsolete term referred to films that, in the wake and spirit of Flaherty's *Nanook* (the 1922 film maintaining critical currency due to the release of a sonorized version in 1931), presented a mixture of fictionalized narrative and non-fictional reportage. The sub-genre often took as its subject distant lands, thus simultaneously providing a lyrical counterpart to more didactic colonialist documentary and a perceptibly more factual counterpart to exoticist fictional film. Georges Lacombe's 1928 *La Zone: au pays des chiffonniers* provides a particularly domestic example of the *documentaire romancé*. A cousin to the city symphony, the film follows a day in the life of a family of rag-pickers who ostensibly lived in the sprawling shantytowns erected in the zone – where building was supposedly forbidden – of the city's final fortifications. The *documentaire romancé*'s hybrid interweaving of fact and fiction was understood to be justified in the service of capturing the 'truth' of a place and people, anticipating precisely what would be valued in 'poetic realist' films later in the decade. In this respect, documentary film found a way to usurp fiction film-making's prerogative to invent characters and/or events in order to move audiences to some better understanding of the world. Thus, the *documentaire romancé* is crucially different from current 'tele-reality' shows such as *Loft Story* (the first popular French reality show) or *Star Academy* (the French answer to *American Idol*), where casting calls recruit people who play themselves in 'real life' daily dramas or competitions. In the present day, the characters created and the dramas they enact are the spectacular entertainment end in and of itself. The *documentaire romancé*, in contrast, keeps much closer to the pedagogical and political goals of its contemporaries.

Those pedagogical and political goals were often characterized as propaganda. In contrast to the extremely negative connotations it carries today, propaganda (*propagande*) in the French cinema's classical (and early classical) period was a fairly neutral term. Propaganda might be industrial, social or political. Industrial films are works commissioned for the purpose of promoting a product or brand. They run the gamut from Citroën's two 'crossing' films – *La Croisière noire*/*The Black Journey* (Léon Poirier, 1926) and *La Croisière jaune*/*The Yellow Journey* (André Sauvage/Léon Poirier, 1932) – to Alain Resnais' *Le Chant du styrène* (1957). The *Croisière* films conjoin the promotion of the Citroën brand to the French colonialist agenda (regardless of territorial precisions,

the spirit of French technological and cultural superiority is evident from depictions of 'natives').[4] In contrast, Resnais' *Le Chant du styrène* is a riotously colourful celebration of polystyrene whose alexandrine verse voice-over scripted by OuLiPo poet and novelist Raymond Queneau never leaves the viewer exactly sure whether it can be taken seriously or not. While the purpose of industrial propaganda, like its cousin advertising, is to persuade, its ideology is more implicit than that of social or political propaganda.

Social propaganda would include the pedagogical cinema mentioned above, for the education of young people. But the state would engage in other attempts to affect social change through cinematic propaganda, such as the productions of the Agricultural Film Initiative, whose films sought to disseminate information on agricultural technologies and better practices, as well as to stem the tide of rural to urban population shift by touting rural careers.[5] These agricultural films of the 1920s and 1930s paved the way for the Vichy government's ruralist ideology. Meanwhile, films commissioned by the parties making up the coalition government of the Popular Front give the most fully realized example of pre-World War II political propaganda. The engaged cinema of the French Communist Party found its documentary apogee in the collaboratively made (with sequences directed by Jean Renoir, Jean-Paul Le Chanois, Jacques Brunius and Jacques Becker) *La Vie est à nous* (1936). The mix of fictional vignettes and political rally footage (staged and unstaged) found in *La Vie est à nous* is typical of the period's engaged film-making, where staged interactions between individuals or small groups build, via montage, into larger groups, with the audience cast as a non-diegetic extension of the community depicted on-screen. While most Popular Front documentaries were relegated to Communist Party ciné-club screenings, for films such as Jean-Paul Le Chanois' *Le Temps des cerises* (1937) a regular distribution visa was sought and obtained. Although the militant cinema of the Popular Front bore no box office successes, the idealistic models it established (both in production and distribution strategies) laid important groundwork for later generations of militant film-making. But the notion of film as political propaganda in fact exceeded the bounds of documentary narratives. In fact, it was a standard feature of film criticism of the interwar period to claim any French film that was successful abroad to be the best possible propaganda for France and for the French film industry.

By the time of the Vichy government and German Occupation, the potential effectiveness of film propaganda was a fairly ensconced notion, and the cinematic efforts of the French authorities were, according to Jean-Pierre Bertin-Maghit, focused on documentary production (Bertin-Maghit 2004). Bertin-Maghit usefully points out that truth, not lies, is the propagandist's most forceful tool, but that the deformation of truth towards specific ideological ends is the hallmark of propagandist production. Indeed, in the Gaullist years following the war, the crucial gesture in political propaganda was that of '*not* filming' the war of Algerian independence, in an effort to reassure metropolitan French audiences about the future of French Algeria (Denis 2008). Of the great post-war documentaries, René Vautier's *Afrique 50* (1950), Alain Resnais and Chris Marker's *Les Statues meurent aussi/Statues Also Die* (1953), and Resnais' *Nuit et Brouillard/Night and Fog* (1956) all suffered problems with authorities. Negatives of *Afrique 50* were seized and for the next 40 years, the film's only distribution was without a visa in anti-colonialist circles; *Statues Also Die* waited ten years (until after decolonization) before its revendication of 'negro art' could be shown in theatres; and visible kepi in *Night and Fog* made the participation of French police in deportations too uncomfortably clear. The increasing stigmatization of 'propaganda' as a mode of discourse associated with totalitarian governments, and the proliferation of progressive film-makers such as those associated with the Left Bank Group, have led to a shift in renaming: what was once propaganda is now 'militant' (*cinéma militant*) or 'engaged cinema' (*cinéma engagé*), while propaganda is a term reserved for clumsily executed militant cinema (particularly that which does not correspond to the critic's political point of view).

With a few notable exceptions (Georges Rouquier's *Farrebique*; Henri-Georges Clouzot's *Le Mystère Picasso/The Mystery of Picasso* [1956]; and Jean Rouch's *Moi, un Noir* [1959]), in the first decade and a half of the post-war period, 'documentary' and 'short subject' (*court-métrage*) were synonymous terms. Indeed, this was something of a golden age of the documentary short in France. Under Vichy, the *double programme*, or double feature, was banned in favour of one feature preceded by a short. This change led to an increase in funds and distribution available for documentary production and it provided the space for many young film-makers to cut their teeth, both in documentary and realist fiction. In December of 1953, the *Déclaration du Groupe des Trente* brought together short film-makers of fiction and animation, as well as documentary, to issue a manifesto in favour of the short film, threatened by the revocation of the 1940 law requiring the showing of a short prior to the screening of each feature-length film as well as the system of a proportional box office share being accorded to the short film. While no aesthetic unity characterized the work of these film-makers (who rapidly numbered far more than 30), they were united by their ambition for quality films and freedom of expression. Many of the members of the group went on to make feature-length films and be affiliated with the Left Bank Group (Jacques Demy, Alain Resnais, Chris Marker), while certain key producers (famously Pierre Braunberger) would function as midwives to the birth of the *nouvelle vague* (Chapuy and Jean-François 2005).

A wave of technological innovation through the 1940s and 1950s would render cameras and audio-recording devices lighter and more dynamic, benefiting both feature film in the form of the *nouvelle vague*'s embrace of a new realist aesthetic and documentary in the appearance of *cinema-vérité*. The year 1960 was a turning point, with Jean Rouch and Edgar Morin's (in conjunction with the Québecois Michel Brault) experiment in domestic ethnography, *Chronique d'un été/Chronicle of a Summer*. Rouch was already at this point well established as a maker of ethnographic films, particularly in Nigeria, where he served as mentor to many burgeoning Nigerian film-makers. The translation of Dziga Vertov's Russian expression *kino pravda* (literally, 'truth cinema') rapidly proved itself too fraught with ideological and ethical problems, and the term was nearly immediately abandoned by Rouch himself (the film-maker most closely associated with it) in favor of *cinéma direct*.

Referring to 'direct' audio recording proved to be less troubling and more durable – Brault, along with Pierre Perrault and other members of the National Film Board of Canada, would be a leader in the North American derivation of direct cinema. Nomenclature aside, *cinema-vérité* and *cinéma direct* both are characterized by ethical concerns about the place of the camera and film-maker in relationship to the subject. The mode can strive to be purely observational ('fly on a wall') or more interactive (such as when Rouch and Morin seek, in *Chronicle*, to provoke reactions from their subjects), but in all cases, the constant question of the relationship between film-maker and subject is of the utmost ethical concern.[6]

Another type of interventionist film-making came in the late 1960s and early 1970s, when film-makers like Chris Marker sought to empower the working class to make their own films (or at least work alongside film-making professionals), documenting strikes and other events of class struggle. Thus, films such as *Puisqu'on vous dit que c'est possible/We Maintain it is Possible* (Scopcolor/Chris Marker, 1973) documented the watershed strike at the LIP factory in 1972. The Groupe Medvedkine and ISKRA-SLON thus attempted to establish a different relationship between film-maker and subject. Chris Marker was simultaneously engaged with projects centred on various 'Third World' class and anti-colonialist struggles, alongside Joris Ivans and Marceline Loridan, among others.

Similarly inclined to use suggestive montage, but much more interested in the interview (in many guises) is Marcel Ophüls, who made a series of films from the 1960s to

1990s (often for Swiss television) that directly interrogate history. Using the deportation of Jews and the Holocaust of World War II as a typical focal point, Ophüls' films tend to unfold such that unexpected connections between events, such as the Nuremberg trials and the My Lai massacre, are revealed by the actors in these events themselves, as military and political functionaries who were youths during World War II would go on to positions of greater power in later years. Rejecting Ophüls' privileging of the words of historical actors, Claude Lanzmann's *Shoah* (1985) limits itself to the testimony of survivors and perpetrators, with no recourse throughout its marathon nine-and-one-half-hour duration to any archival footage – in direct opposition to films such as Nicole Védrès' *Paris 1900* (1947) or Claude Chabrol's *L'Oeil de Vichy/The Eye of Vichy* (1993), made exclusively of archival images.

While one current of late twentieth-century documentary (becoming identifiable in the 1950s and 1960s, and arguably a common form of art cinema by the turn of the twenty-first century) sought to work through history, yet another explored much more personal sorts of histories. If the 'essay film' rarely fits perfectly comfortably in the category of documentary, it is not aptly described as fiction either. Like a written essay, the film essay may take anything as its subject, spinning a meditation around a theme, often with a very strong personal voice as a unifying agent. Because French documentarians have so often worked in a lyrical, artistic mode, they are strongly represented in considerations of the essay film. The documentary corpuses of Raymond Depardon, Nicholas Philibert, Chris Marker, and Agnès Varda are prime examples.

The development of digital video cameras, DVD distribution, and the internet have proven to be even more radical for documentary film-making than the technological advances of the 1950s or the arrival of video in the 1980s. Extremely lightweight cameras and easy-to-use editing software have allowed contemporary documentarians a freedom and flexibility only dreamed of by practitioners of *cinéma direct*, while extending even further the window of accessibility to production and distribution for low-budget projects. For politically engaged cinema such as that of the *altermondialistes* (French anti-globalization activists), internet distribution allows film to do more than aspire to distribution outside of establishment channels and ciné-clubs of the already convinced.

Simultaneously, French documentarians have not neglected the possibilities of new media and interactive cinema. Chris Marker made early forays into CD-Rom art with his essay *Immemory* (1998), while mobilizing the overlaps between street, gallery and World Wide Web for the film *Chats perchés/The Case of the Grinning Cat* (2002).[7] In the soundly institutional realm, the Franco-German television station ARTE has commissioned and houses various interactive cinema works on its website, some of which may be characterized as documentary. Most explicitly, since 2008 the French daily newspaper *Le Monde* has produced an extensive number of 'webdocus' or 'webdocs': interactive documentaries available on lemonde.fr. Addressing a wide variety of historical, cultural and current event topics, lemonde.fr's 'Webdocus' rubric links to numerous other web-documentaries produced by the French multimedia press.

Indeed, since the mid-1980s, when LaSept/ARTE television situated itself prominently to play an active role in the popularization of quality documentary, there has been strong institutional support for documentary film-making – although this has not been without political struggle.[8] Even better news for French documentarians has been the dramatic upswing in box office performance by 'non-animal' documentary films (Cerf and Joyard 2002). With the nearly two million entries that surprisingly placed it in direct numerical competition with Cameron Crowe's *Vanilla Sky* in 2002, Nicholas Philibert's *Être et avoir/To Be and To Have* not only made its 'star' Jojo a poster boy for French documentary box office success, but also provoked fresh reflections on 'the intimacy between documentary and fiction' (Cerf and Joyard 2002: 14). Indeed, the turn of the millennium embrace of the real that has benefited documentary's box office performance interna-

tionally is also evident in the bleeding of documentary aesthetics into mainstream fiction film, such that at least two currents of realist cinema can be identified in France today. On the one hand is a 'traditional' realism such as Pascale Ferran's *Lady Chatterley* (2006) or Karin Albou's *La Petite Jérusalem/Little Jerusalem* (2005), which continues to invest in high production value verisimilitude. On the other hand are films such as Abdellatif Kéchiche's *L'Esquive/Games of Love and Chance* (2003) and Laurent Cantet's *Entre les murs/The Class* (2008), where handheld DV cameras, non-professional actors, and other hallmarks of current documentary style prevail. Indeed the intrusion of the real, or of documentary value, into the domain of fiction inspired the *Cahiers du Cinéma* to cast the 2008 selection at Cannes under the aegis of *fictions documentaires* (documentary fictions), showing that realist fiction and documentary maintain as close a relationship as ever in the twenty-first century.

Margaret C. Flinn

References

Bazin, André (1997) '*Farrebique, or the Paradox of Realism*', in Bert Cardullo (ed.), *Bazin at Work*, New York: Routledge, pp. 103–08.

Bertin-Maghit, Jean-Pierre (2004) *Les Documenteurs des années noires: Les documentaires de propagande, France 1940–44*, Paris: Nouveau monde éditions.

Cerf, Juliette and Joyard, Olivier (2002) 'Documentaire: Comment être et avoir du succès? Le reel est entré dans les salles', *Cahiers du Cinéma*, 573, November, pp. 12–16.

Chapuy, Arnaud and Cornu, Jean-François (2005) 'Les Producteurs du groupe des Trente, fondateurs d'une pré-Nouvelle Vague?', in Dominique Bluher and François Thomas (eds.), *Le Court Métrage français de 1945 à 1968: De l'âge d'or aux contrebandiers*, Rennes: Presses Universitaires de Rennes.

Deleuze, Gilles (1989) *Cinema 2: The Time-image*, Minneapolis: University of Minnesota Press.

Denis, Sébastien (2008) 'Comment (ne pas) filmer la guerre: le cinéma de propagande français sur l'Algérie (1945–1962)', in Jean-Pierre Bertin-Maghit (ed.), *Une histoire mondiale des cinemas de propaganda*, Paris: Nouveau monde éditions, pp. 511–30.

Flinn, Margaret C. (2009) 'Documenting Limits and the Limits of Documentary: Georges Lacombe's *La Zone* and the "*documentaire romance*"', *Sites: Contemporary French and Francophone Studies*, 13:4, pp. 405–13.

Gauthier, Guy (2004) *Un siècle de documentaires français*, Paris: Armand Colin.

Rancière, Jacques (2006) *Film Fables*, New York: Berg.

Notes

1 Two university manuals that lay out the contours of thinking on documentary in French are Guy Gauthier's *Le Documentaire, un autre cinéma* (Paris: Nathan, 1995) and François Niney's *L'Épreuve du reel à l'écran* (Brussels: De Boeck, 2002).

2 See also Jacques Rancière, 'Il est arrive quelque chose au réel', *Cahiers du Cinéma*, 545 (April 2000), pp. 62–64.

3 Gauthier goes on to say that the term would not come into common usage until the 1920s (2004: 41). The *Trésor de la langue française* places the first usage of the substantive *le documentaire* to 1915 (see: http://atilf.atilf.fr/tlf.htm).

4 See Peter J. Bloom, *French Colonial Documentary: Mythologies of Humanitarianism* (Minneapolis: University of Minnesota Press, 2008).

5 See Alison Murray Levine, *Framing the Nation: Documentary Film in Interwar France* (New York: Continuum, 2010).

6 Observational and interactive modes of representation are terms from Bill Nichols' *Representing Reality* (Bloomington and Indianapolis: Indiana University Press, 1991), pp. 38–56.

7 See Margaret C. Flinn, 'Signs of the Times: Chris Marker's *Chats perchés*', in James Austin (ed.), New Spaces for French and Francophone Cinema, *Yale French Studies*, 115 (2009), pp. 93–111.

8 See Jean-Louis Comolli, *Voir et pouvoir: L'Innocence perdue: cinéma, television, fiction, documentaire* (Paris: Verdier, 2004), and the website of the Association des Cinéastes Documentaristes (ADDOC), http://www.addoc.net/.

Les Plages d'Agnès, Ciné-Taramis, Canal+.

The Beaches of Agnès

Les Plages d'Agnès

Studios/Distributors:
Ciné-Tamaris
ARTE France Cinéma
Canal+

Director:
Agnès Varda

Producers:
Agnès Varda
Ciné-Tamaris

Synopsis

In Belgium, Varda creates an installation on the beach using mirrors, stages a re-enactment of herself as a child playing on the beach, and tours her childhood home in Brussels. In Sète, she recounts her adolescence and the making of her first feature, *La Pointe courte* (1954), creates an installation of a whale, and stages a trapeze performance on the beach. At an exhibition of her photographs in Avignon, Varda speaks of her early career as a professional photographer and mourns her mentor, Jean Vilar, and her late husband, Jacques Demy. In Noirmoutier, she recounts the making of *Cléo de 5 à 7/Cleo from 5 to 7* (1962) and other early films and speaks of her family life with Demy and their children. In Los Angeles, Varda visits old friends and discusses the films she made while living in the United States. Back in Paris, she speaks of feminism and revisits *Sans toit ni loi/Vagabond* (1985) and *L'Une chante, l'autre pas/One Sings, the Other Doesn't* (1977).

Critique

The Beaches of Agnès is an autobiographical documentary about the life and work of Agnès Varda. The film is roughly chronological

Cinematographers:

Alain Sakot
Hélène Louvart
Julie Fabry
Jean-Baptiste Morin
Agnès Varda

Composers:

Joanna Bruzdowicz
Stéphane Vilar
Laurent Levesque

Editors:

Jean-Baptiste Morin
Baptiste Filloux
Agnès Varda

Duration:

110 minutes

Genre:

Documentary

Persons:

Agnès Varda
André Lubrano
Blaise Fournier

Year:

2008

and organized around the beaches that have marked her life: the Belgian beaches where she vacationed as a child; Sète, where her family spent the war living on a barge; Los Angeles, where she lived in the late 1960s and then again in the early 1980s; the island of Noirmoutier off the Atlantic Coast of France; and the rue Daguerre in Paris, which she transformed into a beach for the film with the help of the City of Paris and a few tons of sand. The film is an intricate mix of Varda's visits to old friends, clips from her films, re-enactments of the past, and installation-making. *The Beaches of Agnès* is a hybrid documentary that foregrounds the intervention of the director while combining a wide range of source materials, such as interviews, archival footage and staged material. Jumping from one source to another, moving backwards and forwards through time, *The Beaches of Agnès* calls attention to associational links over chronology and celebrates discontinuity over clarity. We are left with a sense of Varda's stylistic experimentation and as well as her ceaseless productivity, her enviably large circle of friends and family, and her love of word play, poetry and paintings.

This is not the first documentary made by Varda infused with autobiography. In *Oncle Yanco/Uncle Yanco* (1967), we see Varda meet her bohemian Greek uncle on his houseboat in Sausalito; *Ulysse* (1986) explores the meaning of a photograph Varda made years previously. *Les Glaneurs et la glaneuse/The Gleaners and I* (2000) is about scavenging, but it also reveals Varda's fascination with her new digital video camera and her perspective on aging. *Beaches*, on the other hand, fits squarely into the subgenre of the autobiographical film, and yet there is nothing generic about it. Although we see snapshots of Varda's siblings, meet her mentors and friends (Chris Marker, Alexander Calder and Jim Morrison), and witness her love of Demy, the film largely avoids the tropes of the standard autobiographical documentary. Instead of exploring personal crisis or revealing a long-hidden childhood trauma, *The Beaches of Agnès* weaves an intricate and joyous tapestry of Varda's art and her life. We plunge into Varda's aesthetic itinerary, from the photographs she made for the Théatre National Populaire in the 1950s to the 2006 exhibition of her installations at the Cartier Foundation. As a result, we are reminded of the richness of her oeuvre, her playful personality, and her extraordinary legacy in both fiction and documentary films.

Varda's documentaries eschew the supposed neutrality of the observational documentaries such as *Etre et avoir/To Be and to Have* (Nicholas Philibert, 2000) or *10e Chambre/The 10th District Court* (Raymond Depardon, 2004). And yet her documentaries also avoid the intimate 'diary' quality of the autobiographical documentary released a year after her own, *Irène* (Alain Cavalier, 2009). Instead, her work is closer to that of Chris Marker and Alain Resnais, friends and fellow members of the Groupe des Trente, an organization comprised of many future New Wave film-makers that emerged in 1953 in support of the aesthetically adventurous short film. The essayistic impulse of *Lettre de Sibérie/Letter from Siberia* (Chris Marker, 1957) and the probing of documentary objectivity, history, and memory expressed in *Nuit et brouillard/Night and Fog*

(Alain Resnais, 1955) traverse Varda's documentary output.

Varda did not begin as a maker of documentaries. Her first film, *La Pointe courte*, was a fiction feature made completely outside of the French film industry and thus denied a standard theatrical release. She managed to establish her professional credentials only after directing *O Saisons, O Chateaux* (1957) and *Du Côté de la côte* (1958), documentary shorts commissioned by the Bureau du Tourisme to attract tourists to the Loire Valley and the Riviera, respectively. Only after making these highly regarded documentaries, along with the self-produced *L'Opéra-Mouffe* (1958), could Varda secure the funding for *Cleo from 5 to 7*, the fiction feature that brought her international visibility. However, in contrast to many film-makers, she continues to move back and forth between the documentary and the fiction film. Documentaries were never for Varda mere stepping stones on her way to fiction film; they were, and remain, central to her evolving aesthetic sensibility.

Little wonder, then, that Varda should enlist the documentary as a vehicle for thinking through the key events of her past. But she also uses *The Beaches of Agnès* to document and fuel her current passion: the multimedia installation. Some of the film's most compelling scenes show Varda at work creating new installations. Beyond documenting the creation of future installations, the film reveals Varda's newfound passion for digital tools and the choices they afford. The film's densely layered compositions, its fragmentation of the frame, and its intensified use of associational editing evoke Varda's installations as much as her earlier films. With regard to this new phase in her career, Varda often quips that she is 'une vieille cinéaste et une jeune plasticienne' (an old film-maker and a young visual artist), but it is also clear that the strategies she gleaned from the art fair and the gallery have fed back into her documentary practice, nourishing it with new energy and ideas.

Kelley Conway

Black Journey

La Croisière noire

Studio/Distributor:
Gaumont

Director:
Léon Poirier

Synopsis

In October 1924, Georges-Marie Haardt and Louis Audoin-Dubreuil set off with a group of eight Citroën halftrack automobiles (*autochenilles*) on an eight-month journey across Africa, remembered as 'La Croisière noire' ('Black Journey'). The voyage covered over 12,500 miles of the African continent, from Algeria to Madagascar. It was a huge public relations triumph for André Citroën. The expedition also created a rich iconographic archive of film, photographs, paintings, and drawings that continue to circulate in the twenty-first century.

Producer:

André Citroën

Screenwriter:

Léon Poirier

Cinematographer:

Georges Specht

Original Music:

Orchestre des Musiciens du
Théâtre National de l'Opéra
conducted by J. E. Szyfer.

Duration:

52 minutes

Genre:

Documentary

Persons:

Georges-Marie Haardt
Louis Audoin-Dubreuil
Alexandre Iacovleff
Charles Brull

Year:

1926

Critique

The most famous of the iconographic traces of the 'Black Journey'
expedition, Léon Poirier's film, is an important milestone in docu-
mentary from the silent era. Its enduring popularity can be partly
attributed to the quality of Georges Specht's images, partly to the
triumph-against-the-elements nature of the expedition itself, partly
to the relentless self-promotion of the Citroën team, and partly to
France's abiding affection for the Citroën automobile. Aside from
these exceptional elements, the music, editing, and commentary
do little to distinguish the film from other colonial documentaries
of its time.

Black Journey alternates between scenes of the road and
vignettes of the travellers' encounters with African people. The cars
struggle through Sahara sands, rumble in and out of craters and
ravines, and float across rivers and lakes balanced on hollowed-
out logs. Occasionally, they get so irretrievably stuck that it takes
an army of Africans to pull them out. When the expedition stops,
Poirier and Specht document what they see: the painter, Alexander
Iakovlev, sketching an African chief; Djerma horsemen perform-
ing in a fantasia; Sara-Djingé women showing off their lip plates;
or the travellers hunting lions and fighting brush fires. The film is
action-packed from beginning to end, right up to the final arrival in
Madagascar.

André Citroën conceived of this expedition as a grand national
enterprise. In addition to publicizing Citroën automobiles, he
wanted to focus international attention on the political, military,
and commercial strength of the French empire and to inspire
colonial vocations in France's youth. The compelling nature of
these arguments as well as his own personal charisma gained him a
meeting with the President of the Republic, an official mission from
the government, and logistical support from colonial authorities
along the way.

The 1926 version of Poirier's Black Journey reflects the pro-
colonialist interests underlying the expedition. The opening
credits dedicate the film to French youth, suggesting the desire
to inspire young people to choose work in the colonies. When the
travellers arrive in Bangui, the titles describe it as a place where
'French energy has done its work: a city is born where no men were
thought to have been able to live'. The commentary makes refer-
ence to 'barbarous' traditions such as human sacrifice, to 'civiliza-
tion's conquests', to white 'sorcerors' amazing Africans by their
technical prowess, to astonished Africans who have never seen
themselves in a mirror, and to 'pygmies' and 'strange little gnomes'
in the forest.

Other elements of colonial propaganda are present in more
subtle forms. By bringing diverse locations into the standard
format of the film frame, under the French flag, the film rationalizes
the empire, making it into a consumable commodity for metropoli-
tan audiences. As with many colonial travel texts and films from
the interwar period, the travellers appear to simply pass through,
sketching, filming, writing, and chatting with their hosts. The

technological mastery over nature that was a key component of the French civilizing mission, however, permeates the film. Guns kill wild animals, all-terrain automobiles cross roadless areas, flood-lights divert malaria-carrying mosquitoes, and cameras, collecting equipment, and scientific classification systems amass images and knowledge. When necessary, the film exaggerates the success of the technology for the purposes of public relations: in the film, the cars slip gently and easily into 'the unknown reaches of the equatorial forest' when in reality, as Haardt reveals in his memoir, it took a team of 40,000 people several months to cut a path through the jungle. The film ends with a montage of images from the journey superimposed on the French flag, encompassing the entire African continent in one sweeping rhetorical flourish.

Black Journey drew unprecedented crowds, and unlike most documentaries of the time, it was separately billed as a full-length feature. Full-page photo spreads were splashed all over the film magazines of 1926, and the coverage at all levels of the popular press was extensive. Reviews were overwhelmingly positive, praising the thrill of adventure and the window onto mysterious landscapes and people delivered by the film. Haardt's 300-page memoir of the journey was published in 1927 and translated into English that same year. There was even a 'croisière noire' rage in popular culture, leading to new trends in ladies' fashion and hairstyles in Paris and a new line of children's toys. The film inspired Hergé's 1930 comic *Tintin au Congo/Tintin in the Congo* and served as an educational tool in French schools for decades after its release. In 1984, the Citroën automobile company, which retains the rights to the film, produced a re-edited version which is entitled *Black Journey* and contains footage from the original. The new version has completely different music and commentary and elides all the references to French colonialism that permeate the original. The film is of interest for its documentary value but also for the fascination it continues to exert on scholars, travellers, and automobile enthusiasts alike.

Alison J. Murray Levine

France is an Empire

La France est un empire

Studios/Distributors:
Ciné Reportages
Réalité

Synopsis

France is an Empire, conceived by the adventure novelist Jean d'Agraives, depicts the French colonial endeavour as a sweeping narrative of national accomplishment. Recently released on DVD by Les Documents Cinématographiques, the film provides a clear snapshot of prevailing colonial values in 1939 France. It is also noteworthy because its production and distribution coincide with the key moment of transition from the demise of the Third Republic to the 'dark years'.

Critique

Jean d'Agraives intended his film as 'a lively synthesis of the French

Distribution parisienne de films et les productions Charles Bauche

Directors:

Gaston Chelle
Hervé Missir
Georges Barrois
Raymond Méjat
André Persin

Producer:

Charles Bauche

Screenwriters:

Jean d'Agraives (Frédéric Causse)
Emmanuel Bourcier

Cinematographers:

Gaston Chelle
Hervé Missir
Georges Barrois
Raymond Méjat
André Persin

Composer:

Van Hoorebéke

Editor:

Jean Loubignac

Narrators:

Jacques Breteuil
Claude Darget
Henri Garden
Maya Noël

Duration:

94 minutes

Genre:

Documentary

Persons:

Eléonore Klarwein
Odile Michel
Anouk Ferjac

Year:

1939

colonial enterprise'. He wanted to make a clean break with traditional colonial documentaries that were a 'hodgepodge of stock footage pulled out of film libraries' (D'Agraives 1939). Instead, he would send camera operators all over the empire to shoot up-to-date images of colonial achievements. Government agencies were enthusiastic, and the production went forward with considerable public backing despite the approach of war. The final cut was finished in the fall of 1939.

France is an Empire is rhetorically similar to many colonial propaganda films that circulated in France during the 1930s. Its basic premise is to oppose an afflicted pre-colonial past to a happier, healthier colonial present. Before the arrival of the French in the colonies, 'famine and sickness decimated animals and humans' and the people had only 'strange and secret rites' and 'barbarous music' to address these problems. Justice was cruel, and people lived under harsh authoritarian rulers.

The French colonizers master and eliminate these problems, following the arguments of French colonial humanism. A map shows a series of pulsating rays of light emanating out from France across the world. Civil administration, based on the universal values of the French Republic, arrives in the colonies. 'Luxurious hospitals' spring up in French Guyana; 'former slaves' in West Africa, 'shivering on bare earth, come to know the caress of white sheets'. Agricultural improvements and modern means of transportation such as roads, railroads, and air routes bring prosperity both to France and to the colonies themselves.

Particularly prominent in this film are pro-colonial arguments based on pronatalism, important to a nation in demographic decline. Western science 'guarantees fertility' to colonized women. Images of immaculate white sheets and clothing reinforce the forward march of hygiene and reproductive vigor. 'The empire constantly grows with little beings': France's imperial future. Also prominent is the ideal of colour blind Republican education as a vehicle for social promotion. European children sit alongside African students with the comment that 'all children learn on the same bench. Same homework, same games, same rewards.' Educated 'natives' serve in diverse positions in the French military, educational and health care systems. They are grateful to 'the mother country, their country'. The French respect and encourage religious liberties and 'native arts' as well.

This view of respect for local cultures builds up to a highly nationalistic and militaristic climax. Because France is a benevolent colonizer, the narrator claims, the peoples of its empire are happy, healthy, and eager to demonstrate their loyalty through military service. Images of colonized people all over the world follow in quick succession. 'An armed force of all colours, of all races, of all religions has risen', proclaims the narrator, 'because there is not one France and its colonies, but one common fatherland, made up of men with a shared ideal: to live free or die'. The last words of this sequence accompany an image of a small Asian child writing in white chalk on a black slate the words, 'France is our fatherland'. The technological mastery of the empire results in a conflation of

the represented empire with a revitalized nation ready to fight.

France is an Empire constantly seeks to appeal to the broad consensus on colonialism that prevailed in France's political centre. This observation helps to explain how a film produced in the late Third Republic could be used for several years in the Vichy government's propaganda campaign. For French people of all political stripes, the empire represented a source of national pride and strength in the face of a humiliating defeat. *France is an Empire* could potentially appeal to either side, since its overarching message and rhetorical strategies are deliberately non-controversial, and various images of the film correspond to differing social visions. The mix of political ideologies in the film demonstrates the reconfiguration of traditional political affiliations on colonial issues.

Having circulated for several years under Vichy, *France is an Empire* was banned on 8 June 1943 by Pierre Laval's film censorship board, which did not record a specific reason for its opposition (Viewing notes 1943). Perhaps their objections were based on the strong message of racial equality that permeates the film, or on the images of women working outside the home, or on the swelling crescendo of French military might at the end. Whatever the reason, the film exemplifies the colonial consensus that reigned in 1939. Many politicians and ordinary people believed that France's colonial project should combine colonial humanism and economic development; that it should proclaim respect for cultural diversity and racial equality, at least in words; and that the empire was a potential source of demographic and patriotic strength in the face of the approaching cataclysm.

Alison J. Murray Levine

References

Commission de contrôle cinématographique (1943) Viewing notes, 8 June, French National Archives, F 60 1560.
D'Agraives, Jean (1939) 'Projet de scénario', 30 March, French National Archives, F60 711.

Farrebique

Studio/Distributor:
Films E. Lallier

Director:
Georges Rouquier

Producer:
Jacques Girard

Synopsis

Filmed between 1944–45, *Farrebique*'s idyllic portrait of a small farm in the south central French region of Aveyron ignores the impact of the four-year-long German occupation on the country. Instead, only the four seasons and nature's commands regulate the everyday and the work of this family led by the patriarchal grandfather. The first few scenes enable Rouquier to present the premises, situate the farm in relation to the nearby village, Goutrens, and introduce briefly the main characters while establishing basic narrative elements. The necessity to repair and extend the living quarters calls for a family meeting in order to plan the grandfather's succession – as a result, his fictional death at the end

Screenwriter:

Georges Rouquier (adapted from an idea by Claude Blanchard)

Cinematographers:

André A. Dantan
Marcel Fradétal
Jean-Jacques Rebuffat

Composer:

Henri Sauguet (directed by Roger Désormières and accompanied by the Concert Orchestra of the Conservatoire)

Editors:

Madeleine Gug
Renée Varlet

Duration:

90 minutes

Genre:

Documentary

Persons:

Residents of Farrebique, the farm, their relatives and neighbours

Year:

1946

of the film almost comes as no surprise. In the early minutes of the film, Georges Rouquier establishes therefore the double nature of his film, which is best described as a fictionalized documentary or a documentary fiction. Throughout the film, views of the farm life alternate with close-ups of the wildlife and weather-altered elements, giving evidence of the harmonious interaction of human presence and nature.

Critique

As an autodidact, Georges Rouquier successfully maintained in most of his films a balance between the timelessness of his cinematic vision and the timely capture of cultural transitions in French society. *Farrebique* is thus poised between, on the one hand, the imperative of filiation through the transmission and the respect of traditions, and on the other, the attraction of urban life and the impulse of modernity and modernization. Several aesthetic projects converge in *Farrebique*. The contemplative, lyrical depictions of Aveyron's landscapes evoke turn of the twentieth-century rural cinema's nostalgic views of the land. However, what could be another example of romanticized objectifications of nature finds a more dynamic force through Rouquier's visual experimentations with time-lapse, a technique inspired by his friend and collaborator Jean Painlevé. Cinema's unique technological capacity to render the invisible visible and surpass the human eye participates here in Rouquier's efforts to make tangible the organic cycles of growth, production, and self-regeneration that equally apply to nature and the farm in the film. If montage sequences, alternating between microscopic, almost scientific, views of the soil and the plants and shots of the human bodies working the land and fighting storms recall Soviet cinema's epic agricultural narratives, *Farrebique* does not share the sociopolitical agenda of Dziga Vertov and Alexander Dovzhenko. One might even suggest that what really interests Rouquier is simply the organic connection that exists between humankind and nature whereas the two aesthetic positions mentioned above – pastoral cinema and Soviet montage – describe the subordination of nature to man-made ideological agendas.

Upon its release, *Farrebique* sparked controversial reactions on the part of certain critics who did not find Le Rouergue, the region where the film was shot, picturesque enough. In 1946, Rouquier's decision to showcase his family region was new, since the success of Marcel Pagnol's films in the 1930s had essentially reduced the French countryside to the lavender fields and sun-bathed vegetation of Provence. Most importantly, his celebration of small farming undermined the political efforts that had been engaged for about two decades to modernize rural areas and industrialize farming. If *Farrebique* ends with the electrification of the farm – the symbol of its access to modern comfort – the visual poetry of Rouquier's images is at its strongest when filming the skillful gestures with which these men and women work the land and sustain themselves in the microcosmic world of *Farrebique*.

In 1948, French film critic André Bazin defended Rouquier's

aesthetic choices, particularly his 'mysterious and paradoxical photographic operation at the end of which all we are left with is the consciousness of this reality' (Bazin 2002: 11). This timely intervention made *Farrebique* an example of what Bazin then saw as a radical shift in cinematic realism away from the picturesque and artificial embellishments. Although distinct in many ways from the neo-realism in vogue at the time, Rouquier shared with his Italian contemporaries a fascination with the mundane, a reliance on non-professional actors, and a concern for duration as the true expression of time. Having his own relatives play the roles instead of asking actors to interpret their life came as a necessity for Rouquier, who believed that professional actors could not grasp the true nature of rural culture and that cinema's recreation of the rural could only look artificial. The film-maker's genius, though, resides in this pursuit of authenticity while providing his 'actors' with lines and adjusting their life to dramatic imperatives. If several influences are tangible in *Farrebique*, this ability to maintain, and even enhance, documentary integrity through fictional accents has distinguished Georges Rouquier's cinema and continues to make it unique.

Awarded the Grand Prix du Cinéma Français and the first FIPRESCI prize by the International Federation of Film Critics in 1946, *Farrebique* remains Georges Rouquier's masterpiece. And rightly so, this atypical fictionalized documentary encapsulates the film-maker's cinematic style and the social concerns that informed his work from his early short documentary films, including *Vendanges* (1929) and the critically acclaimed *Le Tonnelier* (1942), to his last film, *Biquefarre* (1983), *Farrebique*'s sequel. If he tried to diversify his cinema during the 1950s, either by exploring new locations (Spain, Parisian suburbs and Québec) or experimenting with more conventional fictional forms, Georges Rouquier's legacy to French cinema undoubtedly rests with his farmers, whose genuine cinematic presence continues to mesmerize viewers and inspire film-makers in the early twenty-first century.

Audrey Evrard

References

Bazin, André (2002) 'Three Forgotten French Filmmakers: André Cayatte, Georges Rouquier, and Roger Leenhardt', *Cinema Journal*, 42: 1, pp. 3–20.

Hotel Terminus: The Life and Times of Klaus

Barbie

Synopsis

Nominally a biography of the Gestapo chief who deported hundreds of Jews to Nazi death camps and tortured French resistance fighters in Lyon, *Hotel Terminus* is devoted primarily to reconstructing the web of political, ideological, and legal factors that enabled Barbie to evade justice for nearly four decades and to disseminate his genocidal expertise internationally. Using testimony from eighty witnesses recorded in six different countries, Ophüls chronicles

Studio/Distributor:
The Samuel Goldwyn Company

Director:
Marcel Ophüls

Producers:
John Friedman
Marcel Ophüls
Hamilton Fish
Peter Kovler

Screenwriter:
Marcel Ophüls

Cinematographers:
Michael Davis
Pierre Boffety
Reuben Aaronson
Wilhelm Rösing
Lionel Legros
Daniel Chabet
Paul Gonon
Hans Haber

Sound Editors:
Anne Weil
Michel Trouillard

Editors:
Albert Jurgenson
Catherine Zins

Duration:
267 minutes

Genre:
Documentary

Persons:
Klaus Barbie
Claude Lanzmann
Marcel Ophüls

Year:
1988

Barbie's wartime crimes against humanity; his post-war escape from Europe with the aid of the US Army's Counter-Intelligence Corps (CIC) and the Vatican; his subsequent work for brutal military dictatorships in South America; the twelve-year battle surrounding his extradition to France for trial; and finally, his 1987 conviction and condemnation to life in prison.

Critique

Hotel Terminus is the last in a cycle of four epic documentaries that Ophüls made about Nazism, the war, and their pivotal role in shaping western society during the second half of the twentieth century. Just as *Munich, ou la paix pour cent ans/Peace in Our Time: The Munich Accords* (1967) and *Le Chagrin et la pitié: chronique d'une ville française sous l'Occupation/The Sorrow and the Pity: Chronicle of a French City during the Occupation* (1969) rewrote collective historical memory by exposing France and Great Britain's complacent appeasement of Hitler in 1938 and the depth of French collaboration with the Germans during the war, *Hotel Terminus* details the CIC's recruitment of Barbie in 1945 to secure anti-Soviet intelligence and its subsequent tolerance of his anti-communist 'consulting' in Bolivia and Peru. In its sweeping international scope and engagement with the complex legal and moral dimensions of justice, the film also strongly echoes *The Memory of Justice* (1976), Ophüls' earlier film which juxtaposed the Allies' uneven prosecution of Nazi leaders at the Nuremberg Trials, French paratroopers' use of torture during the Algerian War, and American war crimes committed in Vietnam.

The formal composition and tone of *Hotel Terminus* marked a turning point in Ophüls' unorthodox approach to documentary. Whereas his previous work sought to reveal repressed historical truths and revise collective memory through the contrapuntal montage of archival film footage, popular music and newly recorded interviews, often incorporating irony or dark humour as narrative tools, the Barbie film relies almost exclusively on retrospective witness testimony and adopts a more earnest register. This shift is attributable in part to the deep personal resonance of the subject for the half-Jewish Ophüls, who before the age of fourteen twice fled state-sponsored anti-Semitism, leaving Germany for France in 1933 just after Hitler's election as chancellor, and France for America in 1940 following the creation of the collaborationist Vichy regime. Equally crucial were the extraordinarily difficult conditions under which the film was produced and edited. The project consumed more than four years in all, plagued by ad hoc financing, gruelling and expensive travel between three continents, a serious accident in South America that left the director hospitalized for several weeks, and an overdose of prescription medication that also required treatment.

Since the outset of his career, Ophüls had always rejected the premise of documentary objectivity as a self-deluded pretense and defended every director's right to present a personal, partisan point of view. In the 1960s, the director explicitly set his work

against the so-called 'direct' or 'observational' style pioneered by Robert Drew, Richard Leacock and the Maysles brothers. To that end, Ophüls constantly adapted his interview style to colour the testimony of his witnesses, alternatively serving as sympathetic confidant, wry devil's advocate, and didactic rectifier of key factual errors. In *Hotel Terminus* he goes a step further, openly acknowledging his own anger and frustration by bullying and harassing witnesses. On one memorable occasion, he reveals his Jewish heritage to one of Barbie's Bolivian confidants and asks whether Barbie 'taught him how to recognize a Jew'. In another, he surprises another former Gestapo chief at home and demands a justification for the deportation of a two-year-old Jewish girl to Auschwitz. After having the door slammed in his face, Ophüls responds with a cheery 'Merry Christmas' and smiles broadly at the camera.

Such footage, supplemented with several intentionally derisory, comedic skits – including one where the film-maker looks for the same officer in a vegetable garden under frost blankets – underscores the complacent hypocrisy of geriatric Nazis' claims to ignorance of the Holocaust, innocence of any wrongdoing, and the right to privacy. In narrative terms, the staged sequences and 'ambush' interviews fulfill the same function as the insertion of feature film clips and music in *Peace in Our Time* and *The Sorrow and the Pity*. *Hotel Terminus* continues that precedent to some degree by likening the CIC's pursuit of Nazi criminals to an episode of Mack Sennett's Keystone Kops and using Fred Astaire's rendition of 'Pick Yourself Up' to underscore the continuity between Nazi and American anti-communism. However, German folk songs performed a cappella by the Vienna Boys Choir dominate the soundtrack. Recurring nearly two dozen times like an ancient Greek chorus, they remind viewers of the Jewish children that Barbie murdered, establish a link with Ophüls' own childhood, and express the film's leitmotif of finding justice for all the innocent victims of Nazism.

Although *Hotel Terminus* performed poorly at the box office in both the United States and Europe, selling fewer than 35,000 tickets in France and failing to cover production expenses, the dissident, four-and-a-half-hour history lesson was greeted with nearly unanimous critical acclaim. In addition to winning prizes at festivals in Berlin, Amsterdam and Cannes, it received the 1988 Academy Award for Best Documentary. The film also solidified Ophüls' legacy as one of the most influential documentary filmmakers of all time. Among the many directors he has influenced, the best ,known are Kevin Macdonald, who in 2007 released his own investigation of Barbie's South American career under the title *My Enemy's Enemy*, and Michael Moore, who continues Ophüls' tenacious critique of political and legal institutions though ironic contrapuntal montage, confrontational interviews, and darkly humorous playacting.

Brett Bowles

L'Espoir

Studio/Distributor:
Les Productions André Malraux

Director:
André Malraux

Producers:
Edouard Corniglion-Molinier
Roland Tual

Screenwriters:
André Malraux
Max Aub
Denis Marion
Boris Peskine

Cinematographer:
Jean Bachelet

Composer:
Darius Milhaud

Editors:
Georges Grace
André Malraux

Duration:
88 minutes

Genre:
Documentary

Persons:
Andrés Mejuto
José Sempere
Nicolás Rodríguez
Julio Peña
Pedro Codina
José María Lado
Serafín Ferro
Miguel Del Castillo

Year:
1939/1945

Synopsis

Set during the Spanish Civil War, *L'Espoir* focuses on an ill-equipped Republican air squadron near Teruel that must destroy an enemy bridge and airfield to cut off supplies to Franco's troops. The aviators depend on local committees and peasants for information, equipment, and logistics support in an environment where towns are not completely loyal to one side or the other. The early morning bombing mission is successful, but a tangle with Franco's fighters leaves one bomber heavily damaged. It crashes in the mountains, and the film's final sequence features hundreds of townspeople carrying the injured and dead aviators down the mountain to ambulances, honouring their heroic sacrifice.

Critique

Malraux began to develop his film project during a 1937 US tour to rally support for foreign intervention in the Spanish Civil War. Malraux made a number of speeches, but his words failed to convince. The recent documentaries shot in Spain about the conflict had likewise little effect. During the Hollywood leg of his trip, Malraux decided to make a feature-length film that straddled the line between document and fiction. He used fictional techniques in order to increase the emotional impact of the film and attract a wider audience, making it potentially more persuasive than a pure documentary. At the same time, Malraux's contemporaries lauded the film's realism, indicating the extent to which they also viewed the film within the generic expectations of documentary.

Malraux's film is not an adaptation of his novel *L'Espoir/Man's Hope* (1938). Rather, it is based on the same source materials he had used for that novel, most notably, his own experience leading an air squadron in Spain. Malraux had originally wanted to shoot it in French with French actors, but the Republican government that financed the film did not have enough foreign currency to give him, so he was forced to shoot it in Spain with professional and non-professional Spanish-speaking actors. This constraint no doubt increased the film's perceived realism.

The biggest influence on Malraux's cinematic aesthetic was Eisenstein's theories and practices of montage. Malraux admired Eisenstein's work throughout the 1930s and they even collaborated on an adaptation of Malraux's previous novel, *La Condition humaine/Man's Fate* (1933), which was never made. Throughout *L'Espoir* Malraux practices montage within and between images. Indeed, the whole film can be seen as a collection of intense moments loosely connected by narrative. His compositions often emphasize diagonal lines in tension and he repeatedly inserts poetic images for maximal impact. The best example is the scene when two Republican guerillas ram a car into an artillery position held by nationalists. Malraux cross-cuts between an off-axis shot of the Republicans firing from their car and a straight-on shot of

Espoir/Sierra De Teruel, Les
Productions André Malraux.

the cannon barrel. As the car picks up speed, Malraux increases
the pace of the cross-cutting until the moment of the crash, when
he cuts away to a low-angle shot looking straight up at the sky
covered with flying pigeons. Malraux then cuts back to a high-
angle shot looking down on the head and shoulders of a dead
Republican with a car wheel spinning rapidly over his head. The
wheel casts pulsating rhythmic shadows on the scene that echo the
pigeons' movements.

Malraux wrote in his 1939 *Esquisse pour une psychologie du
cinéma* that the invention of the cut allowed film to express point
of view. During the bombing sequence, a peasant desperately tries
to recognize his town from the sky in order to help the aviators
locate the airfield that lies beyond. As he begins to panic, Malraux
cross-cuts between closer and closer shots of his face and the
ground as the plane descends. The shots of the ground flail wildly
in all directions, suggesting the peasant's frantic visual search. It is
only when he finds his mark and relaxes that the camera pulls back
once more.

Malraux also employs a visual lyricism throughout *L'Espoir* that goes beyond the mere realism of the story. When the local Republicans leave their staging area for a mission, the camera pans back and lingers on a large beaker of liquid that vibrates with the sounds of overhead bombs. A later shot features a dead man's head lying next to a running stream of water that contrasts with the blood trickling down the pavement. During the aerial chase sequence just before the crash, Malraux cuts to an extreme close-up of an ant crawling across the gun turret's targeting reticule. Finally, there is the long closing sequence in which hundreds of villagers pass the aviators' bodies down the mountain on stretchers. Malraux cross-cuts between shots of hands passing bodies along, and long tracking shots of villagers looking down at them. As the bodies pass, many silently give the Republican salute. The shots gradually become wider and wider, filled to the brim with more and more villagers. The scope of these final images reinforces a central preoccupation of the film: Malraux's roving camera continually seeks out the community of faces that look on and contribute to the cause as best they can. Despite the particularity of individual characters, Republican actions emerge form, and belong to, the community.

Franco's victory put an end to the film's principal production. Malraux finished the final sequence in France and cut together what he had, but the film had lost its immediate propaganda context. It was not even released in theatres until after French liberation, when an introduction was prepended to the film to link the film's portrayal of Republican struggle to the French Resistance. Nevertheless, the film never had the wide propaganda impact that Malraux had hoped for. *L'Espoir* remains an exciting film to watch, particularly for its dynamic aerial bombing sequence. It embodies one of the central aesthetic tensions of documentary cinema during the 1930s – the fictionalizing that was common in documentaries and the attention to quasi-documentary realism that one finds in fictional cinema like French Poetic Realism. Like his decision to lead a Spanish air squadron despite having no flying experience, Malraux's only film remains a testament to what someone with no film-making experience can do with the support of a strong team when the need was great.

David Pettersen

Blood of the Beasts

Le Sang des bêtes

Synopsis

A short opening sequence, narrated by Nicole Ladmiral's childlike voice, reveals Paris' southwestern outskirts by the Porte de Vanves. Wastelands serve as playgrounds for the neighbourhood's children and bric-a-brac traders set up impromptu flea markets. The camera's initial detours through this peaceful, although incongruous, décor lead to Franju's central subject: the French capital's slaughterhouses. Once the camera has passed the gates, surmounted by

Studio/Distributor:
Forces et voix de la France

Director:
Georges Franju

Producers:
Paul Legros
Forces et Voix de France

Screenwriter:
Georges Franju

Cinematographer:
Marcel Fradetal

Composer:
Joseph Kosma

Editor:
André Joseph

Duration:
20 minutes

Genre:
Documentary

Year:
1949

two stone bulls, Georges Hubert's detached voice-over – strangely reminiscent of Luis Buñuel's ironic pseudo-ethnographic commentator in *Land Without Bread* (1933) – briefly presents the tools and the men behind the doors of the establishment. There follow several extremely graphic scenes: first, the shocking on-screen killing of a horse, and then, numerous shots of dismembered animals hauled around and shipped away carelessly.

Critique

Influenced by Luis Buñuel, Robert Flaherty and John Grierson, Georges Franju's cinema counts feature-length fictions, most notably *Eyes Without a Face* (1960), now a classic example of French horror cinema, and his 1963 remake of Louis Feuillade's 1916 series *Judex*. Franju has also left a fairly small, but amazing, body of documentary works produced for the most part during the 1950s. Critics have essentially focused on what Raymond Durgnat describes as the 'slaughter tryptich': *Blood of the Beasts*, *En passant par la Lorraine* (1950) and *Hôtel des Invalides* (1951) (Durgnat 1968: 43). In spite of the patriotic undertone of the film production company's name, Forces et Voix de France, these three films express Georges Franju's personal reading of his country's scarred history. Strong critiques of industrialization, war, and more generally speaking, of the systemic cruelty of political and economic structures are wrapped up in cinematic poetry.

Blood of the Beasts epitomizes what Gérard Leblanc (1992) rightfully identified as Georges Franju's 'aesthetics of destabilization'. From his early years as a set designer, Franju kept his capacity to enhance the intrinsic theatricality and dramatic intensity of atmospheres and spaces. In *Blood of the Beasts*, this clearly comes through in the juxtaposition of shots filmed inside the slaughterhouse and lingering views of the surrounding wastelands, the gloomy Canal de l'Ourcq and stern building façades. It is Georges Franju's compression of several aesthetics and socio-historical realities in the same cinematic moment and image that makes it such a powerful and disturbing film for its time.

Adam Lowenstein has perfectly noted Franju's Benjaminian allegorization of modern history through these animal carcasses, the victims of everyday predation. If spectators are viscerally repelled and disturbed by the violence that the documentary imposes on them, Franju's sophisticated intermeshing of several film aesthetics conjures up the ghosts of the Holocaust. As Franju borrows from the impressionistic waterways and peripheral industrial zones of 1930s French Poetic Realism, slanted views of freight trains intensify the looming presence of danger across the cityscape and recall the horrific convoys that ended in concentration camps during World War II. Similarly, low- and high-angles of tall, flattened façades backlit by the sky stand, as if detached from the surface of the image, like the architectural skeletons of war zones.

Released only a few years after the end of the war and the public exposure of the camps, *Blood of the Beasts* raises fundamental

questions about humanity and animality. Throughout the film, Franju repeatedly confuses human and animal subjective points of view, inviting his spectators to reassess the meaning of the title: are the beasts the animals being slaughtered or those who dismember them? Do the documentary's shocking aesthetics intend to glorify the butchers or, on the contrary, encourage the spectator to see through the animal victims' eyes? Franju's combination of surrealism, Poetic Realism and still photography explores the blurred line that distinguishes bestial behaviours from human social relations at a time when all ethical safeguards seemed to have collapsed.

Audrey Evrard

References

Durgnat, Raymond (1968) *Franju*, Los Angeles: University of California Press, pp. 43.
Leblanc, Gérard (1992) *Georges Franju: une esthétique de la déstabilisation*, Paris: Creaphis Editions.

Nogent, Eldorado du dimanche

Studio/Distributor:
Studio des Ursulines

Directors:
Marcel Carné
Marcel Sanvoisin
Producers:
Marcel Carné
Marcel Sanvoisin

Screenwriter:
Marcel Carné

Cinematographer:
Marcel Carné

Art Director:
Marcel Carné

Composer:
Bernard Gérard

Editor:
Marcel Carné

Synopsis

A day in the life of the Parisian working classes, who take trains each Sunday from the capital to the nearby rural suburb of Nogent-sur-Marne. Some sunbathe, swim and cycle; others visit the *guinguettes* (dancing halls), taverns and riverside cafés. As people head back to the city, a blind accordionist plays a nostalgic, wistful tune.

Critique

Carné's career can be divided into two distinct phases. Firstly, his output between *Jenny* (1936) and *Les Portes de la nuit/Gates of the Night* (1946) exemplifies the classical French cinema tradition, with its heightened visual style, detailed scripts and star performers. Among those nine films are the Poetic Realist classics *Le Quai des brumes/Port of Shadows* (1938) and *Le Jour se lève/Daybreak* (1939), and Carné's masterpiece, *Les Enfants du Paradis/Children of Paradise* (1945). Post-1946, Carné's emphasis on studio design and rigid narrative determinism was shunted aside by the spontaneity of the *nouvelle vague*, and later films like *Trois chambres à Manhattan/Three Rooms in Manhattan* (1965) and *Les Assassins de l'ordre/Law Breakers* (1971) were coolly received by audiences and critics.

Before all this came *Nogent*, in 1929. Made in between Carné's spells as assistant to Richard Oswald on *Cagliostro/The Mummy* (1929) and René Clair on *Sous les toits de Paris/Under the Roofs of Paris* (1930) a year later, this densely packed, semi-Impressionist silent documentary shows the simple pleasures of the Parisian working class on a Sunday afternoon excursion along the River

Duration:

17 minutes

Genre:

Documentary

Persons:

Anonymous inhabitants of Paris

Year:

1929

Marne. Each Sunday, hoards of Parisians would take the four-mile train journey from Bastille to sites like Nogent-sur-Marne and Joinville-le-Pont, and Carné looks to capture a whole city at play. As couples dance and soldiers relax in a field, his nascent pictorial instinct emerges, and, alongside films by other new directors like Georges Lacombe and Jean Dréville, *Nogent* helped inject a 'New Objectivity' aesthetic into late French silent cinema.

This is Carné's apprenticeship film, working in an unfamiliar documentary mode that nonetheless provided him with an opportunity to explore a specific style and mood. Like other city symphonies popular in this period – *Man With a Move Camera* (Dziga Vertov, 1929), *A Propos de Nice/About Nice* (Jean Vigo, 1930), *Berlin, Symphony of a City* (1926), *Rien que les heures/Nothing But Time* (Alberto Cavalcanti, 1926) and *People on Sunday* (Curt and Robert Siodmak, 1930) – *Nogent* is a combination of blistering energy and movement, and a joyful remembrance of things past. It is also a paean to nature, with extended shots of rivers, rippling currents, grassy banks, and dappled light on leaves. Ideologically, *Nogent* places the working class at the forefront of cultural achievement. Whilst working as a film critic at *Cinémagazine* in the late 1920s, Carné argued vociferously that cinema should be a tool for celebrating and ennobling the working class. *Nogent* is incrementally sketching out a new aesthetic, anticipating the future optimism of the Popular Front years (with its 35-hour working week and paid holidays) with a stylized and nostalgic visual sense.

Carné's sincerity towards his subject matter and his appropriation of populist iconography and topography which would later become key visual motifs in his oeuvre, coupled with *Nogent*'s depiction of escape and freedom from the travails of Paris, anticipates one of Carné's recurrent themes – characters looking to escape from the confines of their grim urban environment into a limitless 'elsewhere' bound by strong community values. The film opens with trains hurtling out of Paris towards the banks of the Marne. Carné intercuts these relentless shots with the blandness of city life left behind – factories, stock exchanges, and rows of silent typewriters – and then shows these ordinary people at play in their newfound Eden; swimming, rowing, fishing and dancing. There is something highly abstract about these opening images – some critics even detect a Futurist bent in *Nogent* – in which the stark diagonal lines of train tracks and industrial pylons carve up the screen, and layer the film with an in-built cyclical structure. The riverside taverns captured by Carné's roving camera seem to have stepped straight out of a Sisley or a Monet, with the play of light and the interaction of the working class. These *guinguettes* (open-air cafés made famous in Julien Duvivier's 1936 *La Belle Equipe/They Were Five*) remain an integral part of French popular culture, like the music that took place in them. Bernard Gérard's non-stop accordion soundtrack further imbues the film with a strong sense of time and place, and is a fitting accompaniment to a film shot entirely outdoors (Carné would rarely stray outside the controlling confines of the studio again).

Though only seventeen minutes long, the film requires several

viewings to appreciate the wealth of social detail. With its rhythmic musical structure, *Nogent* plays out like a symphony, with its final shots heralding the end of the day, the departure back to Paris for its Sunday trippers, and a return to a Edenic peace and quiet in the country. As night falls, a blind accordionist plays, and people troop back to their urban lives – it is this undercurrent of nostalgia, sadness even, which always emanates from Carné's best work. That blind figure appears in Carné's later films – at the start of *Daybreak*, as 'Fate' in *Gates of the Night* – and might even be read as Carné himself, providing the action with insistent maudlin undertones.

Today, the Marne has been transformed into a vast industrial wasteland, dominated by Euro Disney and bland convention centres. *Nogent* thus remains the ultimate time-capsule, showcasing the lives of ordinary working-class Parisians in barely recognizable surroundings. This is also France before the Great Depression, before the political and social fissures that Carné's later films would explore in a far more melancholic register. It is regrettable that, due to illness and lack of money, Carné could not make his final film, an adaptation of Guy de Maupassant's *Mouche/Fly* (1890), which was to have taken place once again down by the Marne. Instead, his last film was *La Bible/The Bible*, made in 1977. A study of the Old and New Testament mosaics on Sicily's Monreale Basilica, it marked a return to the documentary register of *Nogent*, nearly 50 years earlier. Two documentaries thus bookend a remarkable career, full of the kind of woozy visual memories, populist narratives, and graceful camerawork that *Nogent* introduced for the first time.

Ben McCann

Profiles of Farmers: The Approach

Profils paysans: L'Approche

Studio/Distributor:
Canal+
Palmeraie et Désert

Director:
Raymond Depardon

Synopsis

Raymond Depardon's trilogy on French rural life is as much about the disappearance of a way of life as it is about a personal journey. Filmed between 1998 and 2008, *The Approach* and *Daily Life* (the two parts of *Profils paysans* ['Profiles of Peasants']) and *Modern Life* document the everyday resilience of individuals and families who have chosen to stay in, or move to, remote farms in the medium mountains of France's central regions of Lozère, Auvergne, Haute-Loire and Aveyron. Over the years and repeated visits, Raymond Depardon gained the confidence of his hosts. Some, already well in their eighties at the beginning of the project, have died; others have started families or retired. As he films them in their homes and at work, the film-maker negotiates through different styles the difficult encounter of cinema with rural culture. The ethnographic humility of Depardon's works on Africa (*Désert/The Desert* [2000]; *Afriques: Comment va la douleur/Africa: How Are You With Pain* [1996]) meets here the perspicacious observation of the everyday he practiced in psychiatric hospitals (*San Clemente* [1982]), police stations (*Faits divers/News Items* [1983]), emergency rooms

Producer:

Claudine Nougaret

Cinematographers:

Raymond Depardon
Beatrice Mizrahi

Sound Recordists:

Claudine Nougaret
Jean-Alexandre Villemer

Editor:

Roger Ikhlef

Duration:

90 minutes

Genre:

Documentary

Persons:

Marcelle Brès
Raymond Privat
Marcel Privat and others

Year:

2000

Profiles of Farmers: Daily Life

Profils paysans: Le Quotidien

Studio/Distributor:

Canal+
Palmeraie et Désert

Director:

Raymond Depardon

Producers:

Claudine Nougaret
Raymond Depardon

Cinematographer:

Raymond Depardon

Sound Recordist:

Claudine Nougaret

(*Urgences/Emergencies* [1988]), and courts of law (*Délits flagrants/ Caught in the Act* [1994]; *10ème Chambre – Instants d'audience/ The 10th District Court – Moments of Trial* [2004]). Comparisons have been drawn between Depardon's cinematic treatment of civic institutions and Frederick Wiseman's; *Profils paysans* and *Modern Life*, however, bring him closer to Georges Rouquier's truthful documentary depictions of peasantry in the 1940s.

Critique

Born and raised on a farm, Raymond Depardon moved away in the 1950s to pursue a career as a photographer in Paris and travel abroad, but his rural origins continued to inspire his work. In addition to photographs taken on the family farm in the 1980s and a ten-minute video conversation with his brother, *Quoi de neuf au Garet?/What's New at Garet*, in 2005, after his father's death, Raymond Depardon has also completed photography series of French rural lifestyles and diverse landscapes commissioned by *Le Pèlerin* (1986), *Libération* (1990), and more recently, the French Ministry of Tourism (2003–08). While working on this documentary trilogy, Depardon published a collection of essays and photographs (*Errance/Wandering* [2004]) and co-curated an exhibition with Paul Virilio at the Fondation Cartier in Paris (November 2008–March 2009). These two projects engage with the tensions that arise for individuals torn between an inexplicable bond to their homeland and the relentless impulse to wander through the world.

The Approach starts with a slow forward-tracking shot onto a narrow winding road clasped between the valley and a rocky wall of a mountain. Although Depardon's desire to capture a disappearing way of life hardly escapes nostalgia, the initial slow unfolding of the road, accompanied by the haunting, melancholic tune composed by Gabriel Fauré, breaks away from the static quality of pastoral landscapes traditionally used in rural and heritage cinema. Instead, mobility and immersion orient the image in the present and the viewer's experience in the film-maker's roving attitude towards rural life. In this first film, Depardon relies extensively on the fixed-frame cinematography that prevailed in several of his previous documentaries. Marcelle Brès, Raymond and Marcel Privat, and the other people present in the trilogy are typically filmed across kitchen tables with limited intrusions from the film-maker. His remaining absent and silent while his subjects converse with one another emphasizes the distance maintained both as part of the documentary apparatus and by his hosts unimpressed by the camera's presence. By the end of this first film, however, a first stylistic change is introduced: the visible impact of Louis Brès' death on his neighbours leads Depardon to resort to a more traditional interview set-up, reminiscent of testimonial documentaries shot in the aftermath of a traumatic event. Monique Rouvière, Marcel and Raymond Privat's niece, sits facing the camera, now placed closer to her. In order to facilitate her comments, Depardon's low, off-screen voice asks her specific questions.

Picking up a few months later, *Daily Life* resumes and experi-

Editor:

Simon Jacquet

Duration:

85 minutes

Genre:

Documentary

Persons:

Marcelle Brès

Raymond Privat

Marcel Privat and others

Year:

2004

Modern Life
La Vie moderne

Studio/Distributor:

Canal+

Palmeraie et Désert

Director:

Raymond Depardon

Producer:

Claudine Nougaret

Cinematographer:

Raymond Depardon

Composer:

Gabriel Fauré

Editor:

Simon Jacquet

Persons:

Raymond Privat

Marcel Privat and others

Duration:

90 minutes

Genre:

Documentary

Year:

2008

ments further with Raymond Depardon's more interactive, mobile camera. In this second film, exterior shots are more common as Depardon films more of the farmers' professional activities. Yet, closer proximity does not necessarily mean increased access. When he tries to pry further into the lives and feelings of his subjects, the film-maker is often forced to improvise to maintain his film's integrity as the people in front of the camera, most notably Marcel Privat, simply refuse to answer his questions and move away. Of the three films, *Daily Life* is probably the most dynamic insofar as it articulates Depardon's transition from fixed-frame observation to a more fluid *cinema-vérité* style. Notwithstanding a hitch here and there, the clumsy 'Parisian' persona that the film-maker endorses, to encourage his subjects to speak slowly, becomes unnecessary as his growing acceptance makes more intimate conversations finally possible. *Daily Life* ends with a long sequence during which Depardon, filming Alain Rouvière at work, brings him to talk about the causes of high rates of celibacy among farmers and his own romantic life.

Contrary to the two parts of *Profils paysans*, *Modern Life* is self-sufficient and, as such, Depardon mixes filming styles more freely. Yet, by the end, he noticeably returns to more composed photographic portraits and shots that accentuate the impending obsolescence of these characters' way of life. Instead of dismissing Depardon's final aesthetic decision as one that essentializes his entire project, one can see here the film-maker's last homage to the farmers' compliance to documentary conventions all along. In the 1960s, Pierre Bourdieu had conducted research on peasant farmers and photography: he concluded that peasants' traditional pose, facing the camera and standing in the middle of the frame, was the expression of respectful distance, a central value of the rural ethos. The frontal portraits that close the trilogy illustrate therefore Raymond Depardon's renewed proximity with these people while affirming their eternal presence in collective memory.

Audrey Evrard

Le joli mai, Sofracinema.

Le joli mai

Studio/Distributor:
Sofracinema
Pathé Contemporary Films

Directors:
Chris Marker
Pierre Lhomme

Producer:
Chris Marker

Synopsis

A documentary about Paris and its inhabitants. Chris Marker and cameraman Lhomme interview Parisians on the street and in their homes. Interviewees include housewives, shop-workers, hairdressers and engineers, and the topics range from the French-Algerian conflict via the stock market to daily life, housing and working conditions, and marriage. The focus is on how the interviewees perceive themselves, but the themes of Algeria and money (or the lack thereof), are repeated throughout.

Critique

Although possibly a reaction to Jean Rouch and Edgar Morin's *cinema-vérité*-defining *Chronique d'un été/Chronicle of a Summer*

Screenwriters:

Chris Marker
Catherine Varlin

Cinematographers:

Etienne Becker
Denys Clerval
Pierre Lhomme
Pierre Villemain

Composer:

Michel Legrand

Editors:

Madelein Lecompere
Anne Meunier
Eva Zora

Duration:

165 minutes

Genre:

Documentary

Persons:

Simone Signoret
Yves Montand

Year:

1963

(1961), Marker and Lhomme's multi-vocal, anthropological film differs in fundamental ways. Both, however, share guerrilla production values, including the handheld cameras that freed their operators to wander the streets and helped define *cinema-vérité* as a subgroup of the *nouvelle vague*.

Marker, however, preferred the North American term for this documentary genre – 'direct cinema'. He also coined the homophonic, neologism; '*ciné, ma vérité*' ('cine, my truth'), believing that the form could not offer an absolute, objective truth. *Le joli mai* certainly does not attempt to reveal one. Through Lhomme's camerawork and Marker's direction, especially at the editing stage, the pair create *their* truth; manipulating the footage to convey an argument, which is antithetical to the purportedly unsullied, fly-on-the-wall footage of, say, Pennebaker's *Don't Look Back* (1967).

The camera, which moves in synchronicity with interviewees' dialogue (or testimony) adds a depth that regular talking heads framing does not. When the only black interviewee is asked whether he has any white companions, and hesitates to respond, the camera moves sharply right so he is framed left, before he says 'No'. The man is decentred sociologically and politically, posited on the periphery of (the racist) French society, and on the Left. Lhomme also evokes humour from this device. When, for example, they interview a dancer on the floor, who talks about the twist saying that 'dancing takes the place of a woman', the camera pans in on his gyrating hips. The scenes in the Stock Exchange, shot from above, reveal what would become Marker's trademark auteurist, acerbic wit, showing the brokers and traders as ants. Closer, silent shots depict them as braying beasts, in sharp counterpoint to the arrogance that permeates their interviews. This is typical of the film more widely, as some interviewees are undermined, with contradiction constructed through montage, while others are portrayed with sympathy.

The film-makers seem to be offering their subjects' empowerment in sequences such as that of the mechanic who paints abstract art with religious themes. He mentions 'a gallery' and the film cuts to a sequence *inside* one, with what we assume to be petit-bourgeois patrons milling about. The edit questions preconceived ideas about art, its production and consumption. Yet in revealing the authorial hand, they sabotage this impression of democracy; it is the film-makers who are speaking, it is *they* who have final edit. Later, three engineers have their conversation similarly interrupted: first by shots of cats, mainly somnolent, one of Marker's many animal avatars; secondly by shots of people traversing Paris, including Jean-Luc Godard and Anna Karina in a car, Alain Resnais walking down a street and Agnès Varda (all friends of Marker).

Marker's seal is prevalent throughout the text, through the inserts described above and scenes that reference a strike at a Renault works (60 per cent of workers are deaf by 50 as the plant is so noisy) and footage of police brutality; a metonym for the barbarous State. These look forward to Marker's work with the Medvedkin group of the later 1960s (which aimed to give voice to blue-collar

workers) and later films, such as *Le fond de l'air est rouge/Grin Without a Cat* (1977).

Mai has a more poetic sensibility than the films of either *cinema-vérité* or direct cinema, closer to Vigo's sketch of Nice than Rouch's Paris, as in the time-lapse shots that form the penultimate scenes. Here, traffic skirts the L'Arc de Triomphe, trains disgorge passengers, people shop at street markets, all glossed by Simone Signoret's voice-over which reels off facts, in a mock-documentary style, about that month: 999,300 metro trips made, 40 hours less sunlight than average, and food, and births and deaths.

The temporal setting is no accident. May 1962 was considered the first spring of peace after seven or eight years of the Algerian War. It is Algeria, the 'problem' as it is euphemistically referred to throughout, which throws *its* shadow over the film, permeating the text. The groom-to-be, a soldier due to leave for Algeria in a few weeks, and his wife refuse to discuss the situation. The couple is indicative of the ignorance displayed by many (white) French, so much so that the directors counterbalance this denial of racism with footage of an Algerian youth openly discussing the racism he has encountered in France. His testimony, including that his entire family were killed in the 'former' colony, accompanies a travelling-shot through an alleyway in a slum. This is the Paris that the immigrants know, the reality ignored or denied by the 'indigenous' population. An edit here juxtaposes the Algerian youth's interview with the Jeanne d'Arc Feast Day celebrations, attended by military officers. The colonized, are given voice, adjacent to dumb colonizers, is made more pompous by their silence.

Marker's first film to focus on France, in a career that was then a decade old, does not depict his compatriots as being members of an enlightened nation. What begins as ostensibly an ode to the city, 'the most beautiful in the world', soon unveils this as simply a veneer, as the camera burrows into the depths of Parisian society, discovering ignorance and poverty, active racism and greed. The final shots attempt to expose the effects of this on Parisians. The camera hovers over maudlin, lost faces in the crowd; Signoret asks, 'Is it the thought that your noblest deeds are mortal [...] is it because beauty is mortal?' The beauty of the city, and by extension the country, has been debased, ruined by its colonial exploits, which resonates within the experiences of its inhabitants, both white and ethnic.

Kierran Horner

Le Mystère Picasso, Filmsonor.

The Mystery of Picasso

Le Mystère Picasso

Studio/Distributor:
Filmsonor

Director:
Henri-Georges Clouzot

Producer:
Henri-Georges Clouzot

Cinematographer:
Claude Renoir

Composer:
Georges Auric

Editor:
Henri Colpi

Synopsis

An intimate document of Pablo Picasso at work in his studio. Through an innovative process incorporating special inks, semi-transparent canvases, and single-frame photography, director Henri-Georges Clouzot captures the creative process of one of the twentieth century's most important artists. Picasso himself only appears in the film to contextualize the act of his painting or to create a sense of drama. But his presence is felt throughout, articulated through the boldness of his line and the firmness of his direction as he creates a number of illustrations, collages and paintings.

Critique

The Mystery of Picasso is one of the most atypical Henri-Georges Clouzot films. Made just after the director's two greatest works, *Le Salaire de la Peur/The Wages of Fear* (1953) and *Les Diaboliques* (1956), it reveals a very different side of Clouzot. This film broke from the suspense-driven Hitchcockian narratives he was known for, and presented instead a unique document of one of the twentieth century's greatest artists at work. But, as some critics have pointed out, *The Mystery of Picasso* is still a suspense film. It operates on many of the same levels as his narrative films in terms of how information is given to the audience. Many of the paintings in the film change drastically throughout the process of creation, and there is often a sense of not knowing what comes next. One painting

Duration:

78 minutes

Genre:

Documentary

Person:

Pablo Picasso

Year:

1956

depicts the image of a fish, which then transforms into a chicken and finally a sort of tribal mask. There is a real sense of exploration as the paintings progress, but also an awareness that all control lies in the hands of the artist. Picasso will sometimes take an image that feels finished and drastically alter it by blacking out entire areas or repainting over the main figure of the piece. Some paintings reveal the range of Picasso's abilities as an artist, from the technical per-fection he was capable of from an early age to the more cartoonish style he became known for in his later years, as layer upon layer is added to the evolving image.

With *The Mystery of Picasso*, Clouzot and the artist wanted to show the metamorphosis of a painting from beginning to end. Picasso used special inks on a semi-transparent canvas, and the image that bled through on the other side was photographed. The oil paintings featured later in the documentary were filmed by Picasso adding one brush stroke at a time, and then stepping out of the way so the camera could record the evolving images, which Clouzot later pieced together with a series of dissolves. Clouzot worked with cinematographer Claude Renoir (nephew of film-maker Jean Renoir and grandson of painter Pierre-Auguste Renoir), who used black-and-white to show Picasso at work in the studio and colour to emphasize the paintings. The artist produced twenty original pieces for this film, but destroyed them afterwards to ensure that the film became the art. In 1984, the French govern-ment declared the film a national treasure. It remains one of the twentieth century's most unique documentaries.

Brian Wilson

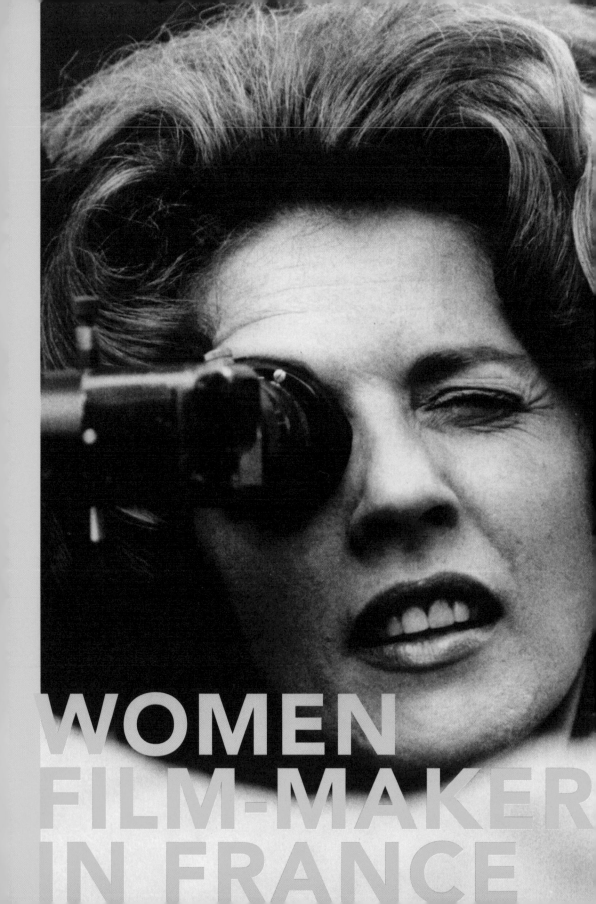

WOMEN
FILM-MAKER
IN FRANCE

Chauvinism surrounds the job of film director – so much so that it often goes unchallenged, as if male control of cinema is somehow inherent to how film-making works. But here France's history of female-made cinema offers a poignant corrective: an alternative model of embattled, constrained, but sometimes prosperous possibilities for women behind the camera. At the outset, though, we must acknowledge that this course of French women's film-making is fraught with historiographical bias and resilient male-centred hegemony. From our contemporary vantage point, however, when the proportion of women-directed features in France can rise as high as 25 per cent each year, progress has clearly been made. How? While France is rarely celebrated for gender equality in a broader social or political sense (see Drake 2011: 122–30), its cinema industry does feature female agency – varyingly catalytic – during all its historical phases. Hence, this essay will explore the roles of women, minority iconoclasts with a growing reach, during France's evolving production modes: the beginnings of the film industry; the classical period of France's (loose) studio system and its professionalized divisions of labour; rival avant-garde alternatives to mainstream film practice; the rise of auteur cinema instilled by the New Wave; the cultural resonance of feminism after the 1970s and 1980s; and lastly the contemporary moment, with women at work more widely than ever before. This is the complex of French women's contested film careers, individually and collectively engaging cinema over a century of conflict on- and off-screen.

Putting everything in perspective, women's film-making in France (and anywhere else) began with a pioneer, Alice Guy, whose pre-eminence as the first *femme du cinéma* will likely never be matched. But irony pervades Guy's checkered career: she succeeded so fluently yet was written out of film history for decades; and she enfranchised herself only before a patriarchal industrialization that stopped others from following in her footsteps. For prior to World War I, as France led the world in film production and export, aligned mainly to its two central outfits Pathé and Gaumont, Guy's course mirrored the national trajectory: rapid advance, calamitous decline. Guy's career had four stages: she was a director and the production manager at Gaumont (1896–1907); a film-maker and studio head (of Solax) in America (1910–14); an independent director-for-hire (until 1920); then, back in France, an exile from the film industry (after 1922). From a celebrity Guy turned into a pariah: beset by misfortune and a feckless husband she divorced, became unemployed, then saw her films attributed to others or else vanish. Léon Gaumont's 1930 studio history ignored everything from before 1907; it was only the mogul's son, Louis, who in 1954 revived Guy's seminal role. Early historians like Jean Mitry and Georges Sadoul then belatedly followed suit; a Cinémathèque Française celebration eventually came on 16 March 1957 (McMahan 2002: xxii–xxiv). Guy's memoir, *Autobiographie d'un pionnière du cinéma*, was finally published in 1976, eight years after her death; its release in English a decade later set in motion Guy's resurrection as a genuine early film icon.

Guy bequeaths us a complicated inheritance. Today, most – but still not all – film histories reintegrate her into the record (McMahan 2002; Simon 2010), correcting its old historiographical gender biases. Better still, Guy's once obscure or archive-only films are reappearing digitally, back from the brink. (Gaumont made amends for its founder's oversights by in 2008 producing two DVDs of Guy's work; a Kino English-language version followed the next year). Guy's is now a rousing story, especially told to beginning film students who are shocked to hear that she is still the only woman ever to own and run a designated film studio (built for Solax in 1912 in Fort Lee, New Jersey). What of Guy's actual films? Alan Williams reflects:

> Difficult to accept for left-leaning cinephiles, but [...] temperamentally [Guy] was a conservative, though an *adventurous* one: conservative in the sense that she reflected traditions, particularly social hierarchies, even when she thought they were strange or funny (which she often did). (cited in Simon 2010: 34–35).

Other scholars are less cautious, and Guy inarguably does provide a vision of female *participation* in early cinema, a witty antidote to the male-privileged work or leisure spectacles of the Lumières and Georges Méliès. In *Une Course d'obstacles/An Obstacle Course* (1906), for example, Guy presents women and men as equals, running amok together, collaborating as much as competing. Pointedly here, Guy's shots of inter-gender escapades feature French tricolours prominently, and while the race is won by a man he does so wearing women's clothes – cross-dressing being a subversion in many of Guy's productions (McMahan 2002: 206–41). Better known films like *Madame a des envies/Madam Has Her Fancies* (1906) make Guy's gender insouciance more overt, with a heavily pregnant id-woman stealing and consuming a lollipop, absinthe, a herring and a pipe, much to her glee and her diminutive husband's chagrin. Sharpest of all – a fixture now in discussions of Guy's French career – is *Les Résultats du feminism/The Results of Feminism* (1906) in which men primp and care for babies while women quaff liquor and aggressively assert their sexual needs. Gender roles revert back at the film's finale, but the opposite apparently occurs in Guy's sadly still lost (or as Joan Simon describes it: 'whereabouts unknown' [2010: 12]) counterpart-sequel, *In the Year 2000* (1912). A one-woman industry, making films of almost all genres, Guy's entertainments and social engagements are still not fully recognized.

After World War I, the professionalization of French cinema, while never as rigidly organized as Hollywood, nonetheless excluded women from most primary roles. As Karen Ward Mahar argues, in becoming a bona fide industry, cinema 'moved towards a model that prized business legitimacy [in a] shift that marginalized the woman film-maker' (2006: 133). (Concomitant to this, of course, were the rising careers of a wealth of female screen performers; feminist historian Paule Lejeune reflects ambivalently that

what's left is 'Stars, nothing but stars' [1987: 12].) Already minority figures, like Alice Guy before them, most studio-era women directors have been poorly served by archives and film history; their careers typically need excavation and archeology as much as analysis. Before sound, French film did accommodate film-makers like Jeanne Roques (aka Musidora), whose stardom let her occasionally produce and direct (her only surviving films are *Soleil et ombre* [1922] and *La Terre des taureaux* [1924], both shot in Spain); even more overlooked are other silent women directors like Renée Carl (alongside Musidora Louis Feuillade's protégée at Gaumont), Marie-Louise Iribe, Rose Lacau-Pansini, Gabrielle Sorère; and, in the documentary mode, Suzanne Devoyod, Eliane Tayar and Lucie Derain. (Derain's *Harmonies de Paris* [1928], which was restored by the Cinémathèque Française in 1996, in particular is a lively, elegant, overlooked city symphony film, a rare Albatros production whose *'Thème et Réalisation'* is credited to a woman.) Mainly the film industry pushed women into ancillary jobs: as editors (given France's perennial technological lag behind other countries, this was a role that stayed manually laborious for decades, the 'women's work' of scissors-and-splices rather than specialized craft using flatbed suites [Denis 2011: 69-73]), make-up artists, costumiers, or, in the faintly patronizing English term, 'script girls' (i.e. continuity or script supervisors). The latter role, summed up dryly by Many Barthod, herself a script supervisor in the 1970s, was to be, 'The woman of the crew [...] appreciated for being gentle and friendly [...] often a mother for the director [...] when she shows too much initiative she's put back in her place' (cited in Lejeune 1987: 13).

Exceptions to these norms, before and around the coming of sound, are Germaine Dulac and, to a lesser extent, Marie Epstein. As part of France's vivid 1920s avant-garde – Dulac as a feminist figurehead; Epstein as a fellow traveller alongside her brother Jean – this duo was singled out in Sandy Flitterman-Lewis' landmark *To Desire Differently: Feminism and the French Cinema* (1996). Dulac was that prized rarity: a prolific triple-threat theoretician/lecturer/film-maker, a staunch advocate, simultaneously, for the rights of women and the legitimacy of cinema. Working intermittently in commercial and independent circles (like her comrades Louis Delluc, Marcel L'Herbier, et al.), Dulac pursued the group's rallying principle of *photogénie*: that film, the putative Seventh Art, had a transformative capacity to render the inner lives of people and objects, transcribing lyrical states through rhythmic cinematography and editing. In Dulac's words, published in 1926 in *L'Art cinématographique*, pure cinema aimed 'to break loose from clearly formulated events [as] it sought an emotional agency in suggestion' (cited in Abel 1988: 393). Unlike many of her male Impressionist or – especially – surrealist peers, Dulac applied *photogénie* to the repressed subjective yearnings of women. Her quintessential motif, before synchronized sound, was the conflation (usually via superimpositions) of musical performances with pent-up feminist sensibilities: interior female lives orchestrated by, notably, the piano recitals of Dulac's iconic protagonist in *La Souriante Madame Beudet/The Smiling Madame Beudet* (1922), the raucous

café-concert performances (with women on banjo, cello and violin) in *L'Invitation au voyage/Invitation to a Voyage* (1927), or, in *Disque 957* (1928), poetic abstractions intercut with a Frédérique Chopin prelude played on a piano (represented by hands whose gender intriguingly changes in the course of the film).

Marie Epstein's situation bridges the advent of sound production; her subsequent neglect underlines the limited prospects of women film-makers in France's classical phase (Morrissey 2011). From the start, Epstein seems to have conceived of herself as a facilitator, a woman in a secondary role. Initially she was an assistant director and actress in her brother Jean's films (most memorably the murderous friend in *Coeur fidèle/Loyal Heart* [1923]), subsequently collaborating with the educational documentarian Jean Benoît-Lévy, then after World War II working under Henri Langlois as a print restorer at the Cinémathèque Française. Later rediscovered by feminist historians – Ginette Vincendeau's stirring 1995 obituary nonetheless calls her an 'excessively modest woman' – Epstein echoed Guy's fate as a once-forgotten woman, excluded from history, a process cued by Benoît-Lévy's 1946 memoir which devotes one solitary (albeit glowing) footnote to his long-time partner (Flitterman-Lewis 1996: 149–50). Despite Epstein's co-direction of nine features, from *Âmes d'enfants* (1928) to *Altitude 3,200/Youth in Revolt* (1938), some film histories even today give Benoît-Lévy sole authorial credit. But Epstein's work demands greater attention: if nothing else for the proto-feminist star vehicles she devised for Madeleine Renaud in *La Maternelle/ Children of Montmartre* (1933) and *Hélène* (1936). *La Maternelle*, a compelling account of empowering maternity (either literally or through Renaud's role as a caregiver to impoverished children in a Montmartre nursery school) is, simply stated, an essential text of 1930s French cinema, an exquisite female-centred counterpart to Jean Vigo's *Zéro de conduite/Zero for Conduct* (1933), and the whole template of male social marginalization in poetic realism. *La Maternelle* today exists on public domain DVD, and it needs to be screened more widely. Beyond Epstein's brittle fortunes, however, the much-vaunted artistic fertility of French classical cinema is not reflected by female directorial involvement. Ephemeral film-making careers were typical: from Solange Bussi (later Solange Térac) making two films in 1931 (*La Vagabonde* and *Mon amant l'assassin*) then never rising above screenwriting again; to three-time director Marguerite Viel; to a few documentarians like Lucette Gaudard, Claudine Lenoir and Elisabeth Sauvy-Tisseyre (aka Titaÿna).

Post-Liberation France saw crucial social reforms (women got the vote in 1944, Simone de Beauvoir's seminal *The Second Sex* was published in 1949) but arguably this period was the nadir of women's film-making. As post-war French cinema became more centrally regimented – principally after 1946 through the state-sponsored Centre National de la Cinématographie (CNC) and its mandated training school L'Institut des Hautes Etudes Cinématographiques (IDHEC) – the trade became further male-defined. A handful of women, nonetheless, apprenticed their way up through the ranks, as per the now standard trajectory. Andrée Feix,

a lifetime editor, managed to direct twice: the Edwige Feuillère vehicle *Il suffit d'une fois/Once is Enough* (1946), and *Capitaine Blomet* (1947). After eight years of assistantships Jacqueline Audry debuted as a director with *Les Malheurs de Sophie* (1946) and went on to make sixteen more films over the next quarter century; most are not well known. In retrospect, though, a key post-war female-made film is Audry's *Gigi* (1949), a faithful and popular adaptation of Colette's 1944 novella, typical for both author and director as a wryly observed comedy of socialization: the grooming of a young girl for, alternately (or interchangeably), marital or courtesan status. (All of the *Gigi*-novella and most of the *Gigi*-film takes place in a single apartment front room; Audry took the confined drama model to claustrophobic extremes with her unjustly obscure Sartre adaptation, the hell-parable and Arletty comeback *Huis clos* [1954].) Alongside Audry's *Gigi*, more notice is also due Nicole Vedrès' fascinating found footage documentary, *Paris 1900* (1947), recipient of the Prix Louis Delluc but probably its least-revived winner. Védrès, a journalist commissioned by producer Pierre Braunberger and assisted by a young Alain Resnais, collated a *fin-de-siècle* portrait of Paris entirely from Pathé's film archives, mostly borrowed from Langlois' Cinémathèque. Narrated in droll tones (by Claude Dauphin in the French release, Monty Wooley in the English-language version), *Paris 1900* ranges from divertingly anecdotal (like shots of Claude Monet, or Maurice Chevalier trying to charm Mistinguet) to socially incisive: early on Védrès features a twenty-minute montage of early twentieth-century women's changing mores, celebrating their efforts towards greater freedom.

The French New Wave sea change of the 1950s and 1960s in part diverted the film industry away from apprenticeships and professionalism towards young, amateur, brazen cinéphiles. This new template was not conducive to women, with the noted exception of Agnès Varda, whose creative persona, during her extraordinary emergence from *La Pointe courte* (1955) to *Cléo de 5 à 7/Cleo from 5 to 7* (1962), was that she was peripheral to the *Cahiers du Cinéma* male enclave and not a film fanatic – although she was quietly adept at marketing her work through the Parisian ciné-club network (Conway 2007). While the New Wave still basks in nostalgic celebrations, Geneviève Sellier has provocatively recast the movement via its male-centredness, the historiographical 'blind spot' of French gender studies, and the New Wave's socio-cultural 'first person masculine singular [...] [reflecting] a considerable gap between the aspirations of young men and young women' (Sellier 2008: 7). Still needing more revisionist work, however, is the effacement of women-directed works from the New Wave era, several of which echo Varda's ambiguous emancipation narrative in *Cleo from 5 to 7*. Audry's *Les Petits matins/Hitch-Hike* (1962), for example, is something of a classical-New Wave hybrid, shot on sets and on location, following the haphazard passage of Agathe (Agathe Aëms) south to the Côte d'Azur as she is set upon by men of all classes and motivations. An equally picaresque female road movie is Paule Delsol's *La Dérive* (1962), like *La Maternelle* a rich yet scandalously uncelebrated film, which actually appeared in

a 1962 *Cahiers du Cinéma* issue, trumpeted as an independent debut feature (i.e. New Wave contender); yet it was not released until November 1963 and has not found favour since. (Sellier protests this omission but only in a footnote, ironically reiterating the film's marginality [2008: 240].) Delsol, François Truffaut's ex-script supervisor (she and her husband even put him up while he shot *Les Mistons* [1957]), ended up a book and television writer, only making two features (her second was 1977's *Ben et Bénédicte*), and so like many women directors falls foul of the ubiquitous *auteur* complex: the peculiar notion that superior, canonical films require their directors' professional longevity. *La Dérive* also follows a restless young woman, Jacqueline (the nonprofessional Jacqueline Vandal), south from Paris to the Narbonais region, where she, as in the film's title, drifts. Tracking her mercurial heroine, Delsol's style is correspondingly audacious: she uses still inserts, freewheeling long takes interspersed with breathless dissolve-montages, documentary footage, jazz and folk musical asides, even silent-film intertitles to relay Jacqueline's enduring energy – and battered idealism – in the face of her declining prospects. *La Dérive* is a major New Wave film, available on DVD, whose obscurity highlights again the male-inclined conservatism of many film histories.

France's social ruptures, from May 1968 into the 1970s, inspired an influx of women film-makers into the trade, even if most of this new generation, like Delsol, did not sustain lifelong careers in cinema, just as their best films are yet to receive their due. In this context, while Jean-Luc Godard's *Weekend* (1967) is typically taken as a watershed moment in France's counter-cultural upheavals, two films by newcomer women, Nadine Trintignant's *Le Voleur de crimes/Crime Thief* (1969) and Nelly Kaplan's *La Fiancée du pirate/A Very Curious Girl* (1969), extend these scathing diagnoses to the social spheres of women as well as men. In *Le Voleur de crimes* Trintignant explores the sociopathy of Jean Giroud (Jean-Louis Trintignant), who witnesses a suicide then is consumed with an anti-social will to power that targets women; at one point a straitjacketed prisoner runs past him down a Paris street, as if rampaging lunatics are France's new social norm. More interesting still is Kaplan's *La Fiancée du pirate*, with Bernadette Lafont in a star vehicle that caustically inverts the sexism of her New Wave roles – especially Truffaut's *Les Mistons* – as a young woman, marooned in a dismal rural backwater, abused by the locals, who becomes a gleefully empowered and acquisitive prostitute, exposing her neighbours' hypocrisies. Here and often elsewhere in her multi-faceted journalistic, documentary, writing and film-making career, Kaplan reworks surrealist and/or pornographic materials into bracingly anarchistic, pro-female texts, from erotic novels like *Un Manteau de fou-rire* (1974) to films such as *Papa, les petits bateaux/Papa, the Little Boats* (1971; whose poster quite representatively features a smirking woman with a gun barrel for a vagina) and *Plaisir d'amour/The Pleasures of Love* (1991) (see Holmlund 1996).

The 1970s and after – a period hailed by Lejeune as 'The time of women' (1987: 69) – saw a far-reaching expansion in France of both women's social rights and women's film-making. In 1967 con-

35 *Rhums*, Wild Bunch.

traception was legalized, abortion was permitted (for a test period under the Veil Law in 1975; permanently after 1979), and in 1975 divorce by mutual consent became a social entitlement for both genders. Alongside these advances, many female film-makers, frequently working in low-budget contexts, began to direct authentically intimate coming-of-age texts, films that often broached identity politics. In this mode the multi-talented Nina Companeez is perhaps a representative figure, the long-time writer-editor partner of Michel Deville, whose lyrical debut feature, *Faustine et le bel été/Faustine and the Beautiful Summer* (1972) uses a painterly aesthetic to explore the artistic-romantic rites of passage of an introspective adolescent, Faustine (Muriel Catala), through her summer holiday experiences with an artistic neighbouring family. Engagingly built around female-centred fantasies (with many inversions of the so-called male gaze), *Faustine et le bel été* is one origin point for what Carrie Tarr and Brigitte Rollet consider a major conceptual trope of women-made cinema from the 1970s to the present day: 'Growing-up films set in the past [which] tap into the collective imagination by evoking nostalgia and longing for a lost, imagined world [...] [or else] evoking anger and pain at past disillusionments' (Tarr with Rollet 2001: 25). Examples of this tendency, observing feminine transitional states and burgeoning desires, often counter-posing girlhood with womanhood, extend from Liliane de Kermadec's *Aloïse* (1975) to Kaplan's *Néa* (1976), from Varda's *L'Un Chant l'autre pas/One Sings, the Other Doesn't* (1977) to Véra Belmont's *Baiser rouge/Red Kiss* (1985), from Michèle Rosier's *Embrasse-moi/Kiss Me* (1989) to Christine Lipinska's *Le Cahier volé* (1993), and many others besides. The acclaimed, semi-autobiographical and sometimes commercially successful career of Diane Kurys also embodies this strand, in works like *Diabolo Menthe/Peppermint Soda* (her 1977 breakthrough debut), *Cocktail Molotov* (1980), *Coup de foudre/Entre Nous* (1983) and *La Baule les pins/C'est la Vie* (1990).

By now, institutional developments were safeguarding the gains of women film-makers, while a diversification process began their permeation of France's broader film culture. The Musidora Association was established in 1973, and the next year it curated an inaugural Paris women's film festival; four years later, managed by Jackie Buet, the Créteil International Women's Film Festival made such celebration of feminine cinema an annual fixture. In 1982 Delphine Seyrig – the iconic lead of Chantal Akerman's *Jeanne Dielman, 23 Quai du Commerce, 1080 Bruxelles* (1976); and director of a trio of films including *Sois belle et tais-toi* (1977), which documented sexism in the film trade – co-founded the Paris-based Centre Audiovisuel Simone de Beauvoir, which maintained an archive of women-directed works and championed female-made audio-visual materials. Oriented initially to specialized distribution contexts like these, and global festival culture more broadly, a trajectory of committed female-authored radicalism emerged: the seminal, minimalist film works of Marguerite Duras (infamously *Détruire, dit-elle/Destroy, She Said* [1969], *Nathalie Granger* [1972], *India Song* [1975] and *Le Camion* [1977]), Catherine Breillat's more

confrontationally graphic coming-of-age films (*Une Vraie jeune fille/A Real Young Girl* [1976; undistributed until 1999], *Tapage nocturne/Nocturnal Uproar* [1979], *36 Fillette* [1988], *Romance* [1999]), then the spare, poetic, voluminously acclaimed films of Claire Denis (*Chocolat* [1988], *J'ai pas sommeil/I Can't Sleep* [1994], *Beau Travail* [1999], *Trouble Every Day* [2001], *35 Rhums/35 Shots of Rum* [2008]) (Palmer 2011: 57–94). While such art house iconoclasts might fit the traditional bill of feminine counter-cinema, as Vincendeau notes the 1980s and 1990s also saw strategic advances by women in more mainstream contexts, 'belying the notion of a homogenous "women's cinema"' (1990: 166). In this frame, certain women film-makers fitfully enjoyed popular as well as critical recognition: especially Kurys, Coline Serreau (whose career spans the feminist documentary inquiry *Mais qu-est-ce qu-elles veulent/What Do They Want?* [1977] to the commercial triumph *Trois hommes et un couffin/Three Men and a Baby* [1985]), Varda (whose 1985 *Sans toit ni loi/Vagaband* was a sizeable hit) and, memorably, Josiane Balasko (*Les Keufs* [1987] and *Gazon maudit/French Twist* [1995]).

The late twentieth and early twenty-first century period takes us to an optimistic note. Today, women's film-making in France is proliferating, its resonance felt in more walks of cinema than ever before. Pivotal in this frame were the gender *parité* campaigns waged socially and politically in France in the late 1990s and early 2000s, as attention focused on the miserable fact that in 1995 only 5 per cent of those in public office in France were women; among all the European Union member states only Greece had a lower proportion (Palmer 2011: 151–53). Advancing women's social agency had a knock-on effect within France's dynamic film school system, especially at the central facility La Fémis, whose recruitment policies encouraged higher numbers of women to enter France's debutant film-making population, which creates each year about 40 per cent of all French cinema (Palmer 2011: 15–56). Speaking broadly, relating present to past, we began with pioneer Alice Guy, whose film-making ranged from frivolous to thought-provoking, commercial to idiosyncratic – and nowadays women are finally working again in all these types of cinema, across France's whole film-making continuum, from intellectual *art et essai* to the commercial mainstream, as well as, intriguingly, intermingling these methods into unclassifiable hybrids. At her auteurist vanguard, France is reliably still represented by Varda and Denis, international festival mainstays, who are regularly now joined by a host of low-budget multimedia experimentalists, like Isild le Besco (*Demi-tarif/Half Price* [2003]), *Charly* [2007] and *Bas-fonds* [2010]), Sophie Calle (*No Sex Last Night* [1996] and *Prenez soin de vous* [2007]) and Laetitia Masson (*Pourquoi (pas) le Brésil/Why (not) Brazil?* [2004] and *Petite fille* [2010, made for TV]). More unprecedented, however, are the careers of female pop-art film-makers intermixing elements of French film cultures high *and* low. Characteristic pop-artists, among France's most stimulating contemporary writer-directors, are Maïwenn le Besco, Valeria Bruni Tedeschi, Sophie Fillières and Noémie Lvovsky, whose brilliantly erratic works (notably, respectively, *Le Bal des actrices/Actress' Ball* [2008], *Il est*

plus facile pour un chameau/It's Easier for a Camel [2003], Gentille (2004) and Les Sentiments/Feelings [2003]) oscillate between psychoanalysis and slapstick, subtle feminine introspection and broad melodrama, intellectual soul-searching and demented farce (Palmer 2011: 122–49).

The final piece of the puzzle, arguably, has arrived in the first decade of the 2000s: an expansive women-made popular cinema, on a large scale now consistently engaging mass audiences. Here, times have truly changed. Following Le Film Français and the French trade press – whose box office analyses use tickets sold rather than the Anglo-American focus on financial grosses – the highest commercial category at stake is le millionnaire, a label applied to any production that attracts over a million paid admissions in its French theatrical run. During the 1980s there were only five female-directed millionaire films; in all of the 1990s just six; but the first ten years of the twenty-first century saw no fewer than 28 of these breakaway hits (Palmer 2012). These female-made millionaire films, moreover, frequently showcase French popular cinema in its most vibrant state: non-patronizing but broadly appealing; aligned to popular genres yet individuated; female-focused with fierce portraits of women in all stages of life. Standing in the ranks of this contemporary club des millionnaires are many sophisticated commercial women film-makers: Nicole Garcia (L'Adversaire/The Adversary [2002] and Un Balcon sur la mer/A View of love [2010], Agnès Jaoui (Le Goût des autres/The Taste of Others [2000]) and Parlez-moi de la pluie [2008]), Danièle Thompson (Décalage horaire/Jet Lag [2002], Fauteuils d'orchestre/Avenue Montaigne [2006] and Le Code a changé [2009]), and Lisa Azuelos (Comme t'y es belle!/Hey Good Looking! [2006] and LOL (Laughing Out Loud) [2008]), to name just four of the eighteen (and counting) women millionaire directors. Ranging from popular templates like intergenerational comedies (LOL) and extended-family dramas (Isabelle Mergault's Enfin veuve/The Merry Widow [2008]), to female-oriented banlieue films (Géraldine Nakache's Tout ce qui brille/All That Glitters [2010]) and political autobiographies (Marjane Satrapi's Persépolis [2007]), this female-made commercial cinema heralds a unique moment in French film history, with women directors routinely responsible for some of France's most meaningful popular hits. In sum, much progress has been achieved in a little over a century – from Alice Guy to Agnès Jaoui – with women historically pushed to the margins yet working to begin, then continue, the long process of reclaiming their stake in France's screen culture. The result is a growing, creatively engaged population of women film-makers that puts other countries, especially North America, to shame. Or, to describe the changing status quo more emphatically: the fact that so many French women nowadays make cinema their line of work is a leading reason why France's contemporary cinema is the most diverse, most diversely fascinating production centre in the world.

Tim Palmer

References

Abel, Richard (1988) *French Film Theory and Criticism Volume I: 1907–1929*, Princeton, New Jersey: Princeton University Press.

Conway, Kelley (2007) 'A New Wave of Spectators: Contemporary Responses to *Cleo From 5 to 7*', *Film Quarterly*, 61: 1, pp. 38–47.

Denis, Sébastien (2011) 'À la recherche du monteur. La lente emergence d'un métier (France, 1895-1935)', 1895: *Revue d'histoire du cinéma*, 65, Winter, pp. 52-81.

Drake, Helen (2011) *Contemporary France*, New York: Palgrave Macmillan.

Flitterman-Lewis, Sandy (1996) *To Desire Differently: Feminism and the French Cinema*, New York: Columbia University Press.

Guy Blaché, Alice (1996) *The Memoirs of Alice Guy Blaché* (trans. Roberta and Simone Blaché; ed. Anthony Slide), London: Scarecrow Press.

Holmlund, Chris (1996) 'The Eyes of Nelly Kaplan', *Screen*, 37: 4, pp. 351–67.

Lejeune, Paule (1987) *Le Cinéma des femmes*, Paris: Editions Atlas.

Mahar, Karen Ward (2006) *Women Filmmakers in Early Hollywood*, Baltimore: Johns Hopkins University Press.

McMahan, Alison (2002) *Alice Guy Blaché: Lost Visionary of the Cinema*, New York: Continuum.

Morrissey, Priska (2011) 'Regards sur les femmes au travail dans le cinéma français des années trente', 1895: *Revue d'histoire du cinéma*, 65, Winter, pp. 168-171.

Palmer, Tim (2011) *Brutal Intimacy: Analyzing Contemporary French Cinema*, Middletown: Wesleyan University Press.

Palmer, Tim (2012) 'Crashing the Millionaires' Club: Popular Women's Cinema in Twenty-First Century France', *Studies in French Cinema*, 12: 3, pp. 201-214.

Sellier, Geneviève (2008) *Masculine Singular: French New Wave Cinema* (trans. Kristin Ross), Durham, NC: Duke University Press.

Simon, Joan (ed.) (2010) *Alice Guy Blaché: Cinema Pioneer*, New Haven: Yale University Press.

Tarr, Carrie and Rollet, Brigitte (2001) *Cinema and the Second Sex: Women's Filmmaking in France in the 1980s and 1990s*, New York: Continuum.

Vincendeau, Ginette (1990) 'France', in Annette Kuhn and Susannnah Radstone (eds.), *The Women's Companion to International Film*, London: Virago.

Vincendeau, Ginette (1995) 'Obituaries: Marie Epstein', 12 June, http://*www.independent.co.uk/news/people/obituariesmarie-epstein-1586102.html*. Accessed 30 August 2011.

A French Gigolo
Cliente

Studio/Distributor:
Gaumont

Director:
Josiane Balasko

Producers:
Cyril Colbeau-Justin
Jean-Baptiste Dupont
Josiane Balasko

Screenwriters:
Josiane Balasko
Franck Lee Joseph

Cinematographer:
Robert Alazraki

Art Director:
Jean-Luc Fouvet

Composer:
Manuel Malou

Editors:
Marie de la Salle
Claudine Merlin

Duration:
105 minutes

Genre:
Comedy

Cast:
Nathalie Baye
Eric Caravaca
Isabelle Carré
Josiane Balasko

Year:
2008

Synopsis

Judith likes men but does not want a relationship. Marco needs money to finance his wife Fanny's business. When Marco becomes a gigolo, Judith finds herself hiring him repeatedly. But when Fanny discovers Marco's secret, things become complicated and painful for everyone involved.

Critique

A well-loved actress and playwright originating in the French *café théâtre*, Josiane Balasko now has seven directorial feature credits to her name. In the mid-1990s, following the success of lesbian-inflected rom-com *Gazon maudit/French Twist* (1995), she was hailed as the most popular French director after Claude Lelouch (Vincendeau 1996: 24–26); but her subsequent films were less well received. With *A French Gigolo*, despite a mediocre box office (620,000 tickets sold) Balasko drew applause from some critics and spectators – and several award nominations – for a film combining wry humour with a considered interrogation of such questions as urban solitude, poverty, and the commodification of intimate relationships today. The film's difficult subject matter – a portrayal of the relationship between a married escort and his ostensibly well-adjusted, successful middle-class client – explains the six years it took Balasko to acquire backing for the project, as well as its indeterminate positioning for and divided reception from audiences.

It would in fact be more accurate to describe *A French Gigolo* as the story of a gigolo, Marco (Eric Caravaca); his client, television saleswoman Judith (Nathalie Baye); his wife, Fanny (Isabelle Carré); and, to a lesser degree, Judith's sister Irène (Josiane Balasko). The first three characters all narrate in voice-over their perspective on the awkward triangle that develops when painter-decorator Marco turns to prostitution to fund Fanny's hairdressing salon. Marco finds himself torn between his love for his wife and his growing attraction to Judith; Fanny between the jealousy she experiences and her desire to keep the salon; and Judith between her desire to retain control and emotional distance in her relationships and her increasing sense of the limitations of such an approach. Balasko's Irène, meanwhile, represents the opposing pole to her sister's take on relationships, describing herself as a romantic.

The film is unusually situated in terms of cinematic tradition in broadly eschewing a grittily realist aesthetic – with the exception of some naturalistically lit external scenes showing Marco against an ugly urban backdrop of train tracks and wire meshing, following his rift with Fanny – but not shying away from the harsher realities of even the highest class of prostitution. From the opening credits, a split screen view of Marco and his point of view – again of geometric lines and urban grids, evoking imprisonment – as he drives around in his car, soon complemented by jump cuts, establishes the identity confusion provoked by his double life. The harsh lines

Cliente, Josy Films.

both within and between the pairs of frames are echoed on the soundtrack by angry French rap filled with hard 'c's and disdainfully spat dental consonants. Here the rap lyrics focus principally on the cruder realities of male prostitution ('My dick's got no eyes / My integrity's in mourning'); later in the narrative, however, the broader economic issues underlying prostitution as a social phenomenon come even more clearly to the fore ('Here the SMIC's no god-send [...] Money keeps man trucking / The carrot for the donkey'). Similarly, many of the film's darkly comical scenes revolve around crowded living conditions at Marco and Fanny's home – Fanny's mother's flat – where her teenage sister Karine films the couple's arguments, and where they are obliged to have sex in silence.

A *French Gigolo*'s other major area of interrogation is of the conventions of romance themselves. The intertext with Baye's starring role in César-winning Tonie Marshall's *Vénus Beauté (Insitut)/ Venus Beauty Salon* (1999) is pertinent. As in that film, the actress, who is known for having carved out a second career as an older (60 playing 51 in this film) but still attractive heroine in rom-coms, plays a character whose past experiences in love, here alluded to in passing, have led her to prefer the freedom of the anonymous encounter. In both films, notably, she indulges enthusiastically in sex in a

stranger's car. In both cases, too this clinical, even tawdry, approach is offered as a seemingly valid choice alongside a detailed exploration of the self-deceit associated with more traditional romance. Thus in *A French Gigolo* Judith's interactions with gigolos look much like being picked up in the old-fashioned way, such as when a flirtatious former employee recognizes her in a bar and remembers her name – although the relative intimacy implied is undercut by her reflection in voice-over that 'it's nice to deal with a real pro.' Similarly, she and Marco engage in ostentatiously romantic experiences including candlelit dinners and a visit to the funfair, consciously staging romance but nonetheless enjoying it. However, a penultimate scene in which Judith dissolves into tears following Marco's return to Fanny, leaving her literally all dressed up with nowhere to go, tempers her final assertion that she has remained a free woman. Equally, the positive resolution of Irène's excessively romantic and improbable love affair with an exotic American Indian who sweeps her off to Arizona is impossible either to ignore or to take at face value. Not unlike *Gazon maudit*'s often overlooked epilogue, this film leaves the viewer to ponder the variety of answers it offers to the crucial question of whether true love really exists. It also sketches more than one possible response for women to this dilemma without finally endorsing any. Her own protests on this subject notwithstanding, *A French Gigolo* in this way, as well as more broadly through its interpolation of older actresses into romantic roles, confirms Balasko's position as a relatively progressive feminist director.

Mary Harrod

References

Vincendeau, Ginette (1996) 'Twist and farce', *Sight and Sound*, 6, no. 4, 1 April, pp. 24–26.

Peppermint Soda

Diabolo menthe

Studio/Distributor:
Gaumont

Synopsis

Fall 1963: it's back to school for 13-year-old Anne and her 15-year-old sister, Frédérique. Their parents are separated, and the girls live in Paris with their mother. They spend their vacations with their well-intentioned but clumsy father. Friendships, first love, defiance of authority, politics: as the school year unfolds, each girl navigates in her own way the troubled waters of adolescence at a time when cool teenagers drink peppermint sodas in cafés.

Critique

Born in Lyon in 1948, Diane Kurys lived in Paris with her mother and sister after her parents' divorce. There she attended a con-

Director:

Diane Kurys

Producer:

Serge Laski

Screenwriters:

Diane Kurys
Alain Le Henry

Cinematographer:

Philippe Rousselot

Art Directors:

Tony Egry
Laurent Janet
Bernard Madelenat

Composer:

Yves Simon

Editor:

Joële Van Effenterre

Duration:

97 minutes

Genre:

Drama

Cast:

Eléonore Klarwein
Odile Michel
Anouk Ferjac

Year:

1977

servative all-girls public school, Lycée Henri IV, which she hated. Later she took to the stage, joining the famous Jean-Louis Barrault company, and appeared in TV movies and even on the big screen, notably in Fellini's *Casanova* (1976). Yet she longed to make her own films and wrote her first, largely autobiographical screenplay, which she eventually filmed on a government grant with a young shooting crew and mostly non-professional actors, in Lycée Henri IV, as a revenge of sorts. *Peppermint Soda* appealed to critics and the public alike and won the prestigious Louis Delluc prize in 1977. Everyone, it seems, could find something of themselves and their own youth in the main two characters.

Parallels with Truffaut's *Les Quatre cents coups/The 400 Blows* (1959) could hardly be avoided since Kurys herself tips her hat to Truffaut with many references, from minor allusions – such as a student smeared with ink – to more striking similarities: confrontations with parents and teachers, a mother at times more preoccupied with her appearance and her boyfriend than with her children, a conversation between mother and child – 'I was young once too' – and, most notably, the final freeze-frame that shows Anne on the beach looking at us over her shoulder just as Antoine Doinel did. Yet while it focuses on female teenagers, Kurys' depiction of rebellious adolescence – which also echoes Vigo's *Zéro de conduite/Zero for Conduct* (1933) – is more universal than Truffaut's: Anne and Frédérique's growing pains are linked to their age rather than solely to their family situation as they do not lack parental affection. In *Peppermint Soda* adults can be as mean as Antoine's teachers: the art teacher terrorizes her students, and the French teacher makes fun of their papers in front of the whole class. Adults are also caricatured and ridiculed: the school concierge is nicknamed 'mushroom' due to his short stature, the *surveillante générale* thinks Oran is a private school, the maths teacher is afraid of her students, and the sports teacher is incapable of demonstrating an exercise. But the history teacher, who encourages her students to reflect on current events, is shown in a positive light, thus offering a better-balanced perspective on adults than Truffaut's. Nor do the girls get into the sort of trouble that leads Antoine to a detention camp, though Anne is caught shoplifting. Rather than replicating Antoine's downward spiral, Kurys' film comes full circle, beginning and ending with the girls' summer vacation by the sea with no noticeable change: in both instances Anne looks sullen while Frédérique pairs up with a boyfriend.

Indeed, the film offers a slice of teenage life, shot in muted colours, rather than a story with a plot. A succession of scenes show life at school or at home, while vacations – with their father, with a boyfriend for Frédérique – are parentheses frozen in a slideshow of activities and smiling faces that remain outside daily experience. National or international events – Edith Piaf's death, Kennedy's assassination, the Algerian war – are part of the fabric of the film but remain in the background, as other matters, such as being allowed to wear pantyhose or to go camping with a boy, are more momentous to the girls. Nonetheless, a classroom evocation of the violent police repression that took place during a protest

near the Charonne Métro station in 1962 plays a strong part in Frédérique's political awakening.

As Truffaut did, Kurys opposes interiors – the mother's cramped apartment, the walled-in school – to exteriors – the streets of Paris, a Sunday in the country, a school outing to Port Royal that marks a shift in Frédérique's allegiances. However, though interiors signal a lack of freedom and exteriors a form of liberation, the contrast is less clear-cut than in Truffaut's film. Indeed, Anne seems as unhappy in the country as she does at school or at home, while home and school are also sources of joy and positive social experiences for both girls, as in the first sequence at school, where the music is redolent of nostalgia. Kurys opens the sequence with a low-angle shot of the school's clock and walls meant to evoke a prison in which students wear drab uniforms and strict teachers serve as wardens, but then uses fluid camera movement to navigate within the school yard between groups of students chatting excitedly about their summer vacation. Newly arrived students, though isolated and set apart by the camerawork and composition of the frames, will soon be fully integrated – one, Muriel, will even play an important part in the heroines' lives. Recurrent crosscut scenes in the school yard allow for parallels, contrasts, and links between the two sisters, who alternately help each other and fight, as siblings are prone to do, Frédérique frequently playing the part of the motherly big sister to a younger sister often envious of her and her closeness to their mother.

Subsequent Kurys films keep exploring her own past: *Cocktail Molotov* (1980) through the lens of the events of May 1968, reflects a later part of her youth, while *Coup de foudre/Entre nous* (1983), featuring two unhappily married women who become very close friends, is inspired by her parents' story. So is *La Baule-les Pins/ C'est la vie* (1990), which portrays a divorce from the perspective of the couple's children. Though in later films she stepped away from personal topics with her studies of famous female literary characters, Kurys' examination of womanhood and the themes of family, youth and love unify the work she started with *Peppermint Soda*.

Brigitte E. Humbert

Itto

Studio/Distributor:
Eden Productions

Directors:
Jean Benoît-Lévy
Marie Epstein

Synopsis

Itto, the daughter of a Chleuh tribal leader, finds herself torn between her lover's allegiance to the colonial forces and her father's struggle against them. A parallel story shows a French military doctor and his wife adjusting to the demands of life in a remote corner of Morocco.

Critique

Part of the unusually intense creative partnership between film-

Producer:

Jean Benoît-Lévy

Screenwriters:

Georges Duvernoy
Etienne Rey

Cinematographers:

Georges Asselin
Paul Parguel

Composer:

Albert Wolff

Editors:

Jean Benoît-Lévy
Marie Epstein

Duration:

97 minutes

Genre:

Drama

Cast:

Simone Berriau
Moulay Ibrahim
Ali Ben Brick
Hubert Prélier
Simone Bourday

Year:

1934

makers Jean Benoît-Lévy and Marie Epstein, like the social melo-drama *La Maternelle/Children of Montmartre* (1933), *Itto* (1934) addresses motherhood, parent-child relationships, and personal sacrifice for the greater social good, but *Itto* takes these themes and applies them to an unlikely sub-genre: the *cinéma colonial*.

Based on a story gleaned from colonial soldier Maurice Le Glay's accounts of the Chleuh, *Itto* takes an atypical approach to a familiar formula. Like most colonial films, *Itto* features French soldiers yet does not focus on them; the film also figures indigenous characters as enemies, yet it does not insist on their anonymity, as seen in Legion films like *La Bandera/Escape from yesterday* (1935) and *Le Grand jeu/The Full deck* (1934). Nor do the native Moroccans remain sworn enemies of colonial forces; by the end of *Itto*, most of the Chleuh fight alongside the French rather than against them. Shot on location in North Africa, the story unfolds from the Chleuhs' point of view, with a cast comprised mostly of Chleuh extras except the role of Itto, played by French actress Simone Berriau. Yet Berriau was no ordinary starlet – she was a colonial officer's widow who was fluent in Berber. Her command of the language was instrumental to the directors' vision, since dialogue among Chleuh characters was (only partially) translated into French via subtitles.

These efforts to foster aesthetic and narrative authenticity already make *Itto* a standout among interwar colonial films, but what makes *Itto* truly unique is Epstein and Benoît-Lévy's unwavering focus on women. Three female characters, including the film's eponymous protagonist, highlight women's involvement on both sides of the conflict. For the French, a military doctor's wife represents the capacity to endure hardship and sacrifice in the service of a higher mission. A secondary character is a vivacious waitress whose demonstrates her affection for the soldiers by visiting them in the field, a gesture that rattles the gender barriers normally considered inherent to the *cinéma colonial*.

With Itto at the centre of the story, the film begins with her plans to marry Miloud, a neighbouring clan leader's son. Primarily a love match, their union also symbolizes their fathers' pact to resist together the French colonial forces encroaching on their territory. But after a military veterinarian saves his clan's flock of sheep from an epidemic, Miloud's father declares allegiance to the French; enraged at the betrayal, Itto's father forbids her marriage to Miloud. With Itto's support, Miloud rallies warriors from his clan to rejoin the fight against the French, but Itto's clan sets up an ambush en route to the outpost, and Miloud takes a shot to the head. After waking up in the infirmary, the French doctor by his side, a grateful Miloud also joins forces with the colonizers.

Despite opposing loyalties, Miloud and Itto continue their clandestine meetings, and soon Itto reveals that she is pregnant. Miloud tries to convince her to leave her clan for good, but Itto refuses, retreating into the mountains to give birth in secret. Passing Miloud's son off as a foundling, she rejoins her clan, but when the baby falls ill, Itto's allegiances become entangled even further. Skeptical of tribal remedies and fearing for her child's life, Itto

sneaks him away to the village, where the same military doctor who saved Miloud also cures his son. As a personification of Western medicine as a conduit to colonial power, this French doctor (the *toubib*) plays a major ideological function. His family life also runs parallel to Itto's when his wife delivers a child; during one key sequence, Itto and the doctor's wife bond over their shared experience of maternity.

Medicine and maternity thus form the narrative linchpins of *Itto*, and both of these themes mark a striking departure from the exclusively male, military-oriented framework that defines most of the *cinéma colonial*. Still, this altered focus does not detract from the film's colonialist agenda; instead of relying on (or simply implying) brute force as a way to wrest control from indigenous peoples, medicine emerges as a means of obtaining and maintaining a kind of power that offers benefits to both sides. Instead of legionnaires ordered to build roads for some indiscernible purpose, as in *La Bandera*, Benoît-Lévy and Epstein portray medical professionals whose inner calling motivates their work and whose presence helps save both livelihoods (i.e. the flock of sheep) and human lives on both sides of the colonial divide. Yet, despite their evident ideological function, French characters remain overshadowed by the Chleuh, whose collective conversion from colonial adversaries to colonial advocates shapes the plot trajectory and delivers *Itto*'s final tragedy.

In political terms, *Itto* makes a fairly conventional case for French imperialism, but in narrative terms it crafts this message using decidedly unconventional material. With a story that hinges on overlooked colonial populations – colonized peoples and French women – *Itto* relies on the seminal contribution of Marie Epstein, herself an often overlooked film-maker. By revising and rearranging the components of the *cinéma colonial* to reflect a more inclusive spirit, Epstein's feminist and humanist vision helped create a colonial (and colonialist) film like no other.

Colleen Kennedy-Karpat

The Intruder
L'intrus

Studio/Distributor:
Ognon Pictures

Director:
Claire Denis

Producers:

Synopsis

Louis Trébor lives alone in the Jura Mountains with his dogs. His only contact with the outside world is his affair with the local pharmacist and his attempts to seduce his dog-breeder neighbour. He rejects his son Sidney, who lives nearby with his wife, a border controller, and his two young sons. Louis is in desperate need of a heart transplant and so attempts to procure one from the black market with the help of a nameless, young Russian woman. Shown elliptically, Louis travels to Geneva, Pusan and Tahiti in search of his long-lost son and in search of a heart.

Humbert Balsan
Jean-Marie Gindraux

Screenwriters:

Claire Denis
Jean-Pol Fargeau
Jean-Luc Nancy

Cinematographer:

Agnès Godard

Art Director:

Arnaud de Moleron

Composer:

S. A. Staples

Editor:

Nelly Quettier

Duration:

130 minutes

Genre:

Drama

Cast:

Michel Subor
Grégoire Colin
Béatrice Dalle
Yekaterina Golubeva
Bambou
Lolita Chammah
Florence Loiret-Calle
Alex Descas

Year:

2004

Critique

Inspired by Jean-Luc Nancy's autobiographical essay of the same name, which detailed his own experiences of undergoing a heart transplant, *The Intruder* presents us with the story of a literally and figuratively heartless man. Denis has described how she read Nancy's text during the shooting of her previous feature, *Trouble Every Day* (2001), and her strongly visceral reaction to the text inspired her to transpose it onto film. A working dialogue between Denis and Nancy had been in place for several years, with Nancy having written critical responses to both *Beau travail* (1999) and *Trouble Every Day*. It is the text's account of a man undergoing a heart transplant which is so strongly present in Denis' film: a film for and about the body of Michel Subor, the actor who plays the film's central character Louis Trébor. Denis has spoken openly about how the film pays homage to Subor (most widely known for his role as the deserter soldier in Jean-Luc Godard's *Le petit soldat* (1963) and who also had central role of Bruno Forrestier in *Beau travail*) and how he is the literal embodiment of the film.

With a marked shift from the visceral and aural excesses of *Trouble Every Day*, here Denis meditates on the post-operative body of Louis and draws on the communicative potential of touch, physical gestures and sound, rather than spoken dialogue. The film introduces us to Louis with a profile shot of his head tilting up towards the sun. As the sunlight bathes his face, the wrinkled skin around his eyes and the moles which decorate his face become visible. As he rests naked in the woods with his dogs and floats weightlessly in the nearby lake, it is clear Louis is at ease with nature. However this idyllic image is suddenly disrupted when he clutches his chest and in a series of gasps and pants, collapses onto the floor in agony. His hands move to rub the left side of his chest, which is the first indication that there is something wrong with his heart.

The only contact Louis has with the outside world is the almost wordless affair he conducts with the local pharmacist. As they make love, the camera is entirely focused on the entwinement of their bodies and throughout the scene it becomes clear that for Louis, this is a relation based purely on physical contact: contact with another's body, another's skin. Stealing away from his lover, Louis goes downstairs and encounters an intruder who he quickly dispenses with by slicing their throat with a large knife. On returning to bed, Louis caresses his lover once more; the same hands which held the knife to cut the throat of the intruder are now engaged in a loving act of touch. This dichotomy of touch as both erotic and fatal highlights Denis' overarching interest in touch throughout the film: how despite being an expression of sensuality and tenderness, touch is also a means of intrusion.

A pivotal scene which underlines this relation based on tactility and gestures is also epitomized during the sequence in which a blind masseuse visits Louis in his hotel room in Pusan. At this point, Louis has undergone the heart transplant and the masseuse has been sent to soothe and heal his post-operative body. As her hands begin to explore the contours of Louis' body, they undo his

dressing gown and find their way to his chest scar. This large and invasive scar, which runs laterally down his chest, sits raised and red-raw, protruding angrily from his skin. On feeling the masseuse's hands touch this most intimate mark, Louis immediately winces in pain, as the camera immediately focuses on his eyes screwed up tight, in a physical communication of this sensed pain.

Louis' existence is paralleled by various female figures in the film: the nameless Russian woman who procures the heart for him and a woman with a crown of thorns referred to as 'la sauvageonne' who appears sporadically throughout the film. As Nancy describes, these are Louis' doubles, representing his femininity and his conscience, he states: 'Trébor only exists as a kind of figure doubled on either side by these two allegories of himself' (Nancy 2010).

While The Intruder is a formally challenging and at times enigmatic film, it nonetheless remains a central film in Denis' oeuvre, illustrating the themes which preoccupy her, such as foreignness/Otherness and intrusion. The film is a cinematic ode to the body of Michel Subor, yet it can also be regarded as a meditation on the ailing male body. Still retaining the literary quality of the text which inspired it, Denis offers up the body of Michel Subor as a focal point of the film, as the embodiment of intrusion and exposure. The film explores the multiple meanings of intrusion, through the figure of Louis, to show that ultimately behind the surgical intrusion which is at the literal heart of the film, intrusion is also present on a number of metaphorical levels.

Sarah Forgacs

References

Nancy, Jean-Luc (2005) 'L'Intrus selon Claire Denis', *http://www.remue.net. spip..php?article679*. Accessed 20 August 2010.

Invitation to a Voyage

L'Invitation au voyage

Director:
Germaine Dulac

Synopsis

A nameless woman, neglected by her husband for his nightly trysts, enters a nautically themed bar on New Year's Eve, where she meets a naval officer. They drink and dance and her imagination fills with fantasies of oceanic voyages to exotic lands. But when the naval officer discovers she is married and has a daughter he loses interest and cavorts with another woman. Feeling slighted, the nameless protagonist-woman returns home to the tedium of her existence, climbing into bed just as her unfaithful husband returns home.

Critique

Germaine Dulac's *Invitation to a Voyage* takes as its starting

Producer:

Germaine Dulac

Screenwriter:

Germaine Dulac (after the
poem 'L'invitation au voyage' by
Charles Baudelaire)

Cinematographer:

Paul Guichard

Art Directors:

Cesaré Silvagni
Hugo Squarciafico

Composer:

Catherine Milliken

Duration:

39 minutes

Genre:

Drama

Cast:

Emma Gynt
Raymond Dubreuil
Robert Mirfeuil
Paul Lorbert
Tania Delayme

Year:

1927

point several lines from Baudelaire's poem of the same name:
'Mon enfant, ma sœur / Songe à la douceur / D'aller là-bas vivre
ensemble… Les meubles luisants / Polis par les ans / Décoreraient
notre chambre. ('My child, my sister / A rapturous dream / To live
there together… Shining furniture / Polished by the years / Will
decorate our bedroom'). Just as in Baudelaire's poem, where the
narrator offers an invitation into a utopian land of exoticism and
voluptuous desire, so too are we, in a similar way, invited into the
flights of fancy of a neglected housewife. *Invitation to a Voyage* is
not a direct translation of Baudelaire, although there are a quite a
number of correspondences; rather Dulac has captured the most
important aspect of the poem, that is, the longing to escape from
a depressing reality into a voyage filled with adventurous pleasures
and luxury, even if that journey is only imaginary. As the dancing
in the club and the fantasy images dissolve back to the narrative,
Dulac makes a sense of poetic rhythm; and with the camera repeat-
edly returning to the sensual dancing of the club's patrons Dulac
creates a species of cinematic rhyme.

The linear narrative that takes place in the club – from the
moment the women enters until she leaves – is punctuated by her
imaginings and fantasies. In the club, tentatively sitting at a table
wrapped in her fur coat, she thinks back to life at home. We see
that she is a bored housewife. Her husband reads the paper and
she embroiders. There is no conversation between them, and as
the calendar traverses another year, the husband's only gesture
is to kiss his wife's hand before he leaves to meet his paramour.
When the naval officer approaches her and recounts his tales
of adventure on the high seas, her fantasies are prompted. She
imagines herself the lover of a brave ship's captain sailing over
uncharted seas beneath foreign skies, towards unimaginable lands.
However, what at first appears to be a case of female subjectiv-
ity and feminine discourse, Dulac perhaps suggests is an entirely
male construct. It is the naval officer who opens up the porthole
through which the woman imagines her fantasies, and it is also the
naval officer who closes it. In a sense he acts as gatekeeper of her
fantasies and purveyor of her desires.

There is a certain sexual ambiguity throughout *Invitation to
a Voyage* where at times it is difficult to differentiate males and
females; many of the club's patrons seem androgynous. This
toying with gender is further emphasized by the reinterpreting of
gender roles, in that occupations typically assigned to males in the
1920s, such a police*man* and bell*boy* are obviously and intention-
ally performed by women. It is no surprise that the ambiguously
gendered bellboy spins the revolving door through which everyone
gains entry into the club, where in such a place it is possible, if only
through fantasy, to participate in a sexual revolution.

The invitation extended in Baudelaire's 'L'invitation au voyage' is
flight into the exotic and the unknown, into the imaginary and away
from the dreariness of reality – escape from an often tedious exis-
tence. Dulac's invitation, like Baudelaire's, is to no specific place,
but rather to endless imaginative possibilities, and, more impor-
tantly, to a realm of liberal sensuality, where races mix freely, where

song and dance are welcome, where music continually plays, where sexes intermix and the genders are ungendered.

Zachariah Rush

LOL (Laughing Out Loud)

Studio/Distributor:
Pathé

Director:
Lisa Azuelos

Producer:
Romain le Grand

Screenwriters:
Lisa Azuelos
Delgado Nans

Cinematographer:
Nathaniel Aron

Art Director:
Yvon Fustec

Composer:
Jean-Philippe Verdin

Editor:
Stan Collet

Duration:
103 minutes

Genre:
Comedy

Cast:
Christa Theret
Sophie Marceau
Jérémy Kapone
Marion Chabassol
Félix Moati

Year:
2008

Synopsis

LOL follows the romantic and other vicissitudes of teenager Lola and her mother Anne over the school year. Maël holds a torch for Lola but his best friend is her ex-boyfriend Arthur. Anne is still involved with the husband from whom she is separated – until a handsome policeman sweeps her off her feet. Meanwhile, as Lola's behaviour becomes wilder, mother and daughter have their own relationship issues to resolve.

Critique

LOL confirms Lisa Azuelos' established interest in exploring contemporary mores from female characters' perspective, primarily through romantic comedy. This film, thanks to the presence of star actress Sophie Marceau, as well as elements from the US teenpic genre, enabled Azuelos to reach a much wider domestic audience (3.6 million), as well as to emulate many – mostly male – predecessors in travelling to Hollywood, where she is currently directing post-production on a US version of *LOL*, starring global A-listers Demi Moore and Miley Cyrus. Azuelos thus exemplifies the increasingly transnational consciousness and ambition of French women's popular film-making in the 2000s.

Focusing on the lives of a mother, Anne (Sophie Marceau), and daughter, Lola (Christa Theret), the film's romantic bent is hinted at by its title. At once Lola's nickname, a subtitle reveals that *LOL/lol* is acronymic for the English phrase *laughing out loud*; but the latter in turn represents a parodic twist on an abbreviation for the common correspondence sign-off *lots of love*. Such contractions have been popularized by online communication, associated with youth culture: a combination that is central here, due to numerous instances of MSN messaging. Even more indicative of the film's young target audience, though, is its soundtrack, stuffed with pop songs from Rolling Stones classics to contemporary hits by Alvin and the Chipmunks, Supergrass and others. Indeed, the rapid editing style of sequences cross-cutting between the homes of its *lycée* students, at the same time as widening the film's ensemble focus and universalizing its teen themes, flirts with a music video style. This aesthetic is paired with a *mise-en-scène* of romantic liaisons across two generations, as Lola abandons last year's dalliance and falls in love, while her mother breaks it off with her ex-husband and embarks on a new relationship.

However, the film's interest goes beyond generic romance and glossy surface. Lola's appropriation of the voice-over which punctuates the narrative and, along with her online communications, facilitates access to her subjectivity, exemplifies a recent preoccupation

LOL (2008), Pathé Renn Prod,
Poisson Rouge Pictures.

with children's experiences in French cinema. Her parents' separation contextualizes her unruly behaviour, which includes emotionally blackmailing her mother by moving in with her father following a row. Discipline is explicitly discussed, but Azuelos declines to offer any prescriptive critique of broken homes. The film's portrayal of teenage girls as active agents of desire, meanwhile, departs from traditions within both France and the global teenpic historically. The same could also be said of *LOL*'s portrayal of female friendship, as a source of laughter and comfort. Indeed, it is noteworthy that *LOL* picks up on a shift noted in the global genre of the female friendship film, from dyadic to group narratives, where several female characters embody different life choices, as also prominent in such popular television series as *Sex and the City* (Hollinger 1998). These are, however, rarer in the teenpic, making *LOL*, an early exponent of the French genre, pioneering in more than one sense. Having said that, the girls' competitive attitudes towards each other, at one point labelling their schoolyard enemy a *slut*, provide a striking example of the powerfully divisive force of romantic rivalry between women, as well as female internalization of misogynistic discourses.

Nor is the exploration of social tensions limited to the adolescent sphere. At one point, Anne voices her own conflicted attitude towards female sexual liberation, which she finds a good idea in principle but troubling in practice. Anne's presentation, too, presents contradictions from a feminist perspective. The first image of her is one of idealized natural motherhood, as she baths with her younger daughter. This is borne out later through her prioritization of relationships with her children and her overall success in maintaining good relations even with the volatile Lola, through a liberal style of parenting. However, in denying Anne any professional ambition, the narrative shows no progress away from the model of pre-millennial US cinema, indicted by E. Ann Kaplan for failing to depict women who combine motherhood with both sexual and professional fulfilment (Kaplan 1992: 183).

Indeed, despite its exploration of the challenges of parenting and structural privileging of romance, *LOL* ultimately champions motherhood. Throughout the narrative, the parallelism of Anne's and Lola's romances, like Lola's habit of borrowing her mother's clothes, hints at the difficulties psychoanalysts have ascribed to mother-daughter relations in terms of identity overlap. But at the end of the film, the mother-daughter union supplants any romantic climax, as the pair gossip together in bed. Moreover, the cyclical teenage time marked by a final act which returns to the same moment as the film's start, the beginning of the school term, and echoes the opening sequence's break-up between Lola and Arthur (Félix Moati) by showing imperfections creeping into the relationship with Maël (Jérémy Kapone), illustrates by contrast the endurance of the maternal relationship. While overall *LOL* is ambiguously situated in terms of the conservatism/progressiveness of its politics, Azuelos' sustained examination of the power of mother-daughter bonds follows in a growing tradition among French female filmmakers (see Tarr, Carrie and Rollet 2001: 112–13), beginning gradually to correct the lack of complex representations of this relationship in global cinema historically.

Mary Harrod

References

Hollinger, Karen (1998) *In the Company of Women: Contemporary Female Friendship Films*, Minneapolis and London: University of Minnesota Press.
Kaplan, E. Ann (1992) *Motherhood and Representation*, London: Routledge.
Tarr, Carrie with Rollet, Brigitte (2001) *Cinema and the Second Sex: Women's Filmmaking in France in the1980s and 1990s*, London and New York: Continuum.

Nathalie Granger

Studio/Distributor:
Mouflet et Cie.

Director:
Marguerite Duras

Producers:
Luc Moullet
Jean-Michel Carré

Screenwriter:
Marguerite Duras

Cinematographer:
Ghislain Cloquet

Editor:
Nicole Lubtchansky

Duration:
79 minutes

Genre:
Drama

Cast:
Lucia Bosè
Jeanne Moreau
Gérard Depardieu
Valerie Mascolo
Nathalie Nourgeois
Luce Garcia-Ville
Dionys Mascolo

Year:
1972

Synopsis

Two women and their little girls share a house in Neauphle, an outlying Paris district. Isabelle is receiving bad reports about young Nathalie from her schoolteacher, who says the girl makes up lies about her family and manifests frightening violence when angered; disturbed by the situation, Isabelle considers sending Nathalie to a boarding school. Both children take piano lessons, and the other woman of the house, who is never named, encourages her daughter Laurence to cultivate qualities of order and control in her playing, even though the women habitually leave sheet music scattered all over the floor. The women are patient and bemused when a door-to-door salesman arrives to deliver a pitch for a washing machine. Nathalie's father is the only other male character, appearing briefly in the first scene. Throughout the film, radio newscasts report on a police hunt for two young murderers holed up in a woods 25 miles away.

Critique

When novelist Marguerite Duras and director Alain Resnais started planning their 1959 masterpiece *Hiroshima mon amour*, they discussed the troubling fact that while they were having their comfortable conversation, planes carrying atomic warheads were circling the globe, ready to spark a nuclear holocaust if some commander gave the word. Duras' subsequent films and screenplays engage with a wide range of situations, emotions and ideas, but some of them share an undercurrent of unseen menace, suggesting that the relative ease and security of modern life are paper-thin façades masking social, political, and psychological threats posed by the instability of human nature and the institutions and technologies it creates.

The importance of this theme to *Nathalie Granger* is signalled in the opening scenes: in the first, the schoolteacher (Luce Garcia-Ville) tells Isabelle (Lucia Bosè) about Nathalie's (Valerie Mascolo) lies and violent rages, and in the second, the household listens to a radio report about the murderers, who are described as only 'kids' themselves. Nathalie's violence is never shown and the killers in the woods are never seen; yet the dangers they represent are recurring presences on the soundtrack, insinuating their way into the texture of the entire film. They loom all the more largely by virtue of their sharp contrast with the activity that does appear on screen, which is minimal and commonplace, consisting largely of housework (ironing, clearing the table) and interludes of the action-free dead time (*temps morts*) that such French New Wave film-makers as Jean-Luc Godard and François Truffaut had turned into a strong expressive tool in the 1960s.

Some critics see *Nathalie Granger* as a precursor of Chantal Akerman's domestic drama *Jeanne Dielman, 23 Quai de Commerce, 1080 Bruxelles* (1975), also featuring a single mother living by the numbers in a (mostly) dull home. But where Aker-

Nathalie Granger, Mouflet et Cie.

man's movie has the mesmeric sprawl of a slow-motion epic poem, Duras' has the economy of a sonnet, the obliquity of a villanelle. The languid movements, motionless poses, abstracted demeanours, and absent-minded gazes of the women mirror the monotony and uniformity of their surroundings, while serving on a deeper level as defences against dreads and anxieties generated by both the world outside, with its killers and manhunts, and the world inside, where flowers of evil may be germinating in the heart of one's own child. Since money, comfort, and leisure are not problems for these people, the household's indolent rhythms and freeze-dried good manners must have roots in something more profound: the fear that identity itself may be gradually leaching away, coming unmoored from its bases like the 'Nathalie Granger' nametag that has fallen off one of the child's garments, or just fading into nothing like reflections in the backyard pond.

If the alarming newscasts and Nathalie's derelictions are not enough to energize this environment, it is a very long shot that the washing-machine salesman (Depardieu) will manage to perk things up. This expectation proves correct, with the proviso that he would not have fared any better with even the most receptive consumers, since he has no discernable talent for his line of work; still, the women hear him out patiently and passively. His hangdog deportment and lifeless sales pitch are ruefully amusing, especially when he belatedly discovers that the women already own the very product he is trying to sell. But his two lengthy scenes are more than

comic relief. They are variations on the existential absurdity that such post-war dramatists as Eugène Ionesco and Harold Pinter had been placing at the forefront of their work; it is as if the eponymous character in Samuel Beckett's 1953 play *Waiting for Godot* actually showed up and proved to be an anticlimactic bore, albeit a gentle and sympathetic one. Absurdist comedy also surfaces in conversations between the women, and Duras injects a subtle visual joke when occasional deep-focus shots along the house's length recall the crooked corridors of Robert Wiene's *The Cabinet of Dr. Caligari* (1920), another film that juggles the unlikely combination of menace, craziness and somnambulism. Less amusingly, electricity pylons tower like lurking giants – demonic, protective or blankly indifferent – against the gray skies outside.

Nathalie Granger acquires its wry power through sound as well as image, making bits of dialogue into leitmotifs and fragments of piano music into aural analogues of the not-quite-contiguous story episodes. Duras shot the richly black-and-white film in her own house, allowing the crew to live there during production, and her own voice is briefly heard in a telephone call from a stranger who dialled the wrong number. Her grand project in film was to create a radically poetic *cinéma different*, and this avant-garde home movie stands with her most spellbinding achievements.

David Sterritt

Pour la nuit

Studio/Distributor:
Neon Productions

Director:
Isabelle Boni-Clavérie

Producers:
Julien Berlan
Antonin Dedet

Screenwriter:
Isabelle Boni-Clavérie

Cinematographer:
Samuel Dravet

Art Director:
Eric Pierard

Sound Recordist:
Florent Tureau

Editor:
Amandine Marout

Synopsis

Pour la nuit follows Muriel on the night before her mother's funeral. She takes a cab ride for escapism and stops at a bar. Here she meets a (white) man and goes for a ride with him. They have sex and part: she for the funeral, he for his wedding.

Critique

Pour la nuit is set overnight in Marseilles, a place which symbolically and literally represents the transnational and mixed nature of France (as a passage to Africa and a multicultural town) and is the locus of many interethnic interactions in French cinema. Muriel (played by mixed-race actress Isabelle Fruleux), spends the night on a cliff top, between the freedoms of nature and the duties of civilization.

The film is shot in black-and-white, an aesthetic choice which emphasizes its subject matter and its mixed protagonist's plurality. The shadows the night light casts on the city and her body expressionistically reveal Muriel's dark and confused emotions. The film is also generically hybrid and mixes melodramatic and road movie conventions.

Muriel fights with her grieving (white) father and goes to her (black) mother's funeral with him the following day. She has casual sex by the coast (thus exhibiting the Freudian understanding of death and sex as inherently linked). It is possible to read her char-

Duration:

26 minutes

Genre:

Drama

Cast:

Isabelle Fruleux
Olivier Augrond

Year:

2005

acterization as based in the American 'tragic mulatta' stereotype; she exploits her sexual power, appears torn between ideas and cannot control her passions. But, she is not searching for a new identity achieved through passing for white, she is searching in the hybridity of the shadows for short-term pleasure and escapism. Thus Boni-Clavérie does not end the film with the punitive resolution so common to mixed-race American films, or with the containment of the mixed female in the white/hetero-normative family/romantic unit; she leaves it open for Muriel to make her own way forward in the light of a new day.

The fluidity of the film recalls Philippe Faucon's *Muriel fait le désespoir de ses parents* (1995), which follows the emotional wanderings of a 17-year-old from the *banlieue* who is equally attracted to a white woman and a black man. Along with *Pour la nuit*, it is one of few films to deal explicitly with non-white or mixed-race female sexuality/gender transformation (Provencher 2007). Although *Pour la nuit*'s Muriel is less adventurous, her sexuality is a key element of her identity and adds to her character (unlike many mixed/black characters whose denied/over-represented sexuality often makes them seem one-dimensional).

Pour la nuit was written and directed by a French-Ivorian female director and thus it provides a stark contrast to most mixed-race representations (almost exclusively made by mono-racial directors). The director's mixed perspective is evident in the film's evasion of dominant themes and established positions, and its refusal to resort to simple conclusions. The film-maker offers no moral judgement or resolution, thus allowing Muriel to enjoy her 'multiple horizons' (Taylor 1989), and the spectator to be an active witness.

Muriel is unusual not because of her ethnic mix necessarily (unusually for French films, no racism is expressed in the film) but rather because she accepts life's contradictions and complexities. She is chic and sophisticated (evidenced by her designer clothes and refined manner), and blends into society (rather than being excluded from it). She is sexually independent and intellectual – after sex she and her one-night stand debate the meaning of love and death. She is thus contextualized as conventionally French, a chic Parisienne.

Pour la nuit can be read as a political film in terms of its narrative and visual choices. The film explores ideas of beginnings and endings, of identity and fulfillment, of lust and love. It is philosophical and poetic, using minimal dialogue and visually focusing on the in-between shades of grey which categorize Muriel's interstitial existence. She is positioned as a mixed 'nomad' (Deleuze and Guattari 1986), moving between physical and emotional spaces.

Zélie Asava

References

Braidotti, Rosi (1994) *Nomadic Subjects: Embodiment and Sexual Difference in Contemporary Feminist Theory*, New York: Columbia University Press.
Deleuze, Gilles and Félix Guattari (1986) *Nomadology: The War Machine,*

New York: Semiotexte.

Provencher, Denis M. (2007) 'Maghrebi-French Sexual Citizens: In and Out on the Big Screen', *Cineaste*, 33:1, pp. 47–51.

Taylor, Charles (1989) *Sources of the Self: The Making of the Modern Identity*, Cambridge: Cambridge University Press.

Romance

Studio/Distributor:

Flach Film
CB Films
ARTE France Cinéma

Director:

Catherine Breillat

Producers:

Catherine Jacques
Jean-François Lepetit

Screenwriter:

Catherine Breillat

Cinematographer:

Giorgos Arvanitis

Art Director:

Valérie Leblanc Weber

Composers:

Raphaël Tidas
D.J. Valentin

Editor:

Agnès Guillemot

Duration:

84 minutes

Genre:

Drama

Cast:

Caroline Ducey
Sagamore Stévenin
François Berléand
Rocco Siffredi

Year:

1999

Synopsis

A young schoolteacher, Marie, is in a steady relationship with Paul, a male model. One day he announces that he no longer wants a sexual relationship with her, leading Marie to begin a quest of sexual self-discovery. Through her subsequent experiences of casual sex with Paolo, and a sado-masochistic relationship with her headmaster, Robert, Marie begins to feel at ease in her sexual body. After accidentally falling pregnant by Paul and witnessing his continuing lack of care for her, Marie leaves him to give birth alone, but not before setting up a fatal accident.

Critique

Catherine Breillat is a figure who has courted much controversy in both the French and British media for the sexually explicit nature of her work, so much so that she has been labelled by critics as the 'auteur of porn' (Price 2002). With her 1999 film *Romance*, Breillat became a renowned figure on the international cinema circuit and simultaneously reignited the art versus pornography debate. On its release *Romance* was given an X rating and French posters for the film featured a red X covering a woman's fingertips reaching into her vagina, suggesting that the reason for the censorship was its expression of female sexuality and desire, to which Breillat responded by saying: 'Censorship is a male preoccupation and the X certificate is linked to the X chromosome' (Brooks 2007).

Romance begins with a close-up shot of a male model's face being dusted with Kabuki powder in preparation for a photo shoot. The model's girlfriend, Marie (Caroline Ducey), is shown from behind, in the position of spectator. This re-writing of classical cinema's modes of looking (where the male point of view is aligned with the spectator and gazes upon the female as a sexual object) with the film's opening sequence, hints that throughout the film Breillat will subvert established gender roles and the gendered gaze in order to present an active female subject. Following this opening sequence, Paul (Sagamore Stévenin) suddenly announces he no longer wants a sexual relationship with her and thus begins Marie's quest for sexual self discovery.

The minimalist, all-white apartment which the couple share is clinical, almost sterile. Marie's plain, beige and white outfit renders her almost indistinguishable against the background and she appears virginal, almost doll-like with her pale skin, red lips and dark hair. This abundance of white hints at the chastity and asexuality which shroud the couple and the shapeless, white clothing serves to conceal their bodies and their sexuality from

vision. As Breillat stated in an interview: 'As far as sexuality and women's sexuality in particular are concerned, women are given an image of themselves that has lost its dignity [...] I know why I make films – partly because I want to describe female shame' (Sklar 1999: 26). Breillat uses Marie's sexual encounters to expose and criticize this shame; the first time we see Marie and Paul in bed together, she attempts to initiate a sexual encounter by performing fellatio. When her advances are rebuffed, despite Paul being aroused, she accuses him of hating her simply for being a woman: 'You hate me because I am a woman. I disgust you, I appal you.' In the middle of the night, she steals away to a bar where she meets Paolo (played by the Italian porn star, Rocco Siffredi), whose name, in recalling Paul's, establishes his position as the sexualized, virile alter-ego. They begin a purely sexual relationship which culminates in a scene of explicit, unsimulated sex after which the relationship ends and Marie enters into a sado-masochistic relationship with her school's headmaster, Robert (François Berléand).

The question of language is integral to *Romance* and is dually-layered over the film, both with spoken dialogue and with Marie's internalized and ventriloquized voice-over, spoken by the actress Caroline Ducey. Marie's monologue, which appears throughout the film, communicates her thoughts on sex, the body and how the two sexes view them; it is striking for its candidness, for example when Marie states: 'That's my dream. To know that for some guy I'm just a pussy he wants to stuff.' This internalization of Marie's thoughts reflects the problem faced by women in expressing their sexuality within the realms of language. Marie's problematic relationship with language is also allegorized in two classroom sequences. In one, she writes a dictation for her pupils to copy down and is interrupted by the arrival of Robert into the classroom who notices her atrocious spelling. She admits to him that she may be dyslexic but repeatedly struggles to say the word; here she is literally outside language. In the second sequence she teaches her pupils the difference between the verbs *être* (to be) and *avoir* (to have). She explains that 'having is not at all the same as being. You can be without having, and you can have without being', which alludes to Marie's explorations of being a sexual object without having sex and vice versa.

Towards the end of the film, Marie falls pregnant by Paul through accidental insemination. After he flirts with women at a bar in front of her and is still passed out as she goes into labour, Marie turns the gas on in the apartment and leaves for the hospital with Robert. Intercut with the shot of the baby's head crowning is the image of the apartment going up in flames, the sound of the bang mimicking the baby's first cry. The film ends with Marie dressed in black, cradling her newborn baby as she follows Paul's coffin. Her voice-over tells us she named him Paul; he literally assumes his father's place. The ending hints at a new beginning for Marie, as she is now secure in her own sexuality and by giving birth to a male child, she finally has the phallus that has so far eluded her.

Sarah Forgacs

References

Brooks, Libby (2007) 'The Joy of Sex', *Guardian Unlimited*, www.film.
 guardian.co.uk/censorship/news/0,,660428,00.html. Accessed 30 May
 2007.
Price, Brian (2002) 'Catherine Breillat', *Senses of Cinema*, www.
 sensesofcinema.com/2002/great-directors/breillat.html. Accessed 5 March
 2006.
Sklar, Robert (1999) 'A Woman's Vision of Shame and Desire: An Interview
 with Catherine Breillat', *Cineaste*, 25: 1, pp. 26.

Salut les cubains

Studio/Distributor:
Ciné-Tamaris

Director:
Agnès Varda

Producers:
Société Nouvelle Pathé-Cinéma
Ciné-Tamaris

Screenwriter:
Agnès Varda

Cinematographer:
Agnès Varda

Animators:
J. Marques
C. S. Olaf

Composer:
Musique cubaine

Editor:
Janine Verneau

Commentary:
Michel Piccoli

Duration:
28 minutes

Genre:
Documentary

Cast:
Michel Piccoli
Nelson Rodríguez
Agnès Varda

Year:
1963

Synopsis

A documentary comprising still images, selected from 1800 photos taken by Agnès Varda on a visit to Cuba in 1962 and later animated in 35 mm in 1963, celebrating Cuban roots, revolution and culture. Voice-over narration is provided by Michel Piccoli and Agnès Varda.

Critique

It should come as no surprise that Agnès Varda thanks, among others, Left Bank colleague Chris Marker in the opening credits of *Salut les cubains*. The style of the documentary, indeed, owes a lot to Marker's *La jetée* (1962) – a series of still photographs that, when animated and explored at the rate of 24 frames per second, comment so eloquently on the very nature of cinema, memory and mimesis, and interrogate the notion of photograph as document. The resulting film is a loving portrait, an undoubtedly flawed appreciation of culture, movement, rhythm, aesthetic and music, whose insouciance is perhaps reflective of a more feminine lyricism and playfulness – or, at least, a fruitful dialogue between male matter-of-factness and female thoughtfulness as witnessed in the voice-over interplay between Michel Piccoli and Varda.

We begin, appropriately and in some ways, at the end – a live action recording of a photo exhibition, 'Cuba: 10 Years of Revolution', in Paris, St. Germain des Prés, June 1963. Excitement is generated by the transplanted Cuban band, which is surrounded by inquisitive (and acquisitive) Parisians, the focus concentrated on those armed with all manner of cameras, who are, thus, slightly removed from – out of step with – the actual experience of the event. Somehow, though, the photos adorning the walls of the gallery space seem dwarfed and confined, overwhelming and overwhelmed; two-dimensional and lifeless representations that even the accompanying music cannot enliven. It is no accident that this scene is introduced to us by the deliberate, gruff voice-over of Piccoli. Despite the vivacious music, we are restricted – trapped in a stolid, typical viewing format, one that is in marked contrast to what ensues.

Following a fade-out and fade-in, the true conceit of the film is revealed – both in form and content. We are presented with a slow track-in to a still photo of a cigar, floating in water; this time, it is Varda who situates us via the soundtrack, 'Cuba, January 1963'.

Piccoli then instructs that Cuba 'was a cigar-shaped island for men. A crocodile-shaped island for ladies', as we see visual still photo asides to a man producing cigars, a crocodile floating in the water – mimicking the shot of the floating cigar – and finally a bask of crocodiles (incidentally, the floating crocodile definitely and cigar possibly appear to be superimposed upon, manipulated into the rippled water). The sequence nicely sets up what really drives the remainder of the film – a kind of he said/she said alternating appraisal of Cuba, albeit from an outsider perspective. This is rein-forced by the differences in voice-over, which generally has Piccoli pontificating about Cuba more objectively, while Varda is allowed to be more subjective; self-reflexive about the process and purpose guiding her film. This system of narration, though, culminates in the sophisticated speak-and-testify rhetoric of the soundtrack, the sometimes competing interests represented by Piccoli and Varda through several 'here/here's to' formulations: for example, Piccoli's literal 'Here are ladies' hats for tourists', followed by Varda's rous-ing rally, 'Here's to Marxism-Leninism in a militia woman's beret.' The images referenced of two women with straw hats and a solitary woman in military dress wielding a machine gun, coupled together and with the voice-over, transcend mere travelogue, belying the more political fancies at work in the documentary.

The film, as a whole, can perhaps best be described as a culture symphony: a face-value, outsider, formal celebration of a culture – its people, its derivation, its expression – and all the problems that this kind of ethnography invites: oversimplification, de-contextual-ization, misrepresentation and fetishism, to isolate a few. Certainly the film, through our more politically sensitive lens, can be uncom-fortable to watch at times with its breezy references to race (e.g. 'or carrying your white doll, if you're a black girl'). But what abides, hopefully, is the joyful form born of a pure empirical process – an entire film constructed in the aftermath, an arrangement based on the content and style of 1800 photographs taken in the moment. The 'final cha-cha-cha' of a country that can pause amidst revolu-tion to relish, realize – and display – its victory.

Liza Palmer

Vagabond/Sans toit ni loi, Films A2, Ciné-Tamaris.

Vagabond

Sans toit ni loi

Studio/Distributor:
Ciné-Tamaris/MK2 Diffusion

Director:
Agnès Varda

Producer:
Oury Milshtein

Synopsis

The film opens with a farm worker discovering the corpse of a young woman frozen in a ditch. Then begins a series of flashbacks showing experiences she had during the winter of rootless wandering that ended in her death. Some of the characters with whom she interacts step out of their narrative roles and comment to the camera on their impressions of her; people she meets include a professor, an agronomist, a maid, a vineyard labourer, and an elderly woman. Over the course of the film we learn that her name was Mona Bergeron, that she once lived in Paris and worked in an office, and that she resented the confinement of bourgeois life. We also see that hunger, exposure, and the hazards of the road took a heavy toll on her; but she never gave any sign of missing the settled lifestyle she abandoned.

Screenwriter:

Agnès Varda

Cinematographer:

Patrick Blossier

Composer:

Joanna Bruzdowicz

Editors:

Agnès Varda
Patricia Mazuy

Duration:

105 minutes

Genre:

Drama

Cast:

Sandrine Bonnaire
Macha Méril
Stephane Freiss
Yolande Moreau
Patrick Lepczynski
Yahiaoui Assouna
Joël Fosse
Marthe Jarnias
Laurence Cortadellas

Duration:

105 minutes

Year:

1985

Critique

Structured as a sort of cinematic inquest, *Vagabond* eliminates conventional narrative suspense at the outset, informing us that the protagonist – a woman who lives 'without roof or law', as the film's French title says – will not survive the events we are about to see. Sentimentality is eliminated too. Technicians zip the cadaver into a body bag and the film cuts to a shot of footprints on a beach as Varda speaks in voice-over. In a tone suggesting both dispassionate observation and empathetic concern, she gives the vagabond's name as Mona Bergeron (played by Sandrine Bonnaire), reports that her unclaimed body was buried in a pauper's grave, and concludes by saying that the 'people she had met recently remembered her […]. She left her mark on them […]. I know little about her myself, but it seems to me she came from the sea'. Varda thus acknowledges her authorship of the character, who now enters the story by walking naked out of the surf, like a *nymphe maudit* whose freedom and artlessness will somehow take her to a tragic end.

The incidents that follow are episodically strung together, linked psychologically by Mona's personality, geographically by the rural and small-town milieus she travels through, sociologically by the races, occupations, and class identities of the people she encounters, and dramatically by the progressive deterioration of her physical and mental well-being as she endures various hardships interspersed with periods of calm, companionship, and a modicum of comfort. The film takes place in the area of southern France where Varda grew up, and she captures its qualities – the variety of the landscape, the presence of ethnic minorities, the proximity of people with very different backgrounds and jobs – with the neo-realistic precision that consistently distinguishes her fiction films as well as her documentaries.

Vagabond is equally exact on a formal level, complementing its emotionally involving story with brilliant use of visual and aural parataxis. When planning the film, Varda decided to punctuate the more or less linear plot with twelve tracking shots of Mona walking alone in various settings, with the character and camera always moving from right to left, accompanied by the only music in the film. She called these shots the 'grand series', since each offers a unique perspective on the overarching subject of Mona's wandering while producing a disjunctive break in the film's dramatic content. The shots are interconnected by rhymes and likenesses: one of them ends with a phone booth in view, for instance, and the next one, several minutes later, begins with a phone booth in the frame; the rhyme is obvious, but it requires considerable sensitivity on the viewer's part – a certain 'persistence of vision', in Varda's phrase – to perceive the correlation, which is further enriched by the contrast between an oblique camera angle in the first shot and a perpendicular angle in the second. Wanting a woman to create the music for this woman-centred film, Varda asked the Polish-French composer Joanna Bruzdowicz to write a series of variations on the andante movement of her 1983 string quartet 'La Vita', which appealed to Varda philosophically as well as musically, since

the sight of Mona walking to her death accompanied by 'La Vita' adds poignant irony to the travelling-shot cycle.

Varda has compared the discontinuous story of *Vagabond* with that of Orson Welles' classic *Citizen Kane* (1941), which also starts with a death, travels back in time for clues to its meaning, and closes on an enigmatic note. Mona does not have the smallest fraction of Kane's wealth and power, to be sure, and what we see of her life is far from exciting or even consequential. And this, paradoxically, is where the film's extraordinary force resides. Like the disadvantaged workers, disenfranchised immigrants, and disillusioned intellectuals she comes across, Mona either cannot fit or refuses to fit into the usual social pigeonholes; yet she lacks the insight, imagination, and self-awareness that might allow her to build an alternative way of living that is more fulfilling than the one she rejects. As another character tells her, she has sought complete freedom and found complete loneliness instead; so drastic is her estrangement that when she stumbles into a village festival near the end, the assault on her senses seems demonic and insane. In the final analysis, the trajectory that takes Mona from the liquid rhythms of the sea to eternal stasis in the frozen earth is inexplicable in its causes and nihilistic to its core, reflecting not a meaningful rebellion against society but the pointless self-destruction of a soul. Instilling her tragic voyage with a sense of human warmth and wonder is a miraculous achievement by one of the greatest modern film-makers.

David Sterritt

AVANT-GARDE

While historians are not obliged to account for every film ever made, there are certain gaps and oversights in film history that are so consciously concerned with the specificity of the medium and its potential that it seems imperative to give these works their rightful attention. The following is an attempt to point to some of the important under-represented avant-garde and counter-cinemas created in France, with a particular emphasis on the post-World War II period and an intensification and proliferation around the events of May 1968. In trying to isolate avant-garde cinema from other cinemas, we are confronted with the question of what designates a production as avant-garde. There are obvious tropes, even clichés, of what avant-garde cinema looks like, but any history of cinema that seeks to articulate its earliest incarnations must necessarily concede from the outset that the technology itself was an avant-garde project. From the beginning of its adventure in France, the debate about cinema's proper office was inscribed in its initial polar utterances. The Lumière brothers and Méliès, through their respective cinematic approaches, gestured towards issues of medium specificity, film form and generic considerations: film could document the reality before it or it could create new realities. Though not limited to these two possibilities, they alone sufficed to make the idea of a specifically avant-garde cinema somewhat oxymoronic.

Yet history makes certain categorical demands, meaning that there is a dominant canon of films that constitutes the French avant-garde, particularly in its pre-World War II manifestations. Generally this *Première avant-garde* (or French Impressionism) takes form and withers across the 1920s. While not necessarily eschewing narrative entirely, the predominance of visual experimentation was the hallmark of this body of work. A good example of a film that pursues new possibilities of the visual while keeping narrative intact is René Clair's avant-garde classic *Paris qui dort* (1923), a work that employs technical innovation, social critique and popular storytelling strategies to create a film that is hard to isolate as either a contribution to the history of avant-garde cinema or to the history of cinema in general. Apart from René Clair, four other figures of immense importance trans-categorically, i.e. for the history of avant-garde film, French film and film *tout court*, participate in this first avant-garde. The founder of IDHEC (Institut des hautes études cinématographiques) and a participant in the creation of the Cinémathèque Française, Marcel L'Herbier made his 1921 *El Dorado* under the flag of this first avant-garde, while Abel Gance included his 1923 mega-narrative *La Roue*. Germaine Dulac's *La Fête espagnol* (1919) is a seminal contribution to the first avant-garde, as is Jean Epstein's *Coeur fidèle* (1923).

Like all rational historical unfolding a second avant-garde follows the first. This second incarnation moved away from the *premiere avant-garde*'s association with Impressionism and towards Dadaist and Surrealist sensibilities. The films that constitute this second wave are again not merely films in the avant-garde canon, but are of paramount importance for the history of cinema as well. A leading case is the foundational text, Luis Buñuel and Salvador Dali's

Tout va bien, Anouchka, Vicco, Empire.

1929 cinematic rupture *Un Chien Andalou*. Jean Vigo also figures among this second avant-garde, with, among other films, his Dziga Vertov inspired *À propos de nice* (1930). And though they might not receive the same degree of popular recognition, what would the history of cinema be without Dimitri Krisanoff's *Ménilmontant* (1926), Marcel Duchamp's 1926 *Anemic Cinema*, Germaine Dulac's *La Coquille et le clergyman/The Seashell and the Clergyman* (1928), or Jean Epstein's *La Glace à trois faces/The Three-Sided Mirror* (1927)?

With the crepuscule of the second avant-garde, we are given an opportunity to break with a chronological fidelity to history and propose a kind of anachronistic 'Third Avant-Garde' whose concerns are as much with modes of production as they are with visual or narrative experimentation. Placed under this rubric might be engaged collective productions, such as the 1913 anarchist film collective Cinéma du peuple and their films *La Commune* (1913) and *Le Vieux docker* (1914). We could also turn to a film collective created during the mid-1930s which sprung from the film pro-duction service of the SFIO (Section française de l'Internationale ouvrière).[1] Along with Marceau Pivert and the ever-present Germaine Dulac, the SFIO film service made *Mur des Fédérés* (1935), an early political documentary on a demonstration about the commemoration of fallen communards.[2] Another possibility here would be Jean Renoir and the other film-makers who worked collectively to make *La Vie est à nous/Life Is Ours* (1936), a work produced by the communist party and sympathetic to the interwar Front Populaire.[3]

With these examples a picture of a nascent militant avant-garde takes form, but a directly political approach to film practice is not requisite criteria for an alternative avant-garde. One film-maker who might steer us away from this conception is Jean Painlevé, whose work is a lucid example of how the avant-garde is constantly in process with aesthetics, method, technical advancement and political positioning. In this sense he could be conceivably the avant-garde film-maker par excellence of this period, if only for his entirely heterogeneous production: Painlevé published articles in the journal *Surrealisme*, served as the delegate for the film com-mission for UNESCO., and later was a founding member of the collective Le Groupe des 30. Painlevé's pre-Cousteau underwater films, such as the 1928 *La Pieuvre/The Octopus* and *Les oursins/ Sea Urchins*, are exemplary models of how his various concerns could be synthesized in single short subject films.

While the Occupation's paucity of experimental production is to be expected, the immediate post-war French cinema did not exactly explode with avant-garde film. (Exceptions which might fall under the rubric of this third avant-garde are: Robert Godin and Albert Mahuzier's clandestinely shot *La Caméra sous la botte* (1944), which showed daily life in occupied Paris, and *Oflag XVII A* (1945), clandestinely shot on 8 mm in a fake dictionary by prison-ers in a camp [Hennebelle 1976: 23].) Yet while the future New Wave film-makers were eschewing the then contemporary 'quality' French film and fawning over American studio productions and

Italian neo-realism, the early 1950s saw the production of at least three films that epitomized a trajectory that was at once political and avant-garde: Rene Vautier's *Afrique 50/Africa 50* (1950), the Lettrist Isidore Isou's *Traité de bave et d'éternité/Venom and Eternity* (1951) and Paul Carpita's *Le Rendez-vous des quais* (1953). Vautier's *Africa 50*, a film aimed at high school students (*Lycéens*) in France, sought to show how villagers in the AOF (Afrique Occidentale Francaise) lived and learned. The film takes a sharp turn, incited by Vautier's discovery that Africans were being used to operate a dam because their labour cost less than electricity. *Africa 50* thus becomes a document of the wreckage of colonialism. The film was shot more or less clandestinely and was banned in France until 1996.

A year after Vautier's nascent militant and formal experimentation, the Romanian born Lettrist Isou made his *discrépant* (i.e. seeking to create disharmony between image and sound) text *Venom and Eternity* (1951). The Lettrist movement held the embryonic germ, along with Cobra, of what would become the Lettrist International and eventually the Situationist International. Isou's *Venom and Eternity* is a hybrid of then contemporary international avant-garde tendencies and forms a tangential lineage with Dziga Vertov's *Man with a Movie Camera* (1929) and Walter Ruttmann's *Berlin: Symphony of a Metropolis* (1927). The film employs avant-garde strategies using inserts of black leader, scratched and marked up film stock, inverted images, and throughout much of the film maintains a pulsating, tribal, Lettrist poetic score to accompany Isou's critical diatribe. Fellow Lettrist and future Situationist Guy Debord's cinematic output also began in the 1950s and was directly inspired by Isou's *Venom and Eternity*. In 1952 Debord gave new meaning to 'black-and-white' with his *Hurlements en faveur de Sade/Howlings in Favor of Sade*, a one-hour film composed of black-and-white leader and occasional voice-over. The *hurlements* or howlings of the title were not in reference to what was coming from the diegesis but rather those that were produced by the spectators of this film after sitting in front of an imageless movie for a few frames too long. In 1959 Debord made *Sur le passage de quelques personnes à travers une assez courte unité de temps/On the Passage of a Few People Through a Rather Brief Period of Time* and in 1961 *Critique de la separation/Critique of Separation*. These films were followed by a period in which Debord's creative and theoretical preoccupations were elsewhere. Debord and another Situationist René Viénet, returned to film as the flame of the first generation of Situationists withered. In 1973 Debord adapted his monumentally influential book *Society of the Spectacle* to film, and he continued with *Réfutation de tous les jugements, tant élogieux qu'hostiles, qui ont été jusqu'ici portés sur le film 'La Société du spectacle'/ Refutation of All Judgments, Pro or Con, Thus Far Rendered on the Film 'The Society of the Spectacle'* (1975) and *In girum imus nocte et consumimur igni* (1978). Meanwhile, René Viénet used the Situationist concept of *détournement* and produced three entirely 'détourned' films, the most well-known being *La dialectique peut-elle casser des*

briques?/Can Dialectics Break Bricks? (1973), a black-and-white martial arts film dubbed with pro-Situationist dialogue. *Détournement* is defined as 'The reuse of preexisting artistic elements in a new ensemble' and it has two fundamental laws, the first being 'the loss of importance of each *détourned* element', and the other is 'the organization of another meaningful ensemble that confers on each element its new scope and effect'. In 'Methods of Détournement' the practice is described as a 'powerful cultural weapon in the service of a real class struggle [...]. It is a real means of proletarian artistic education, the first step toward a *literary communism*'. In the early essays the method was thought to be largely applicable to literary forms, but the practice was found to be applicable to a number of spheres of artistic and cultural production, the cinema being one of the most important.[4]

With French colonialism motivating Vautier's project, and a burgeoning critique of everyday life for Isou's film, prior to the events of 1968, the other major political backdrop that shaped cultural production in France were the wars in Indochina and Algeria. The Marseille born resistant Paul Carpita, who had been working since the mid-1940s with an incipient counter-information group called Cinepax, began work in 1950 on his most well-known film *Le rendez-vous des quais*. The film tells the story of a young dock worker in Marseille who refuses to join the union and ends up being exploited, all of which is underscored by France's military operations in Indochina. What gives *Le rendez-vous des quais* its cinematic and political power is its narrative concern with the organized working class, but also its aleatory and direct shooting style: the film appropriated documentary as both aesthetic approach and film form. Carpita worked on the film until 1953 and shortly after a premiere in 1955 the film was banned. *Le rendez-vous* was considered lost for 35 years until it resurfaced in 1990, and Carpita's importance is only today being assessed after his death in 2009.[5]

Though by no means defining films in terms of influencing the age to come, the 1950s work by Vautier, the Lettrists, and Paul Carpita serves as a kind of filmic salvo for the following twenty years of film-making in the margins. Each film's particular strategy – Vautier's Eisensteinan approach to montage, Isou's use of *détournement*, or the hyper-realism of Carpita – was built upon in succeeding decades. We can see examples of this influence on two film-makers working in the mid to late 1950s, who adopted the strategy of radical realism and documentary as aesthetic form: Marcel Hanoun and Jean-Daniel Pollet. An accomplished and prolific film-maker, Marcel Hanoun never received the kind of attention that his contemporaries received.[6] His work, though rigorous and at times austere, also had the makings of popular fare, meaning that his films ran close to the divide between an abstract avant-garde tradition and narrative film-making. Jean-Daniel Pollet received more critical attention than Hanoun, but his work still remains poorly cited outside of France. Pollet's *Mediterranée*, made in 1963, brought him his most critical acclaim. The film combined an essay form with documentary and something gesturing towards science fiction. Pollet's work was considered by the critics

at *Cinéthique* to exemplify the kind of materialist film they deemed politically effective, and in this sense has special status as a film that represented the cinematic equivalent of the engaged writing being done at *Tel Quel*.

Two final projects of the early 1960s period are *J'ai huit ans* (1961) and *Octobre à Paris/October in Paris* (1962). *J'ai huit ans* is an eight minute collective production created by René Vautier, Yann Le Masson and Olga Poliakoff, with assistance from Franz Fanon, and is composed of a montage of drawings and voice-over by Algerian orphans living in a Tunisian refugee camp. The film was not distributed through standard channels, but rather benefitted from an underground militant circuit. The production of this film was accompanied by the nascent militant tract *Manifeste pour un cinéma parallel* (Manifesto for a parallel cinema) (Hennebelle 1976: 26), which enumerated many of the concerns and strategies for a political avant-garde cinema. In particular it pointed out alternative distribution channels such as community centres, factories and film-clubs, organisms that could project whatever films they chose to given that they were private enterprises. This focus on new modes of distribution was to be of immense importance to the underground film-makers of the coming decade, both in France, and throughout the international underground, or parallel, film movement. Concomitant to this text is *October in Paris*, directed by Jacques Panijel, a biochemist working at the CNRS (Centre national de la recherche scientifique), which recounts the massacre of peaceful FLN demonstrators by the French police in Paris on 17 October 1961. While the French government quickly banned the film, it was Panijel himself who, even after the ban had been lifted, kept the film from being distributed or projected.

The events of May 1968 in France created the conditions for new approaches to film culture, and saw the creation of Les États généraux du cinéma, an ephemeral organization formed in Paris during May 1968, which left behind only three issues of a journal and a six-point proposal for the restructuring of the French film industry. While Les États généraux was not a film-making collective, they did make common cause with a number of militant film-makers and collectives. One of the most prolific of these was the Atelier des recherches cinématographiques (ARC), which made counter-informational films about various strikes, demonstrations and events: *Nantes Sud Aviation* (1968) and *Le Droit à la parole* (1968). ARC, like other militant collectives to come, owed much in the way of politics and visual style to Jean-Pierre Thorn's *Oser Lutter Oser Vaincre/Dare to Struggle, Dare to Win* (1968), which documented the strike at Renault-Flins in 1968 with a hybrid approach to militant cinema, mixing direct cinema techniques and the use of inter-titles with often Stalinist slogans, creating something akin to a Brechtian-Naturalism. During the May events, there also emerged an anonymous collective production, associated with Les États généraux, that went by the name Cinétracts, whose films were predominantly silent, composed of still images and employed in-camera editing. These shorts served as a counter-informational means of communicating the events, clearly faithful to the twin

poles of early Soviet film-makers Eisenstein and Dziga-Vertov. Some of France's most well known film-makers are associated with this project, in particular Jean-Luc Godard, Chris Marker and Alain Resnais. Related to this project was the creation of two closely related film-making collectives, Groupe Medvedkine Besançon and Groupe Medvedkine Sochaux, a collaboration between Parisian avant-garde film-makers and militant factory workers in the Franche-Comté region of France. Their most well known work is *Classe de lutte* (1968), but there was an immense amount of work prior to and after this film.

During the events IDHEC had been instrumental in the production and distribution of militant films, the results of which carried over into the following decade. In spring 1973 the Mouvement de jeunesse contre la loi Debré held a number of large demonstrations of students against the reformation of national service and at IDHEC a group of students and teachers (including Guy-Patrick Sainderichin, Francois Dupeyron, Richard Copans, Jean-Denis Bonan and Mireille Abromovici) depicted this in a film called *Chaud, Chaud, Chaud*. From this production came the formal organization of the film collective Cinélutte. Cinélutte's early preoccupation was documenting strikes, but two of their most original works break with this tradition: *Petites têtes, grandes surfaces – anatomie d'un supermarché* (1974) – about the treatment of cashiers at a supermarket – and *À pas lentes* (1977–79), shot with female workers at the Lip factory.

The post-1968 period continued to see the proliferation of counter-informational and political avant-garde film projects, but with an even broader scope, sometimes linked to the now famous micro-political struggles given currency by post-structuralists like Michel Foucault and Gilles Deleuze. For some this was a period of crisis, but for others a new opportunity for burgeoning counter cinemas. A key voice here emerged across the pages of *Cahiers du Cinéma*, *Tel Quel* and *Cinéthique*, whose well-documented theoretical battles derived from interpretations of Marxist-Leninist theory. Between the *Cahiers* and *Cinéthique* a particular clash took form around Godard, who had distanced himself from the *Cahiers*, in large part because of the constantly changing ownership of the magazine.[7] In 1972, in an effort to reclaim Godard as their own, *Cahiers* printed a critical assessment of two films in issue 238–39, conducted by a group calling itself the Lou Sin groupe d'intervention idéologique. The critique was centred on Godard's Groupe Dziga-Vertov film *Tout va bien* (1972) and Marin Karmitz's collectively made *Coup pour coup* (1972); the *Cahiers* firmly took a pro-Godardian stance.

Meanwhile, *Cinéthique* was also a centre for an alternative militant cinema, as the journal made film production an integral part of its output with an eponymous collective. *Cinéthique* maintained a strange relationship with other film-makers of the same period: on the one hand they were widely criticized by collectives as well as critics, and yet consistently they were included in colloquia and compendiums on militant or avant-garde film-making. *Cinéthique's* first production, *Quand on aime la vie on va au cinema* (1975), took

its name from a campaign in the 1970s to try and reinvigorate a shrinking cinema-going public due to an augmented ticket prices (Faroult 2009). The film proceeds as a collage or montage film, and though perhaps politically antithetical to the Situationists, it did borrow heavily from the practice of *détournement* and resembled *La Société du spectacle/Society of the Spectacle. Cinéthique* would go on to make less abstract films, notably an anti-nuclear weapons proliferation film, *Tout un programme* (1978).

With the new political focus on race, gender and sexuality, a new population was beginning to speak up via cinema: the special needs community. *Cinéthique* collaborated with Le Comité de lutte des handicapés and their journal *Les Mechants handicappés* to make the super-8 film *Bon pied bon oeil et toute sa tete* (1978). Just prior to *Bon pied* another super-8 project was made, *Ames charitables s'abstenir* (1977) by Sabine Mamou and Jean-Luc Heridel. Mamou was a film editor who had worked for Agnès Varda, and Heridel (who later ran a monthly journal for the militant handicapped community, *Bankalement votre*) was a 20-year-old man with cerebral palsy. Their point in common was a sense of marginalization, he as 'handicapped' and she as an immigrant, and the desire to create, or fill a certain void, in what they were calling counter-information.[8]

Elsewhere, other groups associated with the liberation movements of the 1970s were turning to film as well. Prominent here was the Swiss born Carole Roussopoulos, a pioneer in video, who in 1969 set up a collective with her husband Paul called Video Out. Roussopoulos was wildly prolific: her work included projects related to the MLF (Movement de libération des femmes), as well as the FHAR (Front homosexuel d'action révolutionnaire), Lip, Palestine, Angela Davis, and more until her death in October 2009 (Roussopoulos 2007). Among Roussopoulos' first films was a document of a demonstration of the FHAR, a militant organization largely conceived of by 25-year-old Guy Hocquenghem in 1971. This loose group issued from the MLF; clearly, increasingly radical homosexual militants would also participate in experimental-militant film-making. Emerging from this movement was a young cinephile who had been radicalized by the events of May, Lionel Soukaz, who began making Super-8 films in 1972 with homosexuality as their theme. Later in the 1970s Soukaz created three of his most significant works: *Les Sexes des anges*, the documentary *Race D'EP, un siècle d'images de l'homosexualité* and the ciné-journal *IXE. Les sexes des anges* and *IXE* both took up an extremely intimate form of film-making. Largely montage films, these two works employed what were increasingly becoming tropes of experimental cinema, such as scratched emulsion and defamiliarizing juxtaposition (particularly true of *Les Sexes des anges*).

Other social concerns motivated avant-garde film-makers. In 1973 a feminist organization, MLAC (Mouvement de libération de l'avortement et la contraception), formed to assist women seeking to terminate their pregnancies – abortion was illegal in France until the Veil law of 1975.[9] Two films were made about MLAC, *Histoires D'A* (1973) and *Regarde, elle a les yeux grands ouverts* (1980),

the former a collaborative project by film-maker Charles Belmont and editor Marielle Issartel with the militants from MLAC, which focused on the abortion procedure known as the Karman method. The film is quite explicit in showing the procedure, and in this sense *Histoires D'A* was a pedagogical film, transmitting the forbidden knowledge/practice that was at the centre of the controversy MLAC faced. Although *Histoires D'A* was immediately banned, it was reputed to have been seen by 200,000 people in clandestine screenings (Hennebelle 1976: 117). *Regarde, elle a les yeux grands ouverts* was made after the legalization of abortion in 1975; through a combination of documentary and performance it reconstitutes a trial in Aix-en-Provence against MLAC members who had been performing abortions. The film, though made collectively, was principally under the direction of Yann Le Masson.

In the early 1980s, under François Mitterrand's presidency and the hopes that came with his socialist project, the militant avant-garde cinema in France began to settle as other forms of avant-garde film-making took hold. But historical reflection on those political avant-garde cinemas remains sparse. In assessing the work, particularly surrounding the events of 1968, the idea is to expand the canon by adding these films to the history of French cinema, yet there is also a hesitation. One of the deflationary lessons of the Third Cinema model, given to us by Ocatvio Gettino and Fernando Solanas, was the almost inevitable degeneration of the Third Cinema to a status of Second Cinema i.e. what made Third Cinema 'third' was in part its temporal status, that of the present. One of the most adept machines of reification is historical reflection, that vantage point precisely from which an object in process is looked upon as a static and terminated materialization. In this way *Hour of the Furnaces* (Ocatvio Gettino and Fernando Solanas, 1968) is no longer the same revolutionary piece of Third Cinema that required interruptions during a screening in order to discuss the political insights and possibilities of the film but rather it is now an *auteurist*, albeit political, masterpiece, which in turn reduces it (or promotes it according to who is assessing) to second cinema. In the same way we are confronted with other political avant-garde cinemas. The two primary possibilities for assessing work that engages in the political processes of its time, are either appreciation for the work's artistic merits which surpass its political aspirations (often considered a by product or remainder of the aesthetic vision) or more simply the burial of the work. The object of this essay has been to take a somewhat practical approach, that is, to quite simply put this work into an anglophone history of French cinema. Given that here we have only touched the tip of the tip of the iceberg, it seems important to remind ourselves that the objective of assessing so-called counter-cinemas continues, and that the goal of this framing essay is to encourage and spur this kind of new revisionist analysis.

Paul Douglas Grant

References

Faroult, David (2009) '"Marxisme-léninisme" et "analyse concrète": sur *Quand on aime la vie, on va au cinéma* de Cinéthique (1974)', in Jean-Marc Lachaud and Olivier Neveux, *Art Et Politique 2*, Paris: Harmattan, pp. 147–64.

Hennebelle, Guy (1976) *Cinéma d'aujourd'hui*, Paris: Pierre Lherminier Editeur.

Roussopoulos, Carole (2007) 'Donner la parole à celles et ceux qui ne l'ont pas eue', interview with Hélène Fleckinger, *Une Histoire Du Spectacle Militant: Théâtre Et Cinéma Militants 1966–1981*, Vic la Gardiole: Entretemps.

Notes

1 See 'Cinéma militant' in *Cinéma d'aujourd'hui*, no. 5/6, March–April (Rumont: FilmEditions, 1976).

2 See Bertin-Maghit and Jean Pierre, *Une Histoire Mondiale Des Ciné mas De Propagande* (Paris: Nouveau Monde éditions, 2008).

3 See Jonathan Buchsbaum, *Cinema Engagé: Film in the Popular Front* (Urbana: University of Illinois Press, 1988).

4 See Ken Knabb, *Situationist International Anthology*, Bureau Of Public Secrets 9 (2007), pp. 55.

5 See Paul Carpita and Pascal Tessaud, *Paul Carpita: Cinéaste Franc-Tireur* (Montreuil: Échappée, 2009).

6 See Raphaël Bassan's 'Un Grand Meconnu', in Guy Hennebelle and Raphaël Bassan (dir.), 'Cinémas d'avant-garde (expérimental et militant)', *CinémAction*, no. 10/11, printemps-été, 1980, Papyrus editions.

7 See Antoine de Baecque, *Les Cahiers du Cinéma : Histoire D'une Revue*, Tome II (Paris: Cahiers du Cinéma: Diffusion, Seuil, 1991), pp. 247.

8 See Olga Behar, *L'ecran Handicapé*, CinémAction, 27 (Paris: Editions du Cerf, 1983), pp. 117–20.

9 See Élisabeth Auerbacher, *Babette, handicapée méchante* (Paris: Editions Stock, 1982).

Certificate No. X (includes Visa de censure [1967] and Carte de voeux [1969])

Director:
Pierre Clémenti

Composer:
Delired Camelon Family

Duration:
42 minutes

Genre:
Avant-garde

Cast:
Pierre Clémenti
Barbara Girard
Etienne O'Leary
Jean-Marc Momon
Yves Beneyton

Years:
1967–75

Synopsis

An abstract psychedelic film set to improvisational rock and roll.

Critique

Though he was an accomplished avant-garde film-maker, Pierre Clémenti was undoubtedly most well known for playing roles in an impressive array of works by star directors of international art cinema. His extraordinary filmography includes appearances in Visconti's *The Leopard* (1963), Buñuel's *Belle de jour* (1967) and *La Voie lactée/The Milky Way* (1969), Pasolini's *Pigpen* (1969), Bertolucci's *The Conformist* (1970), Jancsó's *The Pacifist* (1970), Rocha's *Cabezas Cortadas* (1970) and Makavejev's *Sweet Movie* (1974). As a film-maker, the majority of Clémenti's output utilized a visual language adapted not from European art cinema, but from the American underground of the 1960s. What his work shared with this movement was an emphasis on psychedelic excess as well as diaristic and ritualistic tendencies. Throughout his experiences in the French counter-culture of the 1960s, Clémenti carried his 16 mm Beaulieu camera, documenting his active involvement in the protests of May 1968 and his far flung travels as a bohemian thespian. In the lysergic travelogues of *La Révolution n'est qu'un début*, *Continuons le combat* (1968), *Certificate No. X* (1967–75) and *New Old* (1979), his camera transcribed the corrosive public violence of the period as well as the pleasure-seeking rites of European youth culture. In these films Clémenti transposed the collective social energies of the period into wild bursts of aesthetic experimentation in which he consistently used rapid montage, densely layered superimposition and *mandala* inspired circular matting.

Set to an entire eponymous LP by French improvisational prog rock collective, the Delired Cameleon Family, *Certificate No. X* is a summary statement on the end of the 1960s. (Though Clémenti began the film in 1967 he did not complete it until September of 1975.) In its current version, it contains two films that were at some point conceived independently; the original titles remain in place on the existing version of the film as *Visa de censure no. X* and *Carte de voeux* (aka *Greeting Card*) respectively. However, there is related and repeated footage in both films, suggesting that during its final restructuring in the mid-1970s, this diptych coalesced into a singular organic film at the hands of Clémenti.

The film opens with images of small waves rippling across the ocean in a deeply saturated pink hue while a gong resonates loudly on the soundtrack. A meditating woman then flashes by, surrounded by candles, before the protagonist enters the frame, naked and seemingly absorbed in a trance. This character walks up a mountainside with his head tilted toward the sky as he encounters a woman draped in a black coat sitting before a fire. This opening tableau introduces a hazy impression of some occult ritual; in it the film-maker himself appears as the nude somnambulist. As this chapter unfolds the actors become visually engulfed in

superimpositions of swirling colour while the soundtrack becomes more frenzied, blending eastern and western instrumentation including tablas and electric guitars. In these climaxes of abstraction, obscure mysticism, and improvisational prog rock, *Certificate No. X* achieves a fever pitch of pseudo-mystical hippie cliché and delirious textural expressionism.

Between the elemental images of water and fire that begin and end the film, young people frolic in the nude unashamedly or they pose self-seriously while performing semi-dramatic scenes. The film thus modulates its tone and style with great dexterity, moving from chases of sped-up *Hard Day's Night* (Richard Lester, 1964) inspired anarchy to vignettes in which semi-clothed actors and actresses don masks and capes in campish derivations of Kenneth Anger. Clémenti also scatters a dense layering of mass cultural images across his film through a frenetic and unceasing superimposition that matches the music in its wild unpredictability. Performative moments of improvisational drama are thus interwoven with a Rolling Stones album cover, handwritten letters by the film-maker, footage of James Brown performing live, pornographic line drawings, an early cartoon of Woody Woodpecker on skis, and news footage of police riots.

Significant portions of the film feature quotidian visions of bohemian life in which hippies strum guitars, smoke pot and bang on tambourines. Yet in other moments there are striking episodes of performative drama. After an orgiastic chapter in which a man slides a violin bow across a woman's naked body, Clémenti returns to the profilmic action in order to stage a strange intervention. In a two-tiered reference to Catholic religious practice and the countercultural ritual of acid consumption, he eats some kind of small circular wafer imprinted with an image of Uncle Sam. He then appears repeatedly spitting out a giant live spider – or perhaps an exotic sea crab? – in relentlessly repeated takes of heavily processed, saturated and solarized imagery. As this example demonstrates, the film's moments of absurd Dionysian excess are also often tinged with acerbic political commentary.

In the opening moments of *Carte de voeux*, the second half of *Certificate No. X*, we see countercultural slogans made explicit through onscreen text such as 'imagination, revolution permanente.' Later, in a section titled 'Paradise Now', Clémenti shows footage of the Living Theater performing their work of the same name in a gesture of anarcho-pacificist solidarity with his exiled fellow artists. This is just one example of the many moments of concrete historical and artistic reference that are scattered throughout Clémenti's mélange of multi-layered superimposition and rapidly flickering light show abstraction. Through its continual return to repeated visual and historical associations, *Certificate No. X* connects to its core celebration of nature, sexuality, pleasure and psychic transformation.

Like many casualties of his generation, Clémenti was absorbed simultaneously by drugs and politics. In 1973 he was arrested for possessing LSD and cocaine in Rome, though he claimed that he

was framed by the police for his radical political associations. After a year-and-a-half in prison, he returned to acting and film-making. However, most people who knew his work as an actor felt that he had lost the dangerous edge of menace and unpredictability that made him so attractive to major European auteurs. Nevertheless, his little known experiments in diaristic, hypekinetic avant-garde cinema continue to pose compelling cases for a French countercultural cinema of psychedelic delirium that is every bit as spectacular and explosive as that of the United States.

Juan Carlos Kase

Un Chien Andalou

Directors:
Luis Buñuel
Salvador Dalí

Producer:
Luis Buñuel

Screenwriters:
Luis Buñuel
Salvador Dalí

Cinematographer:
Albert Duverger

Editor:
Luis Buñuel

Ant Wrangler:
Jean Painlevé

Duration:
16 minutes

Genre:
Avant-garde

Cast:
Simone Mareuil
Pierre Batcheff
Luis Buñuel
Salvador Dalí
Robert Hommet
Marval
Fano Messan
Jaime Miravitlles

Year:
1929

Synopsis

A barber slices the eye of a woman with a razor. Eight years later, she sees a man dressed as a nun fall off a bicycle. She gathers his accoutrements only to have him appear in her room, and they together watch an androgyne collect a severed hand before being run over by a car. The man lusts aggressively after the woman, but finds himself dragging a pair of grand pianos draped with donkey corpses and strapped to two mildly astonished seminarians. Early in the morning, he is punished by a visitor, which turns out to be himself sixteen years ago, and he shoots and kills the punisher/himself. After the man's mouth is replaced by the woman's armpit hair, she storms out and takes up with a new man on the beach.

Critique

Un Chien Andalou is a signature film of surrealism and one of the most influential and widely-seen films of the avant-garde. As the synopsis suggests, a plot summary is both difficult and entirely beside the point. The film draws from a standard girl-meets-boy heterosexual romance storyline, yet turns these conventions on their head. Throughout, temporal and spatial relations are confounded, as are causality and motivation. The film's five intertitles – 'once upon a time,' 'eight years later,' 'toward three o'clock in the morning,' 'sixteen years before,' and 'in spring' – each identify a different type of temporal relocation, but the events that follow these jumps neither advance nor inform the story information of what came before. 'Around three o'clock in the morning', a visitor arrives at the apartment, admitted by the woman (Simone Mareuil). It seems that the previously seen carnal desires of the man (Pierre Batcheff) have subsided, as he now lies in bed in his original nun's garments. The visitor's arrival may have been motivated by those earlier incidents, as he scolds the man and forces him to stand with his forehead against the wall and his arms outstretched. Suddenly, it is 'sixteen years earlier', which connects the man's punishment with that of a naughty schoolboy, seemingly from his own youth. Yet we are in the exact same space of the apartment – the man still

Un Chien Andalou, Buñuel-Dali.

stands at the wall – and it is then revealed that the visitor is in fact the man himself. The schoolboy motif is reinforced by the desk and inkwells that we see, and the slow motion of the action perhaps suggests memory. But when the inkwells transform into pistols and the punished man shoots the visitor/himself, who falls down dead, now in a park, it is as though we never left the present, despite the intertitle – if such a present were possible in the first place. We linger on any trace connections in order to try and impose some kind of causality, but the story steadfastly yields no consistent logic.

The guiding organizational principle of the film is one of association. A close-up of ants crawling out of a hole in the man's palm dissolves to a shot of the underarm of a reclining woman; dissolve to a close-up of a sea urchin; dissolve to several masked high-angle shots of the androgyne as she pokes at a severed hand; wipe to a crowd standing around the androgyne in the middle of a city street. The shape of the slightly cupped palm, along with the darkness of the hole and the ants, link it to the armpit and its hair. The color and texture of the armpit hair in turn links it to the sea urchin, and the spherical shape of the sea urchin connects it to the circular mask surrounding the androgyne that becomes the perimeter of the crowd standing in a circle around her. What matters here is not what these individual images represent or symbolize, but rather how they echo each other and both force and liberate viewer interpretation. Similarly, the small striped wooden box first seen around the man's neck as he rides a bicycle is taken by the woman after

he falls to the curb. From this box, she removes a striped tie and situates it with the box among the man's clothing on the bed. Soon after, the severed hand is placed inside this box, and the androgyne clutches it as she is run over. The box then reappears around the man's neck when he lies in bed dressed again in nun's clothing. The visitor throws it, along with the clothes, out the window, only for them to be found by the woman and her new beau as they stroll along the beach toward the end of the film. The recurring manifestations of the box offer a flimsy unity to the film, a vague consistency from which we draw the connections on which to base our readings.

The film's most memorable imagery is its most notorious: the slicing of the woman's eye. This famous opening encapsulates the surrealists' obsession and anxiety over one of the most fundamental of human curiosities – perceived reality versus experienced fantasy – especially with respect to basic questions of sexual difference and its relationship to human impulses and desires, be they lust or violence. The film investigates such issues at the level of the literal and figurative, but, strikingly, these explorations – like much in the work of surrealism – come to be realized in a varying yet persistent misogyny. All that is unknown, sought, and feared gets repeatedly mapped onto the definitive other: woman.

Luis Buñuel claimed that *Un Chien Andalou* was financed by his mother with a sum of 25,000 pesetas or $2,500, of which he boasted spending only half on the film itself. The film was shot in March 1928 in Le Havre and at Billancourt near Paris and premiered in April 1929 at the Studio Ursulines in Paris to considerable acclaim, surprising Buñuel and Dalí, who had anticipated – and hoped for – protests and riots. Today, the most widely circulating version of the film contains a soundtrack added in 1960 from selections Buñuel made by alternating tango music with an excerpt from Wagner's 'Tristan and Isolde', reportedly based on the original phonograph recordings that he chose for the film's first screening.

Vincent Bohlinger

Be Seeing You

À bientôt j'espère

Studio/Distributor:
Iskra

Directors:
Chris Marker
Mario Marret

Synopsis

Be Seeing You documents a strike at La Rhodicéta, a textile factory in Besançon, France. The film captures the strikers' focus on changes not limited solely to wage increases and reductions in working hours. When the strike's participants find the film a failure, Chris Marker gathers a group of professional film-makers to teach the workers in the region how to make films, and thus represent themselves. *Classe de lutte* is the first film by this group of workers, Le Groupe Medvedkine.

Critique

In March 1967 René Berchoud, the founder of the CCPPO (Centre Culturel Populaire de Palente-les-Orchamps) in Besançon, wrote a note to Chris Marker stating 'If you're not in China or some-

Cinematographer:

Pierre Lhomme

Editor:

Carlos de Los Llanos

Duration:

43 minutes

Genres:

Avant-garde

Documentary

Years:

1967–68

Classe de lutte

Studio/Distributor:

Societe pour le Lancement des
Oeuvres Nouvelles (SLON)

Directors:

Le Groupe Medvedkine

Cinematographers:

Collective

Duration:

40 minutes

Genres:

Avant-garde

Documentary

Year:

1968

where else, come to Rhodia; important things are happening here'
(Berchoud 2003: 45). Berchoud was referring to the strike at La
Rhodiacéta, a textile factory in Besançon that had taken on particu-
lar significance for the Parisian intelligentsia because the workers'
demands were not focused solely on salary and working hours but
also, for lack of a better term, quality of life. Marker showed up in
Besançon with film-maker Mario Marret and sound man Antoine
Bonfanti; together they participated in the strike actions and
documented it on film. This would eventually result in Marker and
Marret's *Be Seeing You*.

Prior to the meeting with Marker and the commencement of the
Groupe Medvedkine, the members of the CCPPO had experi-
mented with producing their own paracinematic forms. As early
as 1962 the CCPPO produced an 8 mm film entitled *Les Cinglés
du CCPPO/The Nuts from the CCPPO*, and CCPPO member
Jean-Pierre Thiébaud created handmade 'films' composed of his
illustrations on a partially transparent spool of paper. The spools
were loaded onto a rudimentary projector intended for classroom
use, which quite simply projected light through the spool of paper
as someone turned a crank to pass the images in front of the gate.
Recordings of audio montage and short narratives accompanied
these 'films'. In April of 1967 members of the CCPPO produced
another paracinematic endeavour entitled *Manuela*, an eight-
minute slide show narrative accompanied by a recorded voice-over
and musical score. *Manuela*, for all its handmade, homemade, no-
budget quality, managed to include the primary aesthetic strate-
gies that were to be the mainstays of post-68 cinéma militant.

The CCPPO had also screened *Loin du Vietnam/Far from
Vietnam* (1967). One year before the May events Chris Marker
established the production-distribution company Société pour
le Lancement des Ouevres Nouvelles, or SLON (also the Russian
word for 'elephant'). SLON was created in order to distribute the
collective film project *Loin du Vietnam*, which brought together
a number of the luminaries of 1960s film-making – including
Jean-Luc Godard, Joris Ivens, Alain Resnais, Agnès Varda, William
Klein, Claude Lelouch and Marker himself in support of the North
Vietnamese. SLON, which was set up in Belgium because of their
permissive censorship laws (versus France's particularly strict ones),
went on to serve as the production and distribution company for
Marker's 1967 documentary on the striking workers in La Rhodia
Besançon: that film is *Be Seeing You*.

Be Seeing You is indebted to the documentary tradition of
cinema direct, but the film maintains the legitimizing voice of its
author. Even if the majority of the film is dedicated to discussion by
and with the workers of the factory, and even if in those discussions
the author's voice takes second place through the technique of the
non-amplified, off-camera interviewer's voice, it ultimately creates
only an illusion of the primacy of the workers' speech, and there
is always a lapse back to the voice-over of the authors. However
effective – as a work that was politically engaged, or as an estab-
lishing project for the development of the Groupe Medvedkine –
this remains essentially Chris Marker and Mario Marret's film.

These issues would not slip past the workers of La Rhodia when they were given a screening of the film at a community centre in Palente-les-Orchamps, during which time the first Groupe Medvedkine would take form. From this screening emerges the imageless 'film' *La Charnière*, an audio recording of the workers' response after a screening of *Be Seeing You*. There is something decidedly telling about this document being only a recording of the voices, as the importance of speech is brought to the fore, suggesting that the first thing needing to be set right was that all speech be put on the same plane.

The workers' critique is harsh, calling the film-makers inept and unable to represent the struggle outside the lens of their own bourgeois identity. Marker responds by saying that as long as he is the one filming he can only be a sympathetic observer; the workers need to be the ones creating the films. Marker then gathers film-makers and technicians to teach the workers at Besançon, over the course of six months, on weekends and evenings, how to use film equipment, and after Marker recounts the story of Alexander Medvedkin and the propagandistic mission of the agit-vehicle *ciné-train*, the first Groupe Medvedkine, and their film *Classe de lutte*, emerged.

Classe de lutte is one of the great films of May of 1968. It harbours all the aspirations of those events, particularly when the film is considered as the third piece of a triptych commencing with *Be Seeing You* and *La Charniere*. It is a film that is at once an object lesson, false mimesis, and a document of liberation. If the story of the Groupe Medvedkine, Besançon and their adventure with film-making is not enough to warm the nostalgic hearts of those who believed film-making would change the world (for the better), then the narrative surrounding the principal character Suzanne Zedet should pull in any reluctant stragglers. Suzanne makes an appearance in *Be Seeing You* as a timid housewife who listens while her husband describes the struggle of work, the strike and even her own misery. In *Classe* she is an actualized militant figure who organizes, makes speeches, prints flyers, and militates in every sense of the term. Suggesting that workers do not think poetry and culture are for them, Suzanne says that on discovering the class or worker's struggle she also discovered culture. While *Classe* is a highlight of the Groupe Medvedkine project, they would go on to make a number of magnificent films in Besançon, before eventually dissolving and re-emerging with Pol Cèbe and Bruno Muel at the infamous Peugeot factory in Sochaux.

Paul Douglas Grant

References

Berchoud, Micheline (2003) *La véridique et fableuse histoire d'un étrange groupuscule: le CCPPO*, Les Cahiers des Amis de la Maison du Peuple de Besançon, Cahier 5, pp. 45.

Coeur fidèle, Pathé.

Coeur fidèle

Studio/Distributor:
Pathé Consortium Cinema

Director:
Jean Epstein

Screenwriters:
Jean Epstein
Marie Epstein

Cinematographers:
Léon Donnot
Paul Guichard
Henri Stuckert

Genres:
Avant-garde
Drama

Cast:
Léon Mathot
Gina Manès
Edmond Van Daële

Year:
1923

Synopsis

In Marseilles, Marie toils joylessly in her adoptive parents' dockside saloon. Marie loves Jean, but her parents have promised her to the thuggish Petit Paul. Jean and Paul fight; Paul escapes while Jean is arrested and imprisoned. Upon his release a year later, Jean seeks out Marie. She is now married to Paul, a shiftless drunk who brutalizes her and ignores their sickly infant. Jean and Marie meet secretly, and Jean gives her money for the child's medicine. Paul discovers the couple and confronts them in a drunken rage.

Critique

Coeur fidèle, a key work of Impressionist cinema, is also Jean Epstein's first fully formed feature. Epstein had already published criticism in Louis Delluc's *Cinéa* as well as an idiosyncratic book of film theory, *Bonjour cinéma*. Epstein's writings on cinema's potential were complex, visionary, and sometimes obscure. Taking much license with Henri Bergson's theories of duration and mobility, Epstein insisted that cinema – an art and science of movement – permits spectators to experience otherwise inaccessible aspects of an essentially mobile and continuous reality. Such ideas inclined Epstein, like other Impressionist theorists, to privilege revelatory moments: isolated close-ups, poised bodies, suggestive superimpositions. The photogenic qualities unleashed in such moments, much more than narrative or characterization, were the source of

cinema's power. Epstein the critic instructed his readers to ignore the banal plots of contemporary movies, and Epstein the theorist had little to say about narrative.

Most critics have interpreted Epstein's early films as a working through of his published ideas. But none of his features is simply a string of revelatory moments; even the most recondite among them rely heavily on melodramatic tropes. *Coeur fidèle* mixes exotic discoveries and what Epstein, introducing the film at a ciné-club in 1924, called a 'studied banality' (Epstein 1974: 124). Designed like a cheap paperback novel to appease the producers at Pathé, the film's title and simple scenario were conceived in one night ('something I would not recommend to others'). The film is structured by a Manichean morality and an emphasis on 'situation' and coincidence over psychology and classical plausibility.

Coeur fidèle does depart from the tangled, incident-rich stories of film and stage melodramas of the time in that its plot is remarkably attenuated. Epstein justified the sparse plotting and the stereotyped characters as his attempt to bring melodrama closer to its origins in classical tragedy. Paul (Edmond Van Daële) is 'the evil force of man. Brutal desire, human and animal, drunk and passionate like Dionysus'. Jean (Léon Mathot) is 'pure and noble love, moral force [...] of an Olympian serenity' (Epstein 1974: 124). But the rudimentary plot serves another function: it permits Epstein freedom to expend lengthy passages on simple actions that other directors, even fellow avant-gardists, would relay in a few brief shots. Thus the film's most celebrated reel, a rapidly edited carnival scene, lasts nearly ten minutes without advancing the plot's causal logic. Indeed, the frantic, rhythmic repetition of shots renders the sequence's signification so redundant that it becomes an exercise in contrasting movements (with a nod to synaesthesia via repeated shots of an organ). This was Epstein's response to the tours de force in Abel Gance's *La Roue* (1923) – and like the train sequences from that watershed film, *Coeur fidèle*'s carnival scene was frequently exhibited in ciné-clubs as an example of 'pure cinema'.

Other sequences, while not so elaborate, are still remarkably distended. An early scene involves Marie (Gina Manès) sneaking away to visit Jean. Only a few 'actions' take place – Jean waits, Marie brings bad news, they embrace – but each is depicted in a series of shots taken from different, often eccentric angles. Epstein's découpage exults in a syntactic freedom: slow dissolves, irises, and wipes are freed from their discrete narrative functions in the still-developing continuity system and instead embellish a narrative in stasis. The most salient elements in this long passage are extreme close-ups of Jean and Marie. These close-ups seem to be Epstein's attempt to spark the *photogénie* that he saw as cinema's reason for being: through the concentrated, isolating attention paid to the surface of two humble faces, the very immanence of the actors' features should not fail to inspire feeling.

We might expect that, having pared the narrative down, frequently to a standstill, Epstein would compensate by making his close-ups of faces maximally expressive and legible. But most are curiously withholding. Jean and Marie, in particular, often stare

inscrutably into a middle distance, betraying little explicit emotion. There are two ways to explain this lack: one following from Epstein's theory, the other gently giving it the lie. In his essay 'Magnification' Epstein writes, 'if the cinema magnifies feeling, it magnifies it in every way' (Epstein 1921: 240). Here he celebrates how cinema permits us to inspect the tiniest muscular twitches, 'the mouth which is about to speak and holds back, the gesture which hesitates between right or left' (Epstein 1921: 236). This insight, redolent of the Symbolist prizing of liminality, implies that the merest suggestion of feeling at the limit of perceptibility is both more moving and more photogenic than an overt, dynamic expression of feeling. We can then motivate the close-ups in *Coeur fidèle* by this logic: the power of cinema to magnify feeling is best demonstrated by magnifying the smallest gestures. But missing from this explanation is any acknowledgment of narrative context's role in making emotions legible, in 'magnifying' feeling in a less literal sense. The melodramatic tropes that drive *Coeur fidèle*'s plot permit, indeed demand, situations of instant emotional intensity and clarity. The Manichean morality and heightened emotionality of melodrama are what render the close-ups affectively legible despite the inscrutability of the faces within them – less *photogénie* than Kuleshov effect.

In his writing, Epstein disavows narrative, locating cinema's power in the bare presence of revealed outer and inner movement. Narrative has likewise played little role in subsequent critical writing that attempts to explain or systematize Epstein's thought. Yet in his features, he continually returns not just to narrative but to the benighted form of melodrama. Although Epstein apologized for his reliance on melodrama as a regrettable but easily ignored compromise with commerce, it is just as likely that the melodramatic frameworks of films like *Coeur fidèle* are doing much of the work that Epstein would credit to *photogénie*. To understand the power of *Coeur fidèle*, and to understand Epstein's film work in general, we must apologize to Epstein and take his use of melodrama seriously, despite his wishes.

Jonah Horwitz

References

Epstein, J. (1921) *Bonjour cinéma*. Paris: Éditions de la sirène.
Epstein, J. (1974). *Écrits sur le cinéma, 1921–1953*, vol. 1. Paris: Seghers.

El Dorado

Studio/Distributor:
Pathé Frères

Synopsis

Sibilla is the featured dancer in a nightclub in Granada, the El Dorado. She struggles to support a sickly young son. His father is the wealthy businessman Estiria, who years earlier had seduced and abandoned Sibilla and now rebuffs her pleas to help the child. Sibilla models for a painter, Hedwick, who carries on a secret affair

Director:
Marcel L'Herbier

Screenwriter:
Marcel L'Herbier

Cinematographer:
Marcel L'Herbier

Composer:
Marius-François Gaillard

Art Directors:
Robert-Jules Garnier
Louis Le Bertre

Duration:
100 minutes

Genres:
Avant-garde
Drama

Cast:
Ève Francis
Jaque Catelain
Marcelle Pradot
Philippe Hériat
Georges Paulais

Year:
1921

with Estiria's daughter, Iliana. In desperation, Sibilla blackmails Estiria by holding Hedwick and Iliana captive and threatening to expose their affair. But Sibilla instead releases them. Hedwick now pleads with Estiria for Iliana's hand, but Estiria attacks him before going mad. Hedwick and Iliana suggest that they take Sibilla's son to Hedwick's mother's country estate to convalesce – an offer which leads to the startling conclusion.

Critique

Marcel L'Herbier began writing, then directing, feature films in the mid-1910s. The first feature he directed, 1918's *Rose-France*, was a Symbolist-inspired psuedo-narrative, equal parts aesthetic reverie and nationalist propaganda. Following its inevitable commercial failure, Léon Gaumont demanded L'Herbier prove himself by adapting Henri Bernstein's boulevard melodrama *Le Bercail*, an experience L'Herbier compared to 'practicing his scales' (Abel 1984: 89). His next several films were part of Gaumont's Serie Pax, an attempt by Gaumont and producer-director Léon Poirier to unite avant-garde experimentation with scenarios designed for popular appeal (Beaulieu 2000: 6–8). Each of L'Herbier's Serie Pax films carried a subtitle that clearly designated the popular mode into which they fit: 1920's *L'Homme du large* was a 'seascape', *Carnaval des verités* a 'realistic fantasy'.

In the Serie Pax films we witness L'Herbier's increasing boldness in embellishing conventional plots with intricate patterns of graphic and rhythmic motifs. As Noël Burch has observed, these follow from the prodigious 'maskings, superimpositions and process shots' of *Rose-France* (Burch 1980: 621). Burch credited L'Herbier with creating films anticipating cinematic modernism by demonstrating that a film's découpage was capable of a complex stylistic organization above and beyond its narrative organization. This argument implies that L'Herbier was interested in his scenarios only as a pretext for experimentation. Indeed, L'Herbier's peers noted a seeming split between form and content. Emile Vuillermoz described *Carnaval des verités* as 'Disagreeable music, but delightful orchestration. [...] All this mastery of elocution is necessary so that we do not notice the poverty of the drama and its unjustified length' (Abel 1988: 228).

But *El Dorado* generated a less ambivalent response. It was both the first popular success and first consensus masterpiece of the French cinema's narrative avant-garde. Critics who had greeted L'Herbier's previous efforts with cautious gratitude now gushed. Léon Moussinac cheered the film's 'glorification of the eternal human truth, grievous and magnificent, which is to be enchanted by and to suffer for love'. Moussinac admired *El Dorado*'s dual appeal, predicting that its stylistic advances would be recognized and welcomed by cinephiles, while 'The public will be shaken by the pathetic power of the drama' (Abel 1988: 253).

The key to *El Dorado*'s power is in its subtitle, 'a melodrama'. The word was itself provocative, for it had an unequivocally negative connotation in contemporary critical discourse. But L'Herbier

replied – at the time and decades later – that film was an essentially popular art and that its vocation was to appeal to large audiences through spectacle and emotion. L'Herbier further justified the melodramatic mode in three concrete ways: by providing it with an exotic alibi, by recalling its etymology (the notion of 'musical drama'), and by synchronizing his embellishments with the film's emotional spikes.

Richard Abel has observed that *El Dorado* belongs to and references a 'Spanish film' cycle, in which Germaine Dulac's *Le Fête espagnole* (1920, also starring Ève Francis) was an earlier entry. The Moorish architecture and the mountainous landscape no doubt appealed to L'Herbier's graphic sensibilities, but as in many of these other *contes arabes*, the 'Oriental' atmosphere of Grenada proved a fitting pretext for a story full of 'bloody conflicts, sensual pleasures, and mystery' (Pierre Boulanger, cited in Abel 1984: 151). Fascinated with Spain from childhood, L'Herbier described it as a 'land of blood, lust, and death' (Beaulieu 2000: 3). The orientalist fantasy of a people closer to the elemental passions is given an additional racial cast by Sibilla's (Ève Francis) gypsy origins. Here the passionate emotionality and violence native to the melodrama are granted a pseudo-sociological (or at least a further generic) alibi by *El Dorado*'s exotic milieu.

L'Herbier also hoped, by subtitling *El Dorado* 'a melodrama', to call attention to the forgotten original meaning of the term: 'musical drama'. This phrase first alludes to an aspiration – and a critical heuristic – common in L'Herbier's milieu: the desire to make films 'like music', i.e. to attain the formal complexity and sublimated signification of a piece by Bach or Débussy. Second, it relates to Sibilla's occupation as a dancer. Francis' performance joins the dance sequences at the film's beginning and end to the rhythmically controlled gestures she employs between. Third, *El Dorado* is a 'musical drama' because it was the first French feature film with an original through-composed score. L'Herbier was especially proud of this, and stressed the importance of Marius-François' work, which imparts a rhythmic stylization to the entire film. Without the score, L'Herbier argued, the film was 'crippled'.

That said, the plot of *El Dorado* is unquestionably a 'melodrama' in the more familiar sense. The plot hinges on extraordinary coincidence, and it establishes an unbridgeable gulf between the virtue of the heroes and the unmitigated villainy of Estiria (Georges Paulais). Much of the 'melodrama' of *El Dorado* is embodied in Sibilla, a 'fallen woman' whose exotic sexuality entices the denizens of the El Dorado but whose innate goodness is immediately apparent to the audience. Most of *El Dorado*'s remarkable stylistic experiments reinforce the plot's moral polarities or underline the moments of Sibilla's suffering. For example, when Sibilla, gamely attempting to entertain the El Dorado's patrons, cannot help but think of her sick child, her portion of the film frame is out of focus. When she recalls her victimization at the hands of Estiria, the 'flashback' image is anamorphically distorted. In a father-daughter confrontation, Estiria appears inside black masking while the innocent Iliana (Marcelle Pradot) is surrounded by white.

Rather than a step on a path toward a splitting of narrative and formal patterning, as Burch would have it, *El Dorado* is L'Herbier's earnest attempt to articulate his experimental pursuits – his interests in graphic decoration, rhythmic editing, and joining image and music – to an unabashedly popular mode. The resulting reception was a harmony of elite and popular opinion, something L'Herbier would only sporadically achieve again.

Jonah Horwitz

References

Abel, R. (1984) *French Cinema: The First Wave, 1915–1929*, Princeton: Princeton University Press.
Abel, R. (1988) *French Film Theory and Criticism 1907–1939: A History/ Anthology, Volume 1, 1907–1929*, Princeton: Princeton University Press.
Beaulieu, M. (2000) notes to *El Dorado* DVD, Paris: Gaumont/Columbia/Tri-Star Home Video.
Burch, N. (1980) 'Marcel L'Herbier', in Richard Roud (ed.), *Cinema: A Critical Dictionary*, vol. 2, London: Martin Secker & Warburg.

The Starfish

L'étoile de mer

Director:
Man Ray

Original Poem:
Robert Desnos

Cinematographer:
Man Ray

Assistant Operator:
J. A. Boiffard

Duration:
15 minutes

Genre:
Avant-garde

Cast:
Alice 'Kiki' Prin
André de la Rivière
Robert Desnos

Year:
1928

Synopsis

A man becomes infatuated with a woman who sells newspapers. Following his aborted attempt to consummate the relationship, the man fantasizes about the woman, fetishizing an object – a starfish encased in glass – that she has allowed him to have.

Critique

The Starfish is a short film that foregrounds the act of seeing – scrutinizes it really – and yet, oddly, as P. Adams Sitney suggests, intentionally resists the cinematic convention of shot-countershot/ eyeline matching (1990: 29): the traditional editing method for making visual connections between viewer and object being viewed. And yet, for a short film, it accomplishes a lot, creating subtexts through the intersection of word and image and delighting in the many ways that viewing can be obscured and/or mediated.

As Sitney relates, *The Starfish* is an adaptation of a poem, now lost, by the poet and film critic Robert Desnos, who ultimately served as Man Ray's collaborator on the film (1990: 26). The resulting twenty intertitles or word references in the film, then, presumably reflect Desnos' prose. Sitney situates *The Starfish* as a response to an ongoing conversation in the 1920s regarding the status of intertitles: should film, as a visual medium, depend upon words to convey meaning (1990: 21–22)? Desnos, as Sitney claims, championed cinema's reliance upon words in his articles on film, believing 'the title [was] an integral part of the art of cinema' (1990: 22). And *The Starfish* certainly reinforces this notion, given that much of the film exists in the seams between intertitle and image.

Take, for instance, the shot of the woman (Alice 'Kiki' Prin) adjusting the garter on her thigh, bookended by the titles, 'Women's teeth are objects so charming' and 'that one ought only to see them in a dream or in the instant of love.' As Sitney observes and we, as viewers, can intuit, this connotes the idea of *vagina dentata*; a fear emphasized both by the man's fascination with the starfish object and his fevered imaginings of the woman as Cybele, the Greek goddess whose cult members were 'eunuch priests' (Smart 1998), wielding a glinting knife.

In another notable example of this deft word-and-image play (and rejection of shot-countershot/eyeline matching), we see: (1) the man (André de la Rivière) in medium shot examining his palms as an iris-in draws our attention not to his palms but to the starfish paperweight to his left; (2) a fade-in to a close-up of the man's palms (not aligned with the direction of his gaze), which he opens towards the camera to display his lifelines accentuated by ink; (3) a dissolve to a yet closer shot of the man's right palm held splayed before the camera; (4) and then the title, 'One must beat the dead while they are cold' (a line, which, interestingly, French censors protested (Sitney 1990: 32)). The words alone suggest masturbation but when coupled with the visuals of the marked-up palms (the highlighted lifelines dually representing sullied hands and wasted time), the meaning is made manifest.

While the figurative inventiveness of *The Starfish* is remarkable, of course, Man Ray's formal survey of viewing and how it is mediated by cinema – always and regardless of shot clarity – is what also distinguishes the film. Much of the film is viewed through a gelatin lens, obscuring and softening its visual information. Clear shots, consequently, are rendered banal (and, for the most part, indeed are, with images of city streets and painstakingly posed still lifes dominating the visual track). But Man Ray pursues this interest literally, as well, through shots of a foggy harbour, the woman in a mask, the woman hiding behind a newspaper, an intricate composite image of roulette wheels and spinning objects, etc. Ultimately, *The Starfish*'s legacy is its experimentation with form, an instructive lexicon of cinematic language and meaning-making.

Liza Palmer

References

Sitney, P. Adams (1990), 'The Instant of Love: Image and Title in Surrealist Cinema', *Modernist Montage: The Obscurity of Vision in Cinema and Literature*, New York: Columbia University Press, pp. 17–37.
Smart, Anthony E. (1998), 'Cybele', *Encyclopedia Mythica*, 19 July, http://www.pantheon.org/articles/c/cybele.html. Accessed 27 September 2011.

The Seashell and the

Synopsis

A clergyman performs what appear to be alchemical experiments,

Clergyman

La Coquille et le clergyman

Studio/Distributor:

Délia Film

Director:

Germaine Dulac

Producer:

Germaine Dulac

Screenwriter:

Antonin Artaud

Cinematographers:

Paul Guichard
Paul Parguel

Editor:

Germaine Dulac

Duration:

31 minutes

Genres:

Avant-garde
Drama

Cast:

Alex Allin
Genica Athanasiou
Lucien Bataille

Year:

1927

measuring and pouring his elixirs with a large oyster shell. He is disturbed by a high ranking military Officer, armed with a sabre, and draped in honorary medals. The Officer snatches the large oyster shell from the Clergyman and destroys it with his sabre. A conflict ensues between the two men, particularly over the appearance of a beautiful young Woman whom the Clergyman attempts to pursue, thwarted at every turn by the Officer. Through a series of dreamlike scenarios this conflict takes place in confessionals, on cliff tops and on sail boats.

Critique

Germaine Dulac's *The Seashell and the Clergyman* can claim to be the seminal surrealist film, as it predates Luis Buñuel and Salvador Dali's *Un Chien Andalou* (1929), although the latter remains more popular and better known. Dulac's film is based on a scenario written by Antonin Artaud, who by this time was an excommunicated surrealist himself. According to legend, Artaud was present for the premier of the film at the Studio des Ursulines and disagreed so vehemently with Dulac's interpretation of his scenario that Artaud and some friends caused a near riot and had to be ejected from the theatre.[1]

The Seashell and the Clergyman is, on some level, like watching an adolescent's dream unfold, whose preoccupation with burgeoning sexual impulses arouses both lust and trepidation. The entire film plays out like a kaleidoscope of sensuous and unconscious symbolism as one strange scene follows after another with no discernable narrative structure. Rather than utilize a linear narrative *The Seashell and the Clergyman* presents states of mind, preoccupations, thoughts, and imaginings that express the unconscious impulses that are the motive force behind those actions considered rational, deliberate and lucid.

If anything approaching narrative or theme exists in these sequential states of mind then it is that of torment. The appearance of 'The Woman' leads to anguish and sexual frustration in the Clergyman (who we can safely assume is celibate), setting up the dialectical conflict between the Clergyman and the obviously libidinous and virile Officer, whose chest of honorary medals evokes manly valour and sexual prowess, and whose large sabre no doubt represents the authority of the phallus. The film contains a series of hostile encounters between the Officer and the Cleric: sometimes the Cleric chases the Officer; another time the two wrestle on a cliff top where the Officer is cast into a void-like abyss; at one point the Cleric strangles the Officer in a confessional, whose garb suddenly changes to that of a priest. By this latter point it might be suggested that both Clergyman and Officer are dichotomous entities of the same mind; the conflict exists not between two men, but within one psyche.

Germaine Dulac's direction ably strings together these seemingly story-less images and tormented states of mind, remaining, for the most part, faithful to Artaud's scenario. There is much to be admired in the film. The sequence where the Cleric crawls on

hands and knees like a religious *Penitente* through the streets of Paris is striking; and of particular note is the ballroom scene where Dulac captures the motion of the many dancers swirling as rhythmically as the introduction of images on screen. Throughout the film the judicious use of dissolves, superimposition, slow-motion, and bravura editing increases the sense of a terrifying existence where the line between reality and surreality are blurred and where ratiocination gets caught in the mechanics of a dream.

Artaud later wrote: 'To understand this film we must simply look deeply into ourselves' (1972: 239). At the heart of *The Seashell and the Clergyman* lies the most basic human impulses, the fundamental drives that sit deep within the unconscious mind and which propel men and women into action, into flights of fear or fancy, into love affairs, into stupidity, into moments of genius and even madness. It is this universalism, this collectivity of unconsciousness, and the, perhaps, infinite interpretations Dulac's film may yield, that continues, almost a century later, to interest and intrigue. Perhaps the best approach to watching *The Seashell and the Clergyman* is to simply sit back and surrender oneself to the vertiginous lyricism of a dream…

Zachariah Rush

References

Artaud, Antonin (1972) 'Endnotes, no. 3', *Collected Works Vol. 3* (trans. Alastair Hamilton), London: Calder & Boyers.

The Virgin's Bed

Le Lit de la vierge

Studio/Distributor:
Zanzibar Films

Director:
Philippe Garrel

Producer:
Sylvina Boissonnas

Cinematographer:
Michel Fournier

Composers:
Nico

Synopsis

A loose retelling of the life of Jesus with Marie and Marie Magdalène.

Critique

Shot in the aftermath of the 1968 uprisings in France, *The Virgin's Bed* is one of the most powerful statements of pacifist allegory produced by the French counter-culture. It was one of thirteen films funded by the heiress Sylvina Boissonnas, between 1968 and 1970, and produced by the group of radical French film-makers and actors associated with Zanzibar Films. This collective, which also included Serge Bard, Jackie Raynal and Patrick Deval, were inspired by both American underground cinema (particularly Andy Warhol) and the French New Wave (especially Godard). As a result of this conceptual marriage, they integrated seemingly contrasting sides of contemporary film experimentation and produced technically accomplished gestures of aesthetic adventure and political resistance.

Garrel was an accomplished film-maker by the time he began *The Virgin's Bed*; he was something of an *enfant terrible* who had

John Cale

Editor:

Philippe Garrel

Duration:

114 minutes

Genres:

Avant-garde
Drama
Fantasy

Cast:

Pierre Clémenti
Zouzou
Tina Aumont

Year:

1969

begun making films at sixteen years of age. For his fifth feature, the film-maker shot an improvised widescreen epic based loosely on the life of Jesus Christ (played by Pierre Clémenti). Garrel's enigmatic work is a blend of myth and agitprop that incorporates the utopian aspirations of hippie bohemia, the post-colonial cynicism of Third Cinema, and the stylistic self-confidence of the French New Wave. In addition to realizing some of the core social and artistic goals of the radical Zanzibar collective, this film is also, perhaps, the masterwork of the group.

Under the influence of LSD, Garrel, his cast, and a small crew decamped for the deserts of northern Africa and the catacombs of Rome. Garrel presents the Moroccan landscape as a place outside of history, like his reconstructed story of the life of Christ in which the son of God carries a megaphone and machine gun fire echoes in the distance while Marie Magdalène (played by Zouzou) washes his feet. To add to the rhetorical crossfire of the work, the same actress, Zouzou (also a model and icon of French youth culture) plays both Jesus' mother and his love interest. Like the then contemporary works of Brazilian film-maker Glauber Rocha, this film is temporally and geographically ambiguous in its ideologically charged vision of the future (or perhaps the present) as a recapitulation of the mythic past.

Garrel's high contrast black-and-white film is composed almost exclusively in long takes. He abandons commercial cinema's logic of narrative causality and systematic editing in favour of a long procession of slowly moving vignettes of minimalist action and exceedingly sparse dialogue. Together these aesthetic details collectively emphasize the terrifying sublime of the desert landscape that functions as an expressionistic resource for representing the tortured psychology of the film's protagonist, and by proxy, the counter-cultural youth culture for which he stands. Throughout *The Virgin's Bed*, Jesus wanders across barren terrain in search of affirmation from an unresponsive father and an overprotective mother. Instead he finds comfort in the company of Marie Magdalène, his primary companion in his quest for meaning and escape from the terrors of modern life.

The film opens in a moment of pronounced anxiety, as a confused Jesus – who, in a typically absurdist gesture, has just been born as an adult! – proclaims to his mother, 'It's terrifying.' He is angry and bewildered about the conditions of the modern world; he turns his head to the sky and yells to his father in heaven, 'Come down and see this shithole!' Garrel's protagonist is angry and listless by turns, an alienated young man without an identity who sits on a beach in North Africa yelling at the sky (in the language of the region's colonizers) while surrounded by a wide expanse of scorched earth.

Like the heroes of Greek tragedy and the archetypes of 1960s counter-culture, Garrel's Jesus is a transient, a man without a home or country. As a member of the French generation that came of age in the wake of the Algerian war, Garrel is an artist whose early work reflects the guilt and frustration of France's past colonial ambitions. In its place, he proposes a new kind of social ideal,

modelled on the counter-cultural appropriation of Christ as a pacifist, a socialist, and a young man in search of purpose. Garrel gives us a vision of this religious leader as a hippie Hamlet trying to find his way in an arid landscape littered with lost souls and punctuated by state-supported violence.

In its tone, Garrel's film achieves a distinctive blend of narrative enigma and dramatic protest. Its explosions of anger and violence are forcefully amplified by the use of an incredibly wide dynamic range in its sonic register, including both its musical score and its sound design: much of the film is silent, featuring neither dialogue nor atmospheric sound. At times its sparse soundscape is punctuated by bits of dialogue, or on other occasions, exploding bombs, barking dogs or Berber music. However, in its most compelling moments, the diegesis of *The Virgin's Bed* becomes overwhelmed by screaming electric guitar feedback or the droning vocal delivery of Nico, whose flat chant-like singing provides the film with its most iconic blend of sound and image. (The singer would later be romantically associated with the film's director.) In these moments the film-maker activates the cultural logic of his generation by using rock and roll to activate the mythology of protest that underpins many of the era's most significant politico-artistic gestures.

The story of Garrel's film is partly a retelling of selected fragments of Christian mythology and partly a gesture of pure hippie iconoclasm. By re-contextualizing splinters of biblical narrative within sparse black-and-white tableaus of counter-cultural frustration, Garrel has constructed a blend of art cinema and avant-garde poetics that bleeds political allegory and hippie defiance at every turn.

Juan Carlos Kase

Le Moindre geste

Studio/Distributor:

Société pour le Lancement des Oeuvres Nouvelles (SLON)

Directors:

Fernand Deligny
Josée Manenti
Jean-Pierre Daniel

Producer:

Inger Servolin

Screenwriter:

Synopsis

Yves, a young man considered to be incurably handicapped, escapes from an asylum. He and another young escapee, Richard, traverse the Cevennes. Richard ends up falling into a hole in an attempt to hide. A young girl from a nearby quarry watches Yves and ultimately decides his fate.

Critique

The films created by groups like Les Méchants handicappés and the other militant 'handicapped' collectives were not solely the products of the shifting and expanding terrain of political activism that was underway in the mid-1970s; these projects also had their own cinematic pre-history, a striking case of which is a collaborative project, spanning two decades, beginning with one of the great French political avant-garde masterpieces, Fernand Deligny's *Le Moindre geste*.

Fernand Deligny

Cinematographer:
Josée Manenti

Editor:
Jean-Pierre Daniel

Duration:
105 minutes

Genres:
Avant-garde
Drama

Cast:
Yves Guignard
Richard Brougère
Numa Durand
Anita Durand
Marie-Rose Aubert

Years:
1962–71

Born in 1913, Deligny was a French educator who specialized in working with adolescents with special needs. The definition of special needs for Deligny was broad, including, for example, autism or schizophrenia, but also those teens characterized as delinquent or socially marginalized. He wanted to provide a place for these kids that was neither a prison nor a hospital; in many ways Deligny was a forerunner of the anti-psychiatry movement with his near total disdain for institutionalization (although complicated by a fascination/love of the asylum life). In 1948, under the guidance of Henri Wallon, Deligny founded La Grande Cordée, a therapeutic educational network that used youth hostels across France. This experiment introduced the children he had been working with to a new method of addressing their various diagnoses. After a few years the first incarnation of La Grande Cordée dissolved and Deligny left Paris for eastern France and then to Vercours, Allier, and the Cevennes with other educators and some of the young students from the project. During this period, in 1956, Deligny met the principal actor/character of *Le Moindre geste*, a former student from La Grande Cordée named Yves who had been diagnosed as psychotic.

Le Moindre geste was first undertaken in 1962 and was eventually screened at Cannes in 1971. The loose narrative follows Yves, who escapes with another boy (Richard) from an asylum, and the two wander the Cevennes. The film is shot in black-and-white and much of the often asynchronous audio was recorded each night after shooting, when Yves would recount his adventures into an audio recorder that served as voice-over for the film. The opening voice-over, however, is Deligny's, and it immediately provides an apt description of the whole film (in its collectivity and spontaneity) as well as giving the spectator an insight into the world of Yves by a man in whose care he had been for nearly a decade. The film opens on a piece of tracing paper while Yves draws a pair of figures and grumbles as he makes mistakes. Deligny's voice takes over:

> Deligny here. The little figure you see here comes from the hands of a 25-year-old boy. Experts say he is profoundly retarded (*débile*). In *Le Moindre geste* Yves is the same as he is in the life that we have lived together for the last ten years. He is such an inexhaustible source of laughter, no matter what happens to him, and in this film, just as in his very workaday life, he is the harbinger of a speech that I must insist does not come from me. Can we say that it is his speech? Do we have to attribute the ownership of speech to someone just because they use it?

This opening, along with a credit sequence that leaves one wondering what role and to what extent each of the participants contributed to the film, is indicative not only of the film project but equally of the egalitarian approach to education Deligny himself touted throughout his career. Across his writings we find the spirit of Jacotot, the egalitarian educator given a second life with the publication of Jacques Rancière's *The Ignorant Schoolmaster*

(1991).[1] In those same writings we also find a man who had a life-long preoccupation with the cinema, clearly attested to in works like *Camérer, La camera outil pédagogique* (1955) and a correspondence with François Truffaut that lasted from 1958 to 1975. Trufaut actually consulted with Deligny for both *Les Quatre cents coups/The 400 Blows* (1959) and *L'Enfant sauvage/The Wild Child* (1971).

Le Moindre geste's anarchic sensibilities allegorize the spirit of the period in which it was made. The narrative is one of escape, an escape evidenced in many of the militant avant-garde projects during the '68 and post-68 period. In 1969 Deligny undertook a project that was a kind of cartographic representation of autistic gestures, which he called 'lines of wandering' (*lignes d'erre*); and any resemblance between this project – along with Yves' 'lines of flight' through the Cevennes – to Deleuze and Guattari's celebrated 'rhizome' is by no means coincidental. From 1965 to 1967 Deligny, at the request of Jean Oury (co-founder of the La Borde clinic along with Felix Guattari), worked at La Borde largely as a cultural animator 'making toys for the children at the nearby hospital, taking care of the ciné-club where he showed militant films [...] and writing scripts and theater pieces with the patients' (Alvarez de Toledo 2001: 41). And after having seen the 'lines of wandering', traced principally on small index cards, Deleuze and Guattari were effectively inspired to work out their theory of the *Rhizome* (Alvarez de Toledo 2001: 41). And, if all this talk of escape seems heavy handed, a final note from the film's review in *Le Monde* after its screening at Cannes puts the nail in the coffin: 'Nine out of ten spectators escaped before the end, the tenth was entranced' (Bedarida 1996).

The project of *Le Moindre geste* led to the meeting between Deligny and a young autodidact named Renaud Victor. Victor saw *Le Moindre Geste* and set out to make a film with Deligny about autism, the result being *Ce gamin, la* (1975), a film that received much technical assistance from the militant collective Cinélutte at IDHEC as well as from Truffaut. In 1989 the pair again made a magnificent essay film, similar to Benoît Jacquot's recording of a Lacan seminar for television, this time with Deligny describing his experience with film and his pedagogical methodology entitled *Fernand Deligny, à propos d'un film à faire*. Renaud Victor died in 1991 and Deligny in 1996.

Paul Douglas Grant

References

Alvarez de Toledo, Sara (2001) 'Légends de Fernand Deligny', *L'Image, le monde*, 2, Autumn, pp. 41.
Bedarida, Catherine (1996) 'Fernand Deligny', *Le Monde*, 21 September.

Notes

1 Jacques Rancière, *The Ignorant Schoolmaster: Five Lessons in Intellectual Emancipation* (trans. K. Ross) (Stanford: Stanford University Press, 1991).

Orpheus

Orphée

Studio/Distributor:
André Paulvé Film
Films du Palais Royal
DisCina

Director:
Jean Cocteau

Producer:
André Paulvé

Screenwriter:
Jean Cocteau

Cinematographer:
Nicolas Hayer

Production Designer:
D'Eaubonne

Costume Designer:
Marcel Escoffier

Composer:
Georges Auric

Editor:
J. Sadoul

Duration:
95 minutes

Genres:
Avant-garde
Drama

Cast:
Jean Marais
François Périer
Maria Casares
Marie Déa
Juliette Gréco

Year:
1949

Synopsis

A narrator (Cocteau) starts the film with a brief retelling of the eponymous Greek myth: Orphée was a troubadour who cared more for his art than for Eurydice, his wife; when Death took her, he travelled into the underworld and retrieved her on condition that he never look at her, and when he broke the condition, the Bacchantes avenged her by tearing him to pieces. Set in the present, the film combines the ancient story with elements of Cocteau's own mythology, spiced with his characteristic humour. Orphée and Eurydice are a squabbling couple; the Bacchantes are Aglaonice and her League of Women; and Death has a chauffeur named Heurtebise who drives her luxury car. Cocteau also alters tradition with a striking reversal to the ending.

Critique

In the Poets' Café, jaded poet Orphée (Jean Marais) looks disdainfully at young Jacques Cégeste, the cultural heartthrob of the moment. In the first of the film's comic touches, a colleague tells Orphée that Cégeste's first poems appeared in a review financed by a Princess who now publishes *Nudisme*, which prints only blank pages – a taunt by Cocteau at the pretensions of avant-garde artists less authentically inventive than he considered himself to be. The colleague then gives Orphée the challenge that Cocteau had received from impresario Serge Diaghilev early in his career: 'Astonish us!'

During a brawl at the café two motorcyclists run Cégeste down, whereupon the Princess, who is actually Death (Maria Casares), takes his body into the backseat of her Rolls-Royce and orders Orphée to come along as a witness. In her crumbling mansion she spirits Cégeste into the netherworld through a mirror. The next day Heurtebise (François Périer) drives Orpheé home and decides to stay as a houseguest.

Orphée now becomes obsessed with the cryptic messages that come over the radio of the Princess' automobile, declaring that their crazy formulations – 'The bird sings with its fingers', 'A single glass of water lights up the world' – are greater than his finest poems. Cocteau is again mocking the superficiality of much modernist art, including that of the surrealist group, with whom he had a conflicted relationship. He is also attacking the twentieth-century 'cult of the machine', even as he transforms machinery into the stuff of myth by using a talking car as the equivalent of a talking animal in a legend or folktale. Cocteau takes note of the modern bureaucratic state as well: Aglaonice (Juliette Gréco) and her allies denounce Orphée to the police for plagiarizing poetry by Cégeste, whose lines were the source for the broadcasts that Orphée has been transcribing and presenting as his own.

Love is also in the air, however. The Princess comes into Orphée's room every night to watch him while he sleeps, and

Orphée, André Paulvé, Films du Palais Royal

jealousy prompts her to take Eurydice's (Marie Déa) life. Here the film gives an elaborate depiction of the process by which Death operates – a fantastic ritual involving telegraph transmissions, flickering lights, magical rubber gloves, and a mirror that connects the realm of the living with the world beyond. Oblivious to the fate that is overtaking Eurydice and too preoccupied with the car radio to heed Heurtebise's urgent warnings, Orphée is nonetheless shocked when he learns his wife is dead, and accepts Heurtebise's offer to take him into the underworld on a rescue mission.

The ritual of death and the voyage into the underworld give Cocteau opportunities to perform a sort of visual alchemy, transforming everyday things into talismanic objects with unearthly resonances. Nothing is more ordinary than rubber gloves, for instance, but Cocteau uses reverse-motion footage to show Orphée putting on a pair with supernatural powers. The effect is uncanny in precisely the sense intended by Sigmund Freud in his 1919 essay 'The Uncanny', where he describes the feeling produced 'when the distinction between imagination and reality is effaced', most powerfully in experiences related 'to death and dead bodies, to the return of

the dead, and to spirits and ghosts'. These are the very subjects of *Orpheus*.

In recent years *Orpheus* has been canonized as the central part of a so-called Orphic Trilogy, which begins with Cocteau's early short film *Le Sang d'un poète/The Blood of a Poet* (1930) and concludes with his last feature film, *Le Testament d'Orphée, ou ne me demandez pas pourquois/Testament of Orpheus, or, Do Not Ask Me Why* (1960). Less radically experimental than the former and free of the self-indulgence that mars the latter, *Orpheus* sets forth one of Cocteau's most coherent statements of a central theme, the need for an artist 'to go through a series of deaths and [...] be reborn in a shape closer to his real being', as he wrote in a 1950 essay. This allows the artist's creative spirit, and the work that flowers from it, to become immortal.

Orpheus is an earthbound film in some respects; scenes in the underworld and the Princess' mansion were shot in an area partially destroyed in World War II, for instance, and the nonsensical broadcasts have been likened to coded Resistance messages during the Nazi occupation. In other ways the film is a reverie and a poem, most movingly in its use of mirrors as portals to the netherworld; as Heurtebise says, by looking in mirrors all your life 'You'll see death at work like bees in a hive of glass'. In a 1950 essay, Cocteau wrote that the ideal audience is people who 'are open to my dream and agree to be put to sleep and dream it with me'. As a more recent film-maker might have phrased it, *Orpheus* is a perfect movie to watch with eyes wide shut.

David Sterritt

References

Cocteau, Jean (1950) 'Orpheus', *Les Lettres Françaises*, 16 November, repr. in Robin Buss (ed.) (1992) *The Art of Cinema*, London: Marion Boyers Publishers.
Freud, Sigmund (1919) 'The Uncanny.' *The Standard Edition of the Complete Psychological Works of Sigmund Freud, Volume XVII (1917-1919): An Infantile Neurosis and Other Works*, pp.217–256.

Tout va bien

Studios/Distributors:

Anouchka Films
Vieco Films
Empire Films

Directors:

Jean-Luc Godard
Jean-Pierre Gorin

Synopsis

A voice says, 'I want to make a film.' Another replies, 'You need money for that,' and an unseen person signs a long succession of checks for director, script, cinematographer, and so on in extreme close-up. To raise money the production will need stars, and to attract stars it must have a story, preferably about love. The story turns out to deal mainly with political action, labour rights and economic fairness. Workers have taken over a factory, holding the manager hostage until their grievances are addressed. Jacques, a film-maker, and Suzanne, a journalist, confront various obstacles as

Tout va bien, Anouchka, Vicco, Empire.

Producer:
Jean-Pierre Rassam

Screenwriters:
Jean-Luc Godard
Jean-Pierre Gorin

Cinematographer:
Armand Marco

Production Designers:
Jacques Dugied
Olivier Girard
Jean-Luc Dugied

Composer:
Paul Beuscher

Editors:
Kenout Peltier
Claudine Merlin

Duration:
96 minutes

Genre:
Avant-garde
Drama

Cast:
Yves Montand
Jane Fonda

they try to cover the strike; the state of their marriage also figures in the story. Various parties then try to understand these events and their own roles as participants or observers.

Critique

One of the more memorable moments in *Tout va bien* occurs when the manager of the sausage plant (Vittorio Caprioli), held hostage by striking employees, says he needs to visit the lavatory. His request gets a hostile response. Under the factory's policy, a striker explains, workers are allowed only three minutes to relieve themselves, and sometimes not even that. Told that he is now subject to his own rules, the manager races to a restroom in another part of the building, arrives just as his three minutes expire, and returns to his office a defeated man. It is a comic episode, but its humour is bitter and carries a pointed message: capital reigns in the workplace, and capital knows nothing of humanity, compassion or even good manners. Score one for the strikers. But do not say 'Everything's okay,' because winning small battles like this one are not the same as winning history's grand struggle in the long run.

Tout va bien was the next-to-last film created by Godard and Gorin under the banner of the Dziga-Vertov Group. The aim of the group, which was really more of a duo, was not to 'make political films' but to 'make films politically', as Godard famously remarked. Formed during the turbulent year of 1968 and influenced by everything from Bertolt Brecht's theories of radical drama to Jerry Lewis' theories of off-the-wall comedy, the group courageously and ingeniously questioned received ideas of style, content, and the

Vittorio Caprioli
Élizabeth Chauvin
Castel Casti
Éric Chartier
Louis Bugette
Yves Gabrieli
Pierre Oudry
Jean Pignol
Anne Wiazemsky

Year:
1972

nature of cinema itself. Such uncompromising works as *Wind from the East/Vent d'est* (1970) and *Vladimir and Rosa/Vladimir et Rosa* (1971) succeeded admirably at evading the film industry's capitalist tentacles, since almost no one would show them and hardly anyone wanted to see them. By the time Rassam offered to produce a feature with a real budget and certified stars, Godard and Gorin were ready to settle down a bit and reach out to a broader audience.

In the star department, Montand and Fonda were excellent choices, internationally known on the screen and widely recognized for their left-wing political activities. Neither was quite prepared for the unique experience of working with Godard and Gorin, however; according to Gorin, the actual stars of the picture were not the top-billed actors but the extras, who represent the common people. Montand was chronically doubtful about the project, and Fonda grew increasingly disengaged. (Little did she know that the final Dziga-Vertov Group film, *Letter to Jane: An Investigation About a Still* [1972], would fiercely analyze a magazine photo of her taken in Vietnam, accusing her of retrograde politics and of upstaging the Vietnamese people in the photo.)

Godard and Gorin wanted their productions to interrogate pieties of the right and left alike. *Tout va bien* is not as universally subversive as that suggests, but it uncovers splits and schisms among the factory workers, shows a modicum of sympathy with the perplexed and beleaguered boss, and demonstrates the pitfalls of trying to report news without properly understanding it. Instead of concluding with the revolutionary flags of Godard's *One Plus One* (1968; also known as *Sympathy for the Devil*) or the clenched fist of his *British Sounds* (1970; also known as *See You at Mao*), the film ends on a modest note, observing that Jacques (Yves Montand) and Suzanne (Jane Fonda) still lack solutions to their personal, professional and political problems, but at least they are more aware of the historical context in which they live and work.

Style is the element that sets *Tout va bien* most conspicuously apart from other Dziga-Vertov Group films. Its boldest visual strokes involve lateral tracking shots. At certain times the factory is seen in a cross-section view that reveals all the interior spaces through the missing fourth wall – a brilliant bit of *mise-en-scène* borrowed directly from Lewis' great 1961 comedy *The Ladies Man* – while the camera paces back and forth in front of it. And the penultimate scene shows politically inspired chaos breaking out in an enormous supermarket, filmed in long, sweeping shots whose simplicity and elegance contrast strikingly with the depicted action. Apart from *Letter to Jane* and the 1976 short *Ici et ailleurs/Here and Elsewhere*, Godard and Gorin did not collaborate again. But the bravura blend of politics, aesthetics, and explosive creativity in *Tout va bien* put a splendid capstone on their partnership.

David Sterritt

Vent d'est

Director:
Groupe Dziga Vertov

Producer:
Artur Brauner

Screenwriters:
Sergio Bazzini
Daniel Cohn-Bendit
Jean-Luc Godard

Cinematographer:
Mario Vulpiani

Editors:
Jean-Luc Godard
Jean-Pierre Gorin

Duration:
100 minutes

Genre:
Avant-garde

Cast:
Gian Maria Volonté
Anne Wiazemsky
Christiana Tullio-Altan
Glauber Rocha

Year:
1970

Synopsis

With the formation of the Dziga-Vertov Group, Godard strove towards a cinema that was radical in structure and content. The group was a cinema-workers collective of film-makers, students and political activists, taking the name of the great Soviet director Dziga Vertov to distinguish themselves from both the ideological seductions of mainstream Hollywood/European art cinema and the political orthodoxies of Eisenstein montage. Each of the Dziga-Vertov Group's films operate as cinematic polemics; perhaps the most significant of these experimental films, *Vent d'est* was intended as a 'Marxist western'.

Critique

Whereas all of Godard's previous features had received a theatrical release, the films he would release as part of the Dziga-Vertov group in the late 1960s were utterly removed from commercial distribution, instead circulating in cinema clubs, universities and various left wing organizations. Here, the system of representation that Godard had begun to critique in his earlier films is assaulted further. No longer content to simply discuss the operation and ideological structuring of a film, the Dziga-Vertov films set about demolishing this very structure itself. Aesthetics are questioned and any sense of cinematic beauty is dispensed with as factory conditions are filmed to look as harsh as they are in the everyday lives of workers. The distinction between character and actor and labourer is collapsed. The soundtrack is fractured from the image, rejecting traditional cinematic ideas that in fiction film the sound should confirm the image or in documentary film the image should confirm the sound. Colin MacCabe (1980) cites *British Sounds* (Godard, 1970) as important in the development of the group's new aesthetic:

> [In *British Sounds*] a Maoist analysis of British capitalist society is kept in tension with a variety of other sounds and a series of images, none of which provides the correct image of society but which, in their juxtaposition, provide the material on which the spectator must work. (MacCabe 1980: 22)

The film hence refuses to support only one conception of things or only one set of complementary elements, forcing the viewer to consider actively the relation of sounds and images, and each element in the film.

Vent d'est is particularly interesting in that it draws attention to the way in which mainstream bourgeois cinema operates. Many of the sequences in the film offer a critique of the workings of the film itself as it simulates bourgeois film-making. One sequence introduces a figure, a young, attractive Italian man (what the film calls 'a typical character in bourgeois cinema'), who addresses the audience and invites them into the film. In a stunningly photographed scene he directs our attention to the beauty of cinematic

representation and in doing so he also directs our attention to the function of such consciously constructed beauty in bourgeois cinema: to invite an emotional rather than a rational response, to encourage illusion and to forget the real exploitative conditions of society. In this one instant of visual beauty we see the seductive qualities of the film itself – a cinematic pout and coquettish invitation to indulge in the desires of the cinematic gaze. This sequence was viewed with varying responses by audiences and critics, as, due to there being two differing prints of the film in circulation, the film would either present a poor quality, muddy 16 mm image or a glossy, well-coloured 35 mm version. It is not clear if this variation in print quality was intentional, which version was intended for circulation, nor even is there any agreement on which version best captures the intentions of the group. Accordingly, *Vent d'est* would provide both a poor quality image that problematizes the visual pleasures offered by the cinema screen by offering its very opposite, and also a high quality image that highlights the seductive qualities of its own images by dwelling on this very seduction.

In another sequence the camera swings abruptly from side to side and then up and down, exploring the space of the shot, or rather, showing the space which the bourgeois film would not, bringing to our attention the space that would be hidden and in doing so directing us to the fact that the space that is shown over that which is not is consciously chosen by the film-maker for an ideological purpose. In 'The Delegate' section of the film, the soundtrack highlights the ambiguity present in the image, as the same image of a woman is shown whilst four different explanations are given by the voice-over ('This woman is Suzanne Monet [...] This woman is called Scarlet [...] This woman has become Ines Mussolini [...] She is called Rachel Darnev'). *Vent d'est* is keen to remind us that images do not speak for themselves and when we uncritically accept an image as possessing an inherent natural meaning we ignore the constructed nature of that meaning and of cinema itself. For a Marxist cinema group in the late 1960s and early 1970s the meaning was always being constructed as already ideological.

In *Vent d'est*, as in many of the Dziga-Vertov group's films, we are forced to confront the ideological uses of images and meanings, and the films show that in any given image there is always a plurality of meanings. As the film's most famous statement attests, the images that bourgeois cinema is keen to present as natural and lacking in any greater social purpose or political reality are anything but so. 'This is not a just image. It's just an image.'

Phillip Roberts

References

MacCabe, Colin (1980) *Godard: Images, Sounds, Politics*, London: Macmillan.

Zero for Conduct

Zéro de conduite

Studio/Distributor:
Franfilmdis
Argui-Film

Director:
Jean Vigo

Producer:
Jean Vigo

Screenwriter:
Jean Vigo

Cinematographer:
Boris Kaufman

Composer:
Maurice Jaubert

Editor:
Jean Vigo

Duration:
41 minutes

Genre:
Avant-garde
Drama

Cast:
Jean Dasté
Robert le Flon
Léon Larive

Year:
1933

Synopsis

The holidays are over, and young Colin, Caussat, Bruel and Tabard must return to boarding school, where the administration attempts to stifle the boys' imaginative freedom. Even the most minor infraction is met with a 'zero for conduct' and detention on Sunday. Fed up with arbitrary rules enforced by a cast of grotesque authority figures, the boys devise a plot to enact a mini-revolution during alumni day.

Critique

The cruelty, tedium, and occasional anarchic joy of French boarding-school life are thrown into absurdist relief in *Zero for Conduct*, Jean Vigo's masterful 1933 film. The film's central conflict is the polarity between child and adult worlds. Children in *Zero* intuitively understand one another; they are co-conspirators living naturally and freely, without the yoke of adult pretensions. Vigo renders this most strikingly through his incorporation of surrealist elements that transform mundane objects into fantastical ones. For instance, on their way back to school young Caussat and Bruel perform slight-of-hand tricks and transform their toys, with Caussat using feathers to change himself into a rooster. This is the first of several child/animal metamorphoses that occur in *Zero*, a motif that emphasizes the children's intimacy with nature and the fluidity of shape and form that they perceive there. Contrast this with the school's administrators – Superintendent Parrain (a long-bearded dwarf who keeps his hat under a glass dome) and Assistant Principal Blanchard – who wear glasses, walk in straight lines, and mechanically follow the arbitrary laws that give their lives shape and meaning. The emotional repression, felt in the exchanges between Parrain, known as 'Dry-Fart', and Blanchard, 'Gas-Snout', shot with a static, straight-on camera, clash with the affectionate, uninhibited play of the boys, seen through fluid camera, high-angle or aerial shots.

 The character between these worlds is the teacher Huguet, played with soft-faced charm by Jean Dasté. Huguet longs for the vitality of childhood, although he operates within a deadening bourgeois order. His classroom is a site of excess and surrealistic play, and he entertains students with his imitation of Chaplin, another figure who walks the line between child-like sensitivity and societal order. Huguet often removes his hat, an accessory other adults in the film use as ideological protection, and is receptive to the sensory world. In a scene that Truffaut would later pay homage to in *Les Quatre cents coups/The 400 Blows* (1959), Huguet leads the children on an excursion and gets separated from them by taking a wrong turn at a corner. As he walks, looking at the street and sky, we see his mussed hair and goofy expression; it is an endearing and poetic portrait, so drastically different from the stiff and physically repulsive characters that inhabit the school. In

this way we are led to identify with Huguet. He bridges the gap between our own nostalgia for childhood and the subjectivity of adulthood, a complexity that is realized in the film's concluding scene.

'It's war! Down with teachers! Up with revolution! Stand firm tomorrow!' The anarchic spirit centres on the children's insurrection on Alumni Day. But this narrative climax is preceded, the night before, by an artistic one: a euphoric explosion of feathers that takes place in the boys' communal sleeping quarters. Worked into a frenzy by another unjust punishment, the boys rise up in their nightshirts around a skull-and-crossbones flag. With a high-angle long-shot showing the mutineers' formation below, cinematographer Boris Kaufman signals that the familiar, sparse setting is about to change into something new. The boys invade the frames on all sides, pulling apart the bedding, jumping from mattress to mattress, as Parrain chases after them. A surrealistic, dreamlike state sets in as the boys, backlit, appear fantastic; white feathers fall like snow, mingling with white sheets and nightshirts. Slow-motion effects and an eerie soundtrack, made by Jaubert's re-recording of the film's earlier melodies backward, help transform the pillow fight into a poetic procession. Sheer imaginative possibility has lifted the mundane dormitory to the level of the sublime. The ecstatic boys walk in slow motion directly toward us, and then beyond us, as the sequence fades to black.

It seems apt that as a celebration of the liberating power of childhood, *Zero* would end with the stylistic tour de force of the feather sequence. But Vigo goes on to show how the boys fulfill their plan on Alumni Day. Our heroes climb to the school roof, hurling cans, shoes, and books directly at the camera. With one revealing image, the audience, too, becomes the object of the children's scorn. Vigo reminds us that we do not belong to their world. Huguet, holding his hat in one outstretched arm, neither joins the adults within nor the children above. He expresses happiness for the boys' feat and, perhaps, a certain sadness that, like us, he cannot join in. The four child-revolutionaries then leapfrog their way up the pitched side of the boarding school roof, defiantly abandoning a bourgeois order that seeks to confine them. As they climb up and away from the camera, towards the roof's peak and seemingly into the expansive white sky, they wave their outstretched arms: it is a gesture of triumph, a triumph that the film, with its visual poetry, celebrates and embodies.

And yet in the film's final shot, which follows the boys' ascent up the roof's slope, the camera does linger long enough to show them come to a halt at the precipice. They are in the distance, standing before the white sky that takes up most of the screen space. What can they do now? When introducing one of the rare public showings of *Zero*, Vigo asked, 'Will I ever set off across those roofs once again, towards a better world, slipping out by that loft which was the only place we could call our own?' In Vigo's nostalgia we can find a key to the film's subtlety. The revolutionary boys have staged their mutiny on Alumni Day, when the products of the school return as incorporated members of the society that waited for them as

schoolboys. Having climbed as high as they can up the roof's side, Caussat, Tabard, Bruel, and Colin have nowhere to go but down, where they will be integrated into a world from which there is, despite all the wistfulness of Vigo's question, no real return. That Vigo is able both to recognize that sadness and to celebrate the moment of childhood, no matter how short-lived, is the greatness of *Zero*.

Mariana Johnson

'Quality' is among the most complex evaluative and generic terms in the history of French cinema. Even in its heyday, from the Liberation to the arrival of the *nouvelle vague* in 1957, no single genre or style of film-making could claim exclusive rights on it. During the peak of its use, 'quality' named a variety of film-makers, forms and modes of film practice. But its relative portability is best understood through a longstanding cultural mission in France, one that has inspired film-makers to work with an assortment of genres, styles and literary sources.

The concept of a *cinéma de qualité* was borne of the view that France's production is a unique expression of the nation's cultural heritage. The term became part of a strategy to protect and celebrate France's particular voice in film culture. Since the mid-1930s, French policymakers have debated and enacted numerous 'protectionist' measures that reflect the national sentiment that France's 'quality' distinguishes it from Hollywood. The fact that French cinema represents a 'cultural exception', as it would become known, makes it worthy of patronage, subvention and international recognition.

In 1934, during a period where the stability of the French industry was threatened by scandal, mismanagement and financial collapse (O'Brien 2005: 61), prominent members of the film industry and government officials took the first steps towards an interventionist policy. During the 1936–37 Renaitour Commission, the future prospects of French genre and style were argued. During one of the commission's inter-parliamentary sessions on 16 December 1936, the issue of the 'defense and promotion of quality cinema' was debated (Leglise 1970: 176). One parliamentarian put the point bluntly: 'The problem of cinema in France is dominated by the question of quality' (Leglise 1970: 176). Jean Zay, then Minister of National Education and the Fine Arts, concurred, as did another parliamentarian, who linked 'quality' to a French national character. 'Yes,' this parliamentarian declared, 'the problem of cinema, it's the problem of all things French: we are a country of quality, and we need to return to this formula for everything' (Leglise 1970:176). Two members of the film industry, directors Marcel L'Herbier and Raymond Bernard, proposed tax breaks for quality films, as well as the creation of a national peace prize for cinema – a 'Nobel Prize for Film' (Leglise 1970:176). After further discussion, a representative of French exhibitors voiced concern about how 'quality' would be defined, arguing that in the event that this system of 'quality' subvention is adopted, 'large theaters would favor these films to the detriment of smaller ones' (Leglise 1970:176).

The German Occupation interrupted these 'quality' debates and imposed a more structured production system. After the Liberation, France returned to a free-for-all market where risk-taking was possible, but only within certain limits. Under these conditions, there were few stable firms that could guarantee consistent output and funding was difficult to secure for smaller production companies. No single company or group of companies was in a position to drive French production in this way or that. Like the late 1930s,

La Règle du jeu/Rules of the Game,
Nouvelle Edition Française.

the situation meant that film-makers had to approach a number of small and undercapitalized entrepreneurs to get their movies made. By 1947, there were 200 such firms in France (Bordwell and Thompson 2003: 373). These companies were so small and unstable that banks were reluctant to loan money to them to finance production.

The French government enacted several provisions in the post-war period – ones directly implicated in the development of a marketplace for 'quality' cinema. In 1946, French Prime Minister Léon Blum and US Secretary of State James Byrnes forged an agreement that eliminated all quotas for imported American films. During the war, American firms were unable to distribute in France. Suddenly, French screens were flooded with Hollywood fare. Among the films French audiences were finally able to see were *Citizen Kane* (Orson Welles, 1941), but as much as this excited and inspired *cinéphiles*, French film-makers protested that the agreement would destabilize the industry because it ensured that resources would be diverted away from indigenous production and towards distributing and exhibiting American films.

Feeling the pressure, the government responded with several protectionist laws designed to safeguard French cinema against American distributors who were benefiting from the open market. Related laws were enacted in 1948, 1953 and 1955 to encourage French production. In 1948, the government established a new quota, limiting the number of US imports. It also created a Temporary Aid Law to support French producers. This law created a new tax for a fund designed to subsidize those producers whose previous films were box office successes.

The law proved to be a boon for French production. Because a commercial success meant subsidy from the aid fund, producers focused on popular genre films with big stars. Between 1950 and 1955, film budgets doubled from 50 to 100 million old francs (Austin 1996: 12). Government measures also allowed French film-makers to take back their screens. In 1948 American films took in 51 per cent of box office receipts and French films only 32 per cent. Ten years later, the situation had been reversed (Austin 1996: 12).

From another standpoint, however, the new aid law created a closed loop, denying risky film-makers access to funding. Many within the industry and the critical press complained about this state of affairs, calling for an aid law supporting a *cinéma de qualité* that took risks. A 16 October 1950 issue of *L'Écran français*, the period's leading cinephilic weekly, included an article devoted to the question of quality, 'Encourageons la qualité: Un aspect important de la Défense du cinéma français'/'Let's Encourage Quality: An Important Aspect of the Défense du cinéma français' (Bloch-Delahaie 1950: 6, 23). The piece summarizes a recent manifesto by the Comité de défense du cinéma français (CDCF). Among other demands, the manifesto calls for a more sophisticated definition of 'quality' in French films. A number of influential figures from the production sector encouraged the industry to remain open to aesthetic discourses defining 'quality'. Among them was Robert Dorfmann, head of Corona, one of the most successful distribution

firms in the post-war period. Dorfmann, who had just produced the critically successful *La Justice est faite/Justice is Done* (André Cayatte, 1950), states boldly: 'To encourage the quality of French cinema, we have to modify the conditions of allocation of the aid fund, giving a wage preferential to quality' (Bloch-Delahaie 1950: 6). Appealing to a sense of public duty, Dorfmann calls for industry and government representatives to support quality French films that appealed to a broad French audience.

Within a few years, the French government started to heed the call. On 6 August 1953 the government created a new fund alongside automatic aid to be awarded to 'quality' short films. This *Prime à la qualité*, or 'Quality Reward', would be decided by a thirteen-person commission, including three government representatives, three critics, three directors of short films, three producers of short films, and the Director of the Centre National de la Cinématographie (CNC), France's national film commission created in 1946. The new measure was fairly conservative; with only 10 per cent of the original aid fund used to foster quality, it could only finance 80 short films per year (Gimello-Mesplomb 2006: 147).

Despite its relatively modest financial commitment, the reward represented a new institutional mindset. No longer was cinema viewed as a commercial commodity alone; from this point on, the French state acknowledged the medium's artistic value in its legislative decisions. The effects were immediate. Short film-making flourished. New auteurs banded together to form the Groupe des Trentes (Group of Thirty) in order to lobby for further refinements to state law. 'Culture' officially became a concern of the CNC. As a result, 'quality' came to symbolize an alternative to commercial cinema. When the Quality Reward law was modified in 1955 to fund feature films, France became a tale of two cinemas: a risky 'quality' cinema that stood in opposition to a popular cinema that continued to benefit from automatic aid. When the state passed a law on 11 March 1957 officially recognizing the status of 'author' for works of an audio-visual nature, France now had in place the measures needed to recognize and support a *cinéma d'auteur* (Gimello-Mesplomb 2003: 101).

The story of 'quality' is more complicated still. Critical discourse had its own uses for the term. Between 1948 and 1957, critics co-opted 'quality' in numerous ways, jockeying for position to strategically attach the label to feature-length narrative films they were both partial to *and* disliked. The label increasingly served a plethora of functions. 'Quality' came to symbolize a welter of artistic practices, styles and genres in this exciting era of cinephilic fervour.

First, 'quality' emerged as a commercially risky *cinéma d'auteur*. The most prominent advocate of this version of 'quality' was the influential critic and theorist, André Bazin. In a 1951 article, 'Difficile définition de la qualité'/'Difficult Definition of Quality', Bazin attacked the 1948 law, proposing that instead of taxing exhibitors to support producers whose previous productions were box office successes, a portion of the money raised should go to artistic risk-takers. Deriding the current law as 'une prime à la mediocrité' (a

prize for mediocrity), and arguing for 'an assembly of disinterested critics rendering decisions on the aesthetic quality of a film' (Bazin 1951: 6), Bazin wanted a portion of the aid law to be responsive to cinephilic taste through a committee of critics mandated to allot the funds.

Three films that had difficulty finding an audience upon their initial release represented the 'risks of quality', as Bazin put it (1951: 6). Jean Renoir's commentary on bourgeois decadence and experiment with deep focus cinematography, *La Règle du jeu/The Rules of the Game* (1939); Marcel Carné's poetic realist masterpiece in flashback storytelling and expressive lighting, *Le Jour se lève/Daybreak* (1939); and Bresson's sparse adaptation of Denis Diderot's *Jacques le fataliste/Jacques the Fatalist and his Master* (1796), *Les Dames du bois de Boulogne* (1949) – each revealed the kinds of experimental risk-taking that policy should promote.

Despite Bazin's conviction, it would remain to other critics to lend the term greater ostensive force. In the hands of Jean-Pierre Barrot and François Truffaut, 'quality' became more specific, pointing to particular traits and values in French cinema beyond 'riskiness'.

'Quality' also became synonymous with a long-term tradition of popular cinema characterized by admirable craftsmanship. Jean-Pierre Barrot's 'Une tradition de la qualité', published in a seminal collection of essays, *Sept ans du cinéma français* (Barrot 1953: 26–37) moved 'quality' from debates surrounding government subvention to a cinephilic discussion about style and genre. Barrot, cultural director of the Fédération Française des Ciné-Clubs (FFCC), names a group of French film-makers – René Clair, Jean Delannoy, Jacques Becker, Christian-Jaque, Jean Dréville, Georges Lampin and Max Ophüls – as the 'guardian of a style, of a tradition in French production'. They are 'eminent and meticulous artists, all flawless craftsmen' (Barrot 1953: 37). For Barrot, this long tradition of polished film-making is the 'legitimate tradition of quality' in France (Barrot 1953: 37). The quality style is best exemplified in a love for the métier of film-making, a concern by the film-makers for doing their jobs well, a need on the part of the film-makers to express themselves through the medium, an intelligent choice of subject matter, a true taste for what is essentially human and valuable, and a refusal of fashionable subjects and styles.

Barrot's 'quality' captured French pride for the workmanship and artistic innovation of pre- and post-war popular cinema. The quality style he identifies is manifested in a number of themes and techniques. Henri Calef's *Les Eaux troubles* (1948) is praised for being shot in 'the purest film noir style' (Barrot 1953: 35), while a very different film-maker, Christian-Jaque, represents the 'quality' approach by virtue of his 'virtuosic' camera and the fact that works like *Fanfan la tulipe/Fan-Fan the Tulip* (1952) 'are popular in the best sense of the word' (Barrot 1953: 34). While Bazin and others sought to drive a wedge between commercial and 'quality' cinemas, Barrot sees notions of 'popular' and 'quality' as intimately intertwined in French film history.

Finally, 'quality' described a postwar 'psychological realist'

cinéma de scénariste. Perhaps the most famous statement on 'quality' is François Truffaut's 1954 *Cahiers du Cinéma* polemic, 'Une certaine tendance du cinéma français' ('A Certain Tendency of French Cinema') (Truffaut 1954: 15–29). Ever acerbic, Truffaut reverses Barrot's 'quality' and refashions it as a pejorative aesthetic label for traditional commercial films. For Truffaut, 'quality' named a group of film-makers who have sent French cinema into a moral and artistic nosedive. The most prominent among these are Pierre Bost and Jean Aurenche, whose screenplays are corrupted by a decadent 'psychological realism'.

Despite Bazin's earlier efforts to defend 'quality' auteurs like Bresson, Truffaut's 'quality' positions Bresson's *Journal d'un curé de campagne/Diary of a Country Priest* (1951) at its antipodes, even reproducing passages from the Aurenche and Bost adaptation that the novelist Georges Bernanos had rejected in 1948. Quality films for Truffaut rely upon the same familiar storytelling template. Adapted from a major literary work by a few award-winning screen-writers who focus on character interiority and self-obsession, the stories told in these films were debauched and formulaic:

> It always consists of a victim, generally a cuckold. (This cuckold would be the only sympathetic character of the film if not for his immeasurable grotesqueness: Blier-Vilbert, etc…). The slyness of his relatives and friends and the hate that his family members show for one another, seals the fate of the 'hero'; the injustice of life, and, painted in local colors, the nastiness of the world (priests, caretakers, neighbors, passers-by, the rich, the poor, soldiers, etc…). (Truffaut 1954: 23)

Truffaut also attacked the films' sordid politics: they are made for the bourgeoisie to attack the bourgeoisie, espousing a negative view of the world by championing 'non-conformism' and 'cheap audacity' (Truffaut 1954: 21). Part of their sordidness also rests in the fact that they encourage the audience to 'identify with the "hero" of these movies' (Truffaut 1954: 28). Perhaps most offen-sive of all for an auteurist critic like Truffaut, 'Tradition of Quality' cinema shows a 'Madame-Bovary/Kafkaesque' side, borrowed from modern literature but ultimately misunderstood, whereby the 'author adopted a cold distance from his subject, an exterior posi-tion, the subject now treated like an insect under the etymologist's microscope' (Truffaut 1954: 28).

This approach to cinematic adaptation had won Bost and Aurenche praise from the foreign press, and had come to represent France at international festivals. Quality adaptations marked the era's production: *Douce/Love Story* (Autant-Lara, 1943), adapted from Michel Davet; *La Symphonie pastorale* (Delannoy, 1946), adapted from André Gide; *Le Diable au corps/Devil in the Flesh* (Autant-Lara, 1947), from Raymond Radiguet; *Dieu a besoin des hommes* (Delannoy, 1950), from Henri Queffelec; *Jeux interdits/ Forbidden Games* (Clément, 1952), from François Boyer; and *Le Blé en herbe/The Game of Love* (Autant-Lara, 1954), from Colette. Joining Bost and Aurenche in Truffaut's 'Tradition de la

qualité' were screenwriters Jacques Sigurd, who adapted Albert Schirokauer in *Lucrèce Borgia* (Christian-Jaque, 1954), and Henri Jeanson, who wrote dialogue for and adapted *Madame du Barry* (Christian-Jaque, 1954). Two of the most successful quality films of the period were *La Chartreuse de Parme* (Christian-Jaque, 1948) and *Le Rouge et le noir* (Autant-Lara, 1954). Both starred Gérard Philipe, one of the period's biggest stars, and were taken from nineteenth-century novels by Stendhal.

For Truffaut, a psychological realism derived from literature, whereby the 'anguished interiority' of the characters, as one historian puts it, drives the plot, supplanted the more venerable 'poetic realist' expressiveness of French cinema of the 1930s (Crisp 1993: 365). The abjection of quality characters, furthermore, was matched by the lack of commitment to them on the part of these suspiciously agile *scénaristes*. Unlike Bost, Aurenche and Jeanson, or the directors Delannoy, Autant-Lara and Clément, true auteurs like Bresson, Jacques Tati, Jean Cocteau, and Jean Renoir composed their own dialogue and wrote and directed their own stories. These film-makers were personally committed to the characters and plots they brought to the screen.

Retrograde, predictable, advocating simplistic cinematic experiences related to the film's protagonist, coldly distant from their characters, and promoting a negative perspective on the relationship between individual and society – quality film-makers were for Truffaut the cause of French cinema's perilous condition in the 1950s. He casts contemporary French cinema as a clash: 'I cannot see any possibility of a friendly coexistence between the Tradition of quality and a *cinéma d'auteur*' (Truffaut 1954: 26).

With time, the policy and critical debates that fuelled these competing cinemas of quality cooled, and Truffaut's usage, minus the vitriol, became the standard one among critics and *cinéphiles*. For most contemporary historians, the concept of 'quality cinema' refers to a 1940s and 1950s trend known for its celebrated screenwriters, lavish sets and costume design, big stars, and recourse to France's literary heritage. But the question of French 'quality' is also vital to the cinema of the 1980s and 1990s. Often compared with the post-war quality tradition discussed by Truffaut, and indebted to an institutional policy similar to the one first debated during the 1930s Renaitour commission, the new genre has come to be known as 'the heritage film'.

The year 1982 proved to be critical to the revival of 'quality'. When the Socialist Party under François Mitterand won the presidency, new funding policies were enacted to support a series of popular and prestigious cultural films. Funded or promoted by Jack Lang, the Minister of Culture and later Education, French filmmakers were encouraged to use cinema for national education – to tell stories that revive France's historical and cultural legacy. Guy-Patrick Sainderichin, then editor of *Cahiers du Cinéma*, declared in an article published the same year the arrival of a 'nouvelle qualité française' (Sainderichin 1982: 18). The main tool at Lang's disposal was the *avances sur recettes* (advance on receipts) law, first passed in 1959 as a revision of the 1948 automatic aid system.

Through the law, the government gave advance loans directly to film-makers, to be repaid from the box office earnings of the film subsidized. Lang refined and redeployed the system, using it to promote new talent (like *cinéma du look* directors Luc Besson and Jean-Jacques Beineix), encourage established auteurs (like Bresson, Agnès Varda and Alain Resnais) and to launch a 'new quality cinema'.

Heritage films benefited the most from Lang's policies. Lang's era was marked by support for what he called 'les industries culturelles' ('cultural industries') (Austin 1996: 144). In his inaugural year, prestigious international co-productions like *Danton* (Wajda, 1982), based on a 1935 Stanislawa Przybyszweka play that had been staged by Wajda throughout the late 1970s and early 1980s, and *Un Amour de Swann/Swan in Love* (Schlöndorff, 1983), an adaptation of Marcel Proust, received support. In 1985, a noted figure in literary circles, publisher Christian Bourgois, was given control over the *avances sur recettes* purse, with a specific mandate to promote 'culture' (Austin 1996: 144). Lang and the socialist regime were briefly ousted from 1986–88, but upon his return, Lang resumed his support for 'high culture for the masses' by creating a new direct aid system that subsidized ten to fifteen 'high quality' films per year (Austin 1996: 144).

The films themselves were for the most part high-culture spectacles designed to attract large audiences. Heritage films aimed to capture 'authentic' French culture, telling stories based on prestigious literary sources, the lives of forgotten historical figures, and on new perspectives on revolutionary and imperial history. A direct line of influence was established with the literary Tradition of Quality when the director Bernard Tavernier collaborated with Pierre Bost and Jean Aurenche in the 1980s, most notably on *Une Dimanche à la campagne/A Sunday in the Country* (1984), adapted from a Bost novel about an elderly painter set in the period prior to World War I. Literary legitimacy was also sought in Claude Berri's adaptations of two Marcel Pagnol novels, *Jean de Florette* and *Manon des sources/Manon of the Spring*, both released in 1986. Berri went on to produce and direct a number of the biggest heritage productions, including *Germinal* (1993), a 160-minute epic adapted from Émile Zola's 1885 novel. Costing in excess of 160 million francs and billed as having the largest budget in the history of French cinema, *Germinal* was a massive success, attracting 5.8 million viewers, the third highest grossing film of 1993, behind *Les Visiteurs* (Poiré, 1993), a comic fantasy in which a medieval nobleman is transported to the modern world, and *Jurassic Park* (Steven Spielberg, 1993) (Austin 1996: 166).

Heritage films also relied upon international star power, exemplified in Ettore Scola's casting of Marcello Mastroianni as the legendary lover Casanova, Harvey Keitel as the English revolutionary Thomas Paine, and Jean-Louis Barrault as the libertarian writer Restif de la Bretonne in *La Nuit de Varennes* (Ettore Scola, 1982). Stylistically, they featured 'legible' continuity storytelling, glossy cinematography punctuated by crane shots and deep focus long takes, massive sets populated by throngs of extras, and scores

derived from cultured sources, like Verdi in *Jean de Florette* and the baroque compositions of Alain Corneau's *Tous les matins du monde* (1992), starring Gérard Depardieu, who Corneau shot in a delicate painterly visual style.

In both its positive and negative uses, the label 'quality cinema' is a token of a long-term effort to defend the best among French film-making talent or to encourage the promotion of French heritage onscreen. The term reflects a consensus held by a broad swath of directors, producers, critics and policymakers across a number of periods: France deserves a critically acclaimed cinema that responds to indigenous cultural, literary and intellectual currents. The debates and interventions of figures have, in their various interpretations of 'quality', conditioned how we see the relationship between film practice and literary and intellectual traditions in France, and defined how state policy balances the needs of the nation's popular, 'cultural' and auteurist cinemas.

Colin Burnett

References

Austin, Guy (1996) *Contemporary French Cinema: An Introduction*, Manchester: Manchester University Press, pp. 12.

Barrot, Jean-Pierre (1953) 'Une tradition de la qualité', *Sept ans du cinéma français*, Paris: Éditions du cerf, pp. 26–37.

Bazin, André (1951) 'La difficile définition de la qualité', *Radio-cinéma-télévision*, 64, 4 August, pp. 6.

Bloch-Delahaie, Pierre (1950) 'Encourageons la qualité: Un aspect important de la Défense du cinéma français', *L'Écran francais*, 275, 16 October, pp. 6 and 23.

Bordwell, David and Thompson, Kristin (2003) *Film History*, 2nd edn, New York: McGraw-Hill, pp. 373.

Crisp, Colin (1993) *The Classic French Cinema, 1930-1960*, Bloomington and Indianapolis, IN: Indiana University Press, pp. 365.

Gimello-Mesplomb, Frédéric (2003) 'Le prix à la qualité', *Politix*, 16: 61, May–June, pp. 101.

Gimello-Mesplomb, Frédéric (2006) 'The Economy of 1950s Popular French Cinema', *Studies in French Cinema*, 6: 2, pp. 147.

Leglise, Paul (1970) *Histoire de la politique du cinéma français, Tome I: Le cinéma et la IIIe République*, Paris: Librairie Générale de droit et de Jurisprudence, pp. 176.

O'Brien, Charles (2005) *Cinema's Conversion to Sound: Film Style and Technology in France and the U.S.*, Bloomington and Indianapolis, IN: Indiana University Press, pp. 61.

Sainderichin, Guy-Patrick (1982) 'La Rupture', *Cahiers du Cinéma*, 336, pp. 18.

Truffaut, François (1954) 'Une certain tendance du cinéma français', *Cahiers du Cinéma*, 31, January, pp. 15–29.

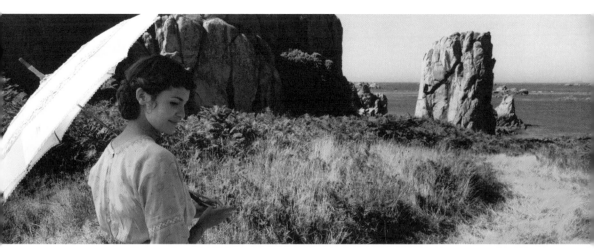

A Very Long Engagement, Warner Bros.

A Very Long Engagement

Un long dimanche de fiançailles

Studios/Distributors:

2003 Productions
Warner Bros.

Director:

Jean-Pierre Jeunet

Producers:

Jean-Pierre Jeunet
Francis Boespflug
Bill Gerber
Jean-Louis Monthieux

Screenwriters:

Sébastien Japrisot
Jean-Pierre Jeunet
Guillaume Laurant

Cinematographer:

Bruno Delbonnel

Composer:

Synopsis

During World War I, a young woman named Mathilde is separated from her childhood love and fiancé Manech when he is sent to fight at the front in 1917. She later receives an official notice stating that he was killed, but she refuses to believe it. She determinedly begins an investigation into the events and people surrounding his last known whereabouts on the battlefield, hoping that they will be reunited.

Critique

With *A Very Long Engagement*, Jean-Pierre Jeunet faced the intimidating task of following up his massive 2001 hit *Amélie*. He and co-writer Guillaume Laurant turned to Sébastien Japrisot's award-winning novel, thus setting off in a refreshingly different direction – and entering a long tradition of 'quality' French period pieces. The resulting film certainly has the makings of an impressive, large-scale production, starting with a story that is considerable in scope and nimbly shifts gears between different genres. For the lead role of Mathilde, Jeunet turned once more to Audrey Tautou. The rest of the cast is filled out by many notable names including André Dussollier, Denis Lavant, Marion Cotillard, Jodie Foster and Jeunet regulars Jean-Claude Dreyfus, Dominique Pinon, and Ticky Holgado in one of his last roles before tragically passing away due to cancer. *A Very Long Engagement* indeed easily qualifies as an epic heritage film, though Jeunet's vision and talent as a storyteller are kept very much intact within its grand canvas.

The film is incredibly designed, plunging headfirst into the period setting of the late 1910s and early 1920s. When not conducting her research or mailing letters from the cosy provincial home where she lives with her aunt and uncle (Chantal Neuwirth

Angelo Badalamenti

Editor:

Hervé Schneid

Duration:

133 minutes

Genres:

Drama
Mystery
Romance

Cast:

Audrey Tatou
Gaspard Ulliel
Dominique Pinon
André Dussollier
Marion Cotillard
Jodie Foster
Clovis Cornillac
Denis Lavant
Albert Dupontel
Julie Depardieu
Jean-Claude Dreyfus

Year:

2004

and Dominique Pinon), Mathilde ventures to Paris, a busy, decadent realm of street markets, train stations, museums and bars. The old-fashioned look of the film is primarily created by Bruno Delbonnel's splendid, gold-hued cinematography and the inclusion of both stock footage and newly created, flickering homages to the silent film era. This aged aesthetic nicely compliments Jeunet's familiar method of conjuring a cluttered, lived-in world of old photographs and forgotten keepsakes while additionally emphasizing the practical difficulties of Mathilde's quest. *A Very Long Engagement* is a mystery that takes into account the imposing factors of time and distance as well as the cumbersome challenges of sifting through records, documents and people's memories in order to procure solid facts from the foggy haze of the past. As a result, the film frequently jumps back and forth in time and revisits events as more facts are discovered and hidden secrets revealed.

One of the most powerful aspects of the film is its vivid depiction of World War I. At the Somme battlefront, the French troops live in a hellish wasteland of rain, mud, blood and jagged wood and metal. Employing both crane shots and tracking shots through the trenches, Jeunet recreates the wretched conditions that eventually drive Manech (Gaspard Ulliel) and four other men to mutilate themselves so they can be sent home. Instead they are court martialed and banished to No Man's Land. The terrible effects of war are driven home in image after striking image, ranging from the bizarre sight of a dead horse hanging from a tree to intense and disturbing combat sequences comparable to the famous ones in *Saving Private Ryan* (Steven Spielberg, 1998).

Acting as a counterbalance to the brutal war segments is the tender love story of Mathilde and Manech, their bond repeatedly signified by the carved initials MMM (Manech 'Aime' Mathilde). Complimented by Angelo Badalamenti's suitably sweeping score, the film's romantic portions often reach unabashedly melodramatic heights while remaining wholly sincere and affecting throughout. Much more fun, however, are the marvellous moments when Jeunet dips into sumptuous Gothic splendour worthy of a Carlos Ruiz Zafón novel, throwing in misty, night-shrouded streets, fantastically macabre murders and even a bartender with a brilliantly designed wooden hand. Best of all is Marion Cotillard's Tina Lombardi, an avenging angel who hunts down the men responsible for her own lover's disappearance. The scene in which she keeps a deadly rendezvous in a dark tunnel is nothing less than a perfect little slice of pulp.

As in Jeunet's previous films, *A Very Long Engagement* is not a single narrative so much as a cluster of interconnected stories, each one more entertaining than the last. In the opening prologue – before Tautou even appears onscreen – each of the five condemned soldiers is given his own introduction in a manner reminiscent of similar scenes in *Amélie*, but with a much more solemn tone. None of the supporting players ever seem extraneous or unnecessary, and each one's individual storyline approaches

one of the film's central themes (love, war, detective work) from a different angle. Among the most enjoyable minor characters are Célestin Poux (Albert Dupontel), a talented front-line chef known as 'the Mess Hall Marauder'; Benoît Notre-Dame (Clovis Cornillac), a tough, resourceful farmer-turned-soldier and a bicycle-riding postman (Jean-Paul Rouve) inspired by Jacques Tati's *Jour de Fête* (1949). While Jodie Foster's appearance is surprising, her performance is thankfully quite substantial and admirably delivered.

While *Amélie* is, inevitably, the film most people will best remember Jeunet for, and *Delicatessen* (1991) and *The City of Lost Children* (1995) will surely remain cult classics, *A Very Long Engagement* is most indicative of his impressive abilities. In it, he manages to successfully venture into new territory in a number of respects, ably wielding his distinctive style while crafting a consistently spellbinding, gloriously realized tale.

Marc Saint-Cyr

Germinal

Studio/Distributor:
Renn Productions

Director:
Claude Berri

Producers:
Claude Berri
Pierre Grunstein
Bodo Scriba

Screenwriters:
Claude Berri
Arlette Langmann

Cinematographer:
Yves Angelo

Art Director:
Olivier Radot

Composer:
Jean-Louis Roques

Editor:
Hervé de Luze

Duration:
160 minutes

Synopsis

Etienne Lantier is a former machinist in search of work. He is taken in as a lodger by Maheu, a fellow miner, and his strong-minded wife and their large family. Lantier is soon drawn to their eldest daughter Catherine, herself a miner, but loses her to the boorish Chaval. Working conditions worsen: a slump in factory output threatens lay-offs; wage-cuts compel the miners to ignore vital repairs. A violent and bitterly divisive strike follows. Maheu is shot by soldiers. The strike is taking its toll and talks begin of a return to work. An act of sabotage by the anarchist Souvarine precipitates the final disaster: the mine is flooded; Lantier, Catherine and Chaval are trapped underground; Lantier kills his rival but Catherine dies. As Lantier leaves, he meets La Maheude on her way back down the mine to feed those members of the family who have survived the debacle of the strike.

Critique

Zola's inspiration for his best-selling novel came from the long miners' strike of 1884 at Anzin (northern France). His *Germinal* was the work of a writer who, discovering the exploitation of the proletariat, was revolted by social injustice. By setting his novel in a nineteenth-century mining community of northern France, he courageously confronted contemporary issues. On the face of it, Claude Berri's adaptation of Zola did not. Yet, in the early 1990s, Berri insisted on the contemporary relevance of a project about injustice, inequality, poverty and unemployment. He had specifically chosen actors with a working-class background (Depardieu, Miou Miou) and set the film location in a region that was once

Genre:

Drama

Cast:

Gérard Depardieu
Miou Miou
Renaud
Jean Carmet
Judith Henry
Jean-Roger Milo
Laurent Terzieff
Bernard Fresson
Jean-Pierre Bisson

Year:

1993

the home of the major French mining community. The last pit had closed two years earlier and many of the locals hired as extras had themselves worked or had relatives – as did Renaud – who had worked in the mines. The son of a Jewish immigrant, Berri claimed that Zola's denunciation of class exploitation struck a sensitive chord in his personal past, and that shooting the film was his way to 'do politics'.

Berri's film is a convincing picture of the travails of capitalism. The basic strengths of the novel are still largely intact, including its prophetic audacity. It shows a world of crude industrialization and the crude human relations it engenders. While the film does not follow Zola in his 'naturalist' description of a class plagued with alcoholism and early dementia, it does effectively contrast the living conditions and mores of the poverty-stricken Maheu family with the Bourgeoisie, represented by the wealthy Grégoire family, the mine's principal shareholders, whose daughter is to be married to the nephew of Hennebeau, the mining company's general manager. The latter is shot in bright colours, while the harrowing world of the miners is mainly shown at night in oppressive dark brownish colours: the relentless black dust of coal, men and women sent down like cattle in the 'entrails of the earth', the haunting faces of hungry children. The harsh landscape of northern France is cold, bleak and oppressive. The violent strike scenes are handled with a masterly touch, as are the almost orgiastic explosions of *joie de vivre* when the workers are intoxicated by beer, games and frenzied dancing. The film is well served by the performances of its stars and by the fervour of its hundreds of extras: more than a role, the film gave them the possibility to express a world that used to be that of their families.

Though Berri's sincerity is not in doubt, the off-screen discourse created by both the media and his approach to film-making and promotion created an uncomfortable dissonance in 1993. He never missed an opportunity to remind the media how costly his choice of France had been as a shooting location and that other directors before him had no qualms in choosing cheaper locations, suggesting that *Germinal*'s price-tag of 172 million FF (over $30 million), combined with the adaptation of one of the most popular French novels about the working classes, was a sign of quality, populism and patriotism. Not only that, but Berri's company, Renn Productions, obtained a loan from the regional council and the regional Fund for audiovisual productions by stressing the short-term employment impact (hiring 800 extras and spending a third of the budget on local services) and the long-term promotion effect that *Germinal* would have on the region. This loan attracted some controversy in the region, as did the television crews and journalists who flocked to the area at Berri's invitation. The publicity exercise turned decidedly sour when, half-way through filming, singer and lead actor Renaud – playing the young outsider who ultimately leads the miners' protest into a doomed strike – encouraged extras to revolt by organizing protests asking for better wages for the long hours they were expected to work.

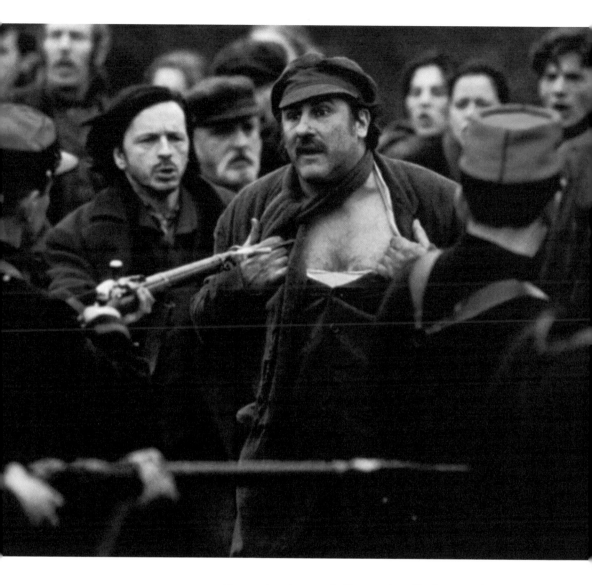

...rminal, Renn Prod,
...nce 2, D.D. Prod.

Like previous large-scale films produced by Renn Productions
(*Manon des Sources/Manon of the Spring* [Claude Berri, 1986], *Jean
de Florette/Jean Florette* [Claude Berri, 1986]), *Germinal* was pack-
aged and previewed to extinction, its creators and stars massively
interviewed in the press and on television. French film critics are
reputed to have a particular distaste for films with commercial pre-
tensions, and there is evidence that the hype surrounding *Germinal*
tainted their reactions, particularly in the Parisian press. The Right
scorned it as a socialist tract, and the Left, with the notable excep-
tion of the daily *Libération* (which labelled the film 'Germinable,
Germinator, Germinus, Germinul') praised it for encouraging people
to reflect on social issues. Others read it as a reassuring confirma-

tion that the working-class myth on which the Left was built now belonged to the past.

Germinal is a great popular French film but it is also a film of its time. In the autumn of 1993, it unexpectedly became French cinema's flagship for the battle to restrict Hollywood's grip on Europe. As the campaign for a 'cultural exception' at the GATT summit reached unexpected proportions, so did the controversy over the merits of Germinal versus Jurassic Park (Steven Spielberg, 1993). Berri was hailed as 'the unique Joan of Arc of French cinema' and newspapers ran headlines like 'Berri versus Spielberg' and 'Cola versus Zola'. To go and see Germinal rather than American-made dinosaurs was seen as a political gesture, a symbol of patriotism and loyalty. In the end, Germinal stands both as a monument to the end of the socialist period during the Mitterrand years and as an ambiguous paradigm of the French cultural specificity so vociferously defended by the French at the time of the GATT negotiations.

Anne Jackel

The Call

L'Appel du silence

Studio/Distributor:
Societé Artistique Commerciale et Industrielle (SACIC)

Director:
Léon Poirier

Producer:
Henry le Brument

Screenwriter:
Léon Poirier

Cinematographers:
Georges Million
Georges Goudard

Composers:
Claude Delvincourt
Joseph-Étienne Szyfer

Synopsis

Based on the biography of Charles de Foucauld, The Call traces the path of a gregarious military officer serving in the colonies who finds religion and abandons loose living to seek a spiritual life as a Catholic missionary in a remote corner of colonial North Africa.

Critique

Léon Poirier's fascination with the life story of Charles de Foucauld (1858–1916) made The Call a long-awaited dream come true. This was not Poirier's first triumph in the field of cinematic exoticism, but until The Call synchronized sound seemed to have thwarted career that had been launched by the celebrated Citroën travel documentary Black Journey/La Croisière noire (1926) and seemingly cemented with the war drama Verdun, visions d'histoire (1928). Technological advancement in the new decade forced a difficult transition for Poirier, who reluctantly adopted sound techniques in a pair of commercial and critical disappointments: Caïn, aventure des mers exotiques (1930) and La Voie sans disque (1933). Poirier also found himself the target of opprobrium within the industry after producers for La Croisière jaune/The Yellow Cruise (1934) – an Asian version of Poirier's exploration documentary – yanked the project from André Sauvage and handed his footage over to Poirier, who saw the film through to its release.

Tarnished as a usurper, Poirier took advantage of his ostracism to realize his longstanding goal of making a film of Foucauld's life. To fund the project, he looked to the public, inspiring tens of thousands of French citizens to make donations in support of

Duration:

96 minutes

Genre:

Drama

Cast:

Jean Yonnel
Pierre de Guingand
Alice Tissot
Jacqueline Francell
Thomy Bourdelle

Year:

1936

his unabashedly patriotic vision. With a soldier-turned-missionary at the root of the project, Catholics felt especially connected to Poirier's agenda, and in addition to parishioners' financial contributions, the Church officially endorsed the project. This prerelease buzz met with generally positive reviews, giving *The Call* a remarkable run that amassed one of the highest attendance figures of the decade. Poirier capped off this popular achievement by winning over the critics as well, with *The Call* declared the winner of the 1936 Grand Prix du Cinéma Français and sent into competition at the 'Venice Biennale'.

Despite this tremendous attention, in the post-war and post-colonial years *The Call* has largely disappeared from critical histories. A tendency to pigeonhole *The Call* as just another example of colonial cinema has limited the film's appeal, yet the candidly ideological thrust of *The Call* as a pro-colonial and anti-modern treatise is unparalleled even within this sub-genre, as is the film's focus on biography. Neither affiliated with the Foreign Legion nor involved in interracial romance – both of which signify colonial cinema – Foucauld is a career military officer who abandons a white lover to join the priesthood. Poirier's unmistakable inflection of heroism also sets *The Call* apart. Generally, characters who perform the dirty, dangerous work of expanding and maintaining an empire meet suspicion, ingratitude, or even death at the hands of the *colonisés*. While Foucauld, too, dies at the hands of a band of indigenous marauders, Poirier makes use of Foucauld's untimely demise to grant him the doubly venerable status of Catholic martyr and national hero. Characters who make the same sacrifice in other films fail to arouse the same degree of admiration, even if, like Jean Gabin's character Gilieth in *La Bandera/Escape from Yesterday* (*Julien Duvivier*, 1935), they manage to earn respect or redemption on a much smaller scale. Considered in retrospect, the skepticism about the colonial project that emerges in the *cinéma colonial* may seem prescient, but this a posteriori perspective obscures the current of imperialist thought that pervaded French right wing politics in the uneasy years of the mid- to late-1930s. It was this pro-colonialism that Poirier tapped with *The Call*, and it was a sentiment that found a broad and enthusiastic contemporary audience.

Instead of considering *The Call* within the reductive context of colonial cinema, this film would be more usefully situated at the intersection of other cinematic tropes of the 1930s. Looking beyond the Legion, military dramas like *Trois de St. Cyr* (Jean-Paul Paulin, 1939) also featured career officers and shared *The Call*'s nationalistic overtones. Foucauld's role in the colonies as a commissioned officer suggests the conventions of military drama rather than the last-resort Legion enlistment typically associated with protagonists in the *cinéma colonial*. The presence of Foucauld's close friend Laperrine, a fellow officer who remains enlisted, further underscores the importance of the French armed forces to the premise of the film. Driving home this point, Poirier ends the film not with Foucauld's own death, but three years later with Laper-

rine's internment alongside him in Algeria. At the service, a soldier proclaims, 'From now on, the soldier of faith and the soldier of France will stand guard side by side.'

The colonial dyad made explicit in this remark points to another unusual feature of Poirier's film. In addition to its colonialist stance, *Appel* emerges as an exception to the pre-war – and pre-*Don Camillo/The Little World of Don Camillo* (*Julien Duvivier*, 1952) – assumption that priests were box office poison. French cinema of the 1930s generally saw clergymen as objects of ridicule rather than reverence; few films had clearly religious motifs, and piety usually fizzled with the public despite the Catholic Church's active efforts to promote morally upright cinematic fare. Still, the Sahara could inspire a different kind of spirituality, and Poirier managed to graft this secular awe of the desert onto a specifically Christian religiosity in *The Call*. Audiences responded enthusiastically, and Poirier succeeded where less savvy directors had failed to capitalize on the public's craving for adventure as a counterbalance to proselytization.

Viewed through this matrix of social and cinematic influences, *The Call*'s insistence on heroism and sacrifice for the *patrie* calls into question its association with the more cynical *cinéma colonial*. Poirier's combination of Saharan spirituality with a Catholic mission, bolstered by bourgeois military valour, proved irresistible to contemporary audiences, and both the Church and the political right promoted the film in France and abroad. *The Call* merits consideration not as a misfit stepchild of the *cinéma colonial*, but as a uniquely successful deployment of cinematic tropes whose ideology countered the left-leaning discourse that tends to be taken for granted in classic, 'quality' French cinema.

Colleen Kennedy-Karpat

La Symphonie pastorale

Studio/Distributor:
Les Films Gibé

Director:
Jean Delannoy

Producer:
Louis Wipf

Synopsis

Pastor Jean Martens adopts an orphaned blind girl, Gertrude, into his family, who live in a remote mountain village. As Gertrude reaches adulthood their relationship deepens, which causes jealous tensions between the Pastor and his wife, Amélie, and his son, Jacques, who has fallen in love with her. After an operation to save Gertrude's sight succeeds, her conflicted emotional loyalties cause disaster.

Critique

When Jean Delannoy died in 2008 at the age of 100, many obituaries cited *La Symphonie pastorale* as the crowning moment of his 60-year career. In 1946, at the inaugural Cannes Film Festival, the film won the Grand Prize for its director and the Best Actress award for its female lead, Michèle Morgan, before going on to attract 6.3 million paid admissions, the third biggest hit of the year. *La*

La Symphonie pastorale, Pathé, Films Gibé IBE.

Screenwriters:

Jean Aurenche

Pierre Bost

Jean Delannoy (based on the
novel by André Gide [1919])

Cinematographer:

Armand Thirard

Composer:

Georges Auric

Editor:

Suzette Bouveret

Duration:

105 minutes

Genre:

Drama

Cast:

Pierre Blanchar

Michèle Morgan

Line Noro

Jean Desailly

Andrée Clément

Year:

1946

Symphonie pastorale was at that point widely considered by critics
and audiences alike to represent all that was right with post-war
French cinema. It certainly had pedigree: Delannoy's consummate
script written with the pre-eminent adaptors Jean Aurenche and
Pierre Bost; the text's origins as a lauded 1919 novel by André
Gide (and concomitantly its roots in Beethoven's Sixth Symphony);
and the immaculate performances of its star pairing Morgan and
Pierre Blanchar. The film's eventual fate as a maligned footnote
– a rather forlorn casualty of François Truffaut's 1950s campaign
against mainstream French cinema – testifies to the fickle course of
film history and what constitutes good cinematic taste.

While Truffaut's pejorative 'Tradition of Quality' label for post-war
cinema unfortunately persists – as it is a verifiable truth rather than
a blustering rhetorical gambit – today *La Symphonie pastorale*
deserves a more nuanced, objective appraisal. (Most textbooks
gloss over Delannoy's film merely as evidence for Truffaut's conclu-
sions; it is unclear how many contemporary historians have actually
seen it.) One way of contextualizing the film, along with many of its
contemporaries, is what we might call its exquisite aesthetic. Versus
the grime and deprivations of much Occupation-era cinema (often
due to limited shooting schedules, minimal budgets, restricted
resources and locations, and flawed or black market film stock),
La Symphonie pastorale's *mise-en-scène* radiates with texture,
beautiful tactility, material abundance, and photographic splendor.
Ten years later this visual design would fall out of fashion almost
overnight, but in 1946 the glistening mountainside vistas, pierc-
ing beams of sunlight, intricately built cabins, and seamlessly

integrated Neuilly studio sets and location work – all of which are showcased in *La Symphonie pastorale*'s opening sequence, as dawn rises above the Pastor's (Pierre Blanchar) homestead – were cutting edge French film craft. Precise classical unities permeate the film, from flawless cinematography to pinpoint edits (especially matches on action; nowadays a lost art), from delicate three-point lighting set-ups to elegantly composed tableaux shots and meticulously choreographed movements from the actors. New Wave venom aside, it is worth remembering that many people mourned the end of this kind of film-making discipline. Bertrand Tavernier, taking just one case, spent decades campaigning for a return to French classical style, from *L'Horloger de Saint-Paul/The Clockmaker of St. Paul* (1974) to *Lasser-passer/Safe Conduct* (2001), the former of which Tavernier co-scripted with Aurenche and Bost in defiant solidarity.

La Symphonie pastorale also shows how refined post-war classicism – again contrary to what Truffaut preached – could create a multifaceted, emotionally engrossing drama with moments of genuine tragedy, a model that declined among the more cynical films of the New Wave generation. Delannoy typically refuses easy judgment over his characters and the tangled web they weave, be it the Pastor's ambiguous paternalism and lack of self-consciousness, Gertrude's (Michèle Morgan) enduring *naïvete*, or the shifting affiliations of the villagers nearby. The accusations of calculating insincerity levelled at Delannoy and others, the pivotal point of the New Wave revolution to come, seem groundless in *La Symphonie pastorale* and many of its peers. While these post-war films certainly dwell on human flaws and failings, the extent to which one person's desires inherently compromise those around them, the tone here is one of measured frustration, rising to fierce bitterness, at the failure of social institutions (religious, social, familial) to protect Delannoy's multi-dimensional protagonists, whether their hopes are humdrum or exalted.

Truffaut called all this facile and scurrilous, an opinion hard to reconcile with the forceful poignancy of many of the set pieces here. Take the scenes between Blanchar and Morgan (whose Gertrude is more privileged than in the Gide novel), in which Delannoy's camera creates a motif of their hands, as distinct from their faces and words, in proximity and distance, fumbling toward touches or else brushed aside, gesturing at the unspoken psychological bond – repressed romantic? symbiotic? – between them; a technique that Robert Bresson would revise in (ironically) Truffaut-approved classics like *Journal d'un curé de campagne/Diary of a Country Priest* (1951) and *Un Comdamné à mort s'est échapée/A Man Escaped* (1956). Equally charged is the sequence when Gertrude returns to the village, her blindness corrected by surgery, and enters the church, where a faltering hymn is in progress. Shot-reverse shots and point-of-view cutaways highlight Gertrude's nervous attempts to recognize the extended family around her; their responses range from delight to unease; back-lighting makes Morgan's body look ethereal but also abstracts her from the community she has belatedly re-joined, which she cannot help but

unravel. Or, alternatively, there is the remarkable shot, famous in *La Symphonie pastorale*'s day, when Gertrude leaves the hospital and sees the outside world for the first time. Morgan plays the scene like a child learning to walk: her hands gradually leave the nurses', her eyes linger on the thin cloud of snowflakes tumbling from the overcast sky, her delight grows as the dancing white blobs rack into focus, for her and us, the viewer. 'So that's snow,' she says simply. If we care to approach Delannoy's film without prejudice, moments like these are rapturous cinema, and on this ten second shot alone *La Symphonie pastorale* was much better judged by its apprecia- tive critics in 1946 than those who came along ten years later, axes to grind.

Tim Palmer

The Crime of Monsieur Lange

Le Crime de Monsieur Lange

Studio/Distributor:
Films Obéron

Director:
Jean Renoir

Producer:
André Halley des Fontaines

Screenwriters:
Jacques Prévert
Jean Castanyer
Jean Renoir

Cinematographer:
Jean Bachelet

Composer:
Joseph Kosma
Jean Wiener

Editors:
Marthe Huguet
Marguerite Renoir

Duration:

Synopsis

A publishing house in a working class neighbourhood re-forms as a cooperative when its capitalist owner, Batala, absconds from Paris to flee his creditors, allegedly dying in a train accident on his way out of town. *Lange* refers to Amédée Lange, who worked as Batala's assistant while writing popular serials about the American West. With Batala gone, the cooperative publishes the *Arizona Jim* tales, which become widely popular, especially with children. Batala's absence also brings fresh life to the workers who live in the courtyard surrounding the publishing house. When he slithers back to town disguised as a priest to resume control of his company, Lange shoots him in the chest and then flees the country. The film begins and ends with Lange's flight from France. In this framing narrative, Lange's girlfriend tells his tale in order to convince the locals in a bar near the border to let them leave the country.

Critique

The Crime of Monsieur Lange was released in January 1936, a few months before the electoral victory that brought a leftist coalition to power and officially inaugurated the Popular Front in France. Renoir's film does not reference historical events directly but rather stages an open-ended morality play about working-class aspira- tions. If anything, *Lange* the film could be said to anticipate or prefigure the Popular Front. Nowhere is the film's leftist politics more apparent than in the murder scene, one of the most famous in film history. When Batala returns late in the film, he takes out a gun and lays it on his desk. After calling the cooperative a load of garbage, Batala tells Lange that he should kill him. Lange takes the gun and shoots him in the courtyard, but it is never entirely clear why he kills him. This ambiguity allows it to seem as if the coopera- tive had killed him. Despite the film's optimism, however, there is

80 minutes

Genre:

Drama

Cast:

René Lefèvre
Florelle
Jules Berry
Nadia Sibirskaïa

Year:

1936

no triumphant happy ending, only a hasty escape to Belgium. The cooperative must continue without Lange, but of course, how will he continue to write the serial that is the lifeblood of the business? Will he even be able to write without the workers around him for 'inspiration'? In this unresolved knot of contradictions, the film evokes the violence of the French workers' revolutionary aspirations, even as it attempts to prevent them from weighing too heavily on viewers.

The story of a cooperative can also be read an allegory of *Lange*'s own production. The focal point of the cooperative's efforts is Lange's wildly popular Arizona Jim serial. As the film unfolds, it becomes clearer that Lange is putting into artistic form the new social aspirations of the workers. The workers gradually become characters in the stories and the stories work out some of the sentimental complications in their lives. In this way, it becomes less and less clear who (or what) is the artist behind *Arizona Jim*. Renoir made *Lange* in a similar spirit of collaboration. Renoir's set designer, Jean Castanyer provided the original story idea, Prévert wrote the script, and many of the actors in the film came from the Groupe Octobre, a radical theatre group in the interwar period with a predilection for improvisation and collaborative authorship.

Lange also explores an age in which individuals' lives are increasingly interconnected by different media. The workers in the courtyard learn of Batala's supposed death via the radio. Renoir opens this sequence with superimposed shots of train tracks filmed from a moving locomotive. With the sound of a crash, he cuts to a close-up of a man adjusting radio dials. As the news report begins, Renoir cuts back to an ironic wide shot of the man's room as he closes the window and shuts out the courtyard. Renoir's camera pans and tracks through the courtyard's darkness, becoming the shared space through which radio waves pass and link each of these isolated rooms and inhabitants. The camera discovers Lange and his girlfriend in bed, and Renoir cuts inside to give viewers their reaction to news. As they turn off the light, the camera pans back towards their window, showing other rooms alight on the opposite side of the courtyard. Renoir cuts back to the radio, reminding viewers what links these spaces. Renoir's inquisitive camera throughout the film both explores the interconnected lives of the courtyard residents and shows how, over the course of the film, they become authors rather than passive consumers of media. Indeed, the film suggests that all forms of media, new and old, even seemingly escapist popular serials, have political possibilities when taken up by the right hands.

With this film, Renoir's contemporaries would begin to view him as a leftist. He would go on to make an even more collaborative militant documentary film several months later, *Life is Ours/La Vie est à nous* (1936). Some of Renoir's films throughout the rest of the 1930s would experiment with different formulas and strategies for making socially engaged films. From a historical epic financed by direct subscription (*La Marseillaise* [1938]) to his biting satire of the French bourgeoisie (*The Rules of the Game/La Règle du jeu* [1939]), such films sought in different ways to find constructive and

critical forms of social and political film-making. Renoir fled to the United States during the Occupation and so began his disenchantment with politics and the left. He would eventually return to France and make many more films, but his interest in the actively political dimensions of film-making waned after World War II. *The Crime of Monsieur Lange*, then, captures the exuberance and optimism of Renoir and the French in the mid-1930s, whereas the more well known *The Rules of the Game* offers a bitter draft of dashed hopes and disappointment.

David Pettersen

Devil in the Flesh

Le Diable au corps

Studio/Distributor:
Transcontinental Films

Director:
Claude Autant-Lara

Producer:
Louis Wipf

Screenwriters:
Jean Aurenche
Pierre Bost (based on the novel by Raymond Radiguet [1923])

Cinematographer:
Michel Kelber

Composer:
René Cloerec

Editor:
Madeleine Gug

Duration:
119 minutes

Genres:
Romance
Drama

Synopsis

Armistice day after World War I. As a funeral begins, a flashback shows François Jaubert, a precocious teenager, pursuing Marthe Grangier, an older woman who works as a nurse. Although Marthe is engaged to a soldier at the front, they have an affair, which François cuts off. In a second flashback they become lovers again, despite Marthe's marriage. The last flashback reveals Marthe, now pregnant by François, falling ill and dying; it is her funeral the present-day François is attending, whose final procession is interrupted by wild peacetime celebrations.

Critique

Devil in the Flesh is, among its many notorieties, cited no fewer than ten times by François Truffaut in 'A Certain Tendency of the French Cinema' (Truffaut 1954: 15–29), making it, along with its caustic director Claude Autant-Lara, the epitome of his putative 'Tradition of Quality'. But even before Truffaut's broadside, *Devil in the Flesh* was riddled with controversy. Autant-Lara's 1947 film, adapted via the prolific Aurenche-Bost partnership, came from the loosely autobiographical 1923 novel by Raymond Radiguet, Jean Cocteau's protégé, who died of typhoid fever aged just twenty. *Devil in the Flesh*'s material was scandalous: a passionate adultery recounted in wholly dispassionate terms, its self-centred couple symbolically betraying France's war effort. This was a tale drastically at odds with French nationalist zeal in the aftermath of World War I (book) and World War II (when the film was released).

Most famous as a lightning rod for Truffaut's assault on post-war French cinema, *Devil in the Flesh* has always been a cause célèbre. Despite protests from the Catholic Church, on its initial release the film was a sizeable hit: with 4.7 million paying customers it came seventh on France's annual box office chart, above *The Best Years of Our Lives* (William Wyler, 1946) and, surprisingly, *Casablanca* (Michael Curtiz, 1946). Clearly, Autant-Lara's film gained an edge over its American rivals, two much less cynical war fables. (In this

Cast:

Micheline Presle
Gérard Philipe
Pierre Palau
Denise Grey
Jean Debucourt
Germaine Ledoyen

Year:

1947

context, an overlooked part of Truffaut's 'Certain Tendency' rant is how much the young critic was raging at *popular* cinema, implicitly condemning French *filmgoers* as well as film-makers for their taste in allegedly shallow, brash, un-cinematic cinema.) Since then, the *Devil in the Flesh* case has stayed on cultural historians' minds. In 1992, veteran critic Serge Daney used an extended filmed interview, *Itinéraire d'un ciné-fils*, to attack anew the 'smutty sentiment […] [and] anti-elitist or anti-intellectual feelings […] [draped] in a so-called love of the people' that he argued emerged with Autant-Lara and were revived by Claude Berri in the 1980s. Similarly, in November 2010, Serge Bozon's co-curated celebration of French cinema at the Centre Pompidou featured for one of its happenings two actors, Lou Castel and Eva Ionesco, reciting 'A Certain Tendency of the French Cinema', to which a respected senior critic, Noël Herpe, gave spirited rejoinders.

Why this enduring furore over Autant-Lara's film? One major reason was the director casting Gérard Philipe as his male lead. Philipe's meteoric celebrity, lasting only twelve years before his 1959 death from liver cancer, began with François in *Devil in the Flesh* and subsequently included star turns in many of the films, notably Christian-Jaque's popular costume drama *La Chartreuse de Parme/The Charterhouse of Parma* (1948), that Truffaut would later smear. As such, Philipe embodied the Tradition of Quality. Playing the – putting it mildly – anti-heroic François, Philipe is startlingly mercurial, volatile even when he gets his way, usually at his most ambivalent in the extended love scenes and post-coital bed conversations perceived by post-war critics to be groundbreakingly frank. With this disaffected screen 17-year-old (two years older than François in Radiguet's book; Philipe was just four months younger than Micheline Presle, co-starring as Marthe), Autant-Lara created an indelible star vehicle. Philipe's François was also a new archetype over which post-war film audiences would obsess – the narcissistic and unpredictable adolescent: charismatic, pretty, sexual, amoral, unmotivated by things like family and work. Although nominally set in France's recent past, *Devil in the Flesh* obviously speaks to the first stirrings of post-war youth culture, long before the famous delinquency films of the 1950s and 1960s, earlier even than Jacques Becker's nascent teenager drama *Rendez-vous de Juillet/Rendezvous in July* (1949).

François is just part of *Devil in the Flesh*'s antagonistic dialogue with France itself, though, as the film systematically seeks social fault lines in which to throw dynamite. Versus the insular novel, limited to François' trains of thought, Aurenche and Bost carefully connect the adultery to hypocritical French institutions. In so doing, the film alternately goads and despairs. Families are represented by François' vacuous bourgeois clan and his spineless, book-keeping father – weak paternity being a ripe cultural scapegoat in France's post-war post-mortems. One striking scene, the lovers' first date, takes place in a pretentious restaurant as the couple flirt by pretending that their vintage wine is corked; the point being, clearly, to sneer at the proprieties of good taste and good conduct. Most vicious of all is *Devil in the Flesh*'s bookending sequence,

Le Diable au corps,
Transcontinental Films.

again invented for the film, in which the shrill religious pomp of Marthe's funeral, a sinner redeemed when she ceases to exist, is broken up first by François' doleful flashbacks and then, climactically, by an exulting mob celebrating Armistice but also, seemingly, Marthe's death. The first flashback cues extraordinary stylistic flourishes: from the funeral, present regresses into past as François gazes at his reflection, ever self-obsessed; his image vanishes and is supplanted by a blurred, double-exposed silhouette of Marthe returning from the dead; muffled war munitions explode on the soundtrack as jubilant peals of church-bells slow into a mournful dirge. In dazzling moments like these, as bold as anything in the New Wave, Autant-Lara scratches relentlessly at society's paper-thin façade, its ingrained class conflicts, double-standards, and desperate covering-up of transgressions. These destructive shaping currents Autant-Lara returned to throughout his career, from *Douce/Love Story* (1943) to *L'Auberge rouge/The Red Inn* (1951), from *La Traversée de Paris/Four Bags Full* (1956) to *En Cas de Malheur/Love is my Profession* (1958). Like his compatriot outcast Henri-Georges Clouzot, Autant-Lara's cinema oozes misanthropy, a corrosive distorting mirror of France on-screen. Whether you watch aghast or flinch and recoil, on the enduring strength of films like *Devil in the Flesh* you cannot help but feel that it is Autant-Lara who continues to have the last, mocking laugh.

Tim Palmer

References

Truffaut, François (1954) 'A Certain Tendency of the French Cinema', *Cahiers du Cinéma*, 31, January, pp. 15–29.

Daybreak

Le Jour se lève

Studio/Distributor:
Les Films Vog

Director:
Marcel Carné

Producer:
Pierre Frogerais

Screenwriters:
Jacques Viot

Synopsis

Factory worker François kills lothario dog-trainer and showman Valentin, recalling the circumstances through a series of flashbacks. They reveal that François was romantically involved with Françoise and Clara. Policemen climb onto the roof of François' apartment, and throw tear-gas grenades into his room in an attempt to capture him.

Critique

With its pared-down narrative, economy of gesture and expressive decorum, *Daybreak* remains Marcel Carné's masterpiece. Pick up any history of French cinema and its iconic images stare out at you: François (Jean Gabin), gazing forlornly out of a window, Valentin (Jules Berry) cajoling his dogs, or Clara (Arletty) playfully covering her body as she steps out of a shower. By 1939, Carné had become the leading standard bearer of the French 'poetic realist' aesthetic. A film style that combined romantic-fatalist narratives

Jacques Prévert

Cinematographer:

Curt Courant

Composer:

Maurice Jaubert

Editor:

René Le Hénaff

Duration:

93 minutes

Genres:

Crime
Drama
Romance

Cast:

Jean Gabin
Arletty
Jules Berry
Jacqueline Laurent

Year:

1939

with claustrophobic milieus and an accentuated *mise-en-scène*, 'Poetic Realism' was epitomized by directors like Carné, Pierre Chenal and Julien Duvivier. Once ruthlessly punned by André Bazin as 'disincarnated' after the war, Carné never marshalled the talents of his technical team in a more controlled or sustained way. French Poetic Realism, a style and a sensibility that he did much to develop and export, reached its apotheosis in 1939, and with *Daybreak*, the legacy of the Golden Age of French Cinema was clinched.

Films like *Daybreak*, *Pépé le Moko* (Julien Duvivier, 1937), and *Gueule d'amour/Ladykiller* (*Jean Grémillon*, 1937) were strong pre-cursors to American film noir, but were also clearly influenced by the austere visuals of German Expressionists like F. W. Murnau and Fritz Lang. The recurring urban iconography and the character types throughout *Daybreak* recall Carné's early mentors René Clair and Jacques Feyder. It is the pivotal film in Carné's canon, for it signals the culmination of the poetic realist register and exemplifies the structural flexibilities and visual and formal experimentation of 1930s French film-making practice. In Dilys Powell's memorable phrase, the genius of Carné and his regular set designer Alexandre Trauner was to transform 'the tawdriness of the everyday' into formal beauty.

Structurally, *Daybreak* is daring and highly influential. It is one of the first films to employ a complex narrative syntax, full of dovetailing flashbacks, flashback-within-flashbacks and ellipses. Small wonder, then, that an explicatory pre-title card was inserted at the behest of a nervous producer. There are three flashbacks: the first recounts how Gabin meets and falls in love with Françoise (Jacqueline Laurent); in the second, Gabin has an affair with Clara; and in the third, Gabin kills Valentin, a man who has had sexual relations with both women. Enveloped around each of these are four sets of events taking place in the present: the murder of Berry and arrival of the police, the arrival of the police fusillade, Francois shouting down to his co-workers assembled in the square and, finally, his suicide and the release of a tear gas canister into his bedroom. *Daybreak* is, in effect, one long flashback, bookended by an expository and concluding scene, and by dint of its persistent moves into and out of flashback that concentrates solely on François' individual subjective remembering, the film is shot through with an implacable determinism: because we have already seen it happen, what will happen, must happen.

Carné's deft deployment of symbolic objects and props predates the American film noir template of doomed, decent men jammed into a claustrophobic architecture by nearly ten years. It was a film that influenced Orson Welles, John Huston and Howard Hawks, but also young French directors like Jean-Pierre Melville, Jules Dassin and Jacques Becker, who borrowed Carné's interweaving of the visual and the psychological to create similar narratives of despair and gloom. Think of the final shot of Belmondo's empty hat in Melville's *Le Doulos* (1962) – a symbol, like the ringing clock at the end of *Daybreak*, for the death of a good man. Or Serge Reggiani in Becker's *Casque d'or/Golden Marie* (1952), guillotined in the street

for having killed a man who had corrupted the woman he loves.

As a performance piece, *Daybreak* is the highpoint of the careers of its lead actors. Berry was never more oleaginous as Valentin, the original showman *raté*. Laurent's china-doll fragility was rarely captured again, and Arletty, so luminous for Carné in *Les Enfants du Paradis/Children of Paradise* (1945), and so guttural in *Hôtel du Nord* (1938), nearly steals the show. Prévert never wrote more lyrical dialogue, Trauner never designed sets more expressive or hyper-real, but *Daybreak* remains above all a film for, with, and about Jean Gabin. Perhaps the greatest actor ever to emerge from French cinema, he dominates the film, appearing in every scene, alternately explosive and tender; nonchalant and nostalgic. Our wholesale identification with François is dolefully played out in *Daybreak*, where Bolop the teddy bear's 'one sad eye and one cheerful eye' stands not just for François but a whole swath of French society marooned between opposing force fields of the Popular Front and France's post-Munich malaise.

Watching the film now, with its claustrophobic dramaturgy and a visual style that provided exact correspondences with individual emotion, *Daybreak* is a clairvoyant film that neatly synthesises the filaments and fears of its historical moment. More than any other released in Europe in the late 1930s, it peered into a near future pregnant with foreboding and pessimism. Carné spent his whole life resisting barometrical readings of his films, but *Daybreak* is a posteriori shorthand for the state of the French nation in 1939, a place full of sombre corners and encroaching extinction. It is very much a 'mood film', and a confirmation of national self-doubt. Despite the ironic implications of its title – 'Daybreak' – the film is engorged with a melancholy that corresponds to a decade's worth of political and social contexts: the breakdown of the Popular Front, the failure of Munich, and the betrayal of the working class. Less than twelve months after *Daybreak* was released, France had capitulated to the German army, and a whole new 'daybreak' would emerge across France until the summer of 1944.

Ben McCann

Port of Shadows

Le Quai des brumes

Synopsis

Having gone AWOL from the French Army, Jean hitches a ride to Le Havre. He falls in love with Nelly, who is hiding from her guardian Zabel, and defends her when the local gangster Lucien appears. Later, Jean slaps Lucien, publicly humiliating him. Before leaving for Venezuela, Jean kills Zabel after he tries to molest Nelly. Jean is gunned down in the street by Lucien, and dies in Nelly's arms.

Studio/Distributor:

Ciné-Alliance

Director:

Marcel Carné

Producer:

Grégor Rabinovitsch

Screenwriter:

Jacques Prévert (based on the novel *Le Quai des brumes/Port of Shadows* [Pierre Mac Orlan, 1927])

Cinematographer:

Eugen Schüfftan

Composer:

Maurice Jaubert

Editor:

René Le Hénaff

Duration:

91 minutes

Genres:

Crime
Drama
Romance

Cast:

Jean Gabin
Michèle Morgan
Michel Simon
Pierre Brasseur

Year:

1938

Critique

Pauline Kael labelled Marcel Carné's work in the 1930s as the 'definitive example of sensuous, atmospheric moviemaking – you feel that you're breathing the air that Gabin breathes' (Kael 1993: 383). The release of *Port of Shadows* in 1938 and *Le Jour se lève/Daybreak* a year later (both starring Jean Gabin) crystallized Carné's textural style, incorporating doom-laden narratives, moody long-shots of disaffected lovers and army deserters, and witty and nostalgic *bons mots* penned by Prévert. In *Port of Shadows*, Carné transposed Pierre Mac Orlan's short story from Paris' Montmartre district to the port town of Le Havre. The universe of Carné's *Port of Shadows* is marked by an ill-defined and murky oppressiveness. Le Havre hence becomes a sealed-off environment, perpetually shrouded in haziness and unremitting gloom (one character refers to the town's 'damn fog'). Characters wander through this soupy gloaming in search of something, anything – a drink, a kiss, an escape. After *Port of Shadows* was awarded the 'Grand prix national du cinéma français' in 1938, the editorial in *Le Petit Journal* did not fight too hard to hide its dismay: this was 'an immoral and demoralizing *film noir*, whose effect on the public can only be harmful' (O'Brien 1996: 10). Of course, the public loved the film: nearly 900,000 would see it, before it was swiftly banned in 1939.

For his lead actor, Carné provided Jean Gabin, still fresh from Renoir's *La Grande Illusion/Grand Illusion* (1937) with one of his quintessential roles: the deserting soldier who hitches a ride and ends up in a lonely bar on the outskirts of town. Jean (Gabin) falls in love with Nelly (Michèle Morgan), falls foul of her lascivious guardian Zabel (Michel Simon), and is eventually killed by local gangster Lucien (Pierre Brasseur). Carné's directorial flourishes throughout are exhilarating – for objects like a ship-in-a-bottle and a translucent raincoat read entrapment and ephemerality – while the film's most memorable scene – a lingering kiss between Jean and Nelly in a fairground back alley – underlines a key Carné trope: that love is nigh on impossible in the face of inexorable hostilities. Even minor characters speak important truths. A suicidal painter, played by Robert Le Vigan, intones: 'When I paint a tree, I make everybody ill at ease. That's because there is something or someone hidden behind that tree. I paint those things hidden behind things. For me, a swimmer has already drowned.' Such a worldview tells us all we need to know not just about the formal and philosophical properties of *Port of Shadows*, but of the French Poetic Realist project more generally. All is not as it first appears.

The fairground kiss is a justifiably iconic. 'You've got beautiful eyes, you know', whispers Jean to Nelly, as all the while Maurice Jaubert's melancholic score swirls in the background. This hyper-sentimental scene plays out a declaration of love that provides respite to the film's increasing tension. It is a romantic musical insertion that seeks to break through a monotone visual scheme,

and that takes place against a backdrop of artifice that is a paradigmatic spatial presentation of Carné's unending concerns with reality and stylization. Jaubert's music in *Port of Shadows* is frequently faint and inaudible, as if trying to emerge out of the grey fog that envelopes the film's visual and tonal texture. It is a highly innovative approach, as the abstention from redundant musical cues and sentimental background sound permits a deepening of the harmony between the film's images and its narrative developments.

Port of Shadows is Carné's most coldly formal work, bespeaking a more transgressive content to his films than simply pretty sets and star actors. The skewed approach to sexual politics mirrors the relationship issues in the likes of *Les Enfants du Paradis/Children of Paradise* (1945) and *Daybreak*. Nelly is configured at the outset as Lucien's 'girl', but when that ownership is undermined by Jean, the end result can only be emasculation for either one or the other man. This triangulation of desire climaxes at the fairground bumper car scene, in which Jean slaps Lucien and seals his own death sentence. The collision between wounded masculinity and public humiliation anticipates the later socio-historical contextualizations of *Daybreak*, as well as Carné's simmering fascination with masculinity, crime and power hierarchies. Yet Brasseur is little more than a petty gangster, a Tybalt, a Benny Blanco from the Bronx. The real villain of the piece is Zabel, Nelly's 'guardian'. Like some distaff prototype of Noah Cross from *Chinatown* (Roman Polanski, 1974), Zabel hides behind the trappings of bourgeois plenitude. His trinket shop is stuffed with refined furniture, and the sounds of classical music and cosy domesticity, but this abject paternal figure is brutally killed by Jean in what can be seen as a conventional working out of Oedipal tensions and the desperate flailing of a powerless, honest working man. Zabel's killing is purgative violence of the most sustained kind, for Jean does not strike him once with a blunt stone, but three more times. Such frenzied bloodletting is directed towards a villain characterized as paedophilic and degenerative, and whose motives remain inexplicable, but scarcely hidden.

'If we have lost the war, it is because of *Le Quai des brumes*,' declared various Vichy spokesmen in 1940, shortly after France's capitulation to the German army, corroborating the misgivings of military censors who saw in Carné's films recurring motifs of powerlessness and emasculation. Spectators beset with late 1930s anxieties over class warfare and social dissolution flocked to see these films precisely because they offered the solace of explosive and purgative violence that invited spectator projection and generated relief through catharsis.

Port of Shadows lives on, recently glimpsed in Joe Wright's *Atonement* (2007), and its DNA can also be detected in those 'stranger-in-a-strange-town' narratives so beloved by American TV networks. The commercial success of *Port of Shadows* meant an acceptance of Carné's dark brooding aesthetics and, in part, an identification with Gabin's powerlessness. Given the abject politico-

psychological climate out of which this, and other Poetic Realist films developed, it is perhaps understandable that high audience numbers were a corollary of the descent into darker and more brooding subject matter.

Ben McCann

References

Kael, Pauline (1993) 'Le Jour se lève', *5001 Nights at the Movies*, New York & London: Marion Boyars, pp. 383.
O'Brien, Charles (1996) 'Film Noir in France: Before the Liberation', *Iris*, 21, Spring, pp. 8.

The River

Studio/Distributor:

Oriental International Films

Director:
Jean Renoir

Producers:
Kenneth McEldowney
Jean Renoir

Screenwriters:
Rumer Godden
Jean Renoir

Cinematographer:
Claude Renoir

Art Director:
Bansi Chandragupta

Sound Recordist:
M. A. Partha Sarathy

Editor:
George Gale

Duration:
99 minutes

Genres:
Drama
Romance

Synopsis

The River is a coming-of-age tale about Harriet, who lives with her English family on the banks of a holy river in Bengal. Her father works in the Jute Mills and in their neighbourhood is an Irish family including a father and his half-Indian daughter, Melanie. An American soldier, Capt. John, related to the Irish family and hurt in the war comes to visit Bengal. Harriet develops an infatuation for him. Capt. John is intrigued by his Indian cousin Melanie, and has a brief affair with an English girl, Valerie. Capt. John returns to America and each of the three young women gain new insights into themselves.

Critique

Jean Renoir made his first colour feature, *The River* in 1951. India had gained independence four years ago, in 1947, and its own cinema was in the grips of charged debates on the question of how this medium would serve a new nation. *The River* is set in a village in Bengal, the east-Indian state where the parallel cinema of masters such as Satyajit Ray and Ritwik Ghatak was to soon germinate. Renoir's unique aesthetic contributions to the Bengali landscape were of course tied to his position as a film-maker from outside looking in. However, he manages to avoid the connotations of orientalism and romanticism that could otherwise easily get linked with a European gaze, adapting elements of his signature style quite effectively to render a contemplative, evocative view of Bengal at a unique moment in history.

 The River is based on Rummer Godden's novel by the same title, set during the receding years of the British Empire in India. The film follows the structure of the novel rather loosely – altering characters, events and adding instances that are specifically cinematic rather than literary that facilitate in making a critical discourse surrounding cultural practice. The film as the novel centres on the experiences of the young Harriet (Nora Swinburne), coming of age

Cast:

Nora Swinburne
Esmond Knight
Arthur Shields
Suprova Mukerjee
Thomas E. Breen
Patricia Walters
Radha
Adrienne Corri
June Hillman

Year:

1951

in adolescence. Seeing Bengal through her eyes and at the world of her English family in Bengal, opens a panorama that exceeds the binaries of native-foreigner, colonizer-colonized categories. *The River* delicately navigates the relationships among characters and, more significantly, with the people of Bengal, who in the film are mostly *at their service* in the English-owned Jute Mills founded under colonialism. What is striking about Renoir's approach is that the relationships between characters of the colonial establishment and the colonized subjects come across as bearing a humane edge that complicates our understandings of colonial encounters at a people-to-people level. This is felt in the relationship between the family members and household staff, as also in their rapport with village folk, seen in those instances when Harriet and other characters move about in the village bazaar or on the river banks.

The River interweaves documentary footage from the village with the film's fictional narrative. This documentary footage pertains to specific outdoor sequences through which the Bengali and Hindu way of life is translated for the viewer. Two sequences stand out most. The first when the river, on the banks of which the film is set, is introduced. Through Harriet's voice-over we learn how Bengali folk live alongside the river; their lives shaped by it in many dimensions ranging from gross economics onto spirituality. The second sequence focuses on the Hindu festival of lights, Diwali. Here we see the English family with their friends celebrating Diwali through their own hybrid rituals that are formed by the confluence of the Bengali cultural landscape and their own cultural background. Images of the celebrating family are intercut with images of folk festivities in the village. This sequence not only provides a cultural interpretation of the importance of Diwali in Hindu life, but also gestures towards how the English family had come to respect the Hindu worldview and its practices. In these sequences, as in the rest of the film, Renoir's use of colour is striking and gestures towards a sophisticated understanding of Indian landscape and light. His compositions are painterly, grounded in the complementarity between warm colours placed next to each other, in some ways referencing the traditions of Indian miniature painting.

In Rumer Godden's novel, Harriet has a deep connection with the river. As an adolescent she is emotionally volatile, as is her infatuation with Capt. John (Arthur Shields), an American visitor at her neighbours'. Her character has a contemplative side that articulates itself through her interest in writing poetry. In the film, this element of her personality pervades the film's cinematography and editing. Renoir's use of long-shots make the landscape not a mere setting for action, but a temporal, living entity that registers the passage of time. *The River*'s construction is lyrical and ecological, as key human events – falling in love, death and birth – arise rhythmically from an image track that spans the onset of autumn to the onset of spring.

In *The River* it is clear that Renoir was not immersing himself in Bengal with the intent to visualize any native viewpoint. The distance he maintains from the landscape facilitates cinematic juxtapositions with implications exceeding the imperatives of

cultural authenticity. The character Melanie (Radha) does not exist in Godden's novel and is introduced to the film by Renoir, the Irish neighbour's daughter from an interracial marriage. Her father (Suprova Mukerjee) views her disposition as an enigma. She on the other hand embodies two civilizations and Renoir highlights this through constructing her femininity as including composure and an aesthetic prerogative derived from India's Sanskritic thought. In a powerful sequence towards the middle of the film we see her perform a Bharatanatyam dance sequence in honour of the Hindu God, Krishna. Bharatanatyam is a dance form from Tamil Nadu in south India. Positioning it in a Bengali landscape constitutes as a powerful cultural juxtaposition that is supported by the choice of Radha, a member of the Theosophical Society in Tamil Nadu who performs the character of Melanie in *The River*. Through this choice, *The River* extends beyond a close evocation of the Bengali cultural landscape to cast a wider civilizational net, through which multiple cultural imperatives are seen intersecting in the film – the very tools by which cultural differences and hierarchies can be interrogated.

Aparna Sharma

THE NEW
WAVE AND
AFTER

Perhaps no other phenomenon in film-making has left such a mark on its national cinema as the French New Wave has on France's. The so-called movement is unquestionably an integral part of film history, most notably in the rise of stylistic, thematic, and economic standards as they are practiced and recognized in film-making today. Its main figures, most popular among them François Truffaut, Jean-Luc Godard, Claude Chabrol and Alain Resnais, are regularly cited for their accomplishments and to many stand out as ideal examples of the genuine auteur. Then there are the films, which have been examined, admired, taught, written about and referred to many times over by critics, scholars, fans and film-makers alike. The New Wave has certainly drawn its share of negative reactions along with the positive ones over the years, but the fact that it has received so much attention itself clearly indicates the depth of its influence.

In any case, it certainly has not made things easy for new French film-makers who have emerged in its wake, if only because of the enormous weight of expectation that continually presses against them. In a way, it is inevitable: the New Wave brought about such a change to the state of French cinema in such a dynamic and visible manner that it would always be a tough act to follow. No matter what the intentions or beliefs a new director might bear in relation to that current of films from the 1950s and 1960s, any signs of creative innovation, originality or boldness are sure to draw some comparison, if not an outright proclamation of the arrival of a new New Wave. And French film-makers have not been alone: whether warranted or not, the French New Wave has served as a standard point of comparison for the numerous other new cinemas that have appeared all over the world, ranging across Japan, Germany, Hong Kong, Taiwan, Argentina, Romania, Thailand and beyond.

A significant reason for the New Wave's persisting hold on people's hearts and minds is the captivating romantic quality of its concept: a fellowship of young, eager movie buffs who set out together to take down the stagnating old guard of French cinema with their own films and managed to pull it off. While there are of course many, many more details to the picture than this overly simplistic summary, as will be explored later, it is first worth recalling the facts that have given rise to this all-too-dominant notion. To begin with, it is true that French cinema in the post-war era (particularly the 1950s) largely consisted of established directors who looked to the past rather than the present for inspiration in their work. Including Claude Autant-Lara, Marcel Carné, Sacha Guitry, Christian-Jaque and René Clair, such figures chose to continue making the same kinds of films that were made and seen in the 1930s (Lanzoni 2002: 150–51). Their motives partly stemmed from simple self-preservation: driven by the desire to remain established among audiences, they utilized conventional stylistic and narrative methods rather than taking risks with creative innovations (Lanzoni 2002: 158). Heavily consisting of ornate period pieces, the output from this aged branch of French cinema may have been competently made and even took advantage of new techniques like colour film, but to many it came to be recognized as a 'scenar-

ist' cinema that remained mired in pre-established forms and was increasingly seen as stale, tired and outdated (158–59). Film journals soon became an invaluable platform for critics to voice their complaints about the current state of French cinema and put forth their own ideas and theories for productive change in the system. One influential piece that did as much was Alexandre Astruc's 1948 *L'Ecran français* article 'Naissance d'une nouvelle avant-garde: La Caméra-stylo'/'The Birth of a New Avant-Garde: La caméra-stylo' on what he described as the *caméra-stylo*, in which he wrote about the need to re-evaluate the capabilities for personal expression in cinema and embrace a more direct and personal form of film language that he saw exemplified in films like Jean Renoir's *La Règle du jeu/The Rules of the Game* (1939) and Orson Welles' *Citizen Kane* (1941) (Neupert 2007: 47–49). Other publications like *Gazette du cinéma*, founded by Eric Rohmer in 1950, and *Revue du cinéma* gave film critics like Astruc, Godard, Truffaut, Jacques Rivette and Jacques Doniol-Valcroze the chance to voice their own views on cinema. Then came that juggernaut of French film journals, *Cahiers du Cinéma*. Began in 1951 by Doniol-Valcroze and André Bazin, it came to be most famous for the articles written by the 'Young Turks' group of Godard, Truffaut, Chabrol, Rohmer and Rivette, in which they would fiercely declare the artistic merits of such Hollywood directors as Alfred Hitchcock, Howard Hawks, Anthony Mann, Samuel Fuller and Nicholas Ray (Neupert 2007: 29–30). With the 1954 publication of his piece 'Une certain tendance du cinéma français'/'A Certain Tendency of the French Cinema' in the journal, Truffaut took the simmering impatience with the old guard (which he classified under the bitingly ironic term 'Tradition of Quality') to a new level, essentially drawing a line in the sand between what he saw as the inadequate, overly script-reliant efforts coming from Autant-Lara and screenwriters Jean Aurenche and Pierre Bost and the more cinematically attuned works of select auteurs like Jean Renoir, Jean Cocteau, Jacques Tati, Robert Bresson and Max Ophüls (31). Before long, the next steps in the growing wave of change were taken when the Young Turks began to put forth their ideas and views on the medium through their own short and feature films. With the popularity of Chabrol's *Le Beau Serge* (1958) and *Les cousins/The Cousins* (1959), Truffaut's *Les Quatre cents coups/The 400 Blows* (1959) and Godard's *À bout de souffle/Breathless* (1960), the New Wave swiftly gained momentum, took shape in the public eye as a distinct entity, and was soon recognized as the new face of French cinema.

That face would come to be known for certain features that, while not entirely representative of all the new films and filmmakers that emerged during that period, nonetheless took root as enduring tokens of youth and change. Black-and-white cinematography shot with lightweight, handheld cameras. Jazz music. The city of Paris, portrayed complete with street vendors, café patrons, and passersby who happened to be in the frame during the chosen take. Streams of quotations, references and tributes that displayed a given director's knowledge of not only film, but also literature,

music, painting, philosophy, and other areas of culture. Character attributes of narcissism, amorality and alienation that were read as both troubling grounds of complaint and authentic depictions of modern-day youth. A refreshingly bold attitude towards sexuality in film that stirred up similar responses, if not more generous dollops of outright scandal.

Alongside these recognizable traits, there were the main players of the New Wave; a social network of artists, actors, technicians and producers who, with their prominence in the media spotlight and interweaving collaborations, themselves came to embody the fresh spirit that had taken hold of French cinema. Of course, that particular function was especially well suited for the most visible of those figures: the actors. The success of *The 400 Blows* made young Jean-Pierre Léaud the poster child for the new French cinema, a position that would only be reaffirmed by his participation in later efforts by Godard, Rivette and, most significantly, Truffaut, with whom he formed a special bond. Other male stars like Jean-Paul Belmondo, Jean-Claude Brialy and Maurice Ronet emerged and left deep impressions with their striking, charismatic performances. Even more captivating were the fresh representations of femininity embodied by such actresses as Brigitte Bardot, Jeanne Moreau, Anna Karina, Jean Seberg and Bernadette Lafont. The next most prominent figures were the directors themselves, mainly due to the pre-existing notoriety many of them had established as critics; the assertions from Astruc, Truffaut, and others emphasizing the centrality of the auteur in the film production model; and the New Wave directors' consequent efforts to situate themselves as the key creative forces in their own film projects. The network extended to other areas, including cinematographers Raoul Coutard, Henri Decaë and Sacha Vierny; musicians Michel Legrand and Georges Delerue; and producers Pierre Braunberger, Georges de Beauregard, Carlo Ponti and Anatole Dauman. Simply through their productivity and associations with one another, they and others helped build the image of the New Wave as a more or less unified movement in cinema – which eventually became appropriated as a recognizable marketing brand of-sorts, a development that Chabrol famously compared to a promotional campaign for soap (Vincendeau 2009: 10).

Numerous practical factors contributed to the distinctive New Wave look seen in the films – namely being the utilization of actual locations, lighter camera and sound equipment, and lesser-known actors that simply allowed for easier, quicker and cheaper productions and enabled more films to receive support and get made (Neupert 2007: 39–41). With a financial boost from the Centre national de la cinématographie's (CNC) Film Aid program which put money from ticket sales behind new film projects, directors could get by with making films on smaller budgets so long as they operated within their means and exercised a certain amount of resourcefulness – limitations that led to an up-close cinematic focus on contemporary society and its youth as captured by the innovative, often on-the-fly methods used by the film-makers (Neupert 2007: 39–41). Thus, inexpensive work methods and the

hip, modern look they produced were initially born of necessity, then, due to critical and financial success, strategically wielded and deployed. A sterling example of this can be seen in *Cléo de 5 à 7/Cleo from 5 to 7* (1962) by Agnès Varda, who, before embarking on the project, was advised by Beauregard to 'make a little black-and-white film that won't cost more than 32 million francs' (Orpen 2007: 6). Even though Varda's photography background and move into film-making with her debut feature *La Pointe Courte* (1954) was more singular and far-removed from the *Cahiers* crowd's origins, she nonetheless managed with *Cleo* to make a film that, with its black-and-white portrayal of 1960s Paris, music by Legrand, and cameo appearances by Godard and Karina, is today virtually inseparable from other key New Wave works if only because of all the links they share. Later films from other directors like *Cahiers* writer Luc Moullet and ex-pat American photographer William Klein would closely emulate the offbeat style first created and honed by the original innovators who came before them.

In the years since its height in the 1960s, the New Wave has developed into a much-beloved era of film history – or, as Geneviève Sellier so accurately calls it, 'a veritable cult object for successive generations of *cinéphiles* and film students' (Sellier 2008: 2). With its mythos upheld and celebrated through various media, it represents to many a seductive era of cool, glamour, romance and energy – cultural revolution at its most chic. In a telling piece for *Film Comment* celebrating the 50th anniversary of *Breathless*, Geoffrey O'Brien unabashedly acknowledges the influence the New Wave cast on its fan base in his examination of the charm and confidence contained in the film and the impact still resonating within its smitten admirers. No wonder, then, that *Breathless* is still held up by so many as the preferred flagship of the New Wave, given its stylistic daring, sharp humour, sex appeal and youthful vitality, all in one package.

The period's exact timeframe has been a matter of much inconsistency and debate among scholars and historians. Of the many books written about it, James Monaco's *The New Wave* (1977) is one of the more misleading ones due to its exclusive focus on Truffaut, Godard, Chabrol, Rohmer and Rivette despite its more expansive title and the loose consideration of all the directors' films made at the time of publication, giving no regard for outlining specific chronological boundaries in favour of a more generalized auteurist approach. In *A History of the French New Wave Cinema* (2007), Richard Neupert takes greater care with the social and cultural context of the time, clearly situating the New Wave between 1958 and 1964 and providing a detailed exploration of the various factors outside of the films themselves that contributed to the movement's formation and popularity, including the emergence of a new post-war generation of youths eager for fresh innovations in art and culture (Neupert 2007: xviii). Sellier's *Masculine Singular: French New Wave Cinema* (2008) puts forth an even tighter timeframe of just one year lasting from September 1958 to September 1959, her explanation stressing the central role audience and critic reactions played in the success of New

Wave films and directors and pointing out the relative decline in enthusiasm seen in the public once the 1960s got underway (Sellier 2008: 42). In the middle of her time span lies the 1959 Cannes Film Festival, a crucial event dubbed by Sellier as the 'official birthday of the New Wave' that featured Truffaut's *The 400 Blows* and Resnais' *Hiroshima, mon amour/Hiroshima My Love* (1959), both extremely influential New Wave works that signified the changes French cinema was undergoing at the time (Sellier 2008: 42).

However, only a few years beyond that fateful film festival lay the decline of the New Wave's reign – which was never completely accepted or invincible to begin with. The *Cahiers* crowd certainly received its share of criticism from other publications, most notably its main rival *Positif*, which produced viewpoints that challenged the condemning opinions of Truffaut and his comrades, published more respectful pieces dedicated to older films and directors, and attacked some of the New Wave's biggest figures, particularly Chabrol and Godard (Neupert 2007: 32–34). The innovations made in *Breathless* that have since been hailed countless times over as instrumental steps in cinema's evolution were definitely not met with unanimous acceptance, as illustrated by Raymond Borde's exasperated reaction to the film (Borde 2009: 228–31). In a trend not too dissimilar from the more recent criticisms against the mumblecore sub-genre in American independent film, the distinctive aesthetic found in so many New Wave films increasingly came to be recognized as a target of complaint, dismissal and even hatred (Vincendeau 2009: 7). Truffaut's *Tirez sur le pianiste/Shoot the Piano Player* (1960), Godard's *Une femme est une femme/A Woman is a Woman* (1961), and Chabrol's *Les Godelureaux/Wise Guys* (1961) all fared poorly at the box office, which seemed to only encourage the press' harshly triumphant diagnosis that the New Wave was on the wane (Brody 2008: 121). As attendance in French cinemas dropped considerably throughout the 1960s, the New Wave essentially went from being a burst of freshness largely met with excitement to a scapegoat of sorts that was overstaying its welcome (Vincendeau 2009: 7–9).

Along with the backlash the New Wave faced in the public realm, the films themselves seemed to signal the end of its short era. From Godard's turbulent career alone, one could choose from any number of symbolic death throes: Bardot's fatal car crash at the end of *Le mépris/Contempt* (1963). Belmondo's spectacular suicide by dynamite on a high cliff overlooking the Mediterranean Sea in the final scene of *Pierrot le fou* (1965), concluding in appropriately definitive fashion the collaborations between the actor and the director. Of course, the final titles of *Weekend* (1967) reading 'End of Story', 'End of Cinema', which effectively announced the finish of Godard's now-legendary run of 1960s genre-inspired pop art exercises and the start of his more experimental forays into political cinema. Whether considering these signs or more reality-based ones like the bitter falling out between him and his old friend Truffaut over money and long-brewing resentments in the early 1970s or the violence of May 1968, the initial spirit of unity and euphoria that emanated from the sudden arrival of so many new

and exciting film-makers would only grow more distant as the years progressed. The illusion unravelled; the party ended.

One component of the New Wave's history that has expanded to overwhelming proportions is the totality of the *Cahiers* film-makers' influence. Although their achievements as both critics and film-makers certainly played important parts in the rise of the New Wave, their voices were far from the only ones being heard in the French film culture of the time. Along with pieces from other publications like *Positif*, *L'Ecran français* and *Cinéma 55* were ones from the very pages of *Cahiers du Cinéma* that offered a multitude of perspectives beyond the ones loudly articulated by the soon-to-be directors (Neupert 2007: 31–32). Yet that specific group has nonetheless come to be most strongly identified with both French film criticism from that time and the French New Wave as a whole, helped significantly by the controversial, passionate nature of their arguments in general and that most controversial and passionate of screeds, Truffaut's 'A Certain Tendency of the French Cinema', in particular. Essentially, in the writing and publication of that article, Truffaut and *Cahiers* created the appearance of a common goal of upheaval against the old cinema that many critics and scholars would use to lump together the boom of young, new film-makers of that period under the New Wave name, regardless of their individual motives, backgrounds or beliefs.

Therein lies the foundation of the romantic, misrepresentative notion of the New Wave as a close-knit band of outsiders, built up by such pieces as *Financial Times* writer Nigel Andrews' in which he describes it as 'the greatest criminal enterprise in cinema history' (Andrews 2009). Instead, it would be more accurate to consider the New Wave not as a group or movement, but rather a momentary flash of transformation in which several eager newcomers seized the rare chance to not only challenge the old guard and reinvigorate French cinema, but also simply launch themselves into the world of film under their own flags. For what also sometimes gets forgotten is the fact that many of these directors aimed to firmly establish themselves and continue to create their own legacies long after the revolution had been won. The friction between the applied perceptions of the New Wave as a group, event or brand, and directors' individual motives and interests can be clearly read from statements from key film-makers negating the limiting classifications that had been thrust upon them. Astruc, Chabrol and Roger Vadim all used a survey from *Le Monde* in August 1959 to voice their shared opinion that a New Wave did not exist in French cinema (Vincendeau 2009: 9–10). While Godard actually stated that he considered himself and the other four most famous *Cahiers* directors to be the core group of the New Wave, he also believed they were meant to pursue new, unexplored areas of potential in the cinematic medium regardless of audiences' expectations (Brody 2008: 123–24). By the early 1960s, Truffaut stressed that the term 'New Wave' at its most accurate referred to the unusually high number of new French film-makers that had emerged rather than an organized collective and expressed much concern about the poor progress their films were facing at the time (Brody 2008:

122). In contrast to Godard's stubborn non-conformist standpoint, he would remain highly aware of both his commercial prospects and his audience throughout his career, carefully sustaining himself in the film industry by regularly returning to accessible genres and themes. Other key directors like Agnès Varda and Louis Malle do not entirely fit within a generalizing New Wave label due to their singular career paths and independent-minded views on their work, despite their invaluable contributions to the rise of new practices in French cinema.

The attention given to specific figures and groups within the New Wave period has been far from equally divided, resulting in many such subjects becoming overlooked if not entirely lost in obscurity. This can even be seen in the central *Cahiers* circle, where Truffaut, Godard and Chabrol have nearly always dwarfed Rohmer and Rivette in terms of popularity and familiarity, which can be partially attributed to the limited initial releases of the latter pair's early efforts. Other *Cahiers* contributors like the journal's co-founder Jacques Doniol-Valcroze and Pierre Kast have remained even less appreciated, as have their relevant works *L'eau à la bouche* (Doniol-Valcroze, 1959) and *Le Bel âge* (Kast, 1959). They are joined by Marcel Hanoun's *Une simple histoire/A Simple History* (1959), Michel Deville's *Ce soir ou jamais/Tonight or Never* (1961), Jacques Rozier's *Adieu Philippine* (1962), and Jean-Pierre Mocky's *Les Drageurs/The Chasers* (1959) and *Les Vierges/The Virgins* (1963), just some of the many notable New Wave films that still have yet to be as widely distributed, discussed or studied as other films now deemed essential classics. Then there are the films like Paulin Soumanou Dieyra's *Afrique sur Seine/Africa on the Seine* (1955) from marginal demographics of French society that drew upon the new film-making resources being made available at the time to tell their own stories – in some cases in a manner that even resembled the more widely recognized New Wave products (Felton 2010). While it is difficult to determine how long it will take until such blind spots are given the proper exposure and focus they deserve, growing developments in areas as far-ranging as film restoration, DVD and online film distribution, and film criticism and blogging all provide hopeful avenues for future discovery, preservation and discussion.

The generations of French film-makers that succeeded the New Wave have long had to contend with the heavy weight of legacy usually thrust upon them by the media and audiences all too eager to build new cultural foundations within their national cinema. Numerous figures who have proven themselves to be unique and important artists in their own right have responded to this burden in various ways and, in some cases, openly addressed, emulated and challenged the New Wave's accomplishments in their work. Christophe Honoré, whose *Dans Paris/In Paris* (2006) and *Les Chansons d'amour/Love Songs* (2007) have drawn many comparisons to the New Wave, looked to it for practical guidance on getting fulfilling results from limited resources and has admitted that his distance from it has allowed him to regard it in a more relaxed manner than some of his older counterparts (Honoré 2011). On the other hand, Olivier Assayas is a director all too aware of

the intimidating, omnipresent image the New Wave casts upon emerging film-makers, and has addressed it and a closely affiliated subject, the concept of authorship, throughout his work (Sutton 2008: 22–29). Easily the most important film of his that accomplishes those goals is *Irma Vep* (1996), which brilliantly addresses cross-cultural influence, authorship, the obsolescence of auteurist ideals in the contemporary age, and the relationship between art, entertainment and commerce. Alongside Assayas, Arnaud Desplechin stands out as an especially fascinating film-maker in relation to both the New Wave spirit and the evolution of French cinema, having garnered much acclaim for his novelistic ensemble films *Rois et reine/Kings and Queen* (2004) and *Un conte de Noël/A Christmas Tale* (2008). His idiosyncratic use of cinematic techniques, shifts between tones and genres, and embrace of both high and popular culture all evoke the films of Godard and Resnais to a degree, though his work very much has its own flavour, perhaps distinguished most clearly by his stylistic confidence, nuanced characterizations and morally complex worldview. But attempts to find a 'new New Wave' have extended even beyond this recent assortment of directors. One fresh batch of emerging film-makers consisting of former *La Lettre du cinéma* critics Serge Bozon, Pierre Léon, Axelle Ropert, Jean-Charles Fitoussi and others was most recently highlighted in an article in *Film Comment* entitled 'The Wave with No Name' (Foundas 2011).

In the meantime, many of the original New Wave players have continued to assert their presences well into the new millennium. Chabrol and Rohmer remained fairly productive until they both passed away in 2010. When Godard's *Film socialisme/Film Socialism* (2010) ran the festival circuit in the same year, it provoked strong and varied responses from critics and viewers alike, demonstrating the still-active film-maker's continuing, frequently incendiary impact on film culture. In contrast, Rivette and Varda have both indicated their desires to move beyond cinema, effectively choosing to cap their film careers with *36 vues du Pic Saint Loup/Around a Small Mountain* (2009) and *Les Plages d'Agnès/The Beaches of Agnès* (2008), respectively. Perhaps the most inspirational (and inspired) of the New Wave legends is Resnais, who has remained rigorously active through his eighties by making such light-hearted, vibrant stories of love as *Pas sur la bouche/Not on the Lips* (2003), *Coeurs/Private Fears in Public Places* (2006) and *Les herbes folles/Wild Grass* (2009), soon to be joined by the upcoming *Vous n'avez encore rien vu*, set to be completed and shown in 2012. Certain actors also still make frequent screen appearances and often serve as symbolic homage figures, the most significant of which likely being Léaud. Yet the cinematic contexts in which they are placed by film-makers are not always limited to mere tributes, but, as demonstrated by Léaud's presence in *Irma Vep*, can also take on more critical dimensions. In this vein, Tsai Ming-liang's *Visage/Face* (2009) features Léaud and fellow Truffaut collaborators Fanny Ardant, Nathalie Baye and Jeanne Moreau in a haunting and poignant meditation on the director's (and, in a broader sense, the New Wave's) death and legacy as seen from the distant perspective

of the twenty-first century.

One might ask which vision best represents the spirit of the French New Wave as it exists today. *Visage*'s funereal sense of loss and age? *Wild Grass*' invigorating eccentricity and creative ingenuity? *A Christmas Tale*'s mixture of melodramatic elements, acidic humour and emotional resonance? In one sense, they and many other works all deserve to be considered part of the complex mosaic of expressions that continue to reflect that legendary era of film-making. But it would perhaps be better to say that none of them do, to free them from the rigid limitations of classification that come with pegging them down to the New Wave story. Several post-New Wave directors like Assayas, Desplechin, Honoré, Philippe Garrel, Claire Denis, and Catherine Breillat have indeed made it difficult for such labels to be applied to them simply through the extraordinary scope and originality of their individual engagements with the medium. While it is impossible to deny the New Wave's importance and its lasting resonance in France and abroad, it should not cast too great a shadow over the unique accomplishments made by certain film-makers, whether they emerged during its heyday or currently seek to establish themselves in the French cinema of today. Beyond any other definitions, the French New Wave is a small window of time and opportunity that opened in another era. Standing above any convenient, summative images of unity, organization or tradition, what matter most are simply the lasting remnants it brought about – the assortment of artists, works and lessons that came through it.

Marc Saint-Cyr

References

Andrews, Nigel (2009) 'When Truffaut met Tarantino', *FT.com*. 4 April, http://www.ft.com/intl/cms/s/2/11f311da-1fe2-11de-a1df-00144feabdc0.html#axzz1Ng6PV3eg. Accessed 10 May 2011.

Borde, Raymond (2009) 'À bout de souffle', in Peter Graham and Ginette Vincendeau (eds.), *The French New Wave: Critical Landmarks*, London: Palgrave Macmillan in association with the BFI., pp. 228–31. Originally published in Raymond Borde, Freddy Buache and Jean Curtelin (1962), *Nouvelle Vague*, Lyon: Premier Plan/Serdoc.

Brody, Richard (2008) *Everything is Cinema: The Working Life of Jean-Luc Godard*, New York: Metropolitan Books.

Felton, Wes (2010) 'Caught in the Undertow: African Francophone Cinema in the French New Wave', *Senses of Cinema*, 57, http://www.sensesofcinema.com/2010/feature-articles/caught-in-the-undertow-african-francophone-cinema-in-the-french-new-wave/. Accessed 13 April 2011.

Foundas, Scott (2011) 'The Wave with No Name', *Film Comment*, March/April, pp. 44–47.

Honoré, Christophe (2011) 'Inside Paris Interview', interview by David Stratton, *At the Movies – ABC TV*, http://www.abc.net.au/atthemovies/txt/s1987888.htm. Accessed 13 May 2011.

Ince, Kate (ed.) (2008) *Five Directors: Auteurism from Assayas to Ozon*, Manchester: Manchester University Press.

Lanzoni, Rémi Fournier (2002) *French Cinema: From its Beginnings to the Present*, New York: The Continuum International Publishing Group Inc.

Monaco, James (1977) *The New Wave*, New York: Oxford University Press.

Neupert, Richard (2007) *A History of the French New Wave Cinema*, Madison: The University of Wisconsin Press.

O'Brien, Geoffrey (2010) 'An Ideal for Living', *Film Comment*, May/June, pp. 28–33.

Orpen, Valerie (2007) *Cleo from 5 to 7*, London: I. B. Tauris & Co. Ltd.

Sellier, Geneviève (2008) *Masculine Singular: French New Wave Cinema* (trans. Kristin Ross), Durham: Duke University Press.

Sutton, Paul (2008) 'Olivier Assayas and the Cinema of Catastrophe', in Kate Ince (ed.), *Five Directors: Auteurism from Assayas to Ozon*, Manchester: Manchester University Press, pp. 22–29.

Vincendeau, Ginette (2009) 'Introduction: Fifty Years of the French New Wave: From Hysteria to Nostalgia', in Peter Graham and Ginette Vincendeau (eds.), *The French New Wave: Critical Landmarks*, London: Palgrave Macmillan in association with the BFI.

Brigitte and Brigitte

Brigitte et Brigitte

Studio/Distributor:
Les Films Luc Moullet

Director:
Luc Moullet

Producer:
Luc Moullet

Screenwriter:
Luc Moullet

Cinematographer:
Claude Creton

Editor:
Luc Moullet

Duration:
73 minutes

Genre:
Comedy

Cast:
Colette Descombes
Françoise Vatel
Michel Gonzalès
Claude Melki
Eric Rohmer
Claude Chabrol
Sam Fuller

Year:
1966

Synopsis

The comic adventures of two girls named Brigitte, from distant but similarly backward mountain villages, who meet upon arrival in Paris and decide to share an apartment and help each other through college.

Critique

Luc Moullet (b.1937–) is the court jester of the French New Wave. In his late teens, he met Eric Rohmer, Claude Chabrol, Jean-Luc Godard, and François Truffaut when they were all writers for *Cahiers du Cinéma*. Moullet stands out among these critics-turned-film-makers because of his rural and working-class origins, his consistent disdain for displays of technique and virtuosity, his calculated avoidance of the spotlight, his lack of a sense of self-importance, and his anarchic leanings.

Moullet was the first *Cahiers* critic to revere the films of Samuel Fuller and Edgar G. Ulmer, and the first to fully appreciate Luis Buñuel's Mexican pictures. He wrote a highly regarded book on Fritz Lang, which Brigitte Bardot reads in the bathtub in Godard's *Le mépris/Contempt* (1963), and continues to dabble in criticism to this day. The short films Moullet directed in the early 1960s attracted little attention, but *Brigitte and Brigitte*, his feature debut, attracted a cult following. The film observes Parisian culture from the perspective of the outsider, as might befit the view of 'the man from the *roubines*', the section of the Rhone Alpes that Moullet calls his ancestral home.

Brigitte and Brigitte is a fish-out-of-water comedy about 19-year-old girls who have much more in common with each other than their name. They come to Paris from small mountain towns (without roads or electricity) on the same day to study at La Sorbonne. After an aerial view of Paris, probably a stock shot, the girls meet some-where inside the train station. They sit side-by-side against a wall with posters of the Alps and the Pyrenees, indicating the moun-tain ranges where their villages are located. Alpine Brigitte is a tall blonde and Pyrenean Brigitte is a petite brunette. Moullet places the camera front and centre and does not move it. It is a decidedly schematic scenario shot with a minimum of means. There are no extras or the ambient noise needed to create the illusion of reality. The film flaunts its artificiality and its austerity. Brigitte and Brigitte amusedly take note of their similarities, they carry matching lug-gage and wear identical blazers and petticoats. They fancy them-selves as stylish but they are dressed in a style that is no longer fashionable in Paris, only in the provincial capitals where they spent their first year of college.

The camera becomes more nimble in the outdoor scenes as the girls transverse Paris in search of proper lodgings. It proves to be a challenging, and hilarious, enterprise. A cousin with an apartment in the West End turns out to be a crazed lecher, the student hostel is run by a hunchback, and new student housing resembles slum

shacks. Paris is stranger and more expensive than they imagined, so they decide to help each other out.

They eventually move into a one-room apartment and get ready for college. *Brigitte and Brigitte* pokes holes in the pretentious fabric of French academia. The girls must contend with overzealous and dogmatic student activists, abhorrent pedagogy, inflexible bureaucracy, crowded classrooms, and construction noise that seems to follow the girls wherever they go on campus. The film is structured as a succession of inventive gags, in the style of the films of Jacques Tati. More specifically, Moullet has declared an affinity with writer Alfred Jarry (b.1873, d.1907), a sort of proto-surrealist with a gift for pranks and a pioneer in the field of absurdist literature ('Ubu the King').

The girls must decide what to study. Every field has its drawbacks. Blonde Brigitte rules out Italian because, as she puts it: 'I hate spaghetti. And they raped Grandma in '40.' English wins out by default. The girls conduct research for brunette Brigitte's essay titled: 'American Cinema: Art or Factory of Myths?' Moullet writes a scenario that allows him to ridicule the righteousness and fanaticism of *cinéphiles* and the obtuseness of academic film criticism. A film buff's ultimate wish: 'to die watching a movie.' One interviewee names Hitchcock, Welles, and Jerry Lewis as 'the' best American directors while another proclaims the same three are 'the worst'. Eric Rohmer makes an appearance as a film studies professor who uses statistics to prove that American movies are a bad influence and disallows any dissenting opinions in his class. This barbed, satirical sequence is aimed directly at intellectuals and colleagues at *Cahiers* who were rather casually adopting Marxist, psychoanalytic and semiological theories in the study of film.

Brigitte and Brigitte does not allow its protagonists to escape unscathed. The *naïveté* and ignorance of these provincial girls is exposed. Blonde Brigitte is flighty and brunette Brigitte is revealed to be racist. One episode involves a farm holiday with two boys they meet at school, a digression with slapstick gags about hunting and the milking of cows. Moullet clearly has a taste for burlesque – forever the prankster – and yet, *Brigitte and Brigitte* is an acutely observed document on French youth at a crucial historical turn that is often compared to pre-1968 Godard. It is not always an easy comparison, however. In the first English-language piece of criticism about Moullet, Jonathan Rosenbaum observes that Moullet's 'echoes of Godard come off as devastating critiques because Moullet is a light-hearted humanist and Godard is not' (Rosenbaum, 2010: 51). The point is not to downgrade Godard but to bring Moullet out of obscurity and shine a light on his undeservedly ignored films. The sharp but genial *Brigitte and Brigitte* is a great place to start.

Oscar Jubis

References

Rosenbaum, Jonathan (2010) 'Luc Moullet', *Film Comment* 13: 6 (1977), pp. 50–55.

When the Cat's Away, France 2 Cinema, Canal+.

When the Cat's Away

Chacun cherche son chat

Studio/Distributor:
Vertigo Productions

Director:
Cédric Klapisch

Producers:
Aïssa Djabri
Farid Lahouassa
Manuel Munz

Synopsis

Chloe, a young, lonely woman living in the Bastille quarter of Paris, is going on holiday but cannot find anyone to look after her cat while she is away. Having left it with an elderly lady, she returns to find that it has disappeared, and along with several friends, neighbours, and new acquaintances she orchestrates a search of the entire neighbourhood. However, her actions soon lead to a personal adventure across the city as Chloe embarks on a series of encounters and prospective new relationships.

Critique

There is a distinct echo of Eric Rohmer to *When the Cat's Away*, the third feature by writer/director Cédric Klapisch. As in *Le Rayon vert/ The Green Ray* (Eric Rohmer, 1986), the film begins with a troubled heroine preparing for a holiday; like Blanche in *L'Ami de mon amie/ My Girlfriend's Boyfriend* (Eric Rohmer, 1987), the central character Chloe is a lonely, reserved, professional twenty-something who feels herself in a rut but seems to lack the requisite self-esteem to break with her routine by her own volition. And like so many of Rohmer's best known titles, Klapisch's film plays out in a quasi-

Screenwriter:

Cédric Klapisch

Cinematographer:

Benoît Delhomme

Editor:

Francine Sandberg

Duration:

95 Minutes

Genres:

Comedy

Romance

Cast:

Garance Clavel

Zinedine Soualem

Renée le Calm

Olivier Py

Romain Duris

Simon Abkarian

Joël Brisse

Year:

1996

carnivalesque, regenerative time-away-from-time, where a fateful, chance occurrence leads to a break with convention and an opportunity for the protagonist to move beyond the hitherto oppressive boundaries of her life.

Whatever its debts to Rohmer, *When the Cat's Away* is also a true Klapisch film. Since the beginning of his career, Klapisch has shown a predilection for exploring the dynamics of an ensemble cast of characters set within an enclosed, clearly demarcated milieu that determines their lives and fates: whether an entire city as *Paris* (2008), a single building as in *Un air de famille/Family Resemblances* (1996) or an apartment in *L'auberge espagnole/Pot Luck* (2002). Klapisch has also frequently been concerned to de-familiarize the familiar, especially as regards his portraits of the French capital. He builds diffuse narratives around characters who view their environment through a particularly marked prism of subjectivity. *When the Cat's Away* unfolds in an enclosed setting, the working-class Bastille quarter of Paris, an area of the city that has rarely been opened up to a penetrating cinematic gaze. But beyond this Klapisch's vision makes of it an interior as well as a vibrantly exterior space. It is a teeming, inchoate milieu that perpetually seems to be pervading the private realms of the characters, bleeding in both visually and aurally through the multitude of open doors and windows and seeming to dictate their feelings and fluctuating states of mind. Paris in *When the Cat's Away* figures as a veritable character in the unfolding drama of the narrative. This it does both denotatively, in that the search for a cat missing in its midst facilitates the adventure that opens up the protagonist's insular existence. But more crucially, the city becomes figuratively transformed before the gaze of the film's reserved protagonist, and functions as both a site of performative display (highlighted in two rhyming moments wherein Chloe has to fend off unwanted advances in her doorway), and a veritable maze. It is an exterior manifestation of the internal turmoil afflicting Chloe, with the search for the cat standing in for a more meaningful, albeit fragile, largely unconscious, quest on her part.

The film's picture of Paris paints a picture of the French capital as a perennial construction site, where the old is demolished in the name of perceived progress. As if to further emphasize this clash, Klapisch places his young protagonist beside a close-knit community of elderly women, led by Madame Renée whose carelessness leads to Chloe's cat going missing in the first place. She and her various friends band together to help out in the search, and their sporadic attempts at reaching out to Chloe (in most cases poorly disguised cries for companionship) become something like external manifestations of her own internal, largely sublimated longing. *When the Cat's Away* is also replete with minority groups in and around its colourful periphery, which contributes to a real sense throughout the film of a thriving, multi-faceted community. In addition to Madame Renée and her friends, there is an ethnic minority in the Arab populace, one of whom, Djamel (an almost perfect male facsimile of Chloe), becomes a key character in the drama. There are also the fashion models that Chloe is responsible

for making up as part of her unrewarding job, and the gay community as represented by her housemate and friend. These various groups become redolent of personal identity in collectivism – of the potential comforts and contradictions (Djamel in particular is perpetually teased by his fellow Arabs) of feeling oneself a part of a clearly defined group.

This particular dimension is perfectly realized in the film's beautifully judged final moments, when a burgeoning new relationship between Chloe and a man who is moving away from Paris is set against an impromptu cafe sing-song (between several sets of characters) extolling the wonder of the city. As the tangible joy of this diegetic melody segues into the non-diegetic personal affirmation of Portishead's 'Glory Box' on the soundtrack, Chloe finally stakes her own claim to the cityscape and begins to run wildly through the streets, more comfortable in herself at a time when she has both found a potential romantic relationship and begun to feel secure in the group environment of the public space. Her dash through the streets bespeaks a mastery of a location to which she was once subservient, a determined movement through Paris on her own terms. It is not a feminist, nor even necessarily a feminine, statement; in fact the point seems rather to subvert any such magniloquence of intent of effect. Instead, it is a human question of individuality, of the extent to which personal happiness is predicated on external precepts. It is a question, and indeed a film, that one feels the late Rohmer would have happily received.

Adam Bingham

Irma Vep

Studio/Distributor:
Dacia Films

Director:
Olivier Assayas

Producers:
Georges Benayoun
François Guglielmi

Screenwriter:
Olivier Assayas

Cinematographer:
Eric Gautier

Art Director:
François-Renaud Labarthe

Synopsis

René Vidal, an ageing French film director, is attempting to remake Louis Feuillade's classic *Les Vampires* starring Hong Kong action star Maggie Cheung (who plays herself), as the film's heroine Irma Vep (an anagram of the word vampire). As problems with production start to appear and the director's decisions for the film become increasingly idiosyncratic, the film-within-the-film is thrown into jeopardy. Towards the end, Vidal has a nervous breakdown and has to be replaced with a new director.

Critique

Irma Vep was first shown in the 'Un Certain Regard' section of the 'Cannes Film Festival' in 1996 and became Assayas' first international success. The initial idea for the film was as a collaboration project between Assayas, Claire Denis and Atom Egoyan, who wanted to explore the idea of a foreigner in Paris. Although the collaboration never materialized, Assayas' film still retains this central premise but instead concentrates on the experiences of

Composer:

Philippe Richard

Editor:

Luc Barnier

Duration:

99 minutes

Genres:

Comedy
Drama

Cast:

Maggie Cheung
Jean-Pierre Léaud
Nathalie Richard
Antoine Basler
Lou Castel

Year:

1996

Hong Kong star Maggie Cheung as she experiences French film production for the first time. Cheung was Assayas' wife at the time, and the role was written specifically for her. At the time of *Irma Vep*'s release, comparisons were made between the film and Truffaut's *La Nuit américaine/Day for Night* (1973), also a meditation on cinema and film-making starring Jean-Pierre Léaud as a director. Though he acknowledged his admiration for Truffaut's film, Assayas credits his inspiration to Fassbinder's *Beware of the Holy Whore* (1971) which starred Lou Castel – who of course plays the director who eventually replaces Vidal when he is forced to abandon the production in *Irma Vep*. With these inter-textual references and reflexivity alone, the film already displays the hallmarks of a post-classical text that comments indelibly on the legacies of the New Wave.

Many passages of *Irma Vep* openly comment on the current state of French film production. In one of the key sequences of the film, Cheung is interviewed by a French journalist, who begins the interview by professing his love for Jackie Chan and John Woo. When asked about French cinema, Maggie recalls how in Hong Kong she can only see films with big stars, such as Alain Delon and Catherine Denueve. When asked about René's films and admitting that she likes them, the journalist throws his head back and cackles, saying she is just being polite. When she insists she is not, the journalist then goes on a tirade against the films of auteurs like René, saying:

> they are typical of French cinema, nombrilistic, only to please yourself, not the public, for the intellectuals, the elite [...] René is the past, old cinema, it's state cinema, France giving money to France to make films no-one sees. You don't think intellectual films killed the cinema industry?

The casting of New Wave icon Jean-Pierre Léaud as the film's, eccentric, mentally unstable director and the expressions of audacity at his daring to remake *Les Vampires* suggest that perhaps Vidal himself is struggling to carry the burden of French cinematic history and the golden days of the New Wave on his shoulders. Cheung, on the other hand, is presented as an international star that can fly in from Hong Kong, film in Paris and then jump on another plane to meet Ridley Scott in New York. By comparison with her jet-setting ways, French cinematic production seems disorganized and fragmented. The opening sequences show the hectic day-to-day, behind-the-scenes atmosphere in Vidal's production office, and the sequences of in-fighting among the members of the production team serve to highlight the chaos entailed in a quotidian French film production.

After René's breakdown, another director, José Murano (Lou Castel), is brought in to replace him. In a conversation with Laure, a co-star of Maggie's in the film, he outlines that he will only agree to do the film if he can change actresses. His insensitive question ('pourquoi une chinoise?'/'why a Chinese woman?') is repeated more than once. Indeed, the entire film seeks to question the 'Frenchness' of French cinema by having an international star

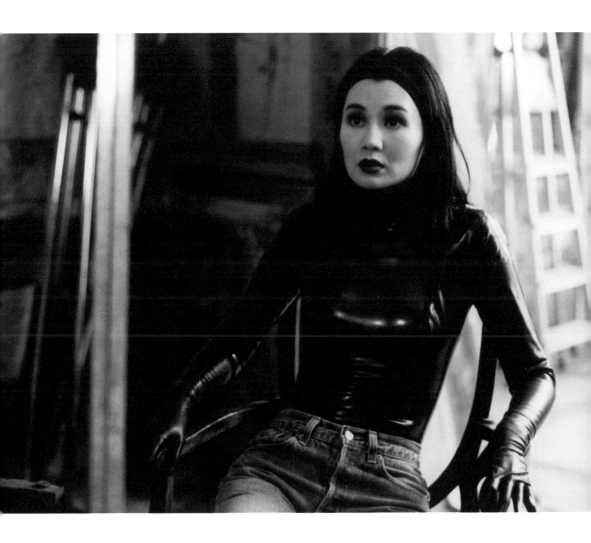

Irma Vep, Dacia Films.

play an iconic French cinematic role but also through the cameo appearance of the Canadian-Armenian star Arsineé Khanjian and by the fact that much of the spoken language of the film is English, suggesting that this is the 'language' of film-making. The film ends with Murano viewing the footage his predecessor had already shot for the failing production. The resultant images are more akin to an avant-garde video, with lines and shapes scratched onto the celluloid and a heavy, discordant soundtrack. The scratches become increasingly destructive of the film's images until we are left with a final series of shots of Maggie's face, lines shooting from her eyes like laser beams before fading to a black, empty screen. This final sequence encapsulates the essence of Assayas' *Irma Vep*, an obsessive cinephilia and a belief in the precious fragility of cinema.

Sarah Forgacs

Last Year at Marienbad

L'Année dernière à Marienbad

Studio/Distributor:
Cocinor

Director:
Alain Resnais

Producers:
Pierre Couran
Raymond Froment

Screenwriter:
Alain Robbe-Grillet

Cinematographer:
Sacha Vierney

Composer:
Francis Seyrig

Editors:
Henri Colpi
Jasmine Chasney

Duration:
95 minutes

Genres:
Drama
Mystery
Romance

Cast:
Giorgio Albertazzi
Delphine Seyrig
Sacha Pitoëff

Year:
1961

Synopsis

A guest at a baroque European mansion attempts to remind or persuade a seemingly married woman that they met the previous year, perhaps at Marienbad, and that they should leave together this time.

Critique

Last Year at Marienbad is a foundational work of modernist cinema. It is an adaptation of a *nouveau roman* (new novel) by screenwriter Alain Robbe-Grillet, a key figure of that emergent literary movement in France in the late 1950s. The *nouveau roman* aspired to break established literary conventions and thus lay bare the blueprint and process of narrative. It privileges ambiguity, abstraction, and subjectivity over characterization and realistic, logical, or linear plotting. In fact, *Last Year at Marienbad* is emblematic of the type of 'art film' that puzzles viewers and generates multiple, often diverging interpretations.

Some may find the film abstruse but, in a sense, it is simple: *Last Year at Marienbad* is a closed-situation drama involving a love triangle. It is set exclusively at a sumptuous palace and gardens used as a vacation destination by a wealthy, cultured elite. The protagonist is also the voice-over narrator. The use of voice-over narration in film, especially when spoken by someone who is also a character, began shortly after the introduction of synchronous sound and had been popularized by film noir during the 1940s and 1950s. What then makes *Last Year at Marienbad* one of the most radical films ever released to a wide audience?

Typically, films manifest congruence between what the narrator describes and the accompanying images so that the author of the film, whether an auteur or a collective, remains concealed behind the voice-over. This is one of several devices used conjointly in classical cinema to facilitate what film theorists call suture: a process that shortens the distance between film and spectator and entices the viewer to suspend disbelief and remain oblivious to the deliberate constructed-ness of fiction. Robbe-Grillet and Resnais endeavour to do just the opposite. Their major strategy is to undermine the reliability of the voice-over, often by means of images that contradict it or render it irrelevant. The protagonist may refer to a meeting in the garden, for instance, but the images show it took place indoors. There is a constant tension between telling and showing, between the mental journey of a character and the creative force behind the film as a whole, between the intradiegetic narrator and the extradiegetic one.

Moreover, the voice-over narrator is intrinsically unstable. Sometimes he forgets what he is telling or corrects himself, or he may give the impression of making things up spontaneously. He cannot pinpoint whether he met the woman who is the object of his desire at Fredericksbad, Marienbad, or another European spa city. He repeats chunks of description as if rehearsing for a role or recount-

Last Year at Marienbad, Terra, Tamara, Cormoran.

ing a recurrent dream. His omniscience is questioned, repeatedly, and yet he has the power to resuscitate the woman after her husband shoots her, stating that such an ending is 'not good'. There is a scene in which he enters the woman's bedroom and advances towards her while the camera tracks in. The expression of fear in Delphine Seyrig's face seems to cue him as to what is about to unfold. He arrests the scene and commands a cut by vehemently protesting: 'No! It was not by force.' Thus, there is a dynamic relationship between two narrative entities throughout the film.

Writing about *Marienbad* can be awkward because the characters are not named. For practical purposes, the script assigns a letter to each of the three main characters and some reviews of the film have followed suit. *Marienbad* includes one scene that reflexively justifies this practice by means of analogy. The narrator and the woman share interpretations of an old statue of a couple which flanks a terrace. They do not know who are the persons represented by the statue. She wants to name them but he argues that, as long as they remain abstractions, the statue could 'mean so many things'. And the sculpted couple 'could as well be you and me… or anyone'. By eschewing specificity and psychological explication, modernist authors like Robbe-Grillet and Resnais assume a philosophical perspective on human beings and open the text to the mental projections of the reader/spectator.

Besides sculpture, *Marienbad* also incorporates theatre in the form of a performance of 'Rosmer', apparently a version of Henrik Ibsen's *Rosmersholm* (1886). This early sequence deserves closer scrutiny than this essay allows. For now, it suffices to state that the *mise-en-scène* is designed to delay our recognition that the dialogue heard off-screen and the partial views belong to a staged play. We become privy to this at the climax of 'Rosmer'. The actress, inanimate like a statue, is awakened by ringing sounds. Then she responds to the actor's seductive persuasion with the curtain-closer 'voilà, I am yours'. An astute viewer may predict that this theatrical ending will foreshadow the ending of *Marienbad* and that it will serve to bracket it and give it a circular structure. Additional concordances between play and film emerge only after retrospective consideration by the viewer.

In the final scene, the twelve chimes of the clock signalling the midnight hour prompt the woman to stand up and walk next to the narrator into the depths of the frame and out of our gaze. At the level of action, the plot is resolved. However, an equally primordial question remains unanswered: did the narrator and the woman meet last year at Marienbad or elsewhere, and if so, did she forget or did she pretend to forget? *Last Year at Marienbad* offers only partial closure. This is a film that enlists the interpretive faculties of the viewer in a search for explanations of its enigmas and radical temporal discontinuities. Ultimately, no matter how one makes sense of it, *Last Year at Marienbad* persuades the viewer to think deeply about the mysterious relationships between life and art, between reality and representation, and between memory and imagination.

Oscar Jubis

Happiness

Le Bonheur

Studio/Distributor:
Parc Film

Director:
Agnès Varda

Producer:
Mag Bodard

Screenwriter:
Agnès Varda

Cinematographers:
Jean Rabier
Claude Beausoleil

Composer:
W. A. Mozart

Editor:
Janine Verneau

Duration:
86 minutes

Genre:
Drama

Cast:
Jean-Claude Crout
Claire Crout
Marie-François Boyer

Year:
1964

Synopsis

François Chevalier is a happily married man. A young carpenter in a modern Parisian suburb, his wife Thérèse, a dressmaker, looks after their two 'adorable' children, Gisou and Pierrot, at home. Life is idyllic for them as they make weekend trips to the country-side and spend time with their extended family in the overgrown gardens and fields surrounding their homes. Until, that is, François meets Émilie, a post office cashier in another suburb, with whom he starts an affair. Though François initially thinks he may have mul-tiplied his happiness, he faces unexpected consequences when he tells Thérèse of the affair while on a visit to the countryside.

Critique

Considered Varda's second *nouvelle vague* film, after 1961's *Cléo de 5 à 7/Cléo' From 5 to 7*, *Happiness* is part feminist tract, part homage to the Impressionist painters and part New Wave experi-ment. The film was often misconstrued by audiences and critics, who missed the ironic tone of its paradisiacal home-life and set-ting, although the title itself should have been indicative enough. Although it is ostensibly one of Varda's fiction films along with *Cléo'* and *Sans toit ni loi/Vagabond* (1985), rather than of the 'documen-tary' strand of her oeuvre (such as *Daguerréotypes* [1976], *Mur murs* [1981]), drawing such distinctions in Varda's work is always a risk.

Here, as elsewhere in Varda's films, the visual arts are fundamen-tal to the imagery. Here there are multiple homages to Impres-sionist painting. Scenes of Parisians, some with straw-boaters, at leisure around a peaceful river, with a wooden-foot-bridge, evoke Pierre-Auguste Renoir's *By the Water* or *Luncheon of the Boating Party* (1880) and Claude Monet's *Water lilies at Giverny* (1917–19). Later, Varda also pays tribute to Renoir's son, Jean, allowing his *Le Déjeuner sur l'herbe/Picnic on the Grass* (1959) to appear on a TV.

From the opening close-up of a lone sunflower, repeatedly inter-cut with a wider shot of a sunflower field in the background, into which the family appear meandering toward us in blurred compo-sition, this film is composed of nakedly ironic clichés. A halcyon, pastoral life envelops the characters to saturation. They are the countryside; the family are perpetually displayed as part of nature, in extended family's gardens, or immersed in countryside jaunts. Thérèse (Claire Crout) speaks of making a 'blanket of grass, walls of leaves', a natural barrier between them and the rest of the world, a literal cocoon.

Yet it is Varda's use of colour that truly absorbs the family into the natural space around them. In the opening scene, they are literally blended, through lack of focus, with the field they are in, where in the final autumnal scene their clothing matches the shades of the leaves and trees. Varda extends this, though, taking full advantage of the opportunities of her first colour feature film, colour-coding various characters, phases and discourses. Notably, there is a suc-cession of primary-colour fades/dissolves between scenes. One such dissolve, in red, exemplifies how she ties strands, characters

and theories together. In a countryside scene, we hear François (Jean-Claude Crout) say 'red skin, red peppers,' as Gisou, in red, holds two red peppers to her eyes like surreal spectacles, as then a rapid sequence of cuts (a red sunset; a red shop; a red truck passing across the screen, in front of François' brother's home) ends with François in a red top, and family, entering the yard of his brother's house, finally fading with a red tint. By contrast, Émilie's (Marie-François Boyer) flat is, initially, all white. The colours of her happiness are missing, although she gradually begins to be associated with lavender. At first there are mere splashes of colour at the edge of shots, but once Thérèse dies, lavender appropriates the *mise-en-scène*, and in a late establishing shot of the post office where Émilie works, which is painted lavender, the colour dominates the frame.

Employing tools widely associated with the New Wave, Varda composes an argument against delineated gender roles and patriarchal dominance. For example, when allowing the interjection of an advert for shaving soap ('A man's soap') into the narrative, Varda cuts to François shaving in the bathroom. Thérèse then enters asking whether François wants to go to see a film with Bridgette Bardot and Jeanne Moreau (Malle's Viva Maria) and asks which of these *nouvelle vague* stars he likes best, 'as a woman'. Before he answers we cut to another quick shot of Uncle Joseph opening a cabinet plastered with pictures of both.

Varda's bold use of advertising aesthetics, pop imagery, postmodernist referencing, and irreverent humour align *Happiness* with other New Wave texts. Yet the film's opposition between essayistic polemics and narrative also looks forward to Godard's films of the mid-to-late 1960's, such as *Pierrot le fou* (1965). So, to define *Happiness* as typically New Wave is to expand the, already loose, definition somewhat. This is a film rooted in the countryside, rather than the Paris of the female flâneur of *Cléo'* or Malle's *Ascenseur pour l'échafaud/Elevator to the Gallows* (1958), one in which Varda subsumes her essayistic argument in an idyllic narrative. A film epiomizing those of the transition out of the first phase of the *nouvelle vague*.

In the end, *Happiness'* stylized, non-naturalistic techniques bleed through and mock its utopian façade. The accelerated shot-reverse-shot when François visits Émilie's flat for the first time explodes, almost comically, from the text. The scene of him cradling Thérèse's drowned body on the river's embankment, which is rapidly repeated with small differences, and intercut with two ambiguous long-shots of Thérèse in the water grasping at tree-branches, reflect his tumultuous loss, but is also a counterpoint to the naturalistic scenes of the family unit preceding it. Both scenes are related to Thérèse, the affair, and its corruptive influence.

Varda is not, as many contemporaneous critics accused her, suggesting that women are interchangeable. Rather, she deliberately leaves her audience to answer questions for themselves as they watch the final shot – the new family meandering away from camera, dissolving into the autumnal scenery, the adults' clothes, golden browns and rusty oranges, melding perfectly with the sur-

rounding foliage, in contrast with the children's primary-red outfits resisting a little longer as the image blurs. The tint turns yellow, then red, and the closing shot is of a blank canvas. Our minds ultimately turn to the question of whether there is any hope for this new generation.

Kierran Horner

The Last Metro

Le Dernier métro

Studio/Distributor:
Les Films du Carrosse

Director:
François Truffaut

Producer:
François Truffaut

Screenwriters:
François Truffaut
Suzanne Schiffman
Jean-Claude Grumberg

Cinematographer:
Néstor Almendros

Composer:
Georges Delerue

Editor:
Martine Barraqué

Duration:
131 minutes

Genres:
Drama
Romance

Cast:
Gerard Depardieu
Catherine Deneuve
Jean Poiret
Andrea Ferreol

Synopsis

During World War II in Nazi-occupied Paris, rising young actor Bernard Granger joins the Théâtre Montmartre. The Jewish manager Lucas Steiner, believed to have fled the country, secretly resides in the basement while his actress wife Marion tends to his well-being and the theatre's business matters. In the meantime, the company of actors and artists prepare for a new stage production amidst numerous challenges.

Critique

A late triumph in François Truffaut's sadly shortened career, *The Last Metro* is a pleasantly unusual World War II film. Steering away from familiar conventions of the war and thriller genres, it instead displays his then-perfected talent for light-hearted humanist drama and easily belongs in the same class of films as *Jules et Jim/Jules and Jim* (1962), *L'Argent de poche/Small Change* (1976) and his Antoine Doinel series. While the war and France's occupation create an unmistakable sense of tension, they are mainly treated as grudgingly accepted conditions of reality, rudely distracting the characters from more appealing concerns of romantic longing and artistic ambition. In true Truffaut fashion, the film is shaped around the course and routines of daily life, albeit with certain intrusions such as power outages, air raids and curfews. Other elements provide moments of subtle suspense and dramatic intensity, the most significant of which being the ever-lurking threat of Lucas Steiner's discovery, heightened by Marion's attempts to transport him away from danger and his rising stress and agitation as the days go by. Fresh from a favourable stint at the Grand Guignol, Bernard throws himself into the Théâtre Montmartre's latest play, *Disappearance*, with great relish while putting himself at risk as a member of the Resistance. Besides the numerous German officers and soldiers frequently seen in the city's streets and establishments, he soon finds himself narrowly eluding the Gestapo as well. A more prominent and despicable enemy in the film can be found in Daxiat (Jean-Louis Richard), the anti-Semitic, collaborating theatre critic for the newspaper *Je suis partout* who attacks the theatre with his venomous reviews. He is perhaps the most overtly villainous character to appear in a Truffaut film, though even he is invested with a certain

Paulette Dubost
Jean-Louis Richard
Maurice Risch
Sabine Haudepin
Heinz Bennent

Year:
1980

degree of complexity that prevents him from becoming a mere caricature of evil.

A similar care can be seen in all of the key players in *The Last Metro*, a fascinating group of people portrayed by an impressive ensemble cast. Catherine Deneuve anchors the film with her unmatched composure and alluring grace. She plays Marion as a fiercely independent and capable woman, whether attempting to obtain a censor's permit, learning her part in the play or managing an active love life. Gérard Depardieu is thoroughly likeable as Bernard, who gradually falls in love with Marion, and Heinz Bennent steals scene after scene as Lucas Steiner with humour, wit and weariness. A collection of unique personalities make up the theatre's family: the reliable director Jean-Loup Cottins (Jean Poiret); the designer Arlette (Andréa Ferréol) who repeatedly rejects Bernard's advances; the comical stage manager Raymond (Maurice Risch); his black market contact Martine (Martine Simonet) who frequently visits the theatre with her merchandise; a young actress (Sabine Haudepin, who previously appeared in *Jules and Jim*) determined to make an illustrious career for herself. They live and work together in an Occupation-era Paris comprised of street corners and closed spaces, with the theatre at its centre. As most of the action unfolds in or around it, the film often feels like a play itself, driven along smoothly by dialogue and character without requiring the grandeur usually lavished upon World War II films. Even though Quentin Tarantino has stated that he is not a great admirer of Truffaut's film, one can detect many similarities between it and his own modestly scaled war epic *Inglourious Basterds* (2009).

Truffaut is clearly most interested in people in *The Last Metro* – more specifically, how they can adapt to oppression and how art can deliver them from it, if only for a short while at a time. As in *La Nuit américaine/Day for Night* (1973), he creates a warm, seemingly safe community brought together by a simple love for the creative process. One of the film's most touching details is a young Jewish girl (Jessica Zucman) who harbours dreams of becoming a costume designer and fearlessly hides the yellow star on her jacket to attend the play. With the threat of war around them, Parisians still regularly go to theatres and cinemas to alleviate their worries. Among the most committed of the actors and technicians working on *Disappearance* is Lucas, who avidly listens to rehearsals through a vent and makes notes and suggestions on how the production can be improved. For these figures, as for Truffaut and his collaborators, art is more than entertainment; it is an absolute necessity.

The Last Metro won an amazing ten César Awards and was nominated for a Best Foreign Language Film Oscar. With its smooth technical polish and intertwining stories of love discovered, concealed and unfulfilled during difficult times, it is one of the finest and most enjoyable gifts Truffaut bestowed to the world.

Marc Saint-Cyr

The 400 Blows

Les Quatre cents coups

Studio/Distributor:
Les Films du Carrosse

Director:
François Truffaut

Producer:
François Truffaut

Screenwriters:
François Truffaut
Marcel Moussy

Cinematographer:
Henri Decaë

Production Designer:
Georges Charlot

Composer:
Jean Constantin

Editor:
Marie-Josèphe Yoyotte

Duration:
99 minutes

Genres:
Crime
Drama

Cast:
Jean-Pierre Léaud
Claire Maurier
Albert Rémy
Guy Decomble
Patrick Auffay

Year:
1959

Synopsis

Antoine Doinel is a young Parisian boy who, neglected by his self-absorbed mother and ineffectual stepfather, plays truant from school with his friend Réne, steals, tells lies, and repeatedly gets into trouble with his school-master, who repeatedly singled him out for punishment. He runs away from home and becomes involved in acts of petty crime before being sent away to a correction centre for juvenile delinquents. During a game of football, Antoine seeks the chance to escape from the centre and he runs away, not stopping until he finally reaches the sea.

Critque

Truffaut's *The 400 Blows* is one of the defining films of the French New Wave and its final frozen image of the young Antoine Doinel staring back into the camera, is one of the most seminal frames in cinema history. Its title meaning 'to repeatedly get into trouble', *The 400 Blows* focuses on a young boy who is both rejected and repressed by society (in this case the education system) and his family. Ultimately, Antoine is a boy who harbours a desire to be loved and to belong. The story of the film is so heavily informed by biographical details from Truffaut's own childhood (he was an illegitimate child who would play truant from school and seek refuge in the cinema) that it becomes difficult to separate the fictional Antoine Doinel from Truffaut himself. The physical resemblance between Truffaut and the actor Jean-Pierre Léaud adds to the difficulty in distinguishing between the two. Truffaut himself also briefly appears in the film during the scene in which Antoine rides a rotor. The film was dedicated to André Bazin, who died just as shooting on the film was about to begin. One of the most important figures in French film criticism and French cinematic history, Bazin was co-founder of *Cahiers du Cinéma*, as well as Truffaut's mentor, guardian and de facto father.

The film is an ode to the city of Paris as much as it is an expression of Truffaut's love of the cinema. The opening sequence is a series of tracking shots of the city (in a display of the light, mobile cameras and location shooting which would come to characterize the formal aesthetics of New Wave film-makers), capturing its streets and buildings, before closing in on the Eiffel Tower, Paris' most iconic building. When Antoine runs away from home, he spends the evening walking through the streets of Paris and steals a bottle of milk, which he gulps down rapidly. Paris is able to provide nourishment for him in the way that his mother is supposed to but does not. The only time Antoine shows any happiness is during a rare family outing in which they go to the cinema to see *Paris nous appartient/Paris Belongs to Us* (1961), a film made by Jacques Rivette, another director associated with the New Wave, along with Truffaut, Jean-Luc Godard and Claude Chabrol. When Antoine and Réne (Patrick Auffay) play truant from school, they go to the cinema to see Ingmar Bergman's *Sommaren med Monika/Monika* (1953)

and steal a poster of Harriet Andersson on their way out.

Antoine's social world is entirely male and the male figures he encounters are draconian (in the case of his teachers) or cuckolded (in the case of his stepfather). The theme of absent fathers (perhaps a reference to Truffaut's own feelings of paternal absence) runs throughout the film. During an English pronunciation lesson, Antoine's friend Réne is forced to repeat the line: 'where is the father?' By contrast women are present as sexualized objects: Antoine is punished at the start of the film for having a photo of a pin-up; his stepfather asks him to contemplate his mother's legs as they climb the stairs to return home; the women he meets at the police station are prostitutes. Antoine's mother rejects him, barking orders at him 'va, chercher mes murs!' (go, fetch my slippers!) and spends the money her husband gives her for new sheets on herself. The only time she shows any warmth towards Antoine is after he catches her embracing another man and thus this warmth is merely an attempt to buy his silence.

After stealing a typewriter and being caught trying to return it, Antoine is sent to a correction centre, where he is interviewed by a female psychologist. She remains off-screen throughout the sequence while Antoine directly addresses the camera. Formally, the scene has no cuts and is a series of dissolves between questions and appears more like an interrogation. She questions Antoine about his childhood and his behaviour and for the first time in the film Antoine, given the opportunity of self-expression, can understand his actions as those of a child seeking acceptance and affection.

The film ends with Antoine seeking the opportunity to escape during a football game, where he slips through a hole in the wire netting. He runs without stopping through the woods and the music from the opening sequence of the film returns. As he finally reaches the sea (the homonym *mer/sea* and *mère/mother* assuming significance) he turns and stares directly into the camera. Although his future remains unclear, for this fleeting moment Antoine escapes the traps of a patriarchal, pedagogical society – and, perhaps, at long last, finds freedom.

Sarah Forgacs

On connaît la chanson, Arena Film, Camera One.

Same Old Song

On connaît la chanson

Studio/Distributor:
Arena Films

Director:
Alain Resnais

Synopsis

Following a chance meeting in Paris, the lives of old acquaintances Camille and Nicholas become entwined. Nicholas once knew Camille's sister Odile, and the pair become re-acquainted, each undergoing a crisis in their marriage. Odile is struggling with her husband over their search for a new apartment, and her estate agent, Marc begins a relationship with Camille, who in turn strikes up a friendship with another estate agent, Simon. Simon falls in love with Camille from afar, while at the same time acting as an estate agent himself, showing Nicholas a series of apartments for him to live in when his wife joins him in Paris. Both Nicholas and Camille begin to suffer from extreme fluctuations in their health, while Odile's marriage hangs in the balance.

Producers:

Bruno Pésery
Michel Seydoux
Ruth Waldburger

Screenwriters:

Agnès Jaoui
Jean-Pierre Bacri

Cinematographer:

Renato Berta

Composer:

Bruno Fontaine

Editor:

Hervé de Luze

Duration:

120 minutes

Genres:

Comedy
Drama
Musical

Cast:

Agnès Jaoui
Jean-Pierre Bacri
Lambert Wilson
André Dussolier
Sabine Azéma
Pierre Arditi
Jane Birkin
Jean-Paul Roussillon

Year:

1997

Critique

Following his productive dalliance with Alan Ayckbourn in the *Smoking/No Smoking* diptych in 1993, Alain Resnais once again looked to Britain when making his musical pastiche *Same Old Song*. This time around, the French luminary took only inspiration from, rather than adapting a work by, his acknowledged source, Dennis Potter (who died in 1994). The film plays out so thoroughly, so organically, in the vein of the English dramatist that it could well have originated from an obscure Potter film, albeit with a concomitant shift away from ebullient, exuberant youth and on to disillusioned and frustrated adulthood.

Same Old Song has an underlying current of heightened psychological malady mixed with characters that break sporadically and spontaneously into famous French ballads and pop songs. The most obvious point of reference here is thus Potter's 1978 television series *Pennies from Heaven*. As in this seminal production, Resnais' 'musical' numbers frequently serve to express thoughts, views and attitudes that the characters struggle to put into words, and further highlight the extent to which popular cultural paradigms can shape emotions and literally enunciate the feelings that are cathartically invested in them. Central to Potter's work is a pronounced dichotomy between fantasy and reality. And while there is little in the way of the overtly fantastical in *Same Old Song* (beyond a smattering of brief daydreams, which are not signalled in the *mise-en-scène*), the film nonetheless feigns toward this opposition through a succinct use of exterior and interior space. Camille (Agnès Jaoui) and Simon (André Dussolier), the two central characters, have the contrasting jobs of tour guide and real estate agent; one traverses the public spaces of the city and elucidates their history, while the other is a connoisseur of indoor, private spaces. The crucial obstacle is Simon's reticence with Camille, his awkward interiority makes him fear telling her how he feels. This divide is shattered in the final reel, in which public and private realms collide at a housewarming party in an apartment prized above all else for its panoramic view of the city.

Resnais largely eschews here the stylized, theatrical register so prevalent in many of his works. Indeed, one of the film's chief pleasures comes from watching this director, always the least Paris-centric of the New Wave, discover the city. Though he refuses the opportunity inherent in Camille's job to indulge in a picture postcard tour of the French capital, Resnais does delight in treating the urban cityscape as a vibrant and tangible, if somewhat contradictory, milieu. The juxtaposition of Odile's (Sabine Azéma's) business headquarters with a graveyard right outside the front door exemplifies this tendency: a literal arena of death contrasts the figurative professional passing that goes on behind closed doors (Odile hires and fires two men over the course of the film).

It is no real surprise that Resnais should turn to this brand of heightened genre cinema when he did, as he had been dipping his toe in the florid waters of melodrama for over a decade prior to *Same Old Song*, and indeed had already produced a very

Potter-like psychological excavation in his film *Providence* (1976). However, the chief problem with the film is that it fails to achieve a completely harmonious synthesis between director and source. Despite the subject matter, the film is an essentially upbeat, airy confection, and agreeable as such, especially as its humorous and self-deprecatory treatment of key Resnais themes undercuts the lingering portentousness that has slightly marred works like *Mélo* (1986). Most overtly, the typical Resnais themes of memory and the past are almost parodied from the beginning. The film opens with a scene featuring a Nazi general struggling over Hitler's orders to destroy Paris, while elsewhere Camille's obtusely historical doctoral thesis on 'Yeoman in the Year 1000 at Paladru Lake' is repeatedly met with confused bafflement, as other characters mock its author's immersion in the past at the critical expense of the present. The problem, though, is that the film's spontaneous bursts into song carry less weight when not juxtaposed with any tangible sense of pain or recognizable human failing and frustration. Resnais is not, of course, beholden to every element of *Pennies from Heaven*, but in denying the catharsis inherent to the source material, the result feels like it floats on air with scarce any weight to anchor its dramatic conceit.

Nonetheless, *Same Old Song* offers a rewarding chance to see Resnais plunge into the heady waters of genre cinema. The musical has, in fact, returned to the fore in French cinema in recent years. Following its Jacques Demy-led status in the 1960s, it resurfaced only sporadically throughout the following two decades. But alongside the work of Resnais – whose recent work also includes the drawing room musical of manners *Pas sur la bouche/Not on the Lips* (2003) – there has been an upsurge in the genre from the mid-1990s onward, including fellow New Waver Jacques Rivette's *Haut bas fragile/Up, Down, Fragile* (1995), Christophe Honoré's Demy homage *Les Chanson d'amours/Love Songs* (2007) and Francois Ozon's *Gouttes d'eau sur pierres brûlante/Water Drops on Burning Rocks* (2000) and *8 femmes/8 Women* (2003), as well as quasi-musicals like Olivier Dahan's *La Môme/La Vie en rose* (2007) and Xavier Giannoli's *Quand j'étais chanteur* (2006). In this context, *Same Old Song* certainly stakes its own idiosyncratic territory and, if for no other reason, this makes Resnais' film a more than worthwhile experience.

Adam Bingham

A Woman is a Woman

Une femme est une femme

Studio/Distributor:
Euro International Film (EIA)

Director:
Jean-Luc Godard

Producers:
Georges de Beauregard
Carlo Ponti

Screenwriter:
Jean-Luc Godard (based on an idea by Geneviève Cluny)

Cinematographer:
Raoul Coutard

Production Designer:
Bernard Evein

Composer:
Michel Legrand

Editors:
Agnès Guillemot
Lila Herman

Duration:
84 minutes

Genres:
Comedy
Drama
Musical

Cast:
Anna Karina
Jean-Claude Brialy
Jean-Paul Belmondo
Marie Dubois
Nicole Paquin
Marion Sarrault
Ernest Menzer
Jeanne Moreau

Year:
1961

Synopsis

Angéla, a young Parisienne who strips at a seedy club in the working-class district of Strasbourg-Saint Denis, is obsessed with the idea of having a baby. She surprises her live-in boyfriend Émile with a request to impregnate her within the next 24 hours, when conception for her is most probable. Émile balks at the idea, and tells Angéla that he prefers to wait a while; besides, he has a bicycle race in a couple of days, and he wants to be well-rested. Furious, Angéla threatens to ask their mutual friend Alfred to give her a child. Angéla and Émile continue their disagreement the following morning; consequently, Angéla is amenable to Alfred's request to meet for drinks that afternoon. At the cafe, Alfred plies Angéla with Dubonnet and shows her a photo of Émile with a prostitute, while a wistful Charles Aznavour record spins on the jukebox. Alfred's attempts at seduction succeed, and he and Angéla return to his apartment and make love. That night Angéla remorsefully tells Émile of her transgression, and the saddened pair prepares to retire for the night when they simultaneously hatch a 'solution' to their dilemma: if they have sex, there is at least a *chance* that Émile will be the father should Angéla become pregnant.

Critique

The opening credit of *A Woman is a Woman*, Jean-Luc Godard's third feature and his first in colour and widescreen, informs the viewer of its Jury Prize at the 1961 'Berlin Film Festival' for shaking up 'the norms of classical film comedy'. In its very first image, in other words, Godard's film signals its complex relationship to genre convention. Certainly, *A Woman* is a revisionist commentary on its genre, much like Godard's later efforts in the arenas of science fiction (*Alphaville* [1965]), film noir (*Bande à part/Band of Outsiders* [1964]), and the war movie *(Les Carabiniers/The Carabineers* [1963]). Yet one should not minimize the degree to which *A Woman* is *also* a 'straight' comedy, more so than any other film in Godard's 50-year-plus career: its plotline is reminiscent of both the French comedy of manners (the heroine even quotes directly from Musset's *On ne badine pas avec l'amour/No Trifling With Love* [1834]) and the early sound-era farces of René Clair and Ernst Lubitsch (especially Clair's *Quatorze Juillet/July 14* [1933] and Lubitsch's *Design for Living* [1933]), and it brims with in-jokes and sight gags. Where homage and critique intersect, perhaps, in *A Woman*, is in its awareness of the distance between the utopian vision of the standard romantic comedy and the bleakness of the contemporary reality inhabited by Godard's protagonists, as embodied by three of the French New Wave's leading lights: Brialy, Karina and Belmondo.

Originally conceived by Geneviève Cluny, *A Woman's* absurd premise – as summarized by the director, 'a woman wants to have a baby, just like that, all at once, the way you feel like having a piece of candy' – would have seemed familiar to French cineas-

Une femme est une femme, Rome-Paris-Films.

tes in 1961, as it had just served as point of departure for the Philippe de Broca comedy *Les Jeux de l'amour/The Lovers* (1960), starring Cluny herself. Godard's own elaboration of Cluny's idea further trades in 'familiarity' through the use of tried-and-true gag structures but also in a characteristically Godardian way: through frequent quotations of other films (such as those of his friends François Truffaut, Agnès Varda and Jacques Demy). These two strategies come together in *A Woman*'s citations of the work of Frank Tashlin, the auteur behind several of Godard's favorite 1950s Hollywood comedies. Tashlin's influence is especially felt in the many outlandish, cartoony sight gags Godard uses to flesh out his scenario. (The scenario Godard worked from, initially published back in the August 1959 *Cahiers du Cinéma*, calls repeatedly for 'various gags' and 'more gags' without specification; many of those appearing in the finished film were improvised during production.) Many of the gags that permeate *A Woman* may lack an obvious referent in Tashlin's work, but they are nonetheless, to use the phrase Godard coined in his *Cahiers* review of *Hollywood or Bust* (1956), 'Tashlinesque'. In one celebrated sequence, Angéla (Anna Karina) hoists a frying egg from her pan, leaves the apartment to take Alfred's (Jean-Paul Belmondo) call on her neighbour's telephone, and returns to her kitchen just in time to catch the egg on its downward trajectory. Though not as obviously zany as, say, Tashlin's satirical opus *Will Success Spoil Rock Hunter?* (1957), *A Woman is a Woman* was nevertheless recognizable upon its release as a comedy. Most mainstream French critics, however, did not laugh. As Geneviève Sellier has documented, many reviewers complained of the antiquated nature of Godard's jokes and comic situations, frequently employing disparaging comparisons to hoary vaudeville routines and to 'schoolboy'-level humour to drive home the point that *A Woman* elicited very little laughter from viewers.

From a more contemporary vantage point, however, this works to the advantage of the film, which can be equally appreciated as a kind of experimental essay on the very *idea* of movie comedy, and thus as an acknowledgment of its own *failure* to attain 'classical' status. In promotional interviews, Godard claimed to have made 'a film on the nostalgia for musical comedy'. The film itself shows its hand during the scene in which Angéla expresses her longing to be in a picture 'with Cyd Charisse and Gene Kelly, choreography by Bob Fosse!' and (with Alfred) strikes a series of poses suggestive of dancers' movements. Sadly, Angéla and Alfred lack the effortless grace of the MGM stars, not to mention the more 'naturalistic' dynamism of the players in the Fosse-choreographed *The Pajama Game* (1957), and the grey, grim environments in which they perform further punctures Angéla's reverie. That Angéla is *not* Cyd Charisse is additionally elucidated by Godard's exploitation of his spouse's awkwardness as an actress. The untrained quality of Anna Karina's voice, already 'marred' by a Danish accent, is further exposed when Michel Legrand's music cuts out at the precise moment when Angéla begins to sing her special number at the Zodiac Club. Though such moments lend Karina's performance a good deal of charm, they also suggest the ways in which

the characters 'fail' the genre conventions – just as the conventions sometimes 'fail' the characters. This hyper-awareness of its own limitations, informed by a deep, almost bitter nostalgia for the triumphant heyday of the studio genre film, makes *A Woman is a Woman* a crucial early entry in Godard's ongoing project of film-making as a means of critically engaging with film history. And so, when Godard later speaks of *A Woman* as both a 'fascinating mistake' and his 'first real film', he is correct on both counts.

Christopher Sieving

POLICIER

This framing essay on French crime cinema seeks not to focus solely on those films that have stood the test of time, but also to draw attention to lesser-known works whose existence results from, but also contributes to, the ambivalent reception of the genre. For if a few crime films are now considered masterpieces and some crime directors auteurs, it is *in spite of* their participation in the low brow crime genre, which so-called intellectual elites find undeserving of critical attention.[1] Crime cinema in France, like comedies, bears the stigma of its popularity, as it addresses, uses the language of, and receives the bulk of its financial rewards from, mass audiences, as opposed to art or auteur film-making. Organized chronologically, this essay engages with crime cinema as the site of negotiation (perhaps even struggle) between its low-brow roots and the high-brow aspirations of some of its participants and aficionados. The corpus of films explored here spans a full century and reflects how the genre evolved and responded to the historical and economic contingencies that affected its conditions of production, thus securing its exceptional longevity.

Noting that crime literature emerged almost concurrently to the industrial revolution, many scholars have argued that crime narratives function as a catalyst through which the collective, unconscious anxieties caused by modernity are processed (Dubois 2006: 22–30). Forced to live in close proximity to the poor, the upper classes feared for their safety; crime narratives at once reflected, justified, perpetuated, and helped briefly forget those fears. Years after the industrial revolution, crime cinema still manifested this discursive exchange, whereby the anxieties and values of affluent classes to which its makers belonged still pervaded narratives that addressed the lower classes (only later was it considered a socially acceptable form of entertainment) (Oms 1978: 67). If a large number of crime films today are inspired by sensational crime news (known in French as *faits divers*) relayed by the media (e.g. Cédric Kahn's *Roberto Succo* in 2001 or André Téchiné's *La Fille du RER/ The Girl on the Train* in 2009) or by popular literary sources (e.g. Claude Chabrol's adaptation of Jean-Patrick Manchette's *Nada/The Nada Gang* in 1974, Mathieu Kassovitz's take on Jean-Christophe Grangé's *Les Rivières pourpres/The Crimson Rivers* in 2000, or André Téchiné's adaptation of Philippe Djian's *Impardonnables* in 2011), Richard Abel reminds us that from the late 1900s crime cinema was already capitalizing on the massive popular appeal of those sources (Abel 1996: 3–9). As early as 1912, the highly publicized feats of 'motorized gangs that roamed the countryside' were filmed as *Bandits en automobile* (Abel 1996: 5–6). Similarly, studios acquired the rights to successful crime serials published in the penny press and adapted them for the screen. Thus, early crime films replicated the serial format and relied on the public's knowledge of the main characters. The most famous of those was probably Marcel Allain and Pierre Souvestres' eponymous *Fantômas*, which Louis Feuillade brought to the screen five times between 1913 and 1914.

Crime cinema's reliance on crime literature did not recede with the advent of sound; far from it. Thus the silent film adaptations of

such works as Emile Gaboriau's *Monsieur Lecoq* (1869) or Gaston Leroux's *Le Mystère de la chambre jaune* (1908) (both directed by Maurice Tourneur in 1914) gave way to more adaptations of the same works and authors during the sound era (e.g. Marcel L'Herbier's adaptations of *Le Mystère de la chambre jaune/The Mystery of the Yellow Room* and *Le Parfum de la dame en noir* in 1930 and 1931, respectively). In that context, Georges Simenon's novels offered a new tone that appealed to the industry and the public, especially the works featuring his star character, Commissaire Jules Maigret.[2] While early crime films relied greatly on the thrills elicited by exceptional heroes (Nick Carter, Judex) and arch-villains (Fantômas, Barrabas), adaptations of Simenon anchored crime cinema in a quotidian realism epitomized by their protagonist. Contrary to wealthy, ratiocinating sleuths removed from worldly matters like the Chevalier Dupin or Sherlock Holmes, what defines Maigret is precisely his normalcy. A civil servant and dedicated worker from modest social origins, he resembles (and thus understands) victims and criminals alike.[3] With him, crime cinema no longer thrives mainly on exhilarating chases but revolves instead around the reassuring, immobile physical presence of a patriarchal figure (Oms 1978: 67). Simenon's novels were thus adapted by some of the most prolific participants in the crime genre: Jean Renoir (*La Nuit du Carrefour/Night at the Crossroads* [1932]), Julien Duvivier (*La Tête d'un homme* [1933]), Jean Delannoy (*Maigret et l'affaire Saint-Fiacre/Maigret and the St. Fiacre Case* [1959]; *Maigret tend un piège/Inspector Maigret* [1957]), or Gilles Grangier (*Maigret voit rouge* [1963]) among others.[4]

However, Maigret's screen presence should not obfuscate the pessimism of the second half of the 1930s. As another conflict with Germany seemed inevitable, French films grew darker, especially those famously labelled poetic realist. With its highly contrasted aesthetics inspired from German expressionism, 'poetic realism' could be conceived of as a sub-genre of crime cinema. Indeed, crime plays a seminal role in the plots of its most famous exemplars: the fatal 'vacherie' (bad luck, fate) Jean refers to in *Quai des brumes/Port of Shadows* (Marcel Carné, 1938) condemns not only him but all the other working-class characters played by Jean Gabin to commit criminal acts and die. Poetic realism constructs Pépé (*Pépé le moko* [1936]), François (*Le Jour se lève/Daybreak* [1939]), and Lantier (*La Bête humaine* [1938]) not as criminals but rather as the victims of an unfair society.

The Occupation of France by the Germans muted the vocal social critique permeating crime films of the pre-war period. Under Maréchal Pétain's collaborationist Vichy government, film production was under tight surveillance, so that censors barred subversive screenplays from being shot and imposed cuts whenever a film seemed to stray from the Vichy ideology (Williams 1992: 260). Crime films, many of which offered tightly woven mysteries, functioned as an effective mode of escapism. Even Maigret adaptations such as *Picpus* (1943) or *Cécile est morte/Cecile is Dead* (1944) traded the novels' realism and grave atmosphere for a lighter, comedic tone, epitomized by the choice of Albert Préjean

to embody the famous detective (Vincendeau 2009: 93). Because Henri-Georges Clouzot worked for the German studio Continental, his films dodged the rigorous scrutiny censors reserved for French productions (Williams 1992: 260). Thus, his two wartime whodunits, *L'Assassin habite au 21/The Murderer Lives at Number 21* (1942) and *Le Corbeau/The Raven* (1943) diffuse discreet, albeit transparent, references to the Occupation, the Vichy regime, and the state of suspicion among the French. In a chilling scene of *The Murderer Lives at Number 21*, the shadow of a man stripped from his clothes appears projected on a wall – an unmistakable reference to the humiliations inflicted upon those arrested by the Nazis and the collaborationist administration. *Le Corbeau* appears more pervasively political in its scathing representation of petty French mentalities in a nameless, allegorical village where a climate of paranoia progressively takes over when a series of anonymous poison-pen letters circulate, accusing prominent local figures of various crimes and vices. The anonymous letters conjure up the widespread practice of informing between neighbours that contributed to the deportation of Jews.

Rare were those, like Clouzot, who looked into France's dark past during the post-war era; and the industry generally paralleled the Gaullist efforts not to dwell on the country's collaborationist past in order to restore its national pride. The period therefore saw the immense popularity of parodic spy comedies, such as the Lemmy Caution franchise in which Eddie Constantine plays an American FBI agent well-versed in French slang (*Cet homme est dangereux/ The Man is Dangerous* [Jean Sacha, 1953]; Bernard Borderie's *La Môme vert-de-gris/Poison Ivy* [1953]; *Les Femmes s'en balancent/ Dames Get Along* [1954]; *Comment qu'elle est?/Women Are Like That* [1960]; *Lemmy pour les dames/Ladies' Man* [1962]; and *A toi de faire… mignonne/Your Turn, Darling* [1964]). André Hunebelle also contributed to this hugely popular, light-hearted sub-genre rife with action-packed and erotically-charged films like *Mission à Tanger/Mission in Tanger* (1949), *Méfiez-vous des blondes* (1950) or *Massacre en dentelle/Massacre in Lace* (1952) (Laurent 2009: 119–29).

Still, some French crime films adopted American film noir's chiaroscuro aesthetics and pessimism to suggest the darker aspects of a rapidly modernizing society. Jacques Becker's *Touchez pas au grisbi* (1954) and Jean-Pierre Melville's *Bob le flambeur* (1956) in particular adopt a rather critical stance on modernity. Foregrounding ageing heroes, played by Jean Gabin and Roger Duchesne, respectively, they present greed, senseless violence, and the loss of moral values as the corollaries to the post-war era. Under the influence of José Giovanni, a former convict turned novelist and screenwriter, Becker and Melville went on to mythologize this struggle between 'old school' heroes abiding by a strict code of honour, and morally corrupt men oblivious to any moral values. It is not the Law which serves as the point of reference to differentiate between Right and Wrong (or Good and Evil) but a transcendent, quasi-Platonic homosocial ideal which must remain unspoiled. In *Le Trou/The Hole* (Becker, 1960), Becker's adaptation of Giovanni's

first novel, the guiltiest of the group of convicts trying to break out of the prison is not the one who committed the worst crime but the one who prefers to betray his cellmates to negotiate a parole with the prison director. Likewise, in *Le Deuxième Souffle/Second Wind* (Melville, 1966; also adapted from a Giovanni novel), Melville portrays Gu Minda as a man whose moral rectitude makes him a more respectable character than Commissaire Blot, for whom the end (arresting Minda) justifies all means (like spreading the false rumour that Minda has snitched on his accomplices). Put simply, Becker and Melville thematize their concern with modernity by re-investing the moral dialectic of 1930s crime cinema eschewed in spy comedies and regularly re-explored ever since.

Yet Becker and Melville's relation to modernity exceeds a mere nostalgic discourse on moral values (Melville's deployment of a fetishistic Hollywood gangster film and film noir aesthetic suggests a fascination with American modernity rather than a rejection of it).[5] If they were so revered by the critics who would later become the spearheads of the New Wave, it is not because they rejected modernity but rather because their films displayed an ambitious and enlightened formal approach to the medium. On top of sharing Melville's cinephilia (they would later adopt the same fetishistic deployment of Hollywood gangster films and film noir iconography) Chabrol, Truffaut, and Godard saw in Melville and Becker masters of *mise-en-scène* whose crime films challenged the generic trends of the time, notably their use of long takes and sequences that dilate time. The New Wave directors' own policiers proved even more self-conscious, though, playfully calling attention to the artificiality of generic conventions. Their murderers and detectives drive the same, huge, American cars and wear similar fedoras and trench coats; their plots feature the same devious villains and untrustworthy girlfriends; but films like Godard's *A bout de souffle/Breathless* (1960) and *Pierrot le fou* (1964), or Truffaut's *Tirez sur le pianiste/Shoot the Piano Player* (1960) establish an ironic distance from, and reject the narrative patterns typical of crime films. By foregoing the techniques that once allowed spectators to suspend their disbelief, they deny viewers the pleasure of experiencing the thrills of suspense and violence. Instead, New Wave directors' iconoclastic approach to crime cinema exaggerated, and thus highlighted, its repetitive nature.

While his fellow New Wave directors' eclecticism led them to explore many other genres, Claude Chabrol pursued a 50-year career predominantly focused on crime narratives, most exposing the moral turpitude the French bourgeoisie conceals underneath its glossy surface. Moral ambiguity, sexual frustration, and transference of guilt pervade *A double tour/Leda* (1959), *La Femme infidèle/The Unfaithful Wife* (1969), *Que la bête meure/This Man Must Die* (1969), *Le Boucher/The Butcher* (1970), *La Cérémonie/* (1995) and *Merci pour le chocolat* (2000). Chabrol's avowed admiration for Hitchcock and Fritz Lang manifests through the precision of his *mise-en-scène* and an effort to express emotions visually rather than through dialogue. His distanced gaze at, and constant questioning (and undermining) of, bourgeois values also reveal him

as an heir to Clouzot, whose aborted project, *L'Enfer*, Chabrol took over in 1994.

Clouzot and Chabrol's isolated representations of a complicit, morally corrupt ruling class anticipate a more systematic and overtly polemical trend in the 1970s. During this decade, the so-called 'fictions de gauche' (also known as 'political thrillers') adopted the policier as a vehicle for a left-wing denunciation of corruption and injustice at all levels of French local, regional, and national Gaullist state apparatus. Yves Boisset stands out as the most prolific, openly political director of this post-1968 trend. Sometimes based on current events and always critical of the authorities, his films exude suspicion and paranoia, which often attracted close scrutiny on the part of the authorities, difficulties in securing funding, and sometimes censorship, as was the case with *Un Condé/The Cop* in 1970. Boisset's depiction of a violent cop foregoing all legal means to avenge his colleague gives way to the vehement condemnation of the French government's complicit involvement in the assassination of a Moroccan dissident in *L'Attentat/The Assassination* (1972).[6] Similarly, *Le Juge Fayard, dit le Shériff/Judge Fayard Called the Sheriff* (1976) and *La Femme flic/The Woman Cop* (1979) explicitly denounce the justice system's systematic protection of the bourgeoisie at the expense of immigrants and other underprivileged populations. Starring the militant leftist Yves Montand, the films of Costa-Gavras attest to similar political inclinations, even though his most famous films engage with international events. *Z* (1969), for instance, recounts the assassination of a leftist political figure orchestrated by the military government of a Mediterranean dictatorship (transparently, though not explicitly, Greece) while *L'Aveu* (1970) adapts former Czech minister Arthur London's autobiographical narrative of his wrongful confession of treason after weeks of torture. Contrary to Boisset's engagement with contemporaneous events, Costa-Gavras' involvement with French politics limited itself to the re-exploration of Vichy government's proactive collaboration with the Nazis in *Section spéciale* (1975), following Marcel Ophüls' controversial documentary, *Le Chagrin et la pitié/The Sorrow and the Pity* (1969).[7]

In the early 1980s, television networks' new financial involvement in film production marked the beginning of a new era in French cinema. Though the arrival of those powerful new investors put larger budgets at directors' disposal, the types of narratives in which Canal + and TF1 (and to a lesser extent, Ciné-Cinéma and state-owned networks) were willing to invest were mostly conceived as vehicles for extremely popular movie stars recognizable to moviegoers and television audiences alike. Although it would be hasty to claim a direct cause and effect, 1980s crime cinema largely abandoned the realm of subversive socio-political critique and (re)-entered the realm of the spectacular. Jean-Paul Belmondo and Alain Delon, who had heretofore played criminals for respected auteurs (memorably Jean-Pierre Melville) and shared the screen with other stars, consolidated their stardom by appearing in movies that capitalized on their personae to reach large audiences (Dehée 1997: 77–83). Georges Lautner's *Flic ou voyou/Cop or Hood* (1979)

and *Le Professionnel/The Professional* (1981), and Jacques Deray's *Le Marginal* (1983) depict Belmondo as a maverick cop struggling against a corrupt institution, while Alain Delon faces similar issues with *Pour la peau d'un flic* (1981) and *Le Battant/The Fighter* (1983), and José Pinheiro with *Parole de flic* (1985) and *Ne réveillez pas un flic qui dort/Let Sleeping Cops Lie* (1988). Reminiscent of the *Dirty Harry* franchise, those films tap into, and reflect, the prevailing individualism of the 1980s by constructing their protagonists as heroes able to withstand thrilling car chases, fistfights against street gangs, explosions – and fast-paced editing.

The rising costs of films induced by this French equivalent of Hollywood's blockbuster policy encouraged massive promotional campaigns and wider releases. It in turn made it more difficult for crime films that did not fit this model to raise funding and to find an audience (an even more dramatic trend with the advent of multiplexes in the 1990s and 2000s). The waning production of crime fictions and their declining box-office results, far from reflecting French moviegoers' disinterest in the genre, coincides with (and can perhaps be explained at least in part by) the birth and ever-growing number of competing made-for-TV films and series. The success of *Commissaire Moulin* (Paul Andréota and Claude Boissol, 1976–82 and 1989–2008), *Navarro* (Pierre Grimblat and Tito Topin, 1989–2007) or *Julie Lescaut* (Alexis Lecaye, 1992–present) on TF1 and *Maigret* (1991–2005), *Nestor Burma* (1991–2003), and *PJ* (Michelle Podroznik and Frédéric Krivine, 1997–2009) on France Télévision gave birth to a constellation of similar shows. Canal+'s ambitious and costly production of *Braquo* (2009), which involves renowned film directors such as Olivier Marchal and Frédéric Schoendoerffer and famous big screen actors like Jean-Hugues Anglade and Nicolas Duvauchelle, attests to the longevity of this phenomenon.[8] The ratings of those TV shows (be they French or imported from the United States) indicate how French audiences still enjoy crime stories; they are simply no longer willing to pay to consume them.

In this less-than-favourable environment, a few films did nonetheless manage to reach a large public without relying solely on a star. Among those, Jean-Jacques Beineix's *Diva* (1981) and Bob Swaim's *La Balance* (1982) stand out as radically different takes on the genre. Considered to be a defining film of the *cinéma du look*, *Diva* playfully confronts high and low cultures, prompting Phil Powrie to label it a 'postmodern thriller' (Powrie 2007: 55–83). Far from *Diva's* oneiric aesthetics, reminiscent of poetic realism, *La Balance* privileges the influence of American action films like those in Belmondo's and Delon's films. With a lopsided script, bombastic visuals and over-the-top dialogue, the film nevertheless offers an important departure from the conventional representation of police detectives by showing them as young men who speak *verlan* and have long traded their predecessors' suits and trench coats for jeans, denim jackets and white sneakers. This iconographic shift confirms what Alain Corneau's *Série noire* (1979) already suggested, that the France shown in traditional policiers no longer exists. Hence, *La Balance* establishes realism and authenticity as

a crucial paradigm further explored and developed in Maurice Pialat's *Police* (1985), Bertrand Tavernier's *L.627* (1992), and more recently in Xavier Beauvois' *Le Petit Lieutenant* (2005). While Swaim's film resorts to numerous action scenes, Pialat, Tavernier, and Beauvois prefer to rid the genre of its spectacular nature in order to de-mythologize law enforcement and the underworld alike. Indeed, if law enforcement has changed it is primarily because criminality has evolved. The criminals shown in those films are not the tough gangsters of the 1950s, the bourgeois, domestic killers of the 1960s or the white colour criminals of the 1970s; instead, the criminals they focus on are drug dealers born out of the social and economic alienation imposed upon North African, Sub-Saharan, and Eastern Europe immigrants.[9]

The 1990s and 2000s confirm crime cinema's box-office decline. Indeed, rare are the policiers which attract large audiences, and the few that do certainly do not adhere to the naturalistic ethos described above. On the contrary, while their plots still rely on the resolution of mystery through investigation, their mode of representation foregoes all verisimilitude in favour of visual effects and scenes imported from other genres and foreign film cultures. François-Xavier Molia thus brands *Les Rivières pourpres/The Crimson Rivers* (Mathieu Kassovitz, 2000) and its sequel *Les Rivières pourpres 2: les anges de l'apocalypse/The Crimson Rivers 2: Angels of the Apocalypse* (Olivier Dahan, 2004) 'polars horrifiques' ('horrific crime thrillers') due to their combination of a whodunit narrative structure and the aesthetics of the horror film (Molia 2009: 45). *Le Pacte des loups/Brotherhood of the Wolf* (Christophe Gans, 2001) and *Vidocq* (Pitof, 2001) adopt the same mix, into which they incorporate the iconography of the heritage film and action scenes inspired by Hong Kong martial arts choreographies and *The Matrix* (Andy Wachowski and Lana Wachowski, 1999). Finally, the immensely popular *Taxi* franchise created by Luc Besson in 1998 and the lesser-known *Gomez et Tavarez* diptych (Gilles Paquet-Brenner, 2003 and 2007) maintain a criminal plot, but their stylized violence and comedic tone align them with the Hollywood buddy movie more than with traditional French crime cinema.[10]

Despite crime films' dwindling box office results, many young contemporary directors engage with the genre in productive ways. Limited as their release might have been, Xavier Giannoli's *Une aventure* (2005) and Cédric Anger's *Le Tueur* (2008) meticulously re-explore the voyeurism and repressed sexuality that prevailed in Hitchcock and Chabrol's works. The rise of such young directors, engaged by the genre's past, challenge French crime cinema's conventions and tradition while the box office success of others helps secure its longevity. Indeed, in a radically different vein, the solid, suspenseful screenplays of hits like Guillaume Canet's *Ne le dis à personne/Tell No One* (2006) and Fred Cavayé's *Pour elle/Anything for Her* (2008) invoke the policier without requiring the use of costly CGI. Finally, the contribution of a few esteemed auteurs who specialize in the crime thriller – including André Téchiné, Jacques Audiard, and to a lesser extent Guillaume Nicloux – secures the genre's cultural respectability. Their works, which receive sup-

port from the profession, critics, and sometimes even audiences (such was the case for many of Audiard's films, and especially *Un prophète/A Prophet* in 2009), bridge the gap between high and low cultures through the self-reflexive, albeit respectful, exploration of generic conventions they fully embrace.

François Massonnat

References

Abel, Richard (1996) 'The Thrills of Grande Peur: Crime Series and Serials in the Belle Epoque', *The Velvet Light Trap*, 37, pp. 3–9.

Dehée, Yannick (1997) 'Les mythes policiers du cinéma français, de 1930 à 1990', *Vingtième Siècle. Revue d'histoire*, 55, pp. 77–83.

Dubois, Jacques (2006) *Le Roman policier ou la modernité*, Paris: Armand Colin, pp. 22–30.

Laurent, Clara (2009) 'Le film d'espionnage français dans les années 50 et 60. Le film de barbouzes': entre film de truands et film d'espions', in Raphaëlle Moine, Brigitte Rollet and Geneviève Sellier (eds.), *Policiers et criminels: un genre populaire européen sur grand et petit écrans*, Paris: L'Harmattan, pp. 119–29.

Molia, François-Xavier (2009) 'Le "polar horrifique" à la française: analyse d'une transposition culturelle', in Raphaëlle Moine, Brigitte Rollet and Geneviève (eds.), *Sellier Policiers et criminels: un genre populaire européen sur grand et petit écrans*, Paris: L'Harmattan, pp. 45.

Oms, Marcel (1978), 'L'image du policier dans le cinéma français', *Cahiers de la Cinémathèque*, 25, pp. 67.

Powrie Phil (2007) 'French Neo-Noir to Hyper-Noir', in Andrew Spicer (ed.), *European Film Noir*, New York: Manchester University Press, pp. 55–83.

Vincendeau, Ginette (2009) 'Maigret pour toujours?', in Raphaëlle Moine, Brigitte Rollet and Geneviève Sellier (eds.), *Policiers et criminels: un genre populaire européen sur grand et petit écrans*, Paris: L'Harmattan.

Williams, Allan (1992) *Republic of Images: A History of French Film-making*, Cambridge, MA: Harvard University Press, pp. 260.

Notes

1 The scarcity of scholarship devoted to French crime cinema (especially in France) testifies to the perceived unworthiness of the genre as a subject of critical inquiry. On the other hand, a quick glance at the high-brow Criterion DVD collection reveals that almost 20 per cent of their 150-some French titles qualify as crime films.

2 According to Ginette Vincendeau (2009: 90), Maigret appears in 203 film and TV screen adaptations of Simenon novels.

3 Studies of Maigret abound. See for instance Francis Lacassin, *Mythologie du roman policier* (Paris: Christian Bourgeois, 1993); and William W. Stowe, 'Simenon, Maigret, and Narrative', *The Journal of Narrative Technique* (19:3, 1989), pp. 331–42.

4 Though critics predominantly present him as an auteur, Jean Renoir nonetheless made many notable murder narratives (*La Chienne/Isn't Life a Bitch?* [1931], *Le Crime de Monsieur Lange/The Crime of Monsieur Lange* [1936], *La Bête humaine* [1938]).

5 See Jill Forbes, 'Hollywood-France: America as Influence and Intertext', *The Cinema in France after the New Wave* (London: BFI and MacMillan,

1992), pp. 47–75; and Tim Palmer, 'Paris, City of Shadows: French Crime Cinema Before the New Wave', *New Review of Film and Television Studies* (6: 2, 2008), pp. 113–31.

6 The film is largely based on the Ben Barka scandal.

7 Other, lesser-known films participate in this sub-genre, among which Pierre Granier-Deferre's *Adieu Poulet/The French Detective* (1975), or Jacques Rouffio's *Sept morts sur ordonnance* (1975).

8 For more information on this trend, see Raphaëlle Moine and Geneviève Sellier, 'Les fictions policières françaises à la télévision: conformisme ou diversité?'; Raphaëlle Moine, Brigitte Rollet, and Geneviève Sellier, 'Préface'; and Pierre-Olivier Toulza, 'Les adaptations françaises de séries policières américaines', in Raphaëlle Moine, Brigitte Rollet and Geneviève Sellier, *Policiers et criminels: un genre populaire européen sur grand et petit écrans* (Paris: L'Harmattan, 2009), pp. 167–79; pp. 11–14 ; and pp. 75–85.

9 Tavernier was severely attacked and accused by some of racism because the criminals shown in the film were almost all of immigrant origin.

10 The advent of CGI further contributed to the steady increase of budgets, making such 'hybrid' crime films riskier financial endeavours in case of a box office failure, as was the case of Pitof's *Vidocq* (2001).

Classe tous risques

Studio/Distributor:
Mondex Films

Director:
Claude Sautet

Producer:
Jean Darvey

Screenwriters:
Claude Sautet
José Giovanni
Pascal Jardin (based on the
novel by José Giovanni [1958])

Cinematographer:
Ghislain Cloquet

Composer:
Georges Delerue

Editor:
Albert Jurgenson

Duration:
108 minutes

Genres:
Crime
Drama
Romance

Cast:
Lino Ventura
Sandra Milo
Jean-Paul Belmondo
Marcel Dalio
Simone France

Year:
1960

Synopsis

Abel Davos, once a gangster kingpin, is now hard-up. Following a failed robbery in Milan, Davos flees with his family to the French south coast. En route, his wife, Thérèse is killed by border police, but Davos escapes with his two young sons and is joined by Eric Stark, a fixer dispatched by his old gang members. Together with Liliane, who falls in with Eric, the group heads for Paris, where Davos soon finds Stark to be his only reliable comrade.

Critique

Classe tous risques is an example of how before, during and after the New Wave, genres like the policier sustained robust and often sophisticated cinema. Unlike the auteurist, conspiracy theorist New Wavers, however, its director, Claude Sautet, quietly paid his dues: graduating from IDHEC (which after 1946 was France's state-mandated film school), apprenticing himself as assistant and second-unit director on made-to-order films like *Bonjour sourire!* (1955; which Sautet completed as nominal director), *Les Truands/The Gangsters* (Carlo Rim, 1956) and the Lino Ventura thriller *La Fauve est laché/The Beast is Loose* (Maurice Labro, 1959). Reminiscing years later, echoing his Japanese counterpart Seijun Suzuki, Sautet remarked that his job at this stage was simply to make terrible scripts, cobbled together by hack directors, a little more interesting to watch.

Sautet's eventual career hinged on two lucky breaks. The first was assisting Georges Franju on the hit *Les Yeux sans visage/Eyes Without a Face* (1960). The second came when Ventura recommended him for his latest star vehicle, based on José Giovanni's novel *Classe tous risques*, a fictionalized account of a fading gangster, Abel Davos (Ventura), whom Giovanni had met while on death row, sentenced for post-Liberation racketeering. Giovanni, pardoned and soon a noted Série Noire author, would write the source texts for three of France's greatest crime films: besides *Classe tous risques*, Sautet's full debut, there was Jacques Becker's *Le Trou/The Hole* (1960), and Jean-Pierre Melville's *Le Deuxième soufflé/The Second Breath* (1966; less successfully re-adapted by Alain Corneau in 2007).

Timing is everything, though, and when *Classe tous risques* was released in Paris, in March 1960, it was overshadowed by *A bout de souffle/Breathless* (Jean-Luc Godard, 1960), which arrived a week later amidst a New Wave marketing blitz. In retrospect, however, Godard's and Sautet's first features have striking similarities. Both exploit the versatile repertoire of rising star Jean-Paul Belmondo, cast twice as a petty thug with flashes of grandeur; both showcase an international female lead (Jean Seberg for Godard; the Sicilian Sandra Milo for Sautet); and both reflect clear debts to genre materials popularized during France's commercially vibrant mid-1950s. *Classe tous risques* is indeed a fascinating foil to Godard's more overt deconstruction of the policier. Whereas

Classe tous risques, Mondex Films, Zebra Films.

Godard begins *Breathless* with Belmondo, ensconced in hotwired hotrod, breaking the law and the fourth wall by giving jaunty plot predictions directly to camera, Sautet, less radical and more respectful towards conventions, opens with a laconic male voice-over, as Davos and his lieutenant prowl the Italian streets: 'For them the city was neither pleasant nor unpleasant – they took no notice of it, and the people were no more real.'

Taking *Classe tous risques* on its own terms, its true value emerges. One of Sautet's key generic shifts is using children and families; most 1950s American and French policiers had mainly focused on solitary males and professional-masculine camaraderies. Throughout Sautet's film, Davos' wife and children represent commentaries on the attritional costs of crime; Davos is a desperate father and breadwinner as much as a waning gangster. After Thérèse (Simone France) is killed early on in Davos' flight, Sautet cuts to a shot of their eldest boy, his limpid eyes trying to grasp what has just happened – a devastating moment in this surprisingly moving film. In the same vein comes a later scene, as Davos heads north, when his two sons trot loyally beside him (a poignant echo of Bruno and Ricci in *Ladri di biciclette/Bicycle Thieves* [Vittorio De Sica, 1948]) only to be warned that they must now walk ten yards behind him to avoid discovery. Although the inevitable gangster betrayals soon pile up, Davos' real point of breakdown – with the underrated Ventura never better at capturing a chronically violent man's melancholies – comes as he relinquishes his children to an old acquaintance. As the kids descend into the Métro, Sautet's staging is wordless but evocative: Ventura turns his back to camera, slumps, presses his twitching hand against a tree, while Belmondo ushers him gently to their waiting car. (Another witty genre inversion is that it is Davos, traditionally the senior mentor to a rookie apprentice, who now needs help from the younger Stark.)

Sautet's *film maudit* is also enlivened by another under-regarded technician, Ghislain Cloquet, a cinematographer perennially in the shadow of New Wave regulars Raoul Coutard and Henri Decaë, yet the man responsible for the images of Robert Bresson's *Au hasard, Balthazar* (1966), *Mouchette* (1967) and *Une femme douce* (1969), Jacques Demy's *Les Demoiselles de Rochefort/The Young Girls of Rochefort* (1967), and even Arthur Penn's American New Wave harbinger *Mickey One* (1965). (Bresson apparently much admired *Classe tous risques*, in part for its aesthetic.) Unlike its flashier New Wave rivals, Cloquet's photography for *Classe tous risques* is economically expressive: like location shots of Nice for an overcast dawn conversation between Davos and Thérèse, striving to maintain morale while their children, blithe, play on a beach in the rearground; to beautifully deep-staged compositions of Davos and his henchman pacing the Milan streets, their nervous body language distinguishing them from the thronging crowds.

After *Classe tous risques*' initially underwhelming reception, Sautet's career ebbed and flowed. Low profile during the 1960s, Sautet was a widely-employed script doctor and reader, part of Bertrand Tavernier's rough cut screener group, and an uncredited contributor to many mainstream products, exemplified by his

script input on spy movies like *Atout coeur à Tokyo pour O.S.S. 117* (Michel Boisrond, 1966). Later in life, though, Sautet triumphed, with a run of critical and popular successes such as *Une Histoire simple/A Simple Story* (1978), *Un Coeur en hiver* (1992) and *Nelly et Monsieur Arnaud/Nelly and Monsieur Arnaud* (1995). But *Classe tous risques* is Sautet's finest hour, an emotionally complex crime thriller, a punchy corrective to the notion that mainstream genre-oriented French cinema of the 1950s and 1960s had nothing to offer.

Tim Palmer

Rififi

Du Rififi chez les hommes

Studio/Distributor:
Pathé-Consortium Cinéma

Director:
Jules Dassin

Producers:
Henri Bérard
René Bézard
Pierre Cabaud

Screenwriters:
Jules Dassin
René Wheeler
Auguste Le Breton (based on the novel by Auguste Le Breton [1953])

Cinematographer:
Philippe Agostini

Composer:
Georges Auric

Editor:
Roger Dwyre

Duration:
118 minutes

Genres:
Crime
Drama
Film noir

Synopsis

After five years in jail, Tony Le Stéphanois is left with only Jo, the kid partner he covered for, to give him respect. With his friend Mario, Jo is planning a small-time smash and grab on a Parisian jewellers. But Tony takes the job over and turns it into a professional heist. Enlisting the help of Italian safe cracker Cesar, they break in and steal over 240 million francs. The police offer a reward, but local gangster Grutter plans to get there first, tracking down Cesar and making him talk. As rival factions intervene, Tony and his team are placed in increasing danger…

Critique

For American director Jules Dassin, *Rififi* came after five years in exile. Blacklisted by the House of Un-American Activities (when his friend, director Edward Dmytryk, exposed Dassin's brief flirtation with Communism), Dassin had been forced to leave the country and drift around Europe, a man without a home. Along the way, several projects were sabotaged by US interference but for French producer Henri Bérard, Dassin was the only man capable of refining Auguste LeBreton's pulp novel *Rififi* into a movie. The book was lurid, trashy and racist (the villains are all North African) but Dassin, thinking of his family, took the job anyway. Eliminating the more offensive subject matter, Dassin rewrote the story, emphasizing the themes of loyalty, trust and betrayal. This was, after all, the truth of Dassin's life at the time.

And truth was a big part of his repertoire. His crime dramas, like *The Naked City* (1949) and *Night and the City* (1950), captured urban environments like New York and London through an unfiltered lens. While the back alleys and neon lights were naturalistic, these stories where peppered with genre archetypes (the good cop, the ruthless hood, the two bit hustler) adding a poeticism to Dassin's view of the world. *Rififi* is no different. Filmed on the streets of Paris, Dassin and cinematographer Philippe Agostini capture only the dangerous side. It is industry, steel pipes, derelict houses, long steps and constrictive archways – the protagonists passing through this broken world with cold breath on their lips. Even a benign café becomes a meeting place where four men plan a crime. It is equal parts Paris as it was and the mean streets of dime store fiction.

Cast:

Jean Servais
Carl Möhner
Robert Manuel
Jules Dassin (as Perlo Vita)
Robert Hossein
Marie Sabouret

Year:

1955

Indeed, at its heart *Rififi* (slang for rough house fight) is the old story of an aging thief attempting one last job. Tony's dress (fedora, long coat) is atypical, as are the places he frequents, like the smoky nightclub or the after hours card game. There is a familiarity to him, but in actor Jean Servais' hands there is also honesty. At the time he too was washed up (his career in decline, he was spotted drinking in a bar by Dassin) and he brings a world-weary defeatism to the part. Only 44 at the time, Servais' face seems ancient, his eyes blank. 'I don't run fast enough anymore,' Tony explains to the group, and he staggers through events with grim resignation. His emotions are burned away and in a disturbing early scene we watch as he strips and savagely beats Mado (Marie Sabouret), the girl who did not wait for him. The camera looks away in horror, but the event barely registers in Tony's eyes.

Tony applies this stony-eyed detachment to the job, a caper they plan with surgical precision. As we watch them buy equipment, test alarms and case the jewellers a thousand times, the film becomes a procedural movie in the vein of Hathaway's *Call Northside 777* (1947), only this time from the point of view of the criminal. The heist scene itself is justifiably famous (inspiring everyone from David Mamet to Steven Soderbergh) – a wordless 25 minute sequence where the sound of the men working is all we hear. It is this matter-of-factness that makes it so engaging. Time ticks away, Tony watches the street outside (checking off every movement in a notebook) and every sound – the clinking of the chisel, the lighting of a match, the crumbling dirt falling into the shop below – is fraught with tension. The men move in unison, each working with complete trust in the other. It is only once they are back on the streets that this trust breaks down.

In his lust for women ('no safe that can resist Cesar and no woman that Cesar can resist') Cesar is unreliable and eventually leads the group to destruction. He is caught and he talks – he names names. Tony finds him tied up in Grutter's club; 'I liked you, Macaroni. But you know the rule,' he utters and as he backs away so too does the camera – leaving Cesar in disgust – before our hero pulls the trigger. This moment can be seen as Dassin's revenge on his 'friends' back in America but then it is also something more. The exchange is shot in tight close-up and in the basement gloom we see, finally, tears in Tony's eyes. Dassin's decision to play the part of Cesar himself draws attention to the fact that he never went before the HUAC board and must have wondered what he would have done if he had. With this in mind the scene becomes empathetic, and offers understanding along with the vengeance. There is a brutal honesty here, but then from Dassin we can expect nothing less.

Tom Fallows

Between Eleven and Midnight

Entre onze heures et minuit

Studio/Distributor:

Francinex

Director:

Henri Decoin

Producer:

Jacques Roitfeld

Screenwriters:

Henri Decoin

Marcel Rivet

Henri Jeanson (uncredited)
(adapted from the novel *La Sosie de la morgue* [1935] by Claude Luxel)

Cinematographer:

Nicolas Hayer

Composer:

Henri Sauguet

Editor:

Annick Millet

Duration:

95 minutes

Genres:

Crime

Drama

Cast:

Louis Jouvet

Madeleine Robinson

Léo Lapara

Jean Meyer

Monique Mélinard

Year:

1949

Synopsis

Inspector Carrel is summoned when the body of an arch-criminal, Vidauban, is discovered, murdered in a Paris subway sometime between eleven and midnight. The twist is that Carrel is Vidauban's exact double, leading him to assume his identity to track down the killer. Carrel takes up with Lucienne, Vidauban's lover, then inveigles his way into his circle of underworld lackeys and betrayed ex-girlfriends, none of whose motives are clear, all of whom are amazed to see him still alive.

Critique

Rarely celebrated today, Henri Decoin was for over 30 years a respected classical French director. Returning often to the policier, Decoin navigated the French film industry through its so-called 1930s Golden Age, his celebrity marriage to Danielle Darrieux (they made ten films together), France's turbulent re-organization during the Occupation (Decoin shot two films for Alfred Greven's Nazi-run Continental-Films, for which he was later condemned), into the commercially buoyant 1950s, working on into his mid-seventies in the 1960s.

Among aficionados *Between Eleven and Midnight* enjoys a cult reputation, and it has been quite regularly revived at the Cinémathèque Française. The film certainly showcases the policier genre as the basis for stylistic idiosyncrasy, an anti-social world-view, compelling caustic performances and a vein of mordant, lacerating humour. While 1940s French critics famously hailed the American film noir for its provocative diagnoses of social malaise, they might have done better, perhaps, to stick with the crime thrillers produced in their home country, en masse, which in the hands of post-war artisans like Decoin, Jacques Becker, Henri-Georges Clouzot and Gilles Grangier, were just as fascinating as anything exported from Hollywood.

While the murder mystery and double-crosses of *Between Eleven and Midnight* might seem formulaic, there is no shortage of subversive, ironic, occasionally full blown surreal set-pieces on offer here. Take the film's opening, which confronts a major problem – that Decoin's grizzled star Louis Jouvet had only two years earlier played another hero-villain double role, in Jean Dréville's *Copie conforme* (1947). Decoin's solution is a beautifully shot ersatz documentary framing sequence: a male voice-over escorts us around Paris, suggesting (falsely) that all of its clocks are incorrect, that Parisians have no sense of time but a highly developed sense of culture (much more true), moving into ruminations about double roles in cinema, inspecting the actual poster of Dréville's film ('There he is – Jouvet!'), moving on to Edward G. Robinson in *The Whole Town's Talking* (1935) and Charlie Chaplin in *The Great Dictator* (1940). The scene ends with the supposedly omniscient voice losing its temper with filmgoers who belittle such movies: one passerby quips, 'How idiotic!'; the voice-over snaps back,

'Why stupid? Not at all!' Clearly, Decoin and his scriptwriters are being jokingly self-reflexive, playing fast and loose with (crime) film conventions. The approach continues in a similarly bizarre scene in Lucienne's (Madeleine Robinson) *haute couture* fashion parlour. As jaded models parade before wealthy matrons, we learn that the dresses on offer have all been named for 'this year's literary hits' – titles which all come from the policier gutter. One catwalk creation is even named *J'irai cracher sur vos tombes* (I Spit on Your Graves) in dubious homage to Boris Vian's 1946 faux-translation of Vernon Sullivan's scurrilous pulp classic (itself adapted for the screen by Michel Gast in 1959).

Reflecting the input of Henri Jeanson, expert screenwriter-for-hire, *Between Eleven and Midnight* is full of these bait-and-switch variations, its narrative built on quicksand. Alongside its overtly implausible plot reversals, the film is equally inventive at the level of language, from its peculiar slang dialogues (most of the slang was invented for the film), to the interchangeably cynical wisecracks of crooks and policemen, to the pseudo-gentile exclamations of the bourgeois victims (the incensed matrons at the fashion show are immediately robbed by Vidauban's hoods). Interrogating a streetwalker, Jouvet's smug delivery style is jolted when she imme-diately calls his bluff: 'I'm a spaniel, I sniff out cops at a hundred meters.' Vidauban next quizzes a nightwatchman, who turns out to be a down-on-his-luck intellectual, busily reading, of all things, the collected works of the ancient Roman historian, Tacitus. No one, and nothing, can be taken at face value. In one initially poignant moment, Carrel-as-Vidauban discovers that his suicidal ex-lover's clothes have been found at sea – cut to the next scene and she miraculously turns up in his apartment, apparently dead again but this time by gunshot; she then leaps to her feet and angrily debates the merits of different types of self-murder. Shooting, she decided, was 'much safer' than drowning.

Pointedly, the gallows humour often turns from arch to scath-ing, especially in Jouvet's implacably amoral performance, which holds the live wires of this highly ambivalent film together. The film's dispassion intensifies near the end, when Perpignan (Léo Lapara), one of Carrel's unctuous underlings (Jeanson apparently hated the actor so much that he scripted him to be called *Imbécile* in all his scenes) gets frustrated when he turns out to have pinned Vidauban's murder on the wrong suspect. 'I deserve,' Perpignan insists, 'all the more credit for having made him confess.' Coming seconds after an informer declares that 'solitude is freedom' – Carrel retorts, 'So people say about work' – *Between Eleven and Midnight* veers towards its nastiest satire: the lingering ideology of the Nazis' *Arbeit macht frei* and the ugly retributions during the Occupation and the post-Liberation *épuration légale* (legal purges) that followed. From the poster of Chapin as Hynkel in *The Great Dictator*, identified by the voice-over merely as a 'Head of State', to the citation of Tacitus (putatively a Germanic sympathizer invoked by Hitler), to these deadpan exchanges, *Between Eleven and Midnight* both endorses and condemns its on-screen world, in which Paris is below the surface still at war, teeming with violence,

Entre onze heures et minuit, Francinex.

a police state in which gangster kingpins and police inspectors
are reflections in the same mirror, facets of the same personal-
ity. Business as usual here is dirty work indeed. And then comes
the final twist, in that Vidauban's murder is revealed to have been
coldly executed by the only apparently calm, reliably respectable
character in the whole film. 'If I testify in favor of the accused,'
Carrel reminds us, 'it'll be an acquittal.' Such is the viciously bleak,
unerringly dark world of the post-war French policier.

Tim Palmer

Night at the Crossroads

La Nuit du carrefour

Studio/Distributor:
Europa Films

Director:
Jean Renoir

Screenwriter:
Jean Renoir (based on the novel by Georges Simenon [1931])

Cinematographers:
Georges Asselin
Marcel Lucien

Editor:
Marguerite Renoir

Duration:
70 minutes

Genres:
Crime
Mystery

Cast:
Pierre Renoir
Winna Winfried
Georges Terof
Dignimont
Georges Koudria
Michel Duran

Year:
1932

Synopsis

Inspector Maigret and his assistant Lucas investigate a murder in an isolated village, when a diamond merchant turns up dead in a stolen car. More corpses accumulate, a gang of robbers is discovered, and suspicion shifts from fallen Danish aristocrat Carl, to thuggish garage owner Oscar, to Carl's alluring sister, Else.

Critique

Night at the Crossroads remains one of Jean Renoir's least known, least celebrated films. It gets mentioned in passing, if at all, for being part of a trio – with Jean Tarride's *Le Chien jaune/The Yellow Dog* (1932) and Julien Duvivier's *La Tête d'un homme* (1933) – of early sound policiers which began the long screen life of Georges Simenon's beloved Inspector Maigret (here played by Pierre Renoir). But actually *Night at the Crossroads* is a fascinating film: a transition from Renoir's 1920s experimental leanings towards more narrative fare, a darkly playful reworking of Simenon's dour original novel, and a brilliant example of nascent approaches to synchronized sound recording. While traditional accounts of Renoir's 1930s career stress his more iconic political films, laboriously so at times, *Night at the Crossroads* is a worthy dark horse, a film singled out for high praise by Jean-Luc Godard himself in a 1957 *Cahiers du Cinéma* Renoir special, a eulogy which also reveals its importance to Godard's plans for *A bout de souffle/Breathless* (1960).

One of the few historians to revive *Night at the Crossroads* in any detail is Charles O'Brien, whose book *Cinema's Conversion to Sound* (2005) shows how creative, self-reflexive, and divergent from American verisimilitude early 1930s French sound films often were. Renoir's flagrantly uneven opening is a great case in point. Over the titles, jarring aural sources jostle for attention: a growling car engine vies with fragments of a jaunty waltz, more cars rev and backfire, all of which are whimsically interrupted by crashes of percussion. Cut into the film's credits is the title caption, under which we see a masked welder burning into metal with an oxyacetylene torch, nicely underscoring Renoir's aggressive melding of sounds and images. The first diegetic shots – Renoir's camera wobbling along from a scooter's travelling vantage point, before two leftward whip pans situate us in Avrainville, 32 dreary kilometers outside Paris – are just as kinetic, and are unmistakably homaged, thirty years later, by Godard's opening joyride through the French countryside in *Breathless*.

Throughout, these kinds of stylistic contortions add flair to Renoir's deliciously complex direction, which favours deep staging and sometimes flirts with total incomprehensibility, as multiple characters go about their business in sequences erupting with life. *Night at the Crossroads* repeatedly gives us three or more conversations in progress at once, in or beyond the frame, set up over separate planes of action, with up to six people talking simultane-

Nuit du carrefour, Europa Films.

ously. Renoir also opts for long shots with people perversely keeping their backs to camera – when the first corpse is discovered, for example, seven characters block our view of the body stashed in a garage, which we do not, at first, actually quite see. If the conversations pall, Renoir drops into the soundtrack samples of other (non-realist) aural flavours: the clopping of passing horse hooves, nearby vehicles accelerating, tinny gramophone songs, dripping rainfall, or whatever other noises he finds appealing. One amazing scene, a stylistic crescendo, comes when Maigret wanders over to Oscar's (Dignimont) garage to survey the gloomy crossroads and drink a *verre*. In three deep space long-takes, Renoir gives us – ebbing and flowing like an orchestral everyday – Maigret's deceptively laconic inquiries, Oscar playing a reprise of the film's theme tune on his accordion, Oscar's assistant hiding a poached rabbit then shaving a car part with a screeching scraper, Oscar's wife staring into middle distance, and a telephone ringing, all amidst background car horns and rumbles of traffic. Finally Maigret protests,

perhaps echoing the amused but confounded viewer: 'Hey, give it a rest, I can't hear a thing anymore!'

In certain ways, Renoir mimics Simenon's famously 'atmospheric' writing style, which in the original novel comes from elliptical dialogues interspersed with incidental observations and reports of Maigret's actions. On-screen, this becomes a witty free-form association process, loosely held together across edits and sound bridges. In one scene, Lucas (Georges Terof), waiting with Oscar and his mechanics, asks what the time is; Renoir cuts to a diagonal shot of a speeding express train; then back to Oscar who now replies, '8:53'. Occasionally the cutaways recall Renoir's 1920s avant-garde sympathies, like a quasi-surrealist insert of Else (Winna Winfried) lying on a white fur rug, eyes shut in rapture, cigarette in hand, stroking a passing tortoise. Or sometimes Renoir's method expands narrative details: Maigret interrogating Carl (Georges Koudria) at the Quai des Orfèvres, bracketed by shots of feet walking past a morning newspaper billboard announcing the murder; which later turns into the *Paris-soir* evening edition, crumpled in the gutter, disclosing that Carl has been released. Headlines at dawn, garbage tonight.

Besides showcasing Renoir's innovative repertoire, *Night at the Crossroads* also deserves a better reputation for its impact on the policier. Like its striking nocturnal car chase sequences, with the camera careening through cloying pools of fog, this 1932 film shows energetically what the genre could do. Other seminal scenes feature Maigret, dolefully played by the director's older brother, Pierre, sparring with Else, prototype femme fatale; his staunch deadpan barely maintained in the face of her flirtatious, kittenish, beseeching, erratic façade of propriety. Wandering through the bizarre bric-a-brac of her crumbling rural chateau, Else transfixes all before her, and after-echoes of this character (much more erotic than Simenon's version) would inspire generations of crime filmmakers both French and American. However you categorize its inventions, though, *Night at the Crossroads* is a strikingly modern film which entertains and rewards close scrutiny. Back to Godard, whose 1957 declaration, reproduced in the filmography of André Bazin's posthumously published book, *Jean Renoir*, was: '[This is] Renoir's most mysterious film […] we are frightened by this strange and poetic film […] every detail, every second of every shot, makes *Night at the Crossroads* the only great French detective movie – in fact, the greatest of all policiers' (Bazin 1973: 231).

Tim Palmer

References

Godard, Jean-Luc (1992) 'La Nuit du carrefour', in André Bazin (ed.), *Jean Renoir* (trans. W. W. Halsey II and William H. Simon), New York: Simon and Schuster, pp. 229–31.

The Butcher

Le Boucher

Studio/Distributor:
Les Films de la Boétie

Director:
Claude Chabrol

Producer:
André Génovès

Screenwriter:
Claude Chabrol

Cinematographer:
Jean Rabier

Composer:
Pierre Jansen

Editor:
Jacques Gaillard

Duration:
93 minutes

Genres:
Drama
Thriller

Cast:
Stéphane Audran
Jean Yanne
Antonio Passalia
Pascal Ferone

Year:
1970

Synopsis

At a wedding in a small French provincial town, local butcher Popaul meets headmistress Hélène, and they begin a chaste relationship. Shortly afterwards, the police caution that a serial killer may be operating in the area. Is Popaul the killer? Hélène initially thinks him innocent, but Popaul stalks her through the schoolhouse and advances towards her with a knife, which he then apparently embeds in his own stomach. Hélène drives Popaul to hospital, and kisses him before he dies.

Critique

Claude Chabrol's *The Butcher* remains perhaps his most unqualifiable film. Ostensibly a thriller about a serial killer in a small village in the Périgord region of France, Chabrol's unremitting feeling for human complexities and incongruities, coupled with his trademark ironic detachment, transforms what might have been an exploitative genre piece into a richly nuanced character study. So deftly does it refuse to fly its genre flag that it can be seen, in turns, as a horror film, a thriller, a small-town romance and a psychological drama. Hailed as the best French film since the Liberation by *Le Figaro*, *The Butcher* is noticeable for its low-key acting, Pierre Jansen's eerily minimalist score, and a bleached-out *mise-en-scène* coupled with a stripped-back script whose longueurs reinforce the film's stifling atmosphere. Rarely has a mushroom-picking scene been imbued with such dread.

Stéphane Audran plays lonely schoolteacher Hélène, inexplicably drawn towards Jean Yanne's ex-army butcher who may or may not be a serial killer plaguing the town. The film is a knight's move away from the traditional 'serial killer' template, however. There are no bloody deaths, and little in the way of police procedural or collective community action. Like Chabrol's earlier *Que la bête meure/This Man Must Die* (1969), in which a man vows to murder the driver who killed his son in a car accident, *The Butcher* meticulously explores a favourite thematic: the existence of the primeval 'butcher' lurking beneath the trappings of bourgeois society.

Chabrol had co-written a study of Alfred Hitchcock with fellow New Waver Eric Rohmer in 1957, and, unsurprisingly, Hitch's shadow looms large. There is the coolly detached evocation of the provincial town, with its hidebound morality and stark sense of geography. There is Chabrol's wife at the time, Audran, whose neatly coiffed blonde hair and glacial demeanour recall Tippi Hedren and Kim Novak. And there is the sense that behind those picturesque cobblestoned streets and town squares reside scarcely concealed violent impulses. What is most horrific about *The Butcher* is precisely the lack of any gratuitous violence or any psychological explanation of Yanne's behaviour. The 'Chabrol touch' is there for all to see. Or rather it is not, for so invisible are his directional flourishes, and so battened down are the central performances, that *The Butcher* remains a subtle, slow-burning

work that draws the audience imperceptibly towards its ambiguous, almost elegiac conclusion. Chabrol's editing techniques crucially withhold plot information, while never sacrificing a genuine sense of creeping paranoia. The film's most inventive scene – its *coup de cinéma* – is straight out of the Hitchcock playbook. Hélène takes her school children on a class trip first to a cave full of pre-historic paintings. On the way back, they stop for a picnic beneath an overhanging cliff and blood drips from above onto one of the children's faces. It is still a shocking scene – the starkness of the blood amidst such bucolic calm – and is doubly exhilarating given that the rest of the film is so understated.

Chabrol sprinkles a few clues as to the butcher's motivations. Popaul (Jean Yanne) may be a killer, but he is also a victim. Even before he met Hélène, he was psychologically scarred by the conflicts in Indochina and Algeria, and appears to suffer from post-traumatic stress disorder. When towards the end of the film he delivers a soliloquy – 'I have a lot of blood – my blood does not stop flowing. I know about blood. I have seen so much blood, blood flowing' – Chabrol is clearly asking the viewer to sympathize with Popaul. The cave paintings layered over the film's opening credits form a genetic link between the primal impulses of Cro-Magnon man and the violent actions of Popaul. Millennia of human development, suggests Chabrol, has resulted in barely altered human drives and compulsions. 'If Cro-Magnon had not survived, the world in which we live wouldn't exist,' confides Hélène to a pupil as they wander through the caves, clinching Chabrol's worldview.

The central relationship between Hélène and Popaul is the clue to the film, and to Chabrol's approach to the genre. They are established as polar opposites – he an uneducated, inarticulate war veteran, she a narcissistic, aloof professional – and so their initial attraction to each other seems awkward, clumsy even; Chabrol's attempt at their 'meet cute' is nowhere near as skilfully choreographed as, say, Rohmer. To reinforce the oddness of their relationship, Chabrol has Hélène read out some lines from Balzac's 1842 *La Femme de trente ans* (whose protagonist was also named Hélène) to her pupils: 'She radiated an air of grandeur, a majestic firmness, a deep emotion which would have impressed the coarsest souls.' And yet, when nudged together, barely concealed neuroses in both characters are magnified, and the collision between the atavistic and the sophisticated becomes a mutually destructive force. It might be argued that it is Hélène who is the film's real monster – she has, either unwittingly or consciously, triggered Popaul's repressed animalistic responses.

Critics and audiences remain furiously divided by the film's ambivalent finale, in which Popaul finally confronts Hélène inside the school house and approaches her with a knife. At the very moment that he seems set to kill Hélène, Chabrol abruptly cuts to black, and in the next shot, the knife is embedded in Popaul's stomach. Is this a suicide attempt, or has Hélène somehow turned the knife on Popaul? She then drives him to the hospital, where she waits for him to die. These unresolved narrative threads are

a moot point: *The Butcher* is a restrained character study, intent on microscopic detail and nuance. Hélène's haunted look in the film's final shot, full of remorse and shared guilt, seems a fitting end to this anti-serial killer film, one that would cement Chabrol's reputation as the dissector of French middle-class mores.

Ben McCann

Le Samouraï

Studio/Distributor:
Compagnie Industrielle et Commerciale Cinématographique (CICC)

Director:
Jean-Pierre Melville

Producers:
Raymond Borderie
Eugène Lépicier

Screenwriters:
Jean-Pierre Melville
Georges Pellegrin

Cinematographer:
Henri Decaë

Composer:
François de Roubaix

Editors:
Monique Bonnot
Yo Maurette

Duration:
105 minutes

Genres:
Crime
Drama
Mystery

Cast:
Alain Delon
François Périer
Nathalie Delon
Cathy Rosier

Year:
1967

Synopsis

Jef Costello, a hired killer, executes a Parisian club owner. Despite his meticulous preparations – stealing a car, changing its plates, setting up an alibi with the woman who loves him – Jef is spotted at the crime scene by the club's beautiful piano player. He is arrested, but his alibi holds and the pianist refuses to identify him. The superintendent, now has him watched, but Jef evades his pursuers, taking a new contract which leads him back to the pianist. Before he pulls the trigger he is shot by the waiting police officers, but the superintendent discovers that Jef's gun was empty.

Critique

Le Samouraï begins in a seemingly empty room. As the camera trombones back and forth, cigarette smoke rises and our eyes are drawn to a figure lying on the bed. It is Jef. He rises, passes the bird cage (its occupant his only companion) and dresses in front of the mirror. He slides into his raincoat and methodically puts on a grey fedora, neatly adjusting the brim with his fingers. And this uniform is full of iconographic intent: it brings to mind Bogart, wet streets (onto which Jef himself will soon step), concealed guns, crime, dames and despair. Director Jean-Pierre Melville has famously confessed that he learnt his trade by watching movies (long before Truffaut and Tarantino) and that he especially loved black-and-white American crime films, *The Asphalt Jungle* (John Huston, 1950) and *This Gun for Hire* (Frank Tuttle, 1942) best of all. The French called these films noirs and *Le Samouraï* is Melville's most adoring reflection of this tendency.

With earlier policiers such as *Bob Le Flambeur* (1956) and *Le Doulos* (1962), Melville homaged hardboiled cinema, presenting the archetypal noir world viewed against a laconic Parisian backdrop. Unlike its predecessors, *Le Samouraï* was shot in colour and oddly this allows a more precise expression of the milieu. Both Jef's mould-ridden apartment and the police station in which he is questioned are monochrome – the latter filled with grey men moving around in grey trench coats. Even the location shot exteriors are overcast and bleak, as if all the city's colour has been washed away in the rain. And like Leone's spaghetti westerns, Melville is more interested in the style of the genre than the psychology. The film

Le Samouraï, Filmel-C.I.C.C., Fida
Cinematografica.

sidesteps the traumatized post-war narratives that defined noir and
instead recreates it in aesthetic terms only.

As a result the characters become archetypes, their typical moti-
vations and anxieties are removed and everything is reduced to its
essence. Jef exists only to commit the perfect crime, the super-
intendent (François Périer) only to stop him, the women merely
a distraction to both. Any hints at an exterior life are absent from
Jef's apartment and he seldom speaks. When Jef is put in a line up,
a witness identifies him because they, 'distinctly remember the sil-
houette,' emphasizing him as nothing more than a shadowy reflec-
tion. Indeed, unlike the moral code of noir protagonists like Philip
Marlowe, Jef's code of the samurai serves only to help him better
do his job. When he becomes infatuated with the pianist (Cathy

Rosier) an exterior life threatens to intervene. But with his sense of purpose undermined, Jef does what any samurai would do – he commits seppuku – by going into a hit with an unloaded gun.

This fatalism is over-emphasized. The title itself hints at an obsession with death, part of the samurai Bushido being to, 'engage in combat fully determined to die.' While anti-heroes like Robert Mitchum's Jeff Bailey in *Out of the Past* (Jacques Tourneur, 1947) seemed reluctant to meet their inevitable doom, here our protagonist accepts it as a way of life. As played by Alain Delon, Jef embodies this resignation with what Raymond Chandler called a 'cool spirit of detachment'. His eyes are glassy and remote, his expression unchanging – whether watching the pianist lie for him in the police station or putting a bullet into a man he does not know. It is as if no matter what happens, the outcome remains the same. So his life becomes paradigmatic and Melville rhythmically watches him go through the motions.

That Melville allows these events to play out in contemporary Paris adds to the feeling that this is noir seen through a looking glass. Both Jef and his police officer pursuers dress in cool 1940s garb, like characters from a black-and-white movie stepped off the screen. But the world they wade through, despite the absence of colour, is 1960s chic – mini skirts and gaudy decor. The result is deliberately iconoclastic, drawing the characters out of context and highlighting their unreal existence. Melville's film becomes the noir of our dreams – a dead genre resurrected without the baggage. It is cool, individualist, and so hip that in the end it reduces everything to play. Indeed, this is the film for any of us who have ever stood in front of a mirror, tried on a fedora hat and pretended, just for a moment, that we were Bogart. *Le Samouraï* may not be the way it was, but it is the way we remember it.

Tom Fallows

Nikita

Studio/Distributor:
Gaumont

Director:
Luc Besson

Producer:
Jérôme Chalou

Synopsis

During a drugstore robbery, Nikita, a junkie, kills a cop. Condemned to death, she is given a second chance by the French state, which stages her fake execution and declares her officially dead. Nikita wakes up in an underground government facility where she learns from her mentor Bob that she has been chosen to become a government assassin. After three years, now slick and deadly, Nikita is released into the world outside but remains under the control of the French secret services who make her carry out classified missions and assassinations. Finally, she deserts and disappears without a trace.

Screenwriter:
Luc Besson

Cinematographer:
Thierry Arbogast

Composer:
Eric Serra

Editor:
Olivier Mauffroy

Duration:
112 minutes

Genres:
Crime
Drama
Romance

Cast:
Anne Parillaud
Tcheky Karyo
Jean-Hugues Anglade
Jeanne Moreau
Jean Réno

Year:
1990

Critique

With other groundbreaking French films from the 1980s and 1990s (notably Jean-Jacques Beineix's *Diva* [1981]), *Nikita* belongs to an influential and innovative trend which critics initially called the *cinéma du look*, or, more occasionally a *cinéma des nouvelles images*, 'fantasy cinema', or 'new formalism'. This was a post- and largely anti-New Wave mode of 'neo-baroque' film-making characterized by an arresting visual style, where sensuous primary colours predominate, by flamboyant cinematography, highly kinetic editing, hyper-photogenic, seductive, and often neo-surrealist visuals, detailed art design, elaborate studio sets, and a steady barrage of cinematic fireworks. With its eccentric yet hip and sexy characters, its technical mastery of the film medium (especially framing and editing), its spectacularly staged action scenes edited à la John Woo, and its cultural roots in adult graphic novels and popular US and French film, *Nikita* is one of the most accomplished gems of the *cinéma du look*.

Although they were acclaimed in popular film magazines such as *Première*, and despite (because of?) their huge commercial success and cult following in the 20-something audiences of the time, the films of the main three 'neo-baroque' directors (the BBC of Beineix-Besson-Carax) were initially often despised, and even hated, for their supposed vacuity. This was what *Cahiers du Cinéma* and *Positif* described as *chic et choc*: a shallow, facile and ultimately vacuous *tape-à-l'oeil* aesthetic. Accused of replacing substance with glossy images (so-called punk aesthetics) and narrative by mood moments, musical atmospheres, or even colours, the *cinéma du look* was dismissed as trivial, escapist, nihilistic, and disturbingly obsessed with childishly regressive fantasies.

More recently, those films have been critically re-evaluated by (mostly Anglo-Saxon) film scholars. Works like *Diva* and *Nikita* are now widely regarded as innovative and complex, both visually, conceptually and ideologically. Far from constituting a degraded blockbuster akin to a James Bond movie, *Nikita* is a playful, clever, and sophisticated postmodern collage: a dynamic inter-textual generic amalgam of everything from spy thrillers, film noir (with femme fatale subtext), and Jean-Luc Godard (as in the first scene's primary colours and infra-red alluding to *Le mépris/Contempt* [1963]), to the cinema of Sam Peckinpah (the slow-motion violence), Moebius/Bilal's futuristic *Heavy Metal* comics, and dystopian cyberpunk science-fiction (Nikita [Anne Parillaud], reprogrammed Robocop-style by the French secret service). Furthermore, the intricate aesthetic system of *Nikita* (and of other seminal *look* films such as *Diva*) seamlessly incorporates many contemporary trends in the visual arts, including hyper-realism, pop art and comic strips, but comic strips mediated through artists like Roy Liechtenstein. Rather than eye candy, *Nikita* thus represents a hyper-contemporary, sophisticated form of postmodern conceptual art. Despite its relentless and often dizzying recycling, Besson creates a cohesiveness in style and tone that gives it a genuine integrity. *Nikita*'s identity also owes much to its director's terrific eye for framing and

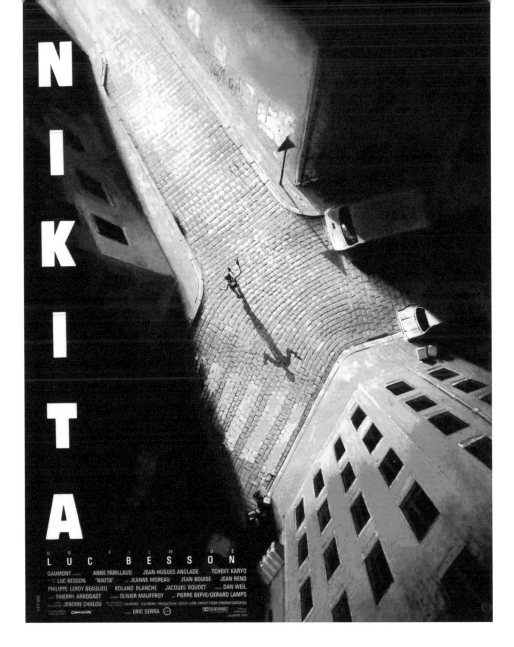

NIKITA

UN FILM DE
LUC BESSON

GAUMONT ____ ANNE PARILLAUD JEAN-HUGUES ANGLADE TCHEKY KARYO
____ LUC BESSON "NIKITA" ___ JEANNE MOREAU JEAN BOUISE JEAN RENO
PHILIPPE LEROY BEAULIEU ROLAND BLANCHE JACQUES BOUDET ___ DAN WEIL
___ THIERRY ARBOGAST ___ OLIVIER MAUFFROY ___ PIERRE BEFVE/GERARD LAMPS
___ JEROME CHALOU ___ GAUMONT GAUMONT PRODUCTION CECCHI GORI GROUP TIGER CINEMATOGRAFICA
____ CINEMASCOPE ___ ERIC SERRA ⊙ _____

Nikita, Gaumont,
Cecchi Gori, Tiger.

editing thrilling action scenes, to Eric Serra's effective and unforget-table musical score, to Parillaud's stunning performance, and to Besson's idiosyncratic mix of graphic, sometimes disturbing vio-lence with tongue-in-cheek, third-degree, irreverent humour (such as the bathroom scene with Victor the Cleaner [Jean Reno]).

On the ideological level, *Nikita* also transcends the limitations of its spy-action thriller genre by offering a complex, critical, post-feminist social text with multiple psychoanalytical and political ramifications. Behind its slick images and humour, the film actually projects a chilling and even desperate vision of contemporary (but also future) societies dominated by hyper-violence and absolutely

hostile to youth. Nikita does kill a cop at the beginning of the film, but the predatory State that captures and reprograms her into what is supposed to be a dehumanized killing robot appears far more amoral and lethal than anything her gang of drug-addicts was capable of. Re-socialized, re-tooled, and re-subjectified by her male and female mentors (Uncle Bob [Tcheky Karyo] and Amande [Jeanne Moreau], Nikita's substitute parents), the mother-less child-woman Nikita is recreated, *re-produced* in a womb-like environment (the underground complex) as the ultimate feminized killing machine for a feral and coercive State. Firmly placed in that subjugated position by a ruthless power apparatus – a veritable 'bachelor-machine' – Nikita is re-gendered according to the stereotypical patriarchal canon of the feminine (physical attractive-ness, a new glamorous look, a job as a nurse, code names 'Marie' and 'Joséphine') in order to be activated at will for off-the-record missions and extra-judicial assassinations. Her now stereotypi-cal femininity and fake life thus serve as the perfect cover for the illegal designs of a nefarious State. Literally *reincorporated* within a totalitarian web of state violence, surveillance, objectifying-subjectifying technologies, and patriarchal control, the young woman has only one recourse for extracting herself from that ruth-less Brave New World before it turns against her too: she deserts, and, in order to protect her own life, vanishes without a trace in an ideologically ambiguous final plot twist. To this day, *Nikita* remains a superb example of how a popular action blockbuster can be entertaining, smart, visually innovative, ideologically critical and conceptually sophisticated.

Alain Gabon

Cop au vin

Poulet au vinaigre

Studio/Distributor:
MK2 Productions

Director:
Claude Chabrol

Producer:
Marin Karmitz

Screenwriter:
Claude Chabrol (adapted from the novel *Une mort en trop*

Synopsis

In a small town, three local businessmen, Hubert Lavoisier, Gérard Filiol and Dr Morasseau, are trying to force the paralyzed Madame Cuno and her son Louis out of their home for a new development project. Louis, who delivers the mail, spies on their correspon-dence, and his friend Delphine, Morasseau's beautiful young wife, is also opposed to the project, though she disappears mysteriously. Louis pulls a prank, disabling Filiol's car, which leads to a deadly accident, so police inspector Jean Lavardin arrives in the small town to investigate. The book's title, translated as 'One Death Too Many', accurately sums up the eventual situation.

Critique

In his 1955 article 'Evolution du film policier', Claude Chabrol writes that the detective film, or policier, is based on 'shock and surprise'. However, he laments that there are only a limited number of dramatic situations available, and that the glut of recent American films noirs has helped exhaust the genre. Chabrol boldly states that the detective film can no longer thrill us, so it is finished,

[1982] by Dominique Roulet)

Cinematographer:

Jean Rabier

Composer:

Matthieu Chabrol

Editor:

Monique Fardoulis

Duration:

110 minutes

Genres:

Crime

Romance

Comedy

Cast:

Jean Poiret

Stéphane Audran

Lucas Belvaux

Pauline Lafont

Michel Bouquet

Jean Topart

Jean-Claude Bouillaud

Year:

1985

providing nothing more than weak copies over and over. However, once Chabrol began making his own detective films, he learned to strike a clever balance between an engaging story, full of surprises and plot twists, and an ironic, often parodic stance. His policiers are indeed generic, but also formally structured games of hide and seek, where characters and film-makers alike are deeply involved in controlling information. Chabrol built a long career out of first critiquing and then creating detective stories, and his narrators excel at manipulating audience knowledge, while playfully reminding us we are watching a movie. *Cop au vin* is not only exemplary of Chabrol's thriller tactics, it also helped revitalize his career during the same year that Jean-Luc Godard was launching his own version of the policier, *Détective/Detective* (1985).

While *Cop au vin* may be less well-known than some other Chabrol films, its mode of production and context are among the more important in his career. After a series of expensive projects that earned very disappointing returns at the box office during the early 1980s, including *Cheval d'orgueil/The Horse of Pride* (1980), *Les Fantômes de Chapelier/The Hatter's Ghost* (1982) and *Le Sang des autres/The Blood of Others* (1984), Chabrol chose to adapt Roulet's novel, *Une mort en trop*. The book already fit many of Chabrol's own traits, since it was set in a small provincial town among the corrupt local bourgeoisie, where crimes of passion and hidden motives eventually make everyone seem guilty or perverse in one way or another. However, his recent critical and box office failures prevented any producers from agreeing to take on this new project. Finally, Chabrol's old friend Marin Karmitz agreed to produce his new film, but only after Chabrol agreed to a low budget with a fast shooting schedule.

In the resulting film, Chabrol emphasized a number of thematic aspects from the original tale, but also altered the narration to an objective, less restrictive perspective, allowing his narrator to study each character from a relative distance. The first half of the film concentrates on young Louis, the postman (Lucas Belvaux), as he proves his devotion to his demanding, invalid mother (Stéphane Audran), protects the home his father long ago abandoned, spies on the crude, wealthy businessmen, and begins a relationship with his seductive post office colleague, Henriette (Pauline Lafont). However, after the frustrated Louis rashly pours sugar into Filiol's (Jean-Claude Bouillaud) gas tank, motivating a fatal car crash, *Cop au vin* gains a new central character, Inspector Lavardin (Jean Poiret). The inspector arrives one-third into the film, and his comical, monomaniacal character becomes a second protagonist. Lavardin is nearly a parody of a cop, who seems to have stepped out of a cartoon somewhere. But Chabrol retains his ideological cynicism as well, allowing all the inhabitants of this little town to possess their own secrets, their own dark sides, and the *mise-en-scène* constantly reminds us that everyone here is trapped in one way or another. For Chabrol, money circulates through contemporary society like contaminated blood, infecting everything it touches. Yet, by the end, the obsessive detective is amused at much of what he has witnessed, and he seems to choose a moral

high ground that nonetheless allows him to overlook one crime while prosecuting the larger sins of the bourgeoisie. Like Chabrol, he practically winks at the audience, while pushing Louis toward Henriette in the final shot to close off this upbeat, commercially successful mystery, with a happy ending and freeze frame.

But if Chabrol takes his usual aim at the pompous bourgeoisie in *Cop au vin*, he also returns to his fascination with the crisis of masculinity as well as the place of the family in contemporary France. In film after film, Chabrol has proven that the bourgeois family is usually a sham, and yet, his films admit they can offer no better solution for love and desire than the promise of a nuclear family, despite all its faults. It is a pathetic yet comically entertaining cycle in Chabrol's view. Every family is fractured in *Cop au vin*, including, apparently, that of Lavardin. Louis obsessively waits on his possessive, neurotic, suffering mother, but the depths of her personal secrets will not be revealed until the final moments, which forces Louis, and us, to rethink her character from the beginning. Of the few intact marriages, none is positive, and Dr Morasseau (Jean Topart) is even willing to kill off his young wife to protect his business deals. Elderly women coddle the men, and seem guilty by extension for tolerating their childishness and criminality. Yet, while the film continually ridicules patriarchy via both its story and style, by the end, it offers up Inspector Lavardin to replace the absent father figure for Louis, and the absent moral compass for this town without a leader. Much like Chabrol's surrogate, Larvardin's manipulative actions and knowing gazes help deliver a generic product that is also auteurist. *Cop au vin* proved Chabrol's brand of policier was still viable, and it led to a sequel, *Inspecteur Lavardin* (1986), and a TV series, *Les Dossiers secrets de l'inspecteur Lavardin* (1988). Thanks in large part to stylish thrillers such as these, *Cahiers du Cinéma* praised Chabrol as perhaps the greatest living French director during the 1990s, proving further that the policier, and Chabrol, evolved well indeed.

Richard Neupert

Subway

Studio/Distributor:
Les Films du Loup

Director:
Luc Besson

Producers:
Luc Besson
François Ruggieri

Synopsis

Fred, a young marginal, steals documents from a powerful gangster then hides in the Paris metro. Soon, the man's wife, Helena finds Fred hiding in the subway. They start a romance but Helena seems terrified of her dangerous husband. Hunted by both the police and the hit men of Helena's husband, Fred is helped by other metro drop-outs. He also tries to bring together a group of amateur musicians to accomplish his dream of becoming a music producer. Fred ultimately manages to create his rock band and stage his first concert – still in the subway – but a hit man kills him during the gig, while an enthusiastic crowd gives his band their first triumph.

Screenwriters:
Luc Besson
Pierre Jolivet
Alain le Henry
Marc Perrier

Cinematographer:
Carlo Varini

Art Director:
Alexandre Trauner

Set Designer:
Alexandre Trauner

Composer:
Eric Serra

Editor:
Sophie Schmit

Duration:
102 minutes

Genres:
Comedy
Crime
Drama

Cast:
Christophe Lambert
Isabelle Adjani
Richard Bohringer
Michel Galabru
Jean-Hugues Anglade
Jean Reno
Eric Serra
Jean-Pierre Bacri

Year:
1985

Critique

Like Jean-Jacques Beineix' seminal masterpiece *Diva* (1980), Luc Besson's groundbreaking *Subway* was received by critics and audiences as a veritable UFO (Unidentified Filmic Object) when it hit France's theatrical screens in 1985. Dismissed (and even despised) by many professional critics as a flashy and over-extended music video, it was nonetheless well received by younger generations as a film that finally captured the signs of their times. Raphaël Bassan indeed argued that *Subway* refreshingly broke with the chronic naturalism – one might also add: with the verbose, didactic, and conventional humanism – that plagued much of the French cinema of the time (Claude Sautet's bourgeois social chronicles, Yves Boisset's *cinéma engagé*, etc.). With its seamless hybridization of usually incompatible genres (the melodrama, the musical and the policier), its stylishness, its hip and sexy neo-punk characters and its interest in marginalized youths who live outside the bourgeois patriarchal society and conventional family structures, *Subway* epitomizes the flamboyant 'neo-baroque' *cinéma du look* of the 1980s and 1990s better than any other Luc Besson film.

If Godard's works of the 1960s (notably *Weekend* [1967]) were the cultural manifestos of the radically politicized, anti-Vietnam war Maoist youth of May 1968, *Subway* might be *the* film that captured Generation Xers: its cool and glamorized romantic despair seemed ideal for the postmodern, post-History, post-ideology, post-everything, disillusioned and 'alienated' generation of the economic crisis and the breakdown of the bourgeois nuclear family during the Socialist Mitterrand years. In *Subway*, visual brilliance supersedes political commitment; the musical effervescence of Fred's (Christophe Lambert) English-language 'F.M. rock' band replaces the revolutionary fervor of May 1968; the film's manic sign fetishism fills the void left by the so-called death of ideologies; and the fashion statements of Adjani's extravagant Iroquois hairstyle or Fred's bleached blonde spikes replace unapologetically the Marxist tirades of Godard's characters. In its panache, brash irreverence and joyful rebelliousness, *Subway* thus represented an antidote to the dominant paradigms of French cinema in its bourgeois realist-humanist version or its more modernist avant-gardist trends.

Short on dialogue, character development and narrative (the superfluous double plot of the stolen documents and the uninteresting love story between Fred and Helena [Isabelle Adjani] is quickly forgotten), *Subway*, like much of *cinéma du look*, is high on glamour, tongue-in-cheek caricatural humour (the Batman-Robin-Galabru trio of ineffective cops), and arresting musical mood moments: Fred and Helena slow-dancing romantically in the empty metro at night, Arthur Simms' audition before the band, etc. Historically, much of *Subway*'s significance and persistent freshness reside in the fact that it brought fantasy back into French cinema without necessarily subordinating fantasy to narrative, ideology, philosophy or social realism. Its neo-baroque exuberance and formal excess (both visual and auditory) displace, supplant, and even frequently obliterate the narrativity of the film; its melodrama/

noir double plot. More than the pulsating soundtrack, *Subway's* baroque aesthetic force, its sensuous, neo-surrealist/hyper-realist interplay between illusion, dream and reality, and its foregrounding of formally appealing elements (all fetishized at the expense of narrative, characters, and social realism) are best experienced in the hallucinatory seduction – the spell – that Alexandre Trauner's decor and set design (of French 'Poetic Realism' fame) cast on the film and its audience. Besson's interviews suggest that the force of Trauner's creation became a permanent problem for the scriptwriters and director: as they realized during the shoot, the decor was *taking over* the entire film. Ultimately, they just could not come up with a storyline or art direction that could keep the intensely atmospheric set design *in its place*. But that failure turned out to be a blessing: had Besson managed to contain the excess of Trauner's vibrant sets, *Subway* would have been a far less original and memorable film!

Still, behind its excess spectacle, rarefied narrative, and deliberately under-developed and stereotypical characters, *Subway* is not devoid of socio-ideological and critical significance. Raphaël Bassan was the first to argue that in the impoverished, disillusioned, and increasingly degraded social world of the post-utopian Mitterrand years, the fetishized signs and glamorous surfaces of *Subway* – the neon lighting, the fashionable clothes and hairstyles, the songs – were actually *signs of death* rather than euphoria or well-being. Far from being an MTV-style ad for the cool countercultural lifestyle of the contemporary Parisian youth – a 'clip promo' for an alternative 'Paris-by-night' – Besson's film, like most of *cinéma du look*, projected a disturbing vision of lonely, alienated, and stifled individuals caught in a lethal web of claustrophobia (the subway's tunnels look like those of the space vessel in *Alien* [Ridley Scott, 1979]), oppressive patriarchy (Helena and her husband), and violence (Fred's death). Confronted with such a grim, harsh, and ultimately nihilistic social world, *cinéma du look* does not ignore that world but chooses to mock, romanticize, or aestheticize it – three strategies present in *Subway*. Thus, Besson's film also projects a poetic vision of an alienated but resistant youth trying to fight, escape, or transcend their desperate world.

Alain Gabon

The Bride Wore Black

La Mariée était en noir

Synopsis

Julie Kohler is on an obsessive mission to execute the five men who killed her husband on their wedding day. Her means: any necessary, including poison, knives, guns, even an arrow from the quiver of Diana. As Julie seeks out (and disposes of) each man on her checklist, nothing apparently will stand in the way of her achieving bloody satisfaction, not family, not love, not art, not even jail.

Studio/Distributor:

Les Films du Carrosse

Director:

François Truffaut

Producers:

Marcel Berbert

Oscar Lewenstein

Screenwriters:

François Truffaut

Jean-Louis Richard (adapted
from the novel by William Irish
[Cornell Woolrich, 1940])

Cinematographer:

Raoul Coutard

Composer:

Bernard Herrmann

Editor:

Claudine Bouché

Duration:

107 minutes

Genres:

Crime

Drama

Mystery

Cast:

Jeanne Moreau

Jean-Claude Brialy

Charles Denner

Claude Rich

Michel Bouquet

Michael Lonsdale

Daniel Boulanger

Year:

1968

Critique

It is no coincidence that *The Bride Wore Black* represents François Truffaut's most consistent homage to Alfred Hitchcock, for it is his first film after the publication of his book-length series of interviews with the Master of Suspense in 1967. The film even features a lush score by Hitchcock composer Bernard Herrmann that plays like the lost soundtrack to a Hitchcock thriller. The merger of Hitchcock's sensibility with Truffaut's gives the ruthless story a giddy charm, tempering the sincerity of Truffaut with Hitchcock's ice-cold cynicism.

Truffaut finds humour in how he twists the focus of Hitchcock's trademark dramatic irony: instead of placing the audience in a more knowledgeable position than the protagonist, Truffaut, aided by Raoul Coutard's stalking cinematography, makes the audience and the protagonist co-conspirators, thus trading Hitch's suspense for dark comedy. The joys of the film come not from worrying over whether Julie (Jeanne Moreau) will succeed but rather from delighting in watching her chauvinist victims discover that not only will they not get laid, they will not survive their encounter with Madame Julie Kohler.

If Truffaut's wicked revenge thriller seems gleeful, it may be because the film comes on the heels of his problematic and sober adaptation of Ray Bradbury's *Fahrenheit 451* (1966), and the film is all the better for Truffaut's immoral delight. In fact, the film may actually have improved with age, with the revelations of the Women's Movement helping to cast Truffaut's sinister tale as a scathing critique of misogyny. While Truffaut returns to the obsessive 'skirt-chaser' throughout his career (most notably in *L'Homme qui aimait les femmes/The Man Who Loved Women* [1977]), *The Bride Wore Black* shifts point-of-view by aligning the audience with the object of the skirt-chaser's gaze as she turns the gaze back onto the men to liberate herself from life as an object for men's delight. Julie's success depends upon her prey feeling as though their virility is under threat, be it from age, marriage, family, or creative stagnation, and that their potency can only be restored through seducing a woman. The twist – and the humour – comes from watching each man realize, too late, that his fantasies of omnipotence are delusional. Here the womanizer becomes the object of the gaze rather than its subject, only in this case he is not an object of scopophilic desire but rather the quarry for the predatory protagonist.

This battle for control of the gaze comes to the forefront in the film's most compelling, yet also most ambiguous and problematic sequence: that in which Kohler entraps her fourth victim, the painter Fergus (Charles Denner), by modelling as Diana the Huntress. Truffaut delights in the irony of this, especially when Fergus asks Julie to aim the arrow at him (the camera), thus merging the metaphorical and literal tension of the scene by making him Diana's prey as well as Julie's. As the sequence plays out, Truffaut injects an air of romance when Julie becomes overwhelmed during a posing session and nearly faints. Or is it romance? What exactly overpowers her? The stirrings of her heart, or the weight of her

violent acts? The ambiguity of Truffaut's intent weakens the tension of this scene. On the one hand, if Fergus' art enchants Julie, then Truffaut undermines Julie's potency in the film; her art destroys rather than creates. On the other hand, Julie could be resisting Fergus' attempts to transform her from an active subject to a passive *object d'art*, thus making this penultimate murder the most symbolic of her struggle for freedom from objectification. Neither reading garners much traction because Truffaut avoids resolving these disparate options, and while the most emotive segment of an often clinical film does liven a rather plodding second half, it comes at the expense of thematic coherence. This dissonance may represent Truffaut's inability to consistently adhere to the rigidly formal style of Hitchcock; the director of *Jules et Jim/Jules and Jim* (1962) aches to be set free of his self-imposed limitations. The deliciously clever twist that brings about the final murder redeems the film by returning to the malevolent glee of its first half, yet the viewer cannot help but puzzle over the disjunctive sequence in an otherwise calculating film.

The Bride Wore Black also provided the template for the feminist revenge films of the 1980s and 1990s, American dark comedies of the 1990s, and even Tarantino's *Kill Bill* (2003–04). The result, while uneven, revitalized Truffaut after the *Fahrenheit 451* fiasco and led to a string of crowd-pleasers such as *Baisers volés/Stolen Kisses* (1968), *L'Enfant sauvage/The Wild Child* (1970) and *La Nuit américaine/Day for Night* (1973). Unfortunately, these later success come without the exuberance of his early films. *The Bride Wore Black*, or more accurately, the Hitchcock book, signalled the start of a decline in Truffaut's cinema, where the rugged vivacity of the *nouvelle vague* converts into sentimentality, restraint, and – dare we say it? – 'quality'. The volatility of *The Bride Wore Black*'s opening, let alone that of *Tirez sur le pianiste/Shoot the Piano Player* (1960), largely disappears from his films after 1968, and the viewer can see the beginning of this change in this film, which, although mean as a cold day in hell, represents an introduction to the kinder, gentler Truffaut, for better or worse.

Mike Miley

The late New Wave director Eric Rohmer may have chosen to label a series of films he made in the 1980s 'comedies and proverbs' but his films have never been reviewed under the generic term comedy. However problematic the attribution of a particular genre to a film may be, in France, this does not seem to apply to comedy: popular with French audiences (usually less in Paris than in the rest of the country), performer-driven, 'unimaginative', 'facile and complacent', comedy is a genre that has consistently been snubbed by *cinéphiles*, neglected by historians, and despised or ignored by film critics despite the facts that the first (albeit brief) fiction film was a comedy, some of the greatest actors of both silent cinema and the talkies were comics, and two-thirds of the box office successes of the post-World War II period have been comedies. Even today, France's *cinémathèques* are more inclined to screen the early films of the French New Wave than some of the 150 films the French comic star Fernandel made between 1930 and 1970, or the greatest French box office success of the twentieth century *La Grande vadrouille/Don't Look Now We're Being Shot At* (1966), even though Gérard Oury's 1966 war time Resistance comedy is still one of the most popular films on (daytime) television. The films of writer-director-actor Jacques Tati remain the exception. French films that make people laugh are rarely shown at film festivals and, until recently, seldom got a mention at awards ceremonies despite – or perhaps because of – their popularity with cinema audiences.

As fairground entertainment, early French cinema catered for the popular classes. It was largely made up of comic scenes such as Lumière's *L'Arroseur arrosé/Tables Turned on the Gardener* (1895) and Alice Guy's farce, *La Fée aux choux/The Cabbage Fairy* (1896), often inspired by cartoons and music-hall shows. Pathé, Gaumont and Méliès, among others, developed a plethora of comic genres, from slapstick, gags, chase sequences, and trick films to character-based comedies. Most comedians came from the circus, the boulevard theatres and the music-halls, and they brought their comic style with them. Max Linder is widely regarded as the greatest comic genius of the French silent cinema. A pioneer, he created much-imitated gags and was a major influence on Chaplin, Harold Lloyd and others. Exploring Pathé's character-based series featuring Boireau (André Deed), Prince/Rigadin, Onésime[1] and Max Linder, along with Feuillade's comedy series starring child actors (*Bébé* [1910–13]; *Bout-de-Zan* [1912–16]) and Eclair's *Willy* (1911–16) series, film historian David Robinson '(Robinson 1987: 198) called the years preceding World War I 'the Golden Age of French comedy'.

Linder's style inspired René Clair's adaptations of Eugène Labiche's farces, *Un chapeau de paille d'Italie/The Italian Straw Hat* (1928) and *Les Deux Timides/Two Timid Souls* (1929). French critics have preferred to discuss the socio-political satires of the 1930s including Clair's *A nous la liberté* (1931), a film which foreshadowed Chaplin's 1936 film *Modern Times*, and Renoir's corrosive – and more profound – films such as *Boudu sauvé des eaux/Boudu Saved from Drowning* (1932) or *La Règle du jeu/The Rules of the*

La Cage aux folles, Prods Artistes Associes, DA MA.

Game (1939) in terms of art cinema rather than under the generic term comedy. Yet, quoting *A nous la liberté* and *The Rules of the Game* in his study 'The Comic Mind' (1973), Gerald Mast asserted that there was 'something very French' about the 'reductio ad absurdum comic plot' with a structure, he described as:

> an investigation of the workings of a particular society, comparing the responses of one social group or class to another, contrasting people's different responses to the same stimuli and similar responses to different stimuli and a plot which is multileveled, containing two, three or even more parallel lines of action. (Mast, cited in BFI 1981)

Many of Renoir's films may be multi-layered and full of humorous characters and jokes but he is reputed as an auteur, not as a maker of comedies.

Ginette Vincendeau (1995: 89) contends that French comedy's lasting popularity owes much to three factors: 'its overwhelming maleness, which has gone hand in hand with the hegemony of male stars at the box office, the importance of language and word-play in French culture and the taste for deriding social and regional types'. This certainly applies to most of the comedies made at the time of the talkies and well into the 1960s.

The 1930s were dominated by light-hearted genres such as musical comedies (often made in multilingual versions at the beginning of the decade), 'filmed theatre' based on the so-called 'comédies de boulevard', and the 'comique troupier' or military vaudevilles. Coming from a long tradition in French entertainment going back to the 1880s, the military films of the 1930s had a fairly immutable scenario in which ordinary soldiers – usually wearing pre-1914 or World War I uniforms – outwitted or annoyed their superiors. Male friendship was strongly valorized. Order always prevailed in the end. The referral back in time ensured that the army was immunized from ridicule – as requested by Law. The 'boulevard comedies' on the other hand, owed much of their success to their witty and sparkling dialogue often written by famous playwrights such as Marcel Achard and Sacha Guitry. The French have always had a passion for their language. The advent of sound posed new problems to film producers who, seeking 'new' formulae to attract cinema audiences, turned to the theatre as a source of inspiration. As a result, the 1930s also saw the emergence of a new brand of scriptwriters and performers. The many talented actors of the period (Louis Jouvet, Raimu, Michel Simon, Marguerite Moreno, Elvire Popesco, Arletty) were happy to accept both tragic and comic parts on stage and on the screen. Successful formulae of the silent era were not abandoned and the most popular comedians of the decade were actors and singers Georges Milton – playing the eternal cheat 'Bouboule', in, among other hits, *Le Roi des resquilleurs/The King of the Gate Crashers* (Pierre Colombier, 1930) – and Fernandel, whose southern accent proved enormously popular in numerous farces, including the notorious *Ignace* (1937) as well as in Marcel Pagnol's *Regain/Harvest* and *Le Schpounz/*

Hearbeat (both 1937), all films set in the French countryside.

A number of French directors also emulated American-style light comedy (Marc Allégret, Christian Jaque, Henri Decoin) in films starring Fernand Gravey, André Duquet, Danielle Darrieux, Micheline Presle and Edwige Feuillère (Vincendeau 1995: 88). If the popular comic genres of the 1930s appeared to be on the side of the individual rather than the institution, they were firmly based on stereotypes, a process which continued well into the 1950s and beyond. In those heydays of relatively cheap and cheerful productions, comedies were an industry staple as strong returns were guaranteed to each performer's vehicle.

The post-war period saw much of the same with the notable exception of comedies based on class distinction: frequent in the 1930s, they became a rare occurrence in post-World War II French cinema. While comedies starring French comics such as Noël-Noël, Darry Cowl, and Francis Blanche remained strictly for home consumption, a number of films starring the greatest comics of the period, Fernandel, Bourvil (usually playing the rural simpleton) and Louis de Funès, managed to cross (European) borders particularly if the films were made as co-productions.[2] In the early 1950s, for example, the French-Italian *Don Camillo* series (*Le Petit monde de Don Camillo/The Little World of Don Camillo* [Julien Duvivier, 1952]; *Le Retour de Don Camillo/The Return of Don Camillo* [Julien Duvivier, 1953]; *La Grande bagarre de Don Camillo/Don Camillo e l'on. Peppone* [Carmine Gallone, 1955]) – starring Fernandel who plays the eponymous parish priest opposite Gino Cervi in the role of Peppone, the communist mayor of an Italian village – dominated the box office both at home and in Italy. The films seem to suggest that local relationships are more important than the dire political and socio-economic situation of the country. Yet, for the film industry, long-run series were the guarantors of financial stability. Calling the post-1945 decade 'a Golden Age' in European cinema, Pierre Sorlin (1991: 110) concluded that the films of the period were 'not great art' but nevertheless constituted 'a valuable document on the concerns and hope of the reconstruction era'.

However, to French film critics, *the* comic cinema of the period was the work of Jacques Tati. Using minimum dialogue and a maximum of visual effect and natural sound, *Jour de fête* (1949), *Les Vacances de Monsieur Hulot/M. Hulot's Holiday* (1951) and *Mon Oncle* (1958) offer a caustic look at contemporary France as it moves into a consumer society. Tati's influence is apparent on the films of his former assistant Pierre Etaix, who gained critical and public acclaim with *Le Soupirant/The suitor* in 1963.

Apart from the films of Tati and Etaix, comedy which made up almost half of the production of the 1950s was marked by repetitiveness and complacency. The great majority of comic films 'displayed a voluntarist myopia to social issues' (Harvey 1993: 188). Marital infidelity was a theme favoured by film-makers such as Guitry, Jaque and André Hunebelle. Humour relies on familiarity, and innovation has rarely been a strong point of (French) comedies. The use of the male duo, a recipe for success almost since the beginning of cinema, was particularly popular in the post-war

period. A feature of French comedy over the following decades, the male duo involved the greatest French comics of their time. They include, in the 1950s, Bourvil and Jean Gabin (*La Traversée de Paris/A Pig across Paris,* [Claude Autant-Lara, 1956]), and, in the 1960s, Darry Cowl and Francis Blanche (*Les Pique-assiette* [Jean Girault, 1960]) as well as the Bourvil-de Funès team in the box office hits directed by Gérard Oury, *Le Corniaud/The Sucker* (1965) and *La Grande vadrouille* (1966) – both films drawing audiences of more than 11 million. In comparison, with its 9.6 million spectators in 1962, *La Guerre des boutons/War of the Buttons* – Yves Robert's film set in rural France about opposing gangs of pre-teen boys who unwittingly play out their parents' bigoted opinions and petty behaviour – registered a more unusual box office hit in the early 1960s.

The 1960s and 1970s saw the rise of a younger generation of directors happy to serve the mainstream market (Georges Lautner, Oury, Edouard Molinaro, Jean-Charles Tacchella, Francis Veber), along with a fresh generation of actors such as Jean Yanne, Philippe Noiret, Michel Galabru, Victor Lanoux, Pierre Richard, Jean-Paul Belmondo and Annie Girardot, as much at ease in comedies (Yves Robert's *Le Grand blond avec une chaussure noire/The Tall Blond Man with One Black Shoe* [1972] and *Tendre Poulet/Dear Inspector* [1978]; *Le Guignolo* [Lautner, 1980]; *L'as des as* [Oury, 1982]) as in action thrillers or the films of the New Wave directors (which, themselves, were not without humour). Louis Malle's *Zazie dans le métro* (1960) may have been a hit with French audiences in 1960, but the versatile New Wave director is hardly remembered today for his slapstick adaptation of Raymond Queneau's surrealist novel. Popular comedies of the period – which again tended to focus on male characters – showed the incompetence of men as endearing (*The Sucker* [Oury, 1965]; *Le Distrait* [Pierre Richard, 1970]; *Les Zozos* [Pascal Thomas, 1973]). Those middle-of-the-road productions had little artistic pretensions. Making a passing reference to the political events of the day (*Les Aventures de Rabbi Jacob/The Mad Adventures of 'Rabbi' Jacob* [Oury, 1973]) – 'post-1968 *oblige*' – and claiming the contributions of the most famous film stars of the period, they were greatly appreciated by French cinema-goers. Some were more caustic than others, for instance, Jean Yanne's films *Tout le monde il est beau, tout le monde il est gentil/Everybody He Is Nice, Everybody He Is Beautiful* (1972) and *Moi, il y en a vouloir des sous/Me I Want to Have Dough* (1973) took on the media and women's movement respectively. The comic stars of the 1950s continued to play an important role in commercial terms with, among others, the highly popular *Gendarme* series directed by Jean Girault and starring Louis de Funès (*Le Gendarme de Saint Tropez/The Gendarme of Saint Tropez* [1964]; *Le Gendarme à New York/The Gendarme in New York* [1965]; *Le Gendarme en balade/The Gendarme Takes off* [1970]). Often set in the countryside, those comedies exploited well-worn formulae using the performance skills of recognized comedians. They did not challenge French society but they did offer French audiences images of their own world or surroundings.

While comedies continued to be the most popular genre in the domestic market, on both large and small screens, they have, for a number of reasons, not exported well, with a few exceptions like *Cousin, Cousine* (Tacchella, 1975) and *La Cage aux folles/Birds of a Feather* (Molinaro, 1978). In Britain, *Cousin, Cousine* was said to represent 'everything Gallic that English audiences looked out for in a French film': sophisticated, adult, entertaining – with the analysis of romantic relationships as well as a denunciation of the artificiality of contemporary bourgeois life. Both films had successful remakes in America. By contrast, French attempts at emulating the success of American teenager comedies were short-lived (i.e. *A nous les petites Anglaises/Let's Get Those English Girls* [Michel Lang, 1976]).

Hypocrisy in French society is denounced uncompromisingly with cynicism in the films of Jean-Pierre Mocky, and revolt in Claude Faraldo's *Bof* (1970) and *Themroc* (1972). In *Themroc*, an anonymous man (Michel Piccoli), tired with his repetitive life, breaks down all barriers and brings a feeling of liberty to his community. A film without dialogue, *Themroc* is an anarchist assault on all aspects of society, and had a mixed critical and public reception when first released, but has, since then, become a cult film among idealistic youth.

In the wake of 1968, France developed a substantial pool of comedians, scriptwriters, and directors whose reputation became an almost guaranteed source of success at the domestic box office. Many members of the group came from the *café-théâtre* movement of the 1970s, and showed a predilection for sharp mockery, socio-political satire, clichés and popular language. This style of alternative comedy, based at the Café de la Gare and Le Splendid theatres in Paris, was brought to cinema-goers in 1973 by Bertrand Blier with his controversial *Les Valseuses/Going Places*[3] (starring Gérard Depardieu, Patrick Dewaere and Miou Miou). In addition to the trio of *Les Valseuses*, the *café-théâtre* movement produced some of the most popular actors of the post-1968 era. They include Josiane Balasco, Michel Blanc, Christian Clavier, Coluche, Gérard Jugnot, Valérie Lemercier and Thierry Lhermitte. Patrice Leconte's film *Les Bronzés* (1978) and its sequel *Les Bronzés font du ski* (1979) about holiday adventures in the sun and the snow and starring Lhermitte, were a mordant parody of the Club Méditerranée but fell short of challenging stereotypes. Yet, the third in the series, *Les Bronzés 3, amis pour la vie* (2006), with a much tighter but less insolent script, topped the French box office when it was released in 2006. The comedies of Bertrand Blier, by contrast, were not populist and not always successful at the box office, either hated[4] or highly praised by film critics. That critics and audiences were often baffled by the plurality of meanings in the films of this 'agent-provocateur' (e.g. *Buffet Froid* [1979]; *Merci la vie* [1991]) seems Blier's greatest appeal.

The influence of television also started to shape comedies with comics such as Coluche and Les Nuls moving from one medium to another. In the early 1980s, Jean-Marie Poiré directed a string of successes adapted from Le Splendid theatre performances, among

them, *Les hommes préfèrent les grosses* (1981), *Le Père Noël est une ordure* (1982) and *Papy fait de la résistance* (1983) which helped launch the careers of their female stars Josiane Balasko, Marie-Anne Chazel and Valérie Lemercier, and in doing so, broke the hegemony of male French comic actors (and directors) in the following decades. Nevertheless, male duo comedies continued to dominate the genre with, for example, the Gérard Lanvin-Michel Blanc duo in *Marche à l'ombre* (Michel Blanc, 1984) and the Depardieu-Pierre Richard team in the action comedies of French director-scriptwriter Francis Veber, whose triology of *La Chèvre/The Goat* (1981), *Les compères/ComDads* (1983) and *Les Fugitifs/Fugitives* (1986), were all later turned into American remakes. The following decades saw a number of box office hits involving various partnerships between the actors who emerged in the 1980s and other French stars – Lhermitte and Jacques Villeret in Veber's *Le Dîner de cons/The Dinner Game* (1998), Lhermitte and Depardieu in *Le Placard/The Closet* (Veber, 2001), Jean Reno and Christian Clavier in *Les Visiteurs* (Jean-Marie Poiré, 1993) and its sequel *Les Couloirs du temps, les visiteurs 2/The Corridors of Time* (Poiré, 1998), and, Clavier and Depardieu in the Astérix films (*Astérix et Obélix contre César/Asterix and Obelix Take on Caesar* [Claude Zidi, 1999]; *Astérix et Obélix Mission Cléopâtre/ Asterix and Obelix Meet Cleopatra* [Alain Chabat, 2002]). By then, French comic actors were also no longer confined to roles on the big screen, as many stars successfully moved between television and the cinema – notably an increasingly prominent group of male actors from an immigrant background (i.e. Samy Naceri and Jamel Debbouze).

The Mitterrand years had seen a significant number of successful comedies challenging French society, whether they targeted France's institutions – the police in Claude Zidi's hilariously amoral film, *Les Ripoux/The Cop* (1984); gender roles in Coline Serreau's *Trois hommes et un couffin/Three Men and a Cradle* (1985) and Bertrand Blier's *Tenue de soirée/Ménage* (1986); ethnic stereotypes in Thomas Gilou's *Black Mic Mac* (1986) and social class in Etienne Chatiliez's *La Vie est un long fleuve tranquille/Life is a Long Quiet River* (1988). Film critics detected a change in audience taste for comedies that, rather than being complacent, took a more caustic if not problematic look at contemporary life in France. The genre was definitively acknowledged as worthy of the Césars when *Three Men and a Cradle*, a film scripted and directed by a woman, won three French awards including the award for best film and best screenplay in 1986. A light comedy that presents an optimistic response to a topical social issue (men's changing role in child rearing), it was critically and publicly acclaimed in France, where it sold over 10 million tickets in the year of its release, and was remade two years later in Hollywood as the even-more-popular worldwide hit *Three Men and a Baby* (Leonard Nimoy, 1987). Outside France, *Life is a Long Quiet River*, a film about two new-born babies switched in the hospital by a nurse, one from a 'respectable' bourgeois catholic family and the other from a vulgar family of dropouts and petty criminals, is often cited as a useful pedagogical tool for the study of French class differences.

The 1980s witnessed a sharp decline in cinema attendance. The major reason for this was that the two most popular genres – comedies and thrillers – tended to be made for or relegated to television. As the number of television channels increased, audiences became more demanding. Cinema was no longer the popular Saturday night entertainment of the earlier decades. The multiplex explosion also brought younger audiences to the cinema. The complacent French comedies of the past no longer satisfied the tastes of a more varied and more discerning cinema-going public. More alarmingly, in a country where film funding depends on the number of cinema tickets sold, French comedy was no longer the driving force in sustaining the viability of the French film industry. Despite new measures to help French cinema, Hollywood blockbusters continued to increase their share of the French market.

Choosing to make people laugh had become a risky business. In 1991, two young film-makers were prepared to take the risk with *Delicatessen*, a surrealist film that brought young audiences in droves to the cinema. Jean-Pierre Jeunet and Marc Caro's first feature evokes both France under the German occupation during World War II (with its evil protagonists, its brownish decors and costumes) and the early years of cinema with its circus tricks and slapstick gags involving a cast of bizarre characters. An inventive and futuristic comedy, *Delicatessen* has now become a cult classic. Ten years later, Jeunet had an even more successful crack at making people laugh with *Le Fabuleux destin d'Amélie Poulain/ Amélie* (2001), a light-hearted comedy that became the biggest French hit worldwide.

Fortuitously, it was in the year of the GATT negotiations that France managed to produce a popular comedy that broke all records at home, including beating Spielberg's *Jurassic Park* (1993) (which dominated cinemas worldwide) and *Germinal* (Claude Berri's 1993 adaptation of Zola's novel). The film was *Les Visiteurs*, Jean-Marie Poiré's time travel comedy. In 1993, Poiré used his hugely popular film to vent his anger at, among others, French actors who, in his experience, had often refused to appear in comedies and, when they had reluctantly accepted to 'debase themselves', had asked for a higher fee for doing so (cited in Nevers and Strauss 1993: 86).

The 1990s witnessed another phenomenon, as female directors were now able to pursue a career both as 'auteurs' and directors of mainstream genres (including comedies), albeit in films in which they also chose to star (i.e. Balasko's *Gazon Maudit/French Twist* [1995]). In the following decade, Agnès Jaoui became the first female director to win four Césars with her film debut, *Le goût des autres/The Taste of Others* (2000), a gentle comedy with sharp and witty dialogues in which all characters try to please someone else to conform to other peoples' tastes and expectations. She also won critical and public acclaim with her next comedies *Comme une image/Look at me* (2004) and *Parlez-moi de la pluie/Let's talk about the Rain* (2008) in which she stars with her actor-husband Jean-Pierre Bacri.

Today, France is openly encouraging the production of films with strong export potential. Faced with a relatively limited domestic

market, the French are using a number of strategies to improve their position on the international market. They include making lucrative sequels (e.g. *Taxi 2* [Gérard Krawczyk, 2000]; *Taxi 3* [Krawczyk, 2003] and *Taxi 4/Taxi 2004* [Tim Story, 2004]; *The Corridors of Time* (1998); *La Vérité si je mens! 2/Would I Lie To You? 2* [Thomas Gilou, 2001] and *La vérité si je mens! 3/Would I Lie To You? 3* [Gilou, 2012]) and producing ambitious comedies that cross borders such as the *Astérix et Obélix* films. Boasting an international cast led by Depardieu and Roberto Benigni, *Asterix and Obelix take on César* (Zidi, 1999) was promoted as the most expensive film made in the French language. With an even bigger budget, its sequel, *Asterix and Obelix Meet Cleopatra* (Alain Chabat, 2002) sold over 14 million tickets, a record performance compared to that of the other films in the series. Launched as the most awaited film of the year in 2008, *Astérix aux jeux olympiques/Asterix and Obelix at the Olympic Games* (Frédéric Forestier and Thomas Langmann) had to bow to *Bienvenue chez les Ch'tis/Welcome to the Sticks* (Dany Boon, 2008) a film shot with a fraction of the budget (€11 million). Seen by over 20 million specta-tors that year, Dany Boon's film smashed all admissions records for a home-grown film. A rural comedy about a post office manager from southern France horrified at the idea that he has been trans-ferred to the 'grim' north, *Welcome to the Sticks*, was hailed as 'the anti-depression film', 'a tribute to friendship' and 'the saviour of the nation'. Not only did it help the French share of the market reach 46 per cent, but, it 'rehabilitated northern France' with its portrayal of the Nord-Pas-de-Calais region as a place with a strong cultural – and linguistic – 'Ch'ti' identity and a warm welcome for outsiders. It also acquired a political dimension with the leader of the 'Front National' claiming that 'the people of Nord-Pas-de-Calais did not look like the characters in the film',[5] French philosopher Alain Finkielkraut stating that the film showed 'the real France', and the socialist François Hollande saying: 'this is the France we dream of, France as it was and as we would like it to be.' More reconciliatory and less prone to reaping laughs at the expense of a stereotyped 'other', *Welcome to the Sticks*, along with other successful comedies produced at the beginning of the twenty-first century mark a break from the more subversive films of the previous decades.

Comedies are often cited as one of the most valuable documents on the societies of their times. Over the years, performers with long-lasting careers such as Fernandel, Bourvil, de Funès, and Clavier along with director/writer/actor teams have dominated French comedy in the twentieth century. To-date, one film has positively captured the mood of the new century, *Welcome to the Sticks*. By producing a film totally lacking in subversiveness, largely undemand-ing yet socially – and politically – relevant, rich in good writing and in memorable performances, Dany Boon has proved that he, at least, has some understanding of what French cinema-goers, distrustful of their politicians and saturated with TV celebrity shows, want at a time of economic gloom and global anxiety. And, for once, French critics have not been blind to the merits of his vigorous, populist cinema.

Anne Jackel

Table 1:

Best performing comedies in France 1958-2010 (over 10 million spectators)

Welcome to the Sticks	2007	20
Les Visiteurs	1993	17
Don't Look Now We're Being Shot At	1966	17.2
Asterix and Obelix Meet Cleopatra	2002	14.3
The Sucker	1965	11.8
Les bronzés 3: amis pour la vie	2006	10.3
Taxi 2	2000	10.2
Three Men and a Cradle	1985	10.1

References

BFI (British Film Institute) (1981) 'A Serious Look at Comedy', document prepared for the BFI for its Education Study Weekend, Manchester, 9–11 January.

Harvey, Susan (1993) French National Cinema, London: Routledge.

Haustrate, Guy (1988) Bertrand Blier, Paris: Edilig.

Nevers, Claire and Strauss, F. (1993) 'Entretien avec Jean-Marie Poiré et Christian Clavier'/ 'Interview with Jean-Marie Poiré et Christian Clavier', Cahiers du Cinéma, 465, pp. 84–89.

Robinson, David (1987) 'Rise and Fall of the Clowns, The Golden Age of French Comedy', Sight & Sound, 56, pp. 198–203.

Sorlin, Pierre (1991) European Cinemas European Societies 1939–1990, London: Routledge.

Vincendeau, Ginette (1995) Encyclopedia of European Cinema, London: BFI.

Notes

1 The characters' names were regarded as the property of the companies and actors were obliged to change names when they moved to other studios.

2 Fernandel and Bourvil continued their successful comic careers until the late 1960s. De Funès made his last Gendarme appearance in 1982.

3 Notorious for its sexually explicit and stylistically naturalistic humour, the film undermines the male stereotype of the macho stud, yet, like most of Blier's work, it never confronts the filmic objectification of women.

4 Guy Haustrate (1988) called Going Places 'a Nazi' film.

5 Both director Dany Boon and lead actor Kad Merad are French. Boon was born in Armentières, near Lille (his father was a Kabyle), Merad was born in Algeria.

Amélie

Le Fabuleux destin d'Amélie Poulain

Studio/Distributor:
Claudie Ossard Productions

Director:
Jean-Pierre Jeunet

Producers:
Claudie Ossard
Helmut Breuer
Jean-Marc Deschamps
Arne Meerkamp van Embden

Screenwriters:
Jean-Pierre Jeunet
Guillaume Laurent

Cinematographer:
Bruno Delbonnel

Art Director:
Marie Laure-Valla

Composer:
Yann Tiersen

Editor:
Hervé Schneid

Duration:
122 minutes

Genres:
Comedy
Fantasy
Romance

Cast:
Audrey Tatou
Mathieu Kassovitz
Rufus
Jamel Debbouze

Year:
2001

Synopsis

A wide-eyed young woman named Amélie Poulain lives an inconspicuous life as a waitress in a quaint area of Montmartre. One day she discovers a tin box hidden behind a wall in her apartment. Upon examining its contents, she determines it is a keepsake left by a boy decades earlier, and sets out to find its now grown-up owner. The man's emotional response to Amélie's efforts inspires her to engage in a series of similar feats of goodwill in her neighbourhood, including an elaborate scheme where she steals her own father's garden gnome and gives it to a globe-trotting air hostess friend, who takes pictures of the little fellow and anonymously mails them back to Monsieur Poulain. Unfortunately, Amélie herself remains too shy to counter the advances of the charming Nino Quincampoix. In the end, she conquers her fears in an emotional dénouement set up by a memorable cat-and-mouse scavenger hunt staged around the Sacré Coeur.

Critique

If Jean-Pierre Jeunet's films often exacerbate French cinema's conflicted relationship to the global market, that is because his signature style continues to be at once commercially appealing and nationally identifiable. All of Jeunet's French-language films pulse with playful references to his home country's heritage and cinematic iconography while employing a sleek aesthetic that draws on trends in global popular film-making. From his co-authored films with Marc Caro in the 1990s to the recent *Micmacs* (2009), this blend of features has inspired some critics to embrace him as a populist, crossover auteur and others to reject him as an all-too willing instrument of corporate profiteering. At no point has this contrast been more volatile than around his fourth feature film, *Le Fabuleux destin d'Amélie Poulain* (known simply as *Amélie* in English) which in 2001 broke box office records, made Audrey Tautou an international star, and reinvigorated perennial questions about the scope of France's cinematic ambitions in a Hollywood-dominated marketplace.

 A large part of *Amélie*'s endurance through the years derives from its deceptive simplicity. An upbeat story about a shy young woman who solves her neighbours' problems through well-intended guile and creative craft-making, *Amélie* exhibits most all of the stylistic preoccupations of Jeunet's prior work, including a systematic use of wide-angle lenses, flagrant close-ups that cast its actors in a cartoonish light, and vibrant colour schemes. Abetted by state-of-the-art digital film processing techniques and the careful lensing of cinematographer Bruno Delbonnel. These elements combine with Yann Tiersen's original, accordion-heavy score to overlay the film's settings with a ludic, almost otherworldly texture. They also mark both a stylistic continuity and departure from the macabre atmospherics of Jeunet's two previous co-directed features with Marc Caro (*Delicatessen* [1991], *The City of Lost*

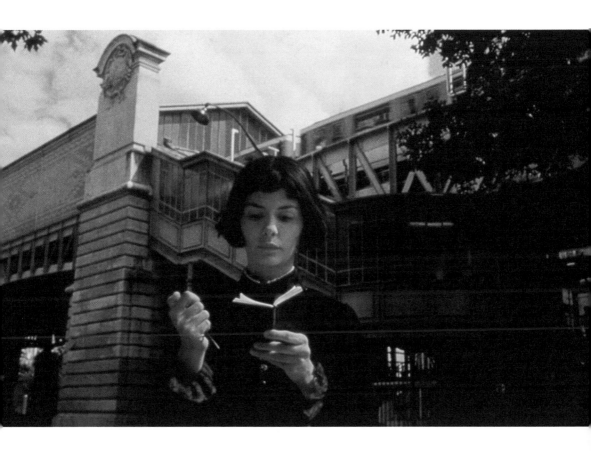

Amélie, Ugc, Studio Canal+.

Children [1995]), which are laced with traces of France's national and cinematic heritage, but remain immersed in their highly stylized worlds, impervious to credible claims of realistic intent. To the contrary, many scenes of *Amélie* were shot on-location in Montmartre, feasting on its surrounding neighbourhoods and rooted in the local particularities of demarked national cultural referents (centred on the now emblematic Café des Deux Moulins). All the same, these sights and sounds are strikingly bereft of the grime and grit that most any regular visitor expects of the Parisian streets (the surfaces of the two featured metro stations, Abbesses and Lamarck-Caulaincourt, look clean enough dine on), not to mention the socio-cultural diversity of the real capital city (Jeunet's 'whitewashing' of the Montmartre *quartier* even involved the refashioning of an Arab-owned grocery store to better fit the desired aura). As if to emphasize this stylistic shift for initiated *cinéphiles*, Jeunet cast the well-known Kassovitz as Nino just as the actor-director's own career was turning away from stark realism of films like *La Haine/ Hate* (Mathieu Kassovitz, 1995) and towards glossy American-style genre films.

As the film's popularity grew, so too did the critical focus on all of these features. Many critics initially trumpeted *Amélie*'s virtues,

embracing the film as a welcome, optimistic variation on the depressing, atavistic norms of other recent French film-making. But this apparent consensus soon induced a backlash, as others charged Jeunet with mortgaging authenticity at the door of universal goals. If *Amélie* offered anything 'French', they claimed, then that was at the expense of trading in a clichéd, consumable form of nostalgia. The most polemical attack came from Serge Kaganski, editor of the hip culture journal *Les Inrockuptibles*, whose acerbic op-ed for the left-leaning paper *Libération*, entitled 'Amélie pas jolie' ('Amélie not so pretty') generated a media firestorm by accusing the film of an outright racist neglect of the ethnic and cultural diversity of contemporary Paris.

Whatever one's stance, it bears noting that *Amélie* itself is far from naïve about the dynamics of its own cinematic interventions. Any careful reading of the film recognizes its quite purposeful turn away from the rough-hewn socialist realism that pervades French cinema's recent international legacy. On this view, Tatou et al. are staged as the veritable puppets in a sort of fantastic allegory for the local particularities of France-as-created-symbolic-place. As Elizabeth Ezra convincingly argues in her recent book on Jeunet, the film fairly trades in various registers of iconic representation – from narrative devices like the fast-paced 'likes and dislikes' segment to the film's overall aesthetic debts to luminaries like Prévert, Carné, Clair and both Renoirs.

So where does *Amélie* fit? Difficult to capture its double-edged legacy any better than Jason Reitman in his 2009 Hollywood romantic comedy *Up in the Air*. One subplot features a soon-to-be married couple unable to afford a honeymoon. As a testament to their unrequited dreams, the two families compile a series of photographs from exotic locales, each with an identical cardboard cutout of the pair in the foreground – much like Monsieur Poulain's (Rufus) garden gnome. When asked about her inspiration for the gift, the bride's older sister explains that she wanted to do something 'like in that French movie'. By now an indelible part of the romantic comedy as international genre, *Amélie* remains one of few foreign titles (let alone French ones) to pierce the consciousness of everyday multiplex-goers the world over. That it accomplished this without mention of the dreaded words 'Hollywood remake' speaks volumes to its place as a contemporary popular classic – as well as a touchstone for Franco-European production practices of the early twenty-first century.

Charlie Michael

Côte d'Azur, Agat Films & CIE, BAC Films.

Côte d'Azur

Studio/Distributor:
Agat Films & Cie

Directors:
Olivier Ducastel
Jacques Martineau

Producer:
Nicolas Blanc

Screenwriters:
Olivier Ducastel
Jacques Martineau

Cinematographer:

Synopsis

On vacation with his family, Charly, a straight teenager, does not correct his parents Marc and Béatrix, who think he might be gay. However, his charade does frustrate his gay best friend Martin, who has a crush on him, as well as Didier, a gay man who meets Charly at a local cruising spot. Meanwhile, Charly's parents are harbouring their own secrets. Béatrix is having a secret affair with Mathieu, and Marc is suppressing his homosexual desires; he once was in a passionate relationship with Didier. When Charly reveals his deception, Marc and Béatrix are both prompted to tell the truth about their love lives.

Critique

Côte d'Azur is an aphrodisiacal sex farce, featuring two enchanting musical numbers. The film builds on the tradition of partners and film-makers Olivier Ducastel and Jacques Martineau to create

Matthieu Poirot-Delpech

Production Designer:

Lise Petermann

Composer:

Philippe Miller

Editor:

Dominique Galliéni

Duration:

96 minutes

Genres:

Comedy
Musical
Romance

Cast:

Valeria Bruni Tedeschi
Gilbert Melki
Jean-Marc Barr
Jacques Bonnaffé
Edouard Collin
Romain Torres
Sabrina Seyvecou
Yannick Baudin

Year:

2005

frothy French films about embracing queer sexuality. The film-makers have acknowledged in an interview that they did not intend to make a farce. Rather, they took their cue from Eric Rohmer's sophisticated comedies like *Pauline à la plage/Pauline at the Beach* (1983). They also did not plan to make a musical, having done so already in their debut feature, *Jeanne et le garcon formidable/ Jeanne and the Perfect Guy* (1998). The film's origins are less about genre, however, and more about character. It was the buried plot-line about Marc (Gilbert Melki) reuniting with his first love, Didier (Jean-Marc Barr), which inspired *Côte d'Azur*.

At the start of the film, Marc and Béatrix (Valeria Bruni Tedeschi) appear to be an affectionate, happily married couple. During an excursion to the beach, they each describe things they thought were true/real but were in fact imagined. This theme plays out throughout *Côte d'Azur* as the parents have trouble distinguishing reality and being honest. Although they enjoy violets (oyster-like crustaceans) that lead to sex, Marc and Béatrix are – she admits to her lover Mathieu (Jacques Bonnaffé) – not particularly active sex partners. However, instead of sorting out their romantic troubles, the couple focuses on their children's sex lives. Their daughter, Laura (Sabrina Seyvecou) leaves shortly after arrival for a 'sex-capade' vacation in Portugal with her biker boyfriend Michaël (Yannick Baudin). After the arrival of Charly's (Romain Torres) queer friend Martin (Edouard Collin), Béatrix soon comes to the erroneous conclusion that her son is gay. The film's many farcical misunderstandings arise as a result of this confusion.

The film-makers also use each character's perpetual horniness to produce laughs. The various characters vigorously masturbate – always in an exaggerated, comic fashion – in the shower, and a running joke concerns the house's lack of hot water. Erections are also the source of embarrassment and humour throughout *Côte d'Azur*. When Martin proudly exposes himself to Charly, his friend runs from the bedroom, causing Martin to tell his penis, 'I think you scared him.' Another incident has Marc aroused after spying on Martin on the beach, and trying to hide his erection from Béatrix when she coaxes him to go into the water.

Duscastel and Martineau use these overly sexualized comic incidents to diffuse hang-ups about gay and straight sexuality. The point of their farce is to suggest that sex in general, and homo-sexuality in particular, is natural and pleasurable – not shameful. As such, Charly and Marc, the two characters who play games with their sexuality, are the butts of the jokes. Charly's 'game' backfires on him not only for the teasing of Martin, who loves him, but when Didier picks him up for gay sex. This episode ends with Didier learning that Charly is his old flame Marc's son, which leads to Marc ending the charade regarding his sexuality. While Marc was once bold and in love with Didier – his romantic letter includes the lines, 'My future is with you. We'll stand up to others. Our love is beauti-ful. It will silence them,' he is now married and shy/closeted. Marc becomes amusingly flustered as his simmering same-sex desires start to boil over whenever he is around Martin – accidently spying on the teen in the shower, and even innocently sharing a bed with

him one night. It is only after he jealously interrupts Martin kissing Didier that Marc resolves his sexual identity crisis.

To help make their points about sexuality, the film-makers claim they deliberately cast openly gay actor Collin and straight actor/gay icon Barr in the film's queer roles. It may be because each actor projected a self-confidence that is irresistible. Martin is touching because he just wants to have sex and be loved – but among all the characters, he has the hardest time fulfilling his desires. In contrast, Barr has no trouble finding sex. Wearing tight t-shirts that accent his buff physique, Didier exacts an almost magnetic pull on the men he kisses. Likewise, Collin and Barr both appear nude (from behind) in the film, which the film-makers suggest emphasizes their comfort with their sexuality and their bodies. Melki, the film-makers insist, was shy regarding nudity, and only agreed to appear 'half-naked' in the film. Melki displays his body only while wearing shorts/bathing trunks. (For the record, Torres' only nude scene has him pressing his buttocks against the glass shower door).

Yet the film is sexual without ever being explicitly erotic. The gay sex – which occurs only between the adult characters Marc and Didier – takes place off screen, indicated by a 'morning after' scene in which the nude Didier removes handcuffs he used to attach Marc to the bedpost. Significantly – and perhaps ironically – most of the on-screen sex in *Côte d'Azur* is of the heterosexual variety. Marc and Béatrix consummate their love after eating the violets, and Béatrix and Mathieu have various trysts outdoors. Amusingly, Béatrix is turned on by talk of seafood, and Mathieu's discussion of crustaceans seduces her.

But while it may be a sex farce, *Côte d'Azur* is really about love. The film ends with a delightful coda in which all the characters are partnered. The actors sing and dance during a fun musical number that echoes a song Béatrix and Marc perform for Charly and Martin at the film's midpoint. The performance emphasizes that everyone is now comfortable with everyone's sexuality.

Gary M. Kramer

The Bear and the Doll

L'Ours et la poupée

Synopsis

Gaspard is a single father living in a country house with his son and three more-or-less adopted nieces. Immersed in domestic routines, he has withdrawn from the world, travelling to Paris only to perform as a concert cellist. Félicia is a wealthy socialite, a multiple divorcée accustomed to urban splendour and endless parties. After they crash cars – Félicia in her Rolls Royce, Gaspard behind the wheel of a trusty 2CV – she pursues him ruthlessly, and he reluctantly, combatively, succumbs to her charms.

Studio/Distributor:
Marianne Productions

Director:
Michel Deville

Producer:
Mag Bodard

Screenwriters:
Nina Companeez
Michel Deville

Cinematographer:
Claude Lecomte

Composer:
Eddie Vartan

Editor:
Nina Companeez

Duration:
85 minutes

Genre:
Comedy

Cast:
Brigitte Bardot
Jean-Pierre Cassel
Daniel Ceccaldi
Georges Claisse

Year:
1969

Critique

The Bear and the Doll is a spritely product of the rich but
neglected partnership between co-writer/director, Michel Deville,
and co-writer/editor, Nina Companeez. Mentioned sometimes in
the same breath as the New Wave, Deville was more commercially
inclined, befitting his origins as for seven years Henri Decoin's
assistant, learning his trade in the 1950s by primarily working on
comedies and policiers. Companeez, alongside Deville for a dozen
memorable films, from *Ce soir ou jamais/Tonight or Never* (1961)
to *Raphaël, ou Le débauché/Raphael or the Debauched One*
(1971), took on the creative role of writer-*dialoguiste*-editor before
starting her solo career as a film and TV director and occasional
script doctor. With *The Bear and the Doll* a definite highlight,
the Deville-Companeez series is characterized by genre-crossing
(period films, contemporary war-of-the-sexes comedies, crime
caper pictures and straight dramas), deliciously droll dialogue,
brisk pacing, usually a compressed timeframe (*The Bear and the
Doll* spans a day, a night, and the early morning after), music and
musical editing patterns, and an oddly affecting parable or fairy
tale-like tone.

A film about bears and dolls, *The Bear and the Doll* is obsessed
with gender sparring. In some ways a reworking of the classical
Hollywood screwball comedy, the film revels in the endless frictions
between its antagonistic central couple. There is Gaspard's (Jean-
Pierre Cassel) high art chamber music versus the raucous 1960s
pop at Félicia's (Brigitte Bardot) never-ending *soirées*; his rural
country home versus her Jacques Tati-like modern city apartment
building; his fatherhood domesticity versus her carefree hedonism;
his poverty versus her wealth; and, of course, his rugged French
2CV versus her English Rolls Royce. Any film starring Brigitte
Bardot tends to draw flak for her lack of range as an actress, but
as Félicia, thirteen years on from *Et Dieu… créa la femme/… And
God Created Woman* (Roger Vadim, 1956) and nine after her
first suicide attempt, Bardot is skillful in the lead role, with a few
worry-lines nuancing her porcelain features, as her character oscil-
lates between pampered pouting and a tinge of something more
sincere. In fact, when *The Bear and the Doll* was released Bardot
credited Deville in interviews with having re-launched and revived
her creatively. This would prove to be the last phase of Bardot's
screen career, however, as she retired in 1973 after being directed
by Companeez for *L'Histoire très bonne et très joyeuse de Colinot
trousse-chemise/The Edifying and Joyous Story of Colinot* (1973).

Besides the assured performances – Bardot's insouciance grind-
ing down Cassel's truculence – *The Bear and the Doll* benefits from
Companeez's flair in her unusual twin job of writer-editor. As dia-
logueist, Companeez delights in puns, alliterations, wordplay and
linguistic reversals. After crashing their Rolls then forgetting exactly
where it happened ('It's a bit vague') Félicia dismisses one ex-hus-
band, shifting gears effortlessly from ditzy to devastating with the
lovely put-down: 'What a pity one can only divorce once.' When
she later turns on an exasperating Gaspard, Félicia blurts in quasi

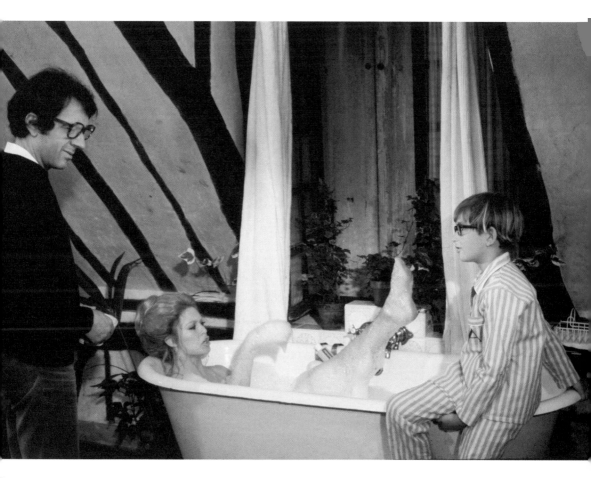

Ours et la poupée, Parc, Marian.

blank verse: 'Lâche! Lâche! Lâche-moi!' ('Coward! Coward! Let me be!') As editor, Companeez's work is similarly deft. One particularly brilliant cut takes us from the sweeps of Gaspard's hand playing the cello in Paris to the back-and-forth of a manicurist rubbing an emery board over Félicia's exquisite fingernails. Companeez's edit at once provides a perfect graphic match, a clever syncopation of physical rhythms, and an early hint of the couple's connected behaviour, that *both* characters are equally demanding: Félicia's oblivious neediness parallels Gaspard having kept the entire orchestra waiting by showing up late for rehearsal. Another running visual gag – Bardot's customary constant costume changes – is also amplified by Companeez's cutting. While Félicia is ensconced at the beauticians she makes phone calls to track Gaspard down, and each cut back to her barking into the phone shows her with a different hairstyle, three across four edits.

For its final segment, *The Bear and the Doll* engagingly dissects the gender alignments of its mismatched couple. Avoiding the increasingly dour political approach of Godard, Deville and Companeez prefer the ironic playfulness of someone like Demy, or, really, a back-and-forth mischief all of their own. (Symptom-

atic of Deville-Companeez's mock self-reflexivity is the opening of their *L'Appartement des filles/Girls' Apartment* [1963], set in an airport, which features a bored tannoy announcer reciting the film's credits.) Holed up overnight at his country house, Gaspard stubbornly resists Félicia's onslaught – at one point hiding in the kitchen behind his pots and pans – and she denounces not only his disingenuous role of domestic provider, but also correspondingly the limited agency allowed to a female pursuer. 'What's normal in a man is ridiculous or shameful in a woman,' she protests: 'We say *un Don Juan* [i.e. in the masculine tense] but *une nymphomane* [i.e. conjugated as feminine] […] our hands are tied!' Next, she changes into more masculine attire ('Some things I can't say but I could if I were a man') and tries a new seduction model, striding towards him as a sexual aggressor, lighting a phallic cigarette, while Gaspard quivers in the corner. This comedic flagship sequence simultaneously mocks French male pride (Félicia starts her routine by blowing smoke in Gaspard's face), knowingly inverts Bardot's sex kitten persona (she kicks Gaspard's housecat aside then compliments him on his pouty lips: 'You know your mouth is driving me crazy?'), and unravels the household's domestic hierarchy (Gaspard shrieks '*Mummy!*' and Companeez cuts to his young son, slumbering in bed upstairs, muttering, 'Shut up, Daddy'). Ultimately, like most of their decade of cinema together, *The Bear and the Doll* shows Deville and Companeez's affinity for elegant entertainments, subversive social *divertissements*, delightful film confections with intriguing aftertastes.

Tim Palmer

Season's Beatings

La Bûche

Studio/Distributor:
Canal+

Director:
Danièle Thompson

Producers:
Christine Gozlan
Alain Sarde

Screenwriters:

Synopsis

For one extended family, Christmas is a time of death, dysfunction and digging up the past. While Yvette loses her husband, her daughters face loneliness and uncertainty about the future. Louba is involved with a married man and unexpectedly pregnant, Sonia's unfaithful husband prepares to leave her and cracks begin to appear in single Milla's armour of aggressive self-sufficiency. However, the unexpected appearance of the girls' secret half-brother, alongside the acceptance by his father of Louba's unborn child and the final triumph of sisterly love, provide some warmth amid the wintry chill.

Critique

Released in the lead up to the last Christmas of the twentieth century, *Season's Beatings* is the directorial debut of prolific screenwriter Danièle Thompson, daughter of well-known comic director, writer and actor Gérard Oury. It is the first of the films which,

Danièle Thompson
Christopher Thompson

Cinematographer:

Robert Fraisse

Composer:

Michel Legrand

Editor:

Emmanuelle Castro

Duration:

106 minutes

Genres:

Comedy
Drama

Cast:

Sabine Azéma
Emmanuelle Béart
Charlotte Gainsbourg
Claude Rich
Francoise Fabian
Christopher Thompson
Jean-Pierre Darroussin

Year:

1999

along with her subsequent (romantic) comedies, have assured Thompson's status as a successful popular film-maker. Peopled by a host of top and middle-level stars, the film drew 1.6 million spectators into cinemas. In addition to its saleable cast, it is typical of French comedy, and particularly films directed by women, in marrying humour with melodrama, the woman's film par excellence, as the English title's punning focus on conflict reflects.

Like the film Thompson co-wrote with director Êlie Chouraqui six years earlier, *Les Marmottes/The Groundhogs* (1993), *Season's Beatings* focuses on relationships within a *famille recomposée*, the complicated form of contemporary family resulting from the rise of divorce. This family comprises, principally, grown-up sisters Louba (Sabine Azéma), Sonia (Emmanuelle Béart) and Milla (Charlotte Gainsbourg), their divorced and initially estranged parents Russian-Jewish immigrant Stanislas (Claude Rich) and Yvette (Francoise Fabian) and their secret illegitimate half-brother Joseph (Christopher Thompson).

Ensemble films like this one appear with a striking frequency in the work of popular female directors in France, perhaps linked to the highly relational structure of women's social experience historically, while depictions of family life offer particular points of significance for female authors and consumers. Interviewed about *La Bûche*, Thompson has additionally stressed her interest in the universal aspect of family stories; and in the film she sets up familial myths in order to explode them. At first, the three sisters are caricatured: Milla is the selfish workaholic youngest sister with no time for others, acerbic, make-up-free and clad in biker leathers or shapeless khaki; Sonia is the perfect bourgeois housewife and mother, with no concerns beyond the Christmas decor; and Louba is the kind but childless and penniless other woman to married Gilbert (Jean-Pierre Darroussin), living with her father at 42. In this play on cultural perceptions and archetypes, the film looks forward in particular to Thompson's later film *Fauteuils d'orchestre/Orchestra Seats'* folkloric tale of the innocent in the big city. However, as the narrative of *Season's Beatings* progresses, these roles are destabilized, not least by their occasional interchangeability in the multi-protagonist constellation. When Sonia tells Louba the story of Joseph's illegitimate birth, instead of sympathizing with their mother, the victim of adultery, Louba, herself pregnant, identifies with the plight of Joseph's poor single mother, left to raise a clandestine child alone. Louba's refusal to judge is only vindicated by an earlier revelation by Yvette that she too cheated prolifically on Stanislas – just as we later discover Sonia is also cheating on her husband, with a butcher whom she barely knows.

The Christmas holiday is key to the film's exploration of the difficulties of familial relationships, with tension evident, for example, in the disputes over invitations to the Christmas Eve dinner, which both Yvette and Stanislas would like to attend, but not together. Secondarily, the festive setting provides a fulcrum for the film's different generic participations. As befits melodrama, the characters of *Season's Beatings* are suffering in the build-up to the holiday: Yvette is newly widowed, Stanislas possibly dying, Sonia on the

brink of divorce, and Milla lonely and tearful. However, if melodramatic themes appear far removed from the optimism of romantic comedy, the festive backdrop, whose lights are celebrated in an opening credit sequence accompanied by a cheery rendition of 'Jingle Bells', simultaneously creates a magical space outside the everyday in the same way as New Year's Eve functions in *When Harry Met Sally* (Rob Reiner, 1989) or Valentine's Day in *Sleepless in Seattle* (Nora Ephron, 1993).This paves the way for the romantic plot-lines which run alongside those of familial drama here. Notably, Louba's adulterous relationship with Gilbert, climaxing on Christmas Eve, at once exploits and acknowledges the power of romance to mystify, as in her remark that he only likes her because she represents bohemia, thanks to her job as an 'exotic' Russian folk dancer. Such details suggest a knowingness about the self-delusion implied by romance.

Elsewhere the narrative focuses repeatedly on the damage divorce causes for children, illustrating a broader cinematic preoccupation in recent years with the fate of French children from a socio-demographic and political perspective. Yet despite this, and arguably mimicking something of the momentum of pregnancy itself as a cultural narrative, Louba's impregnation at 42 is constructed overwhelmingly positively, perhaps reflecting changing attitudes towards the 'right' age for motherhood. Here *Season's Beatings* is typical of French cinema as a whole and contemporary women's film-making in particular in venerating maternity, for reasons that can be linked to the emphasis placed on the female body by influential French feminists (Irigaray, Cixous, Kristeva). Having said that, a degree of narrative reflexivity further contributes to the film's interest in the construction of stories and undermines straightforward interpretations. Notable here are intertitles counting down the days until Christmas and, especially, several instances of to-camera addresses, where characters narrate seemingly significant memories, at odds with the film's otherwise broadly classical style. Interestingly, near the end of the film Sonia's story about her childhood self and a friend bumping into her father with his girlfriend explicitly references Truffaut's *Les Quatre cents coups/The 400 Blows* (1959). Dabbling in the kind of referential play usually associated with auteurs in French cinema, and appropriating one of the definitive films of the New Wave canon to her popular ends, Thompson at once situates herself, as it were, in good company, stresses all narratives' fictionalizing tendency and cocks a final wink to the audience.

Mary Harrod

The Taste of Others

Le Goût des autres

Studio/Distributor:
Canal+

Director:
Agnès Jaoui

Producers:
Christian Bérard
Charles Gassot

Screenwriters:
Agnès Jaoui
Jean-Pierre Bacri

Cinematographer:
Laurent Dailland

Art Director:
François Emmanuelli

Composer:
Jean-Charles Jarrel

Editor:
Hervé de Luze

Duration:
113 minutes

Genres:
Comedy
Drama
Romance

Cast:
Anne Alvaro
Jean-Pierre Bacri
Alain Chabat
Agnès Jaoui
Gérard Lanvin
Christiane Millet

Year:
2000

Synopsis

Castella is a factory owner about to sign a lucrative contract. For his protection he is accompanied each day by his private bodyguard, Franck. He is encouraged by a colleague to learn English, so an appointment is made with an English teacher, Clara Devaux but Castella summarily dismisses her. Later that day Castella's wife Angélique takes him to watch his niece perform in Racine's tragedy *Bérénice*. During the performance Castella sees Clara on stage and is immediately entranced. Enchanted, he tries to insert himself into the artistic and cultural milieu in which Clara moves, but, because of his cultural ignorance, poor taste and philistinism, only succeeds in making a fool of himself. Undeterred, he persists in his efforts to win her affection.

Critique

The Taste of Others was the directorial debut for director/writer/actor Agnès Jaoui, and like her subsequent films *Comme une image/Look at Me* (2004), and *Parlez-moi de la pluie/Let it Rain* (2008), it was co-written with her partner Jean-Pierre Bacri. The plot centres on factory owner Castella (Jean-Pierre Bacri), who is due to sign a lucrative deal, and must be protected by a bodyguard, Franck (Gérard Lanvin), until the contract is signed. Around Castella emerges a nexus of characters whose lives both interact and intersect. Castella's wife Angélique (Christiane Millet) is an interior designer whose only tastes include the chintzy and gaudy. Angélique's chauffeur Bruno (Alain Chabat), whose fiancée is in the United States for four more months, becomes involved with a local barmaid Manie (Agnès Jaoui). Manie, while on a date with Bruno, meets Castella's bodyguard Franck, and begins a relationship with him, until Franck realizes she is a small-time drug dealer who regularly sells hashish to theatre actress and English teacher Clara Devaux (Anne Alvaro), whose pupil is Castella.

If taste can be defined as a personal attitude or reaction, to aesthetic or social phenomena, for good or bad, we can see numerous examples throughout Jaoui's film. Castella lacks any kind of aesthetic taste, finding the verse of Racine annoying, and confusing the opening bars of an operatic piece with 'Juanita Banana'. Castella's wife Angélique deplores the costumes worn at the performance of Racine's Bérénice, yet her house is full of gaudy pinks and yellows with everything covered in flowers. Later, Castella buys one of Benoît's paintings in penance for his homophobic remarks to Antoine at a gallery opening, but he clearly does so with no idea of the artist's concept or theme. Castella buys it simply because he likes it, in much the same way that a cow eats grass because it likes it. Angélique complains that the theatre is boring, yet is riveted by the melodramatic divorces of soap-operas. One clear example of bad taste is when Clara, her friends, and Castella sit at a table discussing theatre and art, it is Castella who is telling 'vomit' and 'faecal' jokes.

Alongside 'the taste of others', we can also detect in Jaoui's film what might be termed the 'otherness of taste'. There is a clear demarcation between Castella and the theatrical crowd into which he tries to insert himself. From the very beginning they are cognizant of Castella as 'other', a tasteless, bourgeois philistine, who is inferior and worth ridiculing. At a post-performance meal while sitting with drinks around a table, they jest with Castella, telling him that Henrik Ibsen and August Strindberg are comic playwrights after Castella remarks that the play just seen by all was 'funny', even though it was deplored unanimously by Clara and her friends. At this point the camera switches to Franck's point-of-view as he watches Castella, and as the table bustles with conversation with everyone talking among themselves, the camera frames Castella who is silent, desperately seeking a conversation in which to engage. Framed in such away, Castella's alterity is made explicit.

The Taste of Others, is a confident debut, by a writer/director who is sensitive to the nuances of character, both the little and the profound things that take place with human relationships. There is more to *The Taste of Others* than taste and alterity; what we find in Jaoui's characters is a human need to be accepted and to offer acceptance when confronted with difference and, more than anything, to respect, if one cannot share, the tastes of others.

Zachariah Rush

Heartbeat

Le Schpountz

Studio/Distributor:

Les Films Marcel Pagnol
French Motion Picture
Corporation

Director:

Marcel Pagnol

Producers:

Marcel Pagnol
Charles Pons

Screenwriter:

Marcel Pagnol

Cinematographers:

Willy Faktorovitch
Roger Ledru

Set Designers:

Synopsis

Meaning 'fool' or 'bungler' in Russian Yiddish, the on-screen 'Le Schpountz' is Irénée Fabre, an obtuse, cinema-obsessed store clerk convinced that he has a natural gift for acting. When Irénée harasses a production crew visiting his small provincial town, they stage a mock audition and draw up a fake contract that brings him to Paris. There he finally realizes the depth of his own ridiculousness, settling for a job in the studio's accessory department until a producer struck by his natural buffoonery casts him in a comedic role that yields immediate fame and fortune.

Critique

Hostile critics often denigrated Pagnol's films as 'canned theatre' in reference to his unsophisticated visual technique claiming that the image should serve as a supplement to the spoken word. But the huge profits generated by *Marius* (1931) and *Fanny* (1932) – co-directed adaptations of his hit plays by the same name – afforded Pagnol a unique measure of independence in an industry struggling to compete with Hollywood imports due to corruption and organizational disarray. From 1933 on, Pagnol served as his own writer, producer, director and distributor, even building his own studio complex and acquiring two small cinemas in his hometown

Marius Brouquier
René Paoletti

Sound Engineers:

Jean Lecoq
Marcel Lavoignat

Composers:

Casimir Oberfeld
Jean Manse

Editor:

Suzanne de Troye

Duration:

129 minutes

Genre:

Comedy

Cast:

Fernandel
Oranze Demazis
Fernand Charpin
Léon Bélières
Robert Vattier

Year:

1938

of Marseille. An incisive satire in the tradition of Rabelais, Molière and Charlie Chaplin, *Le Schpountz/Heartbeat* lays bare the illusory nature of film-making and the problems plaguing the French cinema industry while simultaneously expressing a sincere love for the profession and celebrating its humanistic, socially redemptive potential.

Pagnol took special care to defend comedy, which French social commentators often denigrated as a superficial, frivolous genre responsible for intellectually stultifying the masses. When Irénée (Fernandel) complains to his love interest Françoise (Oranze Demazis) that humiliating oneself for the amusement of others is a 'disgraceful' profession, she replies earnestly, citing Molière and Chaplin before making the following proclamation: 'Don't speak ill of laughter. Laughter is a human thing, a virtue that belongs only to human beings and that God perhaps gave them to console them for being intelligent.' These lines serve as the basis for a theory of comedy that Pagnol fully articulated a decade later in his 1947 essay 'Notes sur le rire'. Like philosopher Henri Bergson, he defined laughter as 'the expression of a sudden, momentary sense of superiority experienced by the laugher over the person being mocked', but went a step further by identifying that dynamic as the key to forging true understanding across artificially constructed social and cultural boundaries:

Feeling compassion means feeling equal to another human being who is suffering and whose fate we fear will befall us. […] Selfish in its causes, compassion is lovely and noble in its consequences. Like laughter, it is uniquely human, and laughter stops where compassion begins. (Pagnol 1995: I, 1006–7)

As in most of Pagnol's films, *Heartbeat* blends comedy and pathos to symbolically purge conflict that threatens to fracture family, community and nation.

At the time of the film's release in April 1938, French society was deeply divided. The Popular Front coalition government led by the Socialists and Communists had just collapsed under vicious attacks from its right-wing adversaries, dashing the hopes of the working classes and reasserting the dominance of the bourgeoisie. By dramatizing Irénée's initial failure to realize his grandiose ambitions, Pagnol underscores the inherent difficulty of socio-economic ascent in French society. The decision to ultimately indulge that same fantasy by having Irénée achieve stardom derives perhaps from Pagnol's own meteoric rise from humble beginnings and his belief in the social value of uplifting art. It might further be read as a reflexive commentary on the financial benefits of selling escapist entertainment to spectators struggling through the Great Depression.

The film also contains a more explicit socio-political dimension by referring to popular anxieties over immigration, anti-Semitism, and the perceived dissolution of French cultural identity. In addition to ridiculing fictitious immigrant director Bogidar Glazounow – described as 'a German or a Turk who took a Russian name and

speaks with an Italian accent, which allowed him to become a great French director' – *Hearbeat* dramatizes the swindles of an assimilated Jewish film producer and studio owner named Meyerboom. Modelled after Bernard Natan, a Romanian Jew arrested for fraud and blamed for the real-life bankruptcy of the Pathé corporation in 1936, Meyberboom unabashedly explains how to create a movie on paper and steal potential investors' money through a web of fake contracts. Yet he ultimately emerges as a sympathetic, even tragic character whose wealth and power have alienated him from others and prevented him from experiencing true love or friendship.

Rather than prompting consensus, such equivocation drew strong criticism from both sides of the political spectrum. While commentators on the Left deplored the film's xenophobic undertones, those on the Right denounced it as excessively conciliatory toward Jews and foreigners. Pagnol responded to the controversy by recalling all copies circulation and cutting the sequence that identifies Meyerboom as Jewish – an unusual and expensive measure that speaks to his personal convictions. In a December 1938 review of the novel *Mangeclous* (1938) by childhood friend Albert Cohen, the film-maker spoke out against the Nazi-orchestrated *Kristallnacht* pogrom in Berlin and made an impassioned plea for the fundamental compatibility of Jewish and French identity:

> Cohen's characters bear no resemblance to the one-dimensional Jews that one sees in certain novels to illustrate an argument or symbolize for Gentiles some aspect of the Jewish soul. They are Jewish as one is Breton or Basque or Marseillais. (Pagnol 1938: 7)

When read in relation to *Heartbeat*, Pagnol's comments can be understood as an implicit critique of his own failed attempt to accomplish the same goal.

If in retrospect the film stands as a testament to the ideological polarization and profound malaise afflicting French society on the eve of World War II, it also deserves to be remembered as a precocious meta-narrative that renders critical reflection on the social, cultural, and human impact of film-making that remains in-dissociable from cinematic self-promotion. In so doing, *Heartbeat* helped found a sub-genre of movies about movies that also includes classics such as Chaplin's *Limelight* (1952), Godard's *Le Mépris/Contempt* (1963) and Fellini's *8½* (1963).

Brett Bowles

References

Pagnol, Marcel (1938) 'En marge du problème juif', *Nouvelles littéraires, artistiques, et scientifiques*, 844, 17 December, pp. 1–7.
Pagnol, Marcel (1995) *Œuvres complètes*, 3 vols., Paris: Fallois.

My New Partner

Les Ripoux

Studio/Distributor:
Films 7

Director:
Claude Zidi

Producer:
Claude Zidi

Screenwriters:
Didier Kaminka
Simon Mickaël
Claude Zidi

Cinematographer:
Jean-Jacques Tarbès

Art Director:
Françoise De Leu

Composer:
Francis Lai

Editor:
Nicole Saunier

Duration:
107 minutes

Genres:
Crime
Comedy

Cast:
Philippe Noiret
Thierry Lhermitte

Year:
1984

Synopsis

In this satirical comedy masquerading as a thriller, René is a veteran Paris police officer who has been making ends meet by accepting bribes from petty criminals while betting on horses. His officious new partner, François, a penal code-toting rookie from a provincial town, with a view to becoming commissioner, strongly disapproves. René sets about convincing François to see things his way, with more success than he anticipated.

Critique

The title 'Les Ripoux' comes from an old form of backslang – 'le verlan', from the inverted syllables of 'l'envers' or 'the reverse' – that regained popularity in the 1970s as a distinguishing feature among young people in French suburbs and is often used in French hip-hop. Many *verlan* words have now made it into mainstream French. 'Ripou' is the inversion of 'pourri', or 'rotten' as René (Philippe Noiret) already is and François (Thierry Lhermitte) will become, thus the plural form: les ripoux. That François does not understand the word when he first arrives from Epinal underlines his provincialism and lack of experience. If the film hardly 'renewed the genre', as the DVD jacket claims, it is nonetheless hailed as a 'cult movie' by older and younger generations of French viewers alike.

My New Partner was nominated for five Césars in 1985 – Best Actor for Noiret, Best Writer, Best Director, Best Editing and Best Film – and won the last three, surprisingly, since in the 10-year history of the Césars the Best Film award had not yet been bestowed on a comedy. *My New Partner* enjoyed wide popularity and spawned two sequels, *Ripoux contre Ripoux/My New Partner II* (1989) and *Ripoux 3* (2003), as well as a recent television series, *Ripoux anonymes* (2011), all partly written and directed by Claude Zidi – and in the case of the latter, Zidi and his son, Claude Jr. – though the series was cancelled after the pilot aired on 17 February 2011, due to mixed reviews and lack of audience enthusiasm.

Zidi has long had a reputation as a purveyor of popular French comedies, known for such farces and franchises as *Les Bidasses/ Rookies Run Amok* (1971) and *Les Sous-doués/The Under-Gifted* (1980). In *My New Partner*, he uses little slapstick, but rather relies on funny dialogue and situations. These include the police commissioner raving about the cocaine-spiked nasal spray that René has provided to keep him off his back. They also include the book-end scenes of two 'ripoux' cops on the verge of being caught: at the beginning of the film, René and his former partner, Pierrot, who gives himself up at René's suggestion ('It would be real stupid for both of us to get caught') then towards the end, François and René, who is now the one to be sacrificed as François repeats his partner[1]s earlier phrase. As a thriller, the film also offers a plot with several twists and turns and a dynamic *mise-en-scène*, with many fluid camera moves through the streets of Paris. *My New Partner*

was shot on location in Montmartre, and, contrary to Jean-Pierre Jeunet's 2000 *Amélie*, does not propose an idyllic, slightly outdated vision of the eighteenth *arrondissement*, though a touch of nostalgia pervades the film. Montmartre is nonetheless shown in a realistic way, with its colourful population, cheap cafés, and small time crooks.

Zidi has also given many a French comedian – Les Charlot, Coluche – access to the big screen. Indeed, the success of *My New Partner* lies mainly in the director's choice of his two main actors. The charismatic, 54-year-old Noiret first appeared on screen in Varda's *La Pointe Courte* in 1956 and died in 2006. His gruff voice, heavy jowls, basset hound eyes, and reassuring bulk haunted French screens for years. Noiret's much younger partner, Lhermitte, founded the *café-théâtre* comedy group Le Splendid with some friends in the 1970s, drawing attention mostly for his good looks and bright blue eyes in film comedies like *Les Bronzés font du ski* (Patrice Leconte, 1979). The undeniable chemistry and complicity between the veteran and the younger actor overshadows a loose thriller plot, involving a drug dealer the Parisian police is trying to catch red-handed. Lhermitte is believable both as the innocent and righteous character who first arrives in Paris fresh from the Epinal police academy, and as the more seasoned 'ripou' who, after falling in love with a pretty prostitute with expensive tastes, outdoes his partner as their tense relationship evolves into friendship. And René, in spite of his bent morals, makes for a loveable horseracing-addicted widowed cop, sternly friendly or fatherly to the criminals he exploits, affectionate with the aging, not quite former prostitute he practically lives with.

The ending, with François and René riding off into the mist in a horse-drawn cart followed by their mink-clad ladyloves, is both totally amoral and deeply satisfying, with fairy tale undertones. François has bought the racehorse and a bar that René had intended to procure with the huge amount of money they stole from a drug dealer. The ending is also highly improbable, but who cares? René is rewarded for protecting his partner-in-crime – he has just spent two years in prison for stealing the money that then supposedly went up in flames with his apartment – and François did not abandon his old partner and keep the money for himself, as we were led to believe: our 'ripoux' are not rotten to the core, all is well.

Brigitte E. Humbert

Les Visiteurs

Synopsis

A twelfth-century knight Godefroy de Montmirail and his loyal vassal Jacquouille la Fripouille return to their native Languedoc after years of fighting abroad. The knight is to marry his betrothed,

Studio/Distributor:

Alpilles Productions

Director:

Jean-Marie Poiré

Producer:

Alain Terzian

Screenwriters:

Cristian Clavier
Jean-Marie Poiré

Cinematographer:

Jean-Yves Le Mener

Art Director:

Bertrand Seitz

Composer:

Eric Levi

Editor:

Catherine Kelber

Duration:

107 minutes

Genres:

Fantasy
Comedy

Cast:

Jean Reno
Christian Clavier
Valérie Lemercier
Marie-Anne Chazel
Christian Bujeau
Isabelle Nanty

Year:

1993

Frénégonde, but, under a witch's curse, he mistakes his intended father-in-law for a bear and kills him with a crossbow. He drinks a magic potion hoping to travel back in time and undo his deed but instead he and his servant find themselves in 1990s France where they meet their respective descendants, the countess Béatrice de Montmirail, an upper-class twit, and the insufferable *nouveau-riche* Jacquard, who now runs the Montmirail estate as a posh hotel-restaurant. Béatrice and her dentist husband take in Godefroy, thinking he is her long-lost cousin, Hubert. Things get out of hand.

Critique

With 13.6 million tickets sold in 1993, *Les Visiteurs* has entered French film history as the second most successful French film of the post-war era. Jean-Marie Poiré and Christian Clavier's film received little attention from French film critics on its release in January. However, after winning over one million fans in its first two weeks, *Les Visiteurs* not only went on to beat *Jurassic Park*, Spielberg's blockbuster, in France, but critics felt forced to reassess it and historians, sociologists, psychologists, linguists and educationalists were all drawn in to explain how a simple time-travel farce had become such a cultural and social phenomenon.

With its reliance on a familiar tale of culture clashes, mistaken identities and starring a male duo, *Les Visiteurs* has many of the regular ingredients of popular comedy. It also belongs to a long tradition of popular culture anchored in national mythology, the presence of which has long pervaded French imaginary, from the portrayal of Vercingétorix, the Gaul hero of schoolchildren's history books, to the Astérix theme park outside Paris. Contrasting medieval customs and twentieth-century modern life, the film was also seen as a satire of the foibles of the provincial bourgeoisie and cited as a pedagogical tool for the study of class differences in 1990s France. In the film, the order is disturbed but, unlike in the more traditional situation comedy, its hierarchies are not re-arranged and the return to the status quo is not unproblematic, a factor that could partly explain the reappraisal of *Les Visiteurs* in France's intellectual circles. To wit, in 1993 *Cahiers du Cinéma* devoted seven pages to *Les Visiteurs* in which it was argued that the film – a comedy in which the values and conventions of the quality costume drama (historical sources, period costumes, spectacular landscape, lavish musical score) shown in the early scenes are subsequently undermined – was a subversion of the heritage genre.

In 1993, director Jean-Marie Poiré and his main actor Christian Clavier were no newcomers to commercial success. The son of Gaumont producer Alain Poiré, Poiré junior came to public attention in the early 1980s with *Les Hommes préfèrent les grosses* (1981), *Le Père Noël est une ordure* (1982) and *Papy fait de la résistance* (1983). His 1982 and 1983 films were co-written by and starred Christian Clavier; they were based on performances from Le Splendid theatre, a group of comedians with a predilection for social satire, clichés and popular language, and whose reputa-

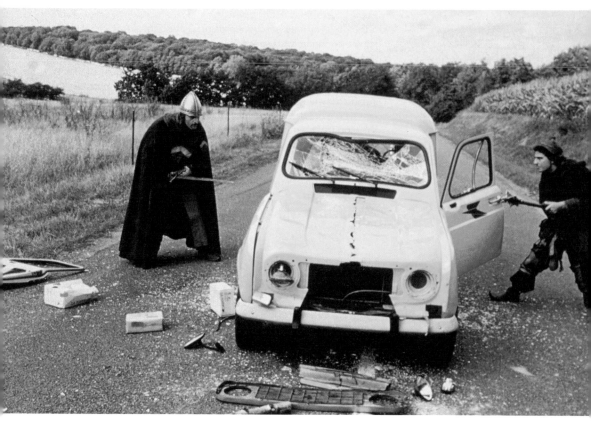

Les Visiteurs, Gaumont, France 3, Alpilles, Amigo.

tion was an almost guaranteed source of success in the 1970s and early 1980s. *Les Visiteurs* uses all the tricks expected from the Poiré-Clavier team, blending various comic sources: silent cinema gags, vaudeville, 1960s burlesque, German scatological sense of humour, parody, and subversion of standard genres including American slapstick comedy and Gallic humour (*l'esprit gaulois*). *Les Visiteurs* plays on stereotypes, and its characters are treated with little nuance or finesse, all played by actors who had previously appeared in Poiré's earlier comedies.

The upper-class elocution of Valérie Lemercier and the vulgar speech of Marie-Anne Chazel were already familiar to French audiences but *Les Visiteurs* goes much further in its non-conformist use of language. The comic conflict between ancient and modern is also linguistic: the film excels in mixing anachronistic vocabulary and old French verbs (employed by Godefroy [Jean Reno]) with more modern – and often extremely rude – turns of phrase. Jacquouille (Christian Clavier) uses a rejuvenated old language that owes less to the stylistics and scatological witticisms of French medieval literature than to slang and Americanisms. What the French call 'le franglais' – a favourite with French youth – is mainly employed by the countess who favours abbreviations *à l'anglaise* (cousin Hubert becomes Hub, and the polaroid camera 'pola'!) and a repeated use of 'hyper',

'super' and 'OK' with a clipped and snooty pronunciation. However ridiculous they may be, Jacquard's (Christian Clavier) attempts to copy the manners of speech, the accent and the terminology of the upper class prove a means to move up the social ladder. Both the knight's medieval phrases and Jacquard's verbal imitations of the upper class gained instant popularity with school children indulging in cool medieval-speak interspersed with prolonged 'okayay'. French youth were also attracted to the frantic pacing of the film and its state-of-the-art special effects, something rarely found in French comedy.

A fervent admirer of Hollywood cinema, Poiré has always been outspoken in his criticism of a cultural establishment that treats comedy as an inferior genre and of the state-supported CNC (the French body responsible for the allocation of film subsidies) for its marked preference for 'cultural projects' including those with a high export potential. Concerned by the declining performance of French films in their home market in the 1980s, the Ministry of Culture took drastic measures to encourage the production of more commercial films (i.e. prestigious large-budget films such as *Valmont* [Milos Forman, 1989] *Germinal* [Claude Berri, 1993] and *Indochine* [Régis Wargnier, 1992]) with mixed results. After Les Visiteurs received five Cesars in 1994 (including one for Best Director, a first for a comedy) Poiré was able to secure more CNC funding for its subsequent films. Production budgets have since soared, including those for French comedies and their sequels. For the opening of the sequel of *Les Visiteurs* in 1998, Gaumont Buena Vista International made five hundred copies available and *Les couloirs du temps: Les Visiteurs II* (1998) benefitted from a huge promotion campaign 'Hollywood-style' which included merchandising (video-games, CD-Rom, books, steel soldiers, clothing, etc.). It is no exaggeration to say that the unexpected success of *Les Visiteurs* in 1993 was a pivotal moment for changing attitudes about the dynamics of cinematic production in France.

Anne Jackel

Play Time

Studio/Distributor:
Jolly Film

Director:
Jacques Tati

Producers:
Bernard Maurice

Synopsis

Jacques Tati's iconic alter ego Monsieur Hulot arrives in a slick, modernist Paris for an appointment. He wanders from one humorous situation to another, crossing paths with various characters before winding up at a new restaurant's disastrous grand opening.

Critique

The distinctive, gentle and artfully constructed comedy of Jacques Tati reached its apex with *Play Time*. Following the much-celebrated *Mon Oncle*'s (1958) juxtaposition of old-fashioned values

René Silvera

Screenwriters:

Jacques Tati
Jacques Lagrange
Art Buchwald

Cinematographers:

Jean Badal
Andréas Winding

Composer:

Francis Lemarque

Editor:

Gérard Pollicand

Duration:

124 minutes

Genre:

Comedy

Cast:

Jacques Tati, and many others

Year:

1967

and community with the rise of sterile consumerist culture, it takes the next logical step by immersing the viewer in a coolly designed, technologically overridden world. A clever, light-hearted study of space, cities and the people within them, it is the end product one might expect if the members of Radiohead tried to make a film in the style of Keaton or Chaplin. So uniquely engaging is the viewing experience it provides that there is little wonder Roger Ebert compared it to such similarly one-of-a-kind works as *2001: A Space Odyssey* (Stanley Kubrick, 1968) and *Russkiy kovcheg/Russian Ark* (Aleksandr Sokurov, 2002).

Shot in expansive, brilliantly utilized 70 mm film stock, *Play Time* is a film that demands to be seen multiple times, all preferably on a large screen so as to properly take in all the meticulously composed actions that occur in the frame. It is set in a Paris as imagined by Tati, a modernist maze of shining metal and glass dictating the straight-angled routes of its citizens' lives with countless hallways, street lanes, parking lots and cubicles. The colour scheme is overrun by an armada of greys and blacks while colour is minimally distributed in select dabs. In the building where much of the film's first portion takes place, the eternally well-meaning Monsieur Hulot encounters many subtly comical sights, including a bewildering panel of buttons operated by a mumbling attendant and a pristine waiting room furnished with black leather chairs that exude funny noises when sat upon. *Play Time* features in true democratic fashion a multitude of characters that follow their individual courses throughout the film, some reappearing when least expected. Many of them seem lost and confused – like Hulot, they also do not quite know what to make of the world of smooth surfaces and automated wonders that envelops them. In contrast to these aimless souls are the chatty American tourists who busily visit such mundane locations as a trade exhibition that showcases the latest appliances, gadgets and furnishings, including a sound-dampening door advertised with the oddly poetic phrase, 'Slam Your Doors in Golden Silence.' Paris' more recognizable landmarks like the Eiffel Tower and Basilique du Sacré-Cœur are shown only through reflections in doors and windows angled in just the right way. The Paris of the past is thus depicted as elusive and transient, present only through these ghostly reminders, or through lingering traces like the flower booth set up on a busy street corner bustling with businessmen and tourists.

While returning to the role of Monsieur Hulot in *Play Time*, Tati sought to reduce the famous character's prominence. He partially achieved this by including several Hulot look-alikes, all also wearing raincoats and bearing umbrellas. Yet behind camera, the filmmaker exercised a near-domineering control during the lengthy production period. *Play Time* was the most expensive French film of its time, largely due to the construction of 'Tativille', the miniature city Tati built solely for the project. He inevitably faced funding shortages, leading him to take out several loans, borrow from friends and family, and even offer up as collateral the rights to his films, which he later lost. Adding to the many difficulties were his eccentric work methods, as he was known to be painfully slow,

Play Time, Specta.

indecisive, and obsessed with the smallest details. A box office failure upon its release, *Play Time* came at a dire cost to its visionary creator. But despite the hardships he brought upon himself, it can be said that Tati successfully emerged with a true masterpiece.

As usual for Tati, *Play Time* eschews a conventional plot in favour of one marvellous gag after another. The film's main set piece is the legendary Royal Garden restaurant sequence, which is easily the most impressive one in Tati's career. During its progression, the order and cleanliness maintained in the film's spaces up to that point give way to chaotic jubilation, the dissolution of the city's invisible, restrictive barriers marked by Monsieur Hulot when he accidentally shatters a glass door. Certain gags are not only deployed, but also continually evolve throughout the sequence: the poor waiter who supplies his coworkers with replacement articles of clothing, a fish that is repeatedly seasoned but never eaten, the metal chairs that leave odd crown-shaped markings on people's backs. The increasingly flustered restaurant staff do their best to save face while Hulot and his new friends embrace the mayhem, in the process achieving a sort of liberation from alienation.

There are few films quite as generous as *Play Time*. As Hollywood mega-productions clamour for viewers' attention with the superfluous gimmickry of 3D technology, Tati's film beats them all at their own game, avoiding deafening spectacle in favour of an enticing offer of discovery and delight. In the film's uplifting finale, the city is transformed into a lively carnival decorated with balloons and banners. Traffic circles packed with vehicles become carousels, with primary-coloured cars and machines doubling as joyous 'rides'. The sequence celebrates a reconciliation of sorts, as the city's people finally achieve harmony with their artificial, previously oppressive surroundings. Contained within this marvelous film is a treasure trove of similar surprises, hidden in plain sight, simply waiting to be found.

Marc Saint-Cyr

Un mauvais garçon

Studio/Distributor:

L'Alliance Cinématographique
Européenne (ACE)

Director:

Jean Boyer

Producer:

Raoul Ploquin

Screenwriter:

Jean Boyer

Cinematographer:

Ewald Daub

Art Directors:

Artur Günther
Max Knaake

Composer:

Lothar Brühne

Editor:

Klaus Stapenhorst

Duration:

90 minutes

Genres:

Comedy
Drama
Musical

Cast:

Danielle Darrieux
Henri Garat
André Alerme
Marguerite Templey
Madeleine Suffel

Year:

1936

Synopsis

On completing her law degree, Jacqueline decides that she is to become a practicing lawyer. Her father has other ideas, stating that she should follow a more traditional path by getting married as soon as possible. When she protests, he agrees to financially support her for eighteen months as she tries to establish herself as a lawyer, with the agreement that if she has not succeeded within this time, she must marry a man of his choice. She meets Pierre, her first client and the 'bad boy' of the title, and after a period of animosity and conflict they eventually fall in love. As the eighteen months come to an end, she resigns herself to the fact that she will not succeed in her career ambitions, and decides to enjoy her final days with Pierre, before she has to marry the man her father has chosen for her.

Critique

Un mauvais garçon is an example of the critically derided popular cinema of the 1930s that has, until recently, largely been neglected in work on French cinema. However, the film, which was released in 1936, provides insight into France during the Popular Front – a coalition of left wing parties that gained a parliamentary majority in 1936. Although the film does not deal explicitly with the political context, in the way that more canonic Popular Front cinema does – such as the avant-garde *cinéma engagé* (engaged cinema) or the political films of Jean Renoir – it presents a fascinating vision of gender relations at this time. Although the Popular Front's main aims were to oppose the rise of fascism and seek better conditions for the nation's workers, its progressive and liberating mood also had a positive impact on women. Following Burch and Sellier's argument about how changes in society and politics in France between 1930 and 1956 are manifested in shifting cinematic representations of gender, we can see *Un mauvais garçon* as a significant example of Popular Front cinema.

Central to this is the stardom of Danielle Darrieux, who in the mid-1930s was France's top female star. Although the film also stars Henri Garat, who was a hugely successful performer of the early 1930s, by 1936 his career had entered into steep decline, making *Un mauvais garçon* first and foremost a Darrieux star vehicle. In this film, Jacqueline (Darrieux) is, like many Darrieux characters, a typical *jeune fille*, a youthful and innocent, idealized daughter figure. She was only nineteen when the film was made, and possessed particularly youthful features: wide eyes, a small pouting mouth and wild, curly hair. Her position as daughter is also conveyed through the power her father (played by André Alerme) has over her, particularly when he decides that she should get married instead of entering a career. At the same time, *Un mauvais garçon* provides a strong depiction of Darrieux's complementary but contradictory persona as a modern woman: more active, glamorous and up-to-date. Most obviously, her independence is asserted through her aspiration to become a lawyer, a traditionally male occupation, which would bring

her independence and a potentially exciting professional life. The pleasure and freedom she derives from this is conveyed in a scene depicting her drive through Paris to meet her first client, who she has been asked to defend (and who turns out to be Pierre [Garat]). Here she is a classic vision of the modern woman: beautiful and glamorous, wearing a jacket and tie, driving a car. As she negotiates the busy traffic, Jacqueline smiles broadly, singing along to a song on the radio, which includes such lyrics as, 'Je veux crier mon bonheur' ('I want to shout out my happiness'). As such, the scene speaks of a moment when women were seeking greater power and mobility and experiencing the period's optimism and, most strikingly, its *joie de vivre*.

Un mauvais garçon establishes an ongoing tension between the conservative (*jeune fille*) and progressive (modern woman) aspects of Darrieux's persona. The film is in many respects a French equivalent of the screwball comedy that emerged in Hollywood a couple of years earlier. As with screwball, it is concerned with open gender warfare. For the majority of the film, Jacqueline and Pierre are in continual conflict. This manifests itself through their various (usually quite petty) attempts to undermine each other: when Jacqueline tells Pierre that she will be his defence, he laughs at her, which makes her lose her confidence and begin to cry; when, once released, he declines her offer of a lift in her car, believing it may ruin his reputation as a criminal, a mischievous look crosses her face – she follows him, honking her horn, noisily reiterating her offer of a lift. These confrontations represent the power-play between the characters, dramatize the tensions in Darrieux's persona, and constitute the film's main moments of comedy. Also in keeping with Hollywood screwball, this surface hostility ultimately masks the protagonists' true feelings towards each other, and inevitably they fall in love. While the female stars of Hollywood screwball were routinely comic *and* romantic, this was a novel combination for a female star in France. More conventionally, the role was split between two characters, such as Annabella (romance) and Arletty (comedy) in *Hôtel du Nord* (Marcel Carné, 1938). For this reason, *Un mauvais garçon* represents a significant departure in French comedy of the period.

The ending of the film reveals that much of Jacqueline's agency has been an illusion, and that her father controlled her all along. On the one hand, this reaffirms the power of the older male generation, whose power in the broader political sphere was under threat at the time. On the other, scenes depicting Jacqueline's independence, demonstrating the pleasures of liberation, would have made a strong impact with audiences at the time, perhaps more so than the traditional constraint of her modernity in the final scenes. Regardless of whether or not the modern triumphs over the traditional, the film highlights tensions that existed during this period between progressive and regressive ideas of gender. Exploring conflict between generations and genders, and the threat to a father's authority, *Un mauvais garçon* was a timely piece of cinema during the Popular Front.

Jonathan Driskell

The horror genre is not an extensive or sustained aspect of the French national cinema tradition in the same way as 1920s German Expressionism, British 1950s Hammer horror, or 1970s Italian *giallo*. While the on-going popularity of the horror genre in other international cinemas (Japan, Spain, Australia, Korea) can be contextualized within a broader consideration of the increasing cross-cultural nature of contemporary horror, the recent emergence of a distinct French corpus of horror films is somewhat surprising given the general perception of French cinema as 'a classic realist cinema [...] little inclined to explore the fantastic or the grotesque' (Vincendeau 1987: 11–12). Nonetheless, the French horror tradition is rich and varied, drawing from literature, folklore, and Euro-exploitation conventions. In the last decade alone, several films – *Promenons-nous dans les bois/Deep in the Woods* (Lionel Delplanque, 2000), *Haute tension/High Tension* (Alexandre Aja, 2003), *Les Revenants/They Came Back* (Robin Campillo, 2004), *Ils/Them* (David Moreau and Xavier Palud, 2006), *Sheitan/Satan* (Kim Chapiron, 2006), *Eden Log* (Franck Vestiel, 2007), *Humains/Humans* (Jacques-Olivier Molon and Pierre-Olivier Thevenin, 2009), *Mutants* (David Morlet, 2009), *La Meute/The Pack* (Franck Richard, 2010) – have thrived on unsettling the audience on a visceral, violent level, while others have experimented with genre hybridity to combine horror with comedy (*Poltergay* [Eric Lavaine, 2006]), eighteenth-century martial arts (*Le Pacte des loups/Brotherhood of the Wolf* [Christophe Gans, 2001]), and action (*Bloody Mallory* [Julien Magnat, 2002]). Many of them smuggle subversive comments on contemporary heteronormative codes or endorse particular ideological positioning, making French horror particularly fertile terrain to interrogate state-of-the-nation concerns.

Oftentimes, the thematic features of the horror film 'can be treated as articulations of the felt social concerns of the time' (Tudor 2002: 50). Familiar examples of this reflectionist horror discourse include the 1950s American science-fiction horror films (*The Thing from Another World* [Christian Nyby, 1951], *Them!* [Gordon Douglas, 1954], *Invasion of the Body Snatchers* [Don Siegel, 1956]), which are on the surface a thematic treatment of alien invasion or the risks of nuclear power, but also mount a deeper interrogation of specific contemporaneous fears, such as xenophobia, anti-communism and technological change. More recently, the term 'torture porn' has been used to describe extreme, prolonged graphic torture, abduction, rape and dismemberment in American films such as *Saw* (James Wan, 2004) and *Hostel* (Eli Roth, 2005). These works confront willing audiences with visceral, grotesque imagery and implicit political content that reflect post-9/11 and post-Abu Ghraib anxieties. Likewise, French cinema's recourse to horror in the new millennium is suffused with both a sanguinary explicitness and social and political implications. Horror films like *Martyrs* (Pascal Laugier, 2008) and *La Horde/The Horde* (Yannick Dahan and Benjamin Rocher, 2009) mark the incorporation of an aggressively politically-inflected discourse into a popular genre, in turn imbuing it with ideologically progressive or recuperative resonances. These resonances are common tropes

Haute tension, Alexandre Films, Europa Corps.

in Western horror cinema, obsessed as it is with the notion of the body, both corporeal and social. Horror and body-horror graphically enacts 'the perpetual intimate apocalypse of the human body revealed not as a consolidated and impregnable citadel, but as a flexible assemblage that disallows for illusions of corporeal integrity or of the sovereignty of the human form' (McRoy 2005: 6). These new French horror films situate their horrors in the immediacy of contemporary France – À l'intérieur/ Inside (Alexandre Bustillo and Julien Maury, 2007) and Frontière(s)/ Frontier(s) (Xavier Gens, 2007) contain images of the autumn riots of 2005 – and suggest that the physical destruction of the body in these films allegorizes fractures in the national body politic. Clearly then, French horror cinema is a dynamic site of contested meanings and fluctuating interpretations that provides a legitimate discursive framework for interrogating state-of-the-nation preoccupations whilst at the same time remaining faithful to its generic and visual parameters.

The tropes most common in recent French horror – excess, psychological horror, exploitation and 'body horror' – recycle and respond to several principal antecedents. France's horror film heritage arguably stems from the turn of the twentieth-century popularity of the Théâtre du Grand-Guignol in Paris and Georges Méliès' The House of the Devil (1986), which, with its collection of bats, skeletons and witches, as well as the first depiction of Satan on film, showcased the potential for early cinema to traffic in the supernatural. Later Méliès horror films, such as The Cave of the Demons (1898) and Summoning the Spirits (1899), continued in this vein, deploying a mixture of pantomime 'he's behind you' shock effects and whimsical fantasy sequences that influenced the early Hollywood horror aesthetic. Abel Gance, better known for the monumental Napoléon (1927), also got into the act early, with horror shorts like The Mask of Horror (1912) and Help! (1924). The latter starred Max Linder as a man who accepts a wager that he can stay in a haunted castle for one hour without crying for help – a direct inspiration for William Castle's 1959 House on Haunted Hill, and William Malone's 1999 remake. Luis Buñuel's Un Chien Andalou (1929) took a different course, moving away from manufactured scares towards a clinical depiction of body horror. The celebrated shot of a woman's eye being slit with a razor suggested the perversities of human behaviour through horrific imagery. For several years after, French horror cinema revolved around numerous adaptations of classic horror literature, such as Maurice Tourneur's retelling of the Faust legend in La Main du diable/The Devil's Hand (1943), Jean Cocteau's La Belle et la Bête/ Beauty and the Beast (1946) and Jean Renoir's version of Dr Jekyll and Mr Hyde, Le Testament du Docteur Cordelier/Experiment in Evil (1959).

At the same time, Jacques Tourneur worked comfortably within the Hollywood studio system at RKO, and imported characteristic tonal qualities into American cinema at a time when the Universal horror films like The Mummy (Karl Freund, 1932), Frankenstein (James Whale, 1931) and The Wolf Man (George Waggner, 1941)

were the genre mainstays. His *Cat People* (1942) and *I Walked with a Zombie* (1942) both used elegant compositions and exaggerated sound and lighting design to overcome the essential hokiness of their subject matter.

Other touchstones include Henri-Georges Clouzot's *Les Diaboliques* (1955) and Georges Franju's *Les Yeux sans visage/ Eyes Without a Face* (1959), which layer their realist narratives with images of the grotesque and the *fantastique*. The former is a mixture of film noir and 'suffocating horror in which the [spectator] can no longer breathe' (Hayward 2005: 27) and the latter a combination of fairy tale, melodrama and shock cinema that challenge traditional auteur cinema/exploitation cinema dichotomies. The 'mad scientist' film also emerged in France in the 1960s, kick-started by Edmond Gréville's *The Hands of Orlac* (1960), in which a concert pianist has his hands substituted by those of a murderer. Other entries into this sub-genre include Pierre Chevalier's *La Vie amoureuse de l'homme invisible/Dr. Orloff's Invisible Monster* (Pierre Chevalier, 1971) and *L'Homme au cerveau greffé/Man with the Transplanted Brain* (Jacques Doniol-Valcroze, 1971). The latter was directed by Jacques Doniol-Valcroze, co-founder of the influential journal *Cahiers du Cinéma* and a leading light of the New Wave movement. These less realist strands of French horror are best exemplified by the sexploitation and fantasy cinema of Jean Rollin. His *Le Viol du vampire/The Rape of the Vampire* (1967) established new levels of extreme sexuality and graphic violence that capitalized on relaxing French censorship laws and the emergence of pornography into mainstream culture, and indicated how previously marginalized voices were, post-May 1968, incorporating subversive gender ideologies into an aesthetic of excess. The fusing of sex and violence in Rollin's subsequent vampire series (*La Vampire nue/The Nude Vampire* [1970], *Vierges et vampires/Caged Virgins* [1973] and *Le Frisson des vampires/Strange Things Happen at Night* [1971]) should not be dismissed as pulp genre horror. Working consistently and independently throughout the 1960s and 1970s, Rollin can be regarded as much an auteur as Godard or Tavernier. Despite his audacious subject matter, his films are not pornographic or misogynistic tracts. Instead, they elucidate the very clear historical and cultural links between horror and eroticism, while their elliptical, dreamlike narratives mark a direct link back to the early surrealism of Franju, Buñuel, Gaston Leroux, and the 'cinema of attractions' of Feuillade. Rollin also dabbled in that other Euro-exploitation staple, the zombie film. His 'zombie trilogy', capitalized on George Romero's earlier *Night of the Living Dead* (1968) and *Dawn of the Dead* (1978). *Le Lac des morts vivants/Zombie Lake* (1981) pushed the envelope further by making the zombies Nazis, *Les Raisins de la Mort/The Grapes of Death* (1978) contained an ecological message, expressing concern about pesticides and environmental damage, while *La Morte Vivante/The Living Dead Girl* (1982) contained the sort of graphic gore that would become commonplace in future Rollin-inspired zombie films like *The Horde*.

French horror copied Rollin's template of cheaply-made and

quickly-shot films and found favour with fans of the burgeoning Euro-horror genre. Alongside Rollin, Alain Jessau was the only French director who regularly contributed to the fantastic/ horror genre during the 1970s and 1980s. *Traitment de choc/ Shock Treatment* (1973) starts out as a fairly routine critique of consumerism and post-68 hedonism, but transmutes into something far more harrowing as the nightmarish secrets behind a rejuvenation clinic are revealed. Thematically similar to *Soylent Green* (1973), Jessau's fable, like Rollin's vampire series, cleverly holds a mirror up to society's own preoccupations with surface beauty and youthfulness. His *Frankenstein 90* (1984) relocates Mary Shelley's classic tale to a near-future Earth, mixing satire, parody and cult casting (Jean Rochefort and singer Eddy Mitchell) with genuine chills. The film looks and feels like a homage to the demented *mise-en-scène* of the British 1950s Hammer films, and also indicates how directors were consistently producing popular genre cinema during a period when retro-nostalgia and high-tech aesthetics were the hallmarks of French cinema.

Two further trends in French horror – the New French Extremity and 'shock horror'– have emerged most recently. The first has been defined as

> Bava as much as Bataille, Salo no less than Sade seem the determinants of a cinema suddenly determined to break every taboo, to wade in rivers of viscera and spumes of sperm, to fill each frame with flesh, nubile or gnarled, and subject it to all manner of penetration, mutilation, and defilement (Quandt 2004: 20).

These films do not reproduce tropes of horror in the traditional sense, but instead embrace images of the corporeal and the abject in order to interrogate issues such as sexual violence, female emancipation, and the crisis of masculinity. The emergence of this *cinéma du corps* – whose agenda 'is an on-screen interrogation of physicality in brutally intimate terms' (Palmer 2006: 171) and whose narratives blend high art elements such as auteur directors (Philippe Grandrieux, Claire Denis, Gaspar Noé and Marina de Van) with images of the pornographic and abject – is exemplified in the 'body horror' tendencies of *Trouble Every Day* (Claire Denis, 2001) and *Ne te retourne pas/Don't Look Back* (Marina de Van, 2009), in which bodily processes and the violation of the body by foreign organisms are explicitly foregrounded. Martine Beugnet recognizes that the *cinéma du corps* is 'a cinema wedged between traditional narrative forms and pure experimentation, saturated with the horror of the real, yet opening film form onto uncharted perspectives' (Beugnet 2005: 183). The New French Extremity also continued French cinema's fascination with the vampiric figure, thus continuing a thematic link established by Jean Rollin, but presented in a far less titillating manner. Vampires surface in *Pola X* (Leos Carax, 1999), *Trouble Every Day*, *Demonlover* (Olivier Assayas, 2002), *La Vie nouvelle/A New Life* (Philippe Grandrieux, 2002), *L'Intrus/The Intruder* (2004), and even in one segment of the

2006 portmanteau film *Paris je t'aime* (Olivier Assayas et al). Their reappearance hints at a collective unease about the nature and effects of globalization, for these films each suggest that vampirism thrives within the global city and functions as a monstrous representation of insatiable greed and a compelling indication of the city's fluid and breachable borders. The vampires in these films appear and reappear at will, refusing to honour the sanctity of barriers. Traditional literary and cinematic representations of the vampire tend to focus on the figure's invisibility and elusiveness, which in a modern context can again be related to current concerns over clandestine immigration. This fear of porosity and the attendant threat to the integrity of the human body in recent French horror relates to wider concerns in contemporary French cinema on the issues of *fracture sociale* and insecurity.

The 'shock horror' tradition revels in exploitation and schlock effects, whilst also tapping into pre-existing French traditions of the *fantastique* and *cinéma du corps*. Directors such as Xavier Palud, David Moreau, Alexandre Bustillo, Julien Maury, Xavier Gens, Pascal Laugier, and Alexandre Aja are at the vanguard of a new horror movement that has been enthusiastically greeted by both French and non-French audiences. Unrelenting in their tonal and narrative components, films such as *Them*, *Inside* and *Frontier(s)* engage in a fascinating dialogue with recent political and social events in France, grafting metaphors of border porosity and domestic invasion onto their narratives of visual excess. What characterizes these films are claustrophobic atmospheres of anxiety, events taking place within naturalistic surroundings, and a sense of unease emanating from the supposed normality of the diegetic world.

The films situate horror in the everyday world of contemporary France and project that horror onto a foreign invader. French horror currently represents the collective nightmare of a nation undergoing social and political fragmentation, condemning itself to annihilation while the 'barbarian at the gate' pushes at the edges. Certainly the emotional and ethical resonances of this 'shock horror' tradition suggest consonances with the *cinéma du corps* of the 1990s and early 2000s, but whereas these films were deliberately, almost archly, philosophical in their explorations of physicality, the corporeal and the abject, the new corpus cleaves much closer to the conventional horror tropes of American cinema. These directors may seek to interrogate deeper cultural and political anxieties, but they are also careful to satisfy their core audience, seek worldwide distribution for their films, and gain praise (or notoriety) as proponents of popular genre cinema in a cinematic climate that has always jealously guarded the psychological and intimate concerns of auteur cinema.

Moreover, these new films are profoundly nihilistic, bespeaking an ideological emptiness at the heart of modern French society. The monsters in these works, whether murderous children, a female serial killer or neo-Nazi cannibals, are all projections of a particular set of fears that does not correspond with the dominant paradigms of modern existence (stability, civility, orthodoxy) but

rather embody modes of disruption that threaten the consensual frameworks of modern French society. They each trade in imagery of mutilation, torture and bodily destruction, and appropriate generic codes and archetypes to traumatize audiences by juxtaposing images of the unwatchable and the unspeakable with uncomfortably familiar socio-political nuances. In this way, they provide a dynamic conceptual continuum between art-house body-horror, multiplex gore cinema, and the earlier traditions of French horror cinema. These auteur-driven films provocatively explore issues of sexual and gender politics within postmodern culture and seek to engage in new modes of conceptually dynamic film-making. To compare the depiction of cannibalism in *Trouble Every Day* and *Frontier(s)* is to acknowledge the two different approaches currently manifest in French horror cinema. In the former, Claire Denis leaves 'sense and storyline aside in order to stay with the inexplicable horror of purely audio-visual sensation' (Prédal, cited in Beugnet 2007: 39). In the latter, a similar amount of blood, gore, and cannibalism is designed 'to satiate even the most ravenous gore hounds' and 'recycle various clichés [...] with flair and tight timing' (Dargis 2008). One strand eschews the traditional story arcs associated with the horror film; the other unfolds within strict generic parameters. For Denis, cannibalism is but a symptom of the primeval nature of human desire, while for Gens, the flesh-eaters of *Frontier(s)* are merely distaff versions of other varied incarnations, from *Cannibal Ferox* (Umberto Lenzi, 1981) to *Delicatessen* (Marc Caro and Jean-Pierre Jeunet, 1991), via *The Cook the Thief His Wife & Her Lover* (Peter Greenway, 1989), but with more excessive levels of gore.

The future of French horror cinema seems rich in possibilities. It thrives domestically by providing a viable alternative to an American and East Asian product, and also succeeds abroad by imitating and recycling proven generic templates, and recasting them in a new light. The major off-shoot of this infrastructural flexibility has had important industrial implications for French cinema. Alexandre Aja's knowledgeable appropriation of the slasher movie format in *High Tension* led to him directing a Hollywood-financed remake of *The Hills Have Eyes* (2006) and *Piranha 3-D* (2010), Xavier Gens helmed *Hitman* (2007), and David Moreau and Xavier Palud directed an American remake of the Hong Kong horror-thriller *The Eye* (2008). Thus the horror film traditions of separate national cinemas are engaged in a dynamic process of cross-cultural exchange with American mainstream horror. French horror cinema can be distinguished by specific national, linguistic and cultural parameters, but it is also increasingly subject to the flows of the global film economy and the dissolution of rigid national cinema boundaries. It is perhaps too early to say whether these films constitute a conscious attempt to beat American cinema at its own game, given that these new directions in French horror may simply be the result of another cyclical change in the genre imperatives and new focus points of an ever-changing French national cinema. What is important is the cultural specificity of the political contexts that French horror films are engaging with in spite of their generic similarities

to Hollywood and/or other global cinemas.

Much of the significance of the modern horror film lies in the suggestion that 'horror is not something from out there, something strange, marginal, *ex*-centric, the mark of a force from out there, the inhuman'. Instead, contemporary horror films suggest 'that the horror is not merely among us, but rather part of us, caused by us' (Polan 2004: 143). Modern French horror films all share a deep suspicion towards the 'outsider', generally personified by the malicious individual(s) whose motives remain inexplicable, contradictory or pathologically brutal. As such, they serve as a bellwether reflecting a profound scepticism towards the broadening of the European Union and a fearfulness of the ramifications of flows and movements across and through French frontiers. Horror films have now emerged as a new means of projecting particular fears and threats that destabilize the perceived dominant consensual paradigms of contemporary existence in France. What they finally suggest is that those paradigms of stability, civility, orthodoxy and superiority are in fact a fallacy, and that modern France is an increasingly paranoid realm subtended by the atavistic, the irrational, and above all, the primal.

Ben McCann

References

Beugnet, Martine (2005) 'Evil and the senses: Philippe Grandrieux's *Sombre* and *La Vie Nouvelle*', *Studies in French Cinema*, 5: 3, pp. 175–84.

Beugnet, Martine (2007) *Cinema and Sensation: French Film and the Art of Transgression*, Edinburgh: Edinburgh University Press.

Dargis, Manohla (2008) 'After making it out of Paris, finding there's no escape', *New York Times*, 9 May, pp. 16.

Hayward, Susan (2005) *Les Diaboliques*, London and New York, I.B. Tauris.

McRoy, Jay (2005) 'Introduction', in Jay McRoy (ed.), *Japanese Horror Cinema*, Edinburgh: Edinburgh University Press, pp. 1–11.

Palmer, Tim (2006) 'Under your skin: Marina de Van and the contemporary French *cinéma du corps*', *Studies in French Cinema*, 6: 3, pp. 171–81.

Polan, Dana B. (2004) 'Eros and Syphilization: The Contemporary Horror Film', in Barry Keith Grant and Christopher Sharrett (eds.), *Planks of Reason: Essays on the Horror Film*, Lanham, Toronto and Oxford: Scarecrow Press, pp. 142–52.

Quandt, James (2004) 'Flesh & blood: sex and violence in recent French cinema', *Art Forum*, 42: 6, pp. 20–24.

Tudor, Andrew (2002) 'Why Horror? The Peculiar Pleasures of a Popular Genre', in Mark Jancovich (ed.), *Horror: The Film Reader*, New York: Routledge, pp. 47–56.

Vincendeau, Ginette (1987) 'Women's cinema, film theory and feminism in France', *Screen*, 28: 4, pp. 4–18.

Inside

À l'intérieur

Studio/Distributor:

La Fabrique de Films

Directors:

Alexandre Bustillo
Julien Maury

Producers:

Vérane Frédiani
Franck Ribière

Screenwriter:

Alexandre Bustillo

Cinematographer:

Laurent Barès

Art Director:

Marc Thiébault

Composer:

François Eudes

Editor:

Baxter

Duration:

83 minutes

Genres:

Horror
Thriller

Cast:

Alysson Paradis
Béatrice Dalle

Year:

2007

Synopsis

On Christmas Eve, a heavily pregnant Sarah is alone at home when a woman knocks on her door. The woman tries to remove Sarah's unborn child by piercing her belly with a pair of scissors. The woman reveals that she was driving the other car involved in the crash at the start of the film involving Sarah, and as a result had lost her own unborn baby.

Critique

Alexandre Bustillo and Julien Maury, the co-directors of *Inside*, reject the restrained aesthetics of recent Euro-horror, and adopt instead harrowing imagery, an unrelenting visceral style and schlock excess. On Christmas Eve, a heavily-pregnant Sarah (Alysson Paradis) is about to give birth when a mysterious scissor-wielding woman (Béatrice Dalle) calls at the house, wanting Sarah's baby by any means necessary. The 'interior' of the title refers both to the film's isolated Paris house and the inside of the womb. This is the ultimate 'domestic invasion' narrative, quite literally mapped onto the (female) body.

Bustillo and Maury have fashioned a story that revels in its blood-drenched aesthetic and unrelenting soundscape, and gets full purchase from its airtight 83 minute running time. From the opening POV shot (an unborn baby is slammed into the side of the womb by the force of a car crash), *Inside* marks the *ne plus ultra* of modern French horror. Earlier examples, like *Haute tension/High Tension* (Alexandre Aja, 2003), played fast and loose with the horror tradition, while *Ils/Them* (Moreau and Palud, 2006) was as much concerned with atmosphere and mood as the mechanics of gore. This time round, Bustillo and Maury combine the visceral kinetic energy of the former, and the nail-biting implacability of the latter. It helps that *Inside* is shot by Laurent Barès (also responsible for Xaviers Gens' *Frontière(s)/Frontier(s)* [2007]) in 35 mm, which accentuates the film's crazed, off-kilter universe, and provides a broad canvas on which the mayhem plays out. Rarely can 'body horror' have been taken so literally – heads are severed, eyes gouged, bellies gutted, genitals sliced – with each scene pushing the genre's boundaries further. While the single woman trapped alone in a supposedly impregnable house is a long-cherished staple of horror, *Inside* focuses as much on the motivations and interactions between Paradis and Dalle as it does on generic conventions. Dalle was in Claire Denis' *Trouble Every Day* (2001), where she played a crazed cannibal with an insatiable bloodlust. Yet where that film was a detached, cool commentary on the aesthetics of horror, *Inside* is an unapologetic slasher film that deploys gratuitous shock tactics and nods ironically to previous genre rules (Parisian policemen are just as ponderous and ineffective as Texan ones, it seems). As is always the case in horror, it is about obliterating the interlopers before the main business can commence. Towards the end of the film, with Dalle standing over Paradis'

swollen belly with a pair of scissors, ready to deliver an impromptu C-section, one cannot help wondering if there any taboos still left to dismantle.

Refracted through a less hysterical lens, *Inside* evokes the fear of pierced borders on both a corporeal and a social level. This is reflected in a crucial component of the film's *mise-en-scène* when Sarah fights her assailant, as, in the background, the television shows live footage of the riots in October and November 2005. Critics noted that the Parisian border has traditionally been called the 'pregnant Parisian woman' (*l'enceinte parisienne*). In this light, *Inside* becomes a metaphorical restaging of the confrontation between Paris residents and its disaffected *banlieusards*. Although the narrative avoids clear-cut explanations, one compelling reading emerges. Pregnant Sarah, symbolically due for birth on Christmas Eve, combats the spectral force of *La Femme* in a Paris house that allegorically conflates the battles between the civilized and the disenfranchized.

France's current preoccupations with migration, immigration, and border porosity are well served in *Inside*. By smuggling a more radical social commentary into its conventional genre trajectories, the film calls attention to the porosity of domestic borders and makes capital out of the asymmetrical power relations between hosts and migrants. Through the prism of the horror film, the nation state is registered as dysfunctional and paranoid, its complacency and cultural hegemony suddenly vulnerable to what Jean Baudrillard once described as 'even the mildest of viral attacks'.

Whether a mooted American remake by Jaume Balagueró (*REC* [2007]) can add anything extra to the socio-political heft of *Inside* remains debatable. Given also the waning enthusiasm for the *Hostel* and *Saw* franchises, it is unclear how English-speaking audiences will respond to a film that stands at the vanguard of the French horror movement. For their part, Bustillo and Maury are rumoured to be working on a remake of Clive Barker's 1987 *Hellraiser*. What *Inside* has undoubtedly accomplished is to reopen the debate over the perceived merits of non-American genre cinema and the ongoing possibilities that foreign horror films can explore. Following in the footsteps of the recent success of Spanish, Australian, and Korean horror films in America, the establishment of a loyal cult audience for French horror is indicative of the global reach of well-made genre cinema, and highlights how, alongside the welter of well-made nineteenth-century costume dramas and Parisian-set romantic comedies, French cinema is currently rich in fertile, exportable trash that provides a welcome addition to its effortless treasures.

Ben McCann

Eden Log

Studio/Distributor:
Impéria Films

Director:
Franck Vestiel

Producer:
Cédric Jimenez

Screenwriters:
Franck Vestiel
Pierre Bordage

Cinematographer:
Thierry Pouget

Production Designer:
Jean-Philipe Moreaux

Composers:
Alex Cortés
Willie Cortés

Editor:
Nicolas Sarkissian

Duration:
98 minutes

Genres:
Horror
Mystery
Sci-fi

Cast:
Clovis Cornillac
Vimila Pons

Year:
2007

Synopsis

An amnesiac awakens in a pool of mud within a dimly-lit cavern. A pre-recorded message suggests that he is an underground worker for Eden Log, a program in which immigrant workers care for a massive energy-producing tree in exchange for eventual citizenship in the 'paradise' aboveground. The protagonist learns that troops have been sent underground to squelch a worker revolt; packs of monstrous workers, mutated by the tree's potent sap, also rove the caverns. After finally reaching the top level of the facility, he discovers his true identity as Tolbiac, the captain of the troops, as well as Eden Log's dark secret.

Critique

Eden Log, the directorial debut of Franck Vestiel, is remarkable in its creation of a fully realized, immersive science fictional environment despite its relatively low budget. The film's deep shadows and low-key lighting create a 'haunted house' mood that primes the audience for the horror of the mutant attacks, yet these techniques also stretch the film's budget by suggesting the complexity of the architecture in the underground facility without necessitating the construction of large sets. In this way *Eden Log* achieves the flavour of Ridley Scott's *Alien* (1979) without that film's blockbuster cost.

Perhaps the most notable stylistic element of *Eden Log* is its sound design. Sound achieves an unusually privileged position in the film, as Vestiel boldly strips away the more common stylistic techniques used to ground an audience in the narrative world. The poorly illuminated sets and handheld camerawork does not allow the viewer to make clear sense of the narrative space. The film also contains a minimum of dialogue; apart from a few bursts of exposition, themselves fragmentary and cryptic, *Eden Log* relies little on conversation to explain the narrative action. A more conventional film would have paired Tolbiac with a partner to whom he could explain his actions and thoughts. Instead, non-dialogue sound becomes a primary means of narration – for instance, the disturbing watery sound of subterranean putrescence as Tolbiac slides out of the primordial ooze in the film's opening.

Narratively, *Eden Log* recalls a number of American genre films, most notably Richard Fleischer's *Soylent Green* (1973) in which overpopulation leads to institutionalized cannibalism. To this *Eden Log* adds the amnesia plotline of films like *Total Recall* (Paul Verhoeven, 1990), *Memento* (Christopher Nolan, 2000) and *The Bourne Identity* (Doug Liman, 2002), including their hero-is-actually-a-villain plot twist. Yet in terms of narrative structure *Eden Log* is more closely linked to video games than cinema. Specifically, the film is reminiscent of survival-horror games like *Silent Hill* (1999) and *Dead Space* (2008) in its mixture of abrupt, startling moments of violence and quiet, slowly paced scenes of exploration, as well as

its reliance on overt exposition via recorded messages. Like a game player, the viewer of *Eden Log* is meant to identify with a thinly-drawn character as he travels from one level to the next, canvassing his mysterious environment while avoiding dangerous pursuers and encountering friendlier characters (such as the architect and the botanist) who fill gaps in his knowledge. Ultimately the character achieves a mastery over his labyrinthine surroundings and uncovers the mystery of his captivity.

One byproduct of *Eden Log*'s game-like narrative is a lack of strong character identification. Tolbiac, who speaks very little and spends much of the film in an amnesiac daze, is little more than a cipher meant to guide the audience through the Eden Log facility. His deteriorating physical condition due to mutation causes him to revert to primal bestiality (including a violent sexual assault of the botanist), which further distances him from the audience. Rather, identification occurs on a primarily visceral level. Vestiel and cinematographer Pouget favour handheld cameras, meant to reinforce the character's sense of unease and disorientation. While point-of-view shots are infrequent, the camera remains closely tied to Tolbiac. For instance, when the botanist throws a heavy net onto Tolbiac and drags him to her lab, the camera remains inside the net, darting from one side to the other, as if probing its structural soundness. While the shot does not technically reproduce Tolbiac's perceptual perspective, as he remains on camera, its frantic movements simulate his panic. The scene ends with a fade, as the botanist administers an anaesthetic to the struggling Tolbiac – again style creates a bond between audience and character, if only on the level of base instinct.

This tight focalization around Tolbiac also serves an economic function. As with the dark cinematography, *Eden Log*'s robust sound design helps to create a convincing narrative space through mere suggestion. For instance, early in the film Tolbiac is trapped in a suspended cube used to store corpses for consumption by the tree. Attempting to escape, he pushes against the sides of the cube, trying to topple it. The scene is represented entirely through interior shots of Tolbiac within the cube. The viewer never sees the cube topple, but understands that it does through the combination of the pendulous camera movements and the loud crash and Tolbiac's scream on the soundtrack.

Despite the film's efforts to bind the narration to Tolbiac, he remains emotionally inaccessible. *Eden Log*'s eschewal of classical character development makes it a challenging film for the average viewer; indeed, the film did not receive a wide theatrical release internationally. Yet if some of its plot elements seem familiar, and others are unnecessarily cryptic, *Eden Log* remains an outstanding example of low budget world building and creative use of sound. Its restrained visual style, even if it was necessitated by budget limitations, makes the film's final images all the more spectacular, as the tree shatters the Eden Log greenhouse and spreads its limbs toward the skyline of a mysterious, futuristic city.

Bradley Schauer

Blood and Roses

Et mourir de plaisir

Studios/Distributors:

Films EGE

Director:

Roger Vadim

Producer:

Raymond Eger

Screenwriters:

Roger Vadim
Roger Vailland
Claude Brulé
Claude Martin (based on the
novella Carmilla [1872] by
Joseph Sheridan Le Fanu)

Cinematographer:

Claude Renoir

Art Directors:

Jean André
Robert Guisgand

Composer:

Jean Prodromidrès

Editor:

Victoria Mercanton

Duration:

81 minutes

Genre:

Horror

Cast:

Mel Ferrer
Elsa Martinelli
Annette Vadim

Year:

1960

Synopsis

The film centres around a love triangle between Count Leopoldo von Karnstein, his cousin Carmilla, and Leopoldo's fiancée Georgia Monteverdi. Carmilla's jealousy and anguish intensify as Leopoldo and Georgia's wedding day nears. A fireworks display meant to celebrate the marriage accidentally unearths the 200-year-old tomb of Millarca von Karnstein, killed by peasants who suspected her of being a vampire. Camilla, who closely resembles Millarca, investigates the tomb.

Critique

Blood and Roses was released two years after the international success of Hammer Studios' *Dracula* (Terence Fisher, 1958), starring Christopher Lee. Initially it might seem as though Vadim were following in the Hammer tradition, spicing up the traditional vampire film with more overt violence and sexuality. The source material for *Blood and Roses*, Le Fanu's 1872 novella *Carmilla*, has a strong homoerotic subtext, and inspired a raft of lesbian vampire films in the 1970s. Yet Vadim, well known for his flamboyant use of sexuality, actually takes a more restrained, subtle approach than Hammer's combination of gore and heaving bosoms. *Blood and Roses* relies more on atmosphere than explicit content. Lesbianism is a key subtext, but remains just that (as opposed to Hammer's *The Vampire Lovers* [Roy Ward Baker] from 1970, for instance). In Vadim's film, the same-sex kiss that occurs is motivated by Carmilla's vampirism, as she kisses a drop of blood off Georgia's lips.

Foremost in the creation of *Blood and Roses'* mood is Claude Renoir's masterful Technirama cinematography. The film's lush colour, suggestive of the barely repressed eroticism of the narrative, anticipates Mario Bava films such as *Tre volti della paura/Black Sabbath* (1963) and Roger Corman's Poe adaptations like *The Masque of the Red Death* (1964). Renoir frequently uses the extreme long-shot to aestheticize the grounds of the manor; dwarfed by her surroundings, Carmilla in her flowing white gown is nearly abstracted as she seems to float along the banks of a lake. In contrast, the film's long-takes and camera movement help ground the narrative by establishing Karnstein's mansion as a plausible, living environment, especially in terms of the servants, who work and gossip as the camera weaves around them.

The interplay between the aestheticized and the quotidian is linked to the film's ambiguous treatment of the supernatural, another example of its narrative restraint. In a surreal, Cocteau-esque dream sequence, Georgia learns that Millarca killed Carmilla and took possession of her body on the night of the fireworks. But the film never explicitly reveals Carmilla engaging in vampirism or using any supernatural abilities. On the contrary, it poses an alternate explanation; at the film's conclusion Dr Verari suggests that Carmilla was simply driven insane by the shock of Leopold's engagement to Georgia: 'she escaped from herself through

neurosis […] the defeated Carmillla became the uncompromising Millarca.'

Blood and Roses was also released in an English language version; dialogue scenes were shot in both languages. The English version, released in America by Paramount Pictures, eliminates the ambiguity of the French version in favour of a more conventional supernatural approach. For instance, in the English version the framing sequence is narrated not by Dr Verari, but by Millarca herself: 'I will tell you the story of my most recent life.' The scene with Verari on the plane is cut, leaving only unmotivated air travel footage over which Millarca's spectral voice reflects: 'Paris to Rome in 90 minutes. Five-hundred years ago, the same journey took almost two months.' Millarca declares that 'the world of the spirit' might seem outmoded in 'this age of jets and rockets', but 'it is still true'. At the end of the film, Millarca's voice-over explicitly rejects Virari's rationalism: 'The true explanation lies in the world of the spirit.' By giving Millarca the role of the omniscient narrator, the film affirms her existence. The English version also drops the superstitious young girls Martha and Marie entirely; in the French version they serve as a gentle mocking of the ancient fears that the English version asks its audience to take seriously.

In its efforts to fashion a more conventional horror film, the English edit also creates a grimmer, more concrete conclusion. In the French version, Leopold argues that Georgia's scream during Millarca's attack 'saved her life', as Carmilla was forced to interrupt her attack. After Carmilla's death, Leopoldo and Georgia leave on their honeymoon. Dr Vivari's voice-over intones, 'For those who believe in vampires, the legend didn't die with Millarca. It continues with the last female Karnstein, Georgia.' The film ends on this ambiguous, uneasy note with the couple embracing on an airplane. Again the English version seeks to close down meaning, to favour the supernatural explanation for the film's events. Over the same shot of Leopoldo and Georgia, Millarca offers this chilling comment: 'Ah, Leopoldo. Another modernist. Funny […] three months on a honeymoon, and still he thinks it is Georgia he married.' Millarca's English voice-over disrupts the ambiguous tone carefully built over the course of the film; at the same time, the downbeat and ironic conclusion of the English version is arguably a more dramatically powerful end to this subtle, beautiful film.

Bradley Schauer

Eyes Without a Face

Les Yeux sans visage

Studios/Distributors:

Lux Compagnie
Cinématographique de France

Director:

Georges Franju

Producer:

Jules Borkon

Screenwriters:

Boileau-Narcejac
Jean Redon
Claude Sautet
Pierre Gascar (dialogue)
(adapted from the 1959 novel
by Jean Redon)

Cinematographer:

Eugen Shuftan

Art Director:

Margot Capelier

Production Designer:

Auguste Capelier

Composer:

Maurice Jarre

Editor:

Gilbert Natot

Duration:

90 minutes

Genres:

Fantasy
Horror

Cast:

Pierre Brasseur
Alida Valli
Juilette Mayniel

Year:

1960

Synopsis

Louise drives her car down a country road at night, transporting a strange-looking figure that proves to be a corpse she is taking to dispose of in a river. She works for Dr Génissier, an authority in the exceedingly difficult field of skin grafting. Summoned to a police station to identify a corpse with a mutilated face, Génissier says it is the body of Christiane, his disfigured daughter. He is lying, since Christiane is alive and living secretly in his home. Her face was indeed destroyed, in a car accident caused by his irresponsible driving, and the corpse fished from the river was that of a young woman whose face Génissier tried to graft onto hers. His next attempt succeeds, restoring Christiane's beauty at the expense of still another life. The success is short-lived, however.

Critique

Eyes Without a Face is one of many films – others range from William Friedkin's *The Exorcist* (1973) to Quentin Tarantino's *Pulp Fiction* (1994) – that actually or allegedly caused audience members to faint when they first reached the screen. The respected French newspaper *L'Express* reported that 'spectators dropped like flies' at the sight of Christiane's flayed face, a spectacle that director Georges Franju carefully built towards in the earlier scenes. Since the premiere of *Eyes Without a Face* in 1960, films of horror and the fantastic have amplified their shock-and-awe tactics so hyperbolically that it is hard to imagine many current moviegoers being sent into a swoon by a deliberately paced black-and-white drama with little explicit blood or violence. Taken on its own terms, however, Franju's nightmarish classic stands with the strangest, most unsettling movies of its time.

The basis of *Eyes Without a Face* was a novel by Jean Redon, adapted by the author along with Claude Sautet, soon to become an important director himself, and the celebrated team of Pierre Boileau and Thomas Narcejac, whose previous crime-fiction novels had inspired such major films as Henri-Georges Clouzot's *Les Diaboliques* (1955) and Alfred Hitchcock's *Vertigo* (1958). Franju had directed a string of documentary shorts – including the extraordinary *Le Sang des bêtes/Blood of the Beasts* (1949), juxtaposing peaceful Paris neighbourhoods with footage shot in the city's slaughterhouses – and he signed on to *Eyes Without a Face* while he was still completing his first fiction feature, *Head Against the Wall* (1959), about a man wrongly held in an insane asylum. Franju said he filmed *Eyes Without a Face* in black-and-white because its ghastly images would be repellent in colour – the same claim that Hitchcock sometimes made about *Psycho*, also released in 1960. To photograph these images Franju recruited Eugen Schüfftan, who had shot movies by Max Ophüls, René Clair, G. W. Pabst, Marcel Carné, and other giants; he also invented the Schüfftan process, used internationally to combine live action with miniatures or drawings. Maurice Jarre composed the music, built

Eyes Without a Face, Champs-Elysées, Lux.

around a dance-like theme evoking childhood, mania and delirium.

The crowning touch of the production is its casting, especially that of Edith Scob, who brings Christiane alive in all her sadness and complexity despite having to play most of her scenes in a plain white mask. The long-established star Pierre Brasseur portrays Génissier, who dons a different kind of white mask when he performs his illicit surgeries, and his son Claude Brasseur plays a police inspector. The equally distinguished Alida Valli portrays Louise, the mad scientist's secretary and enabler. While all are excellent, the indispensable player is Scob, an exquisite and eccentric presence who made several more Franju films in subsequent years.

Eyes Without a Face values uncanny moods over graphic horrors, not shocking the audience into submission but burrowing slyly under its skin; hence its tactfully filmed murders and fleeting, out-of-focus views of mutilated visages. The exception to this is the disquieting scene in which Génessier laboriously prepares, detaches, and removes a victim's facial skin in pursuit of his doomed attempt to make his damaged daughter whole. Even this appalling display is more clinical than terrifying in its effect, and like much of the film, it is bathed not in spooky shadows but in the light associated with science and reason – an incongruity handled as artfully by Franju as by Hitchcock, who also felt evil is scariest in nondescript surroundings. A dubbed and edited version of *Eyes Without a Face* was released in the United States as *The Horror Chamber of Dr. Faustus*, an irrelevant title meant to hoodwink B-movie fans. But silly distributor tricks cannot obscure Franju's well-earned reputation as a master of the *fantastique* in its highest, most artful form.

David Sterritt

Frontier(s)

Frontière(s)

Studio/Distributor:
Cartel Productions

Director:
Xavier Gens

Producer:
Laurent Tolleron

Screenwriter:
Xavier Gens

Cinematographer:
Laurent Barès

Art Director:
Olivier Afonso

Composer:
Jean-Pierre Taieb

Editor:
Carlo Rizzo

Duration:
108 minutes

Genres:
Crime
Drama
Horror

Cast:
Karina Testa
David Saracino
Aurélien Wiik
Chems Dahmani
Jean-Pierre Jorris

Year:
2007

Synopsis

In Paris, a far-right government is elected, and riots break out all over the city. In the ensuing chaos, Yasmine, her ex-boyfriend Tom, and her friends Alex and Farid commit a bank robbery, and escape to a remote hostel on the French border, run by the von Geisler family. Alex is axed in the head, Farid is steamed to death, and Tom's Achilles tendons are severed. The von Geisler family, headed by 'Father', are revealed to be Nazis.

Critique

Xavier Gens' *Frontier(s)* constitutes a pioneering example of what some critics have termed 'Sarkozy horror'. If horror films suggest violent disruptions in the everyday world, transgressing and violating boundaries, then *Frontier(s)* continues this on-going, unsettling preoccupation with borders and thresholds. The film presents a politicized narrative that grafts images of inner-city riots and street lootings similar to those of October and November 2005 onto its popular genre framework. In the near-future, a far-right presidential candidate is on the verge of taking power. In the ensuing riots, a gang of looting criminals escape to the country and stop at a roadside motel run by a clan of neo-Nazi cannibals seeking to establish a New World Order. The remainder of the film documents the battle for survival between the multi-cultural youths of the Paris *banlieue* and the border *paysans*.

The film's visual tricks, such as an extensive use of hand-held cameras and shutter effects, add considerably to the final product. With their lack of natural light, many scenes feel almost medieval, reminiscent of the bleached and blasted landscapes of recent post-apocalyptic, existential 'horrors' like *The Road* (John Hillcoat, 2009) and *The Book of Eli* (Albert Hughes and Allen Hughes, 2010). In keeping with the film's numerous generic antecedents, the horrors that await the band of criminals at the von Geisler house combine the sanguine, the sickening, and the slashing of Achilles tendons. Unlike other recent French horrors, which have tended to focus on houses under threat from outside, and reveal events through a series of slow, incremental scenes, *Frontier(s)* relies upon a sustained use of set-pieces that plays out more like a set of end-of-level videogame platforms. Fans of *The Descent* (Neil Marshall, 2005) will enjoy an excruciatingly claustrophobic crawl through a tunnel, and we watch on as characters melting inside ovens, and being stalked by murderous butchers. *Frontier(s)* looks and feels like an American genre hybrid, with its photogenic multi-racial band of 'heroes', its narrative momentum, and its reliance upon numerous money shots to satiate fans.

So far, so *grand guignol* derivative. Yet *Frontier(s)* reflects a number of contemporary anxieties, most notably the possibility of the accession to power of an extreme-right wing president. Released in January 2008, less than one year after the election of Nicolas Sarkozy, its use of urban riots and an aggressive police

response recalls events of autumn 2005 and Sarkozy's denunciation of rioters. Moreover, a key aspect of Sarkozy's 2007 presidential campaign was his appropriation of far-right rhetoric to woo supporters of Front National candidate Jean-Marie Le Pen to his own UMP party by promising a new Ministry of Immigration and National Identity. Accordingly, *Frontier(s)* embodies a powerful trauma narrative that foregrounds contemporary iconography and current national fears (riots in Paris, urban dissolution, youth-police clashes) and proposes a radical alternative in which the extreme right verges on taking power. It thereby dramatizes the fractures of recent political events in France, most notably Le Pen party reaching the second round of the 2002 presidential election.

Mid-way through the film, these documentary impulses are replaced by more conventional horror tropes, and *Frontier(s)* mutates into an example of what Paul Wells calls 'the rural gothic', films which call upon 'the brutalities of a mythic past' and distort 'the imperatives and philosophy of frontier life'. The template for these works stretch back to *The Hills Have Eyes* (Wes Craven, 1977) and *The Texas Chainsaw Massacre* (Tobe Hopper, 1974), which have both been read as tracts indicative of the delegitimization of authority in a post-Vietnam era. In *Frontier(s)*, a similar reading emerges, only this time around, Gens' visualization of right-wing extremism is strengthened by the suggestion that the mutant von Geisler family embodies a virulent strain of racism. By categorizing them as bloodthirsty Neo-Nazis rather than the 'crazy hillbillies' that first surfaced in John Boorman's *Deliverance* (1972), the graphic symbolism of *Frontier(s)* breaks through to show a more abject horror beneath the surface of the real. As controlled by the paterfamilias (veteran French character actor Jean-Pierre Jorris, who bears an uncanny resemblance to Le Pen), the von Geisler family despise Yasmine (Karina Testa) and her *beur* friends because they lack racial purity, and the repetitive cannibal visual references reinforce the 'multicultural youths as meat' metaphor.

The 'Final Girl' of *Frontier(s)* is Yasmine, the young woman of the *banlieue* who escapes physical and mental degradation, kills the Nazi family, and is 'saved' by driving into a police roadblock. Whether or not this ending proposes a restorative ideology of multi-cultural resourcefulness and dominant femininity remains unresolved – it remains difficult to see Yasmine's degradation as anything but punishment for her criminal lifestyle and for jeopardizing the well-being of her unborn child. Nonetheless, the triumph of the New France – *banlieuesard* and *beur* – over the Old – reactionary, xenophobic – reinforces how a popular genre can provide a deft conceptual framework for current political preoccupations. Things are not entirely so clear-cut by the final reel, however. As Yasmine escapes the von Geislers, and is arrested by the police, a whole new subtext emerges, and remains unexplored – just what will be the future in for Franco-Muslim relations? Has Yasmine fled from one form of primal terror into another, more institutionalized version?

Frontier(s), like its antecedents in the New French Extremity *Sheitan/Satan* (Kim Chapiron, 2006) and *Calvaire/The Ordeal* (Fabrice

Du Welz, 2004), uses violated bodies and the abject hidden away in the French countryside as starting points for social commentary. Gens uses the possibility of a far-right government and the restoration of a fascist ideology as collective national punishment for the events of 2002 and the unchecked rise of Sarkozy's immigration plans. Ultimately, no matter how horrific the monsters in *Frontier(s)*, they are both part of us and caused by us.

Ben McCann

High Tension

Haute tension

Studio/Distributor:
Alexandre Films

Director:
Alexandre Aja

Producers:
Alexandre Arcady
Robert Benmussa

Screenwriters:
Alexandre Aja
Grégory Levasseur

Cinematographer:
Maxime Alexandre

Art Director:
Grégory Levasseur

Composer:
François Eudes

Editors:
Baxter
Al Rundle
Sophie Vermersch

Duration:
91 minutes

Synopsis

Marie goes away for the weekend with her college friend, Alex, to study for exams at Alex's family farmhouse. Late at night, a homicidal maniac breaks in, kidnaps Alex, and slaughters the rest of her family. Marie, who manages to elude the killer's rampage, follows him when he leaves with her captive friend. Can she save Alex before it is too late?

Critique

When French film-makers Alexandre Aja and Grégory Levasseur began writing *High Tension* (known as *Switchblade Romance* in Britain), they wanted to pay tribute to the usual suspects of 1970s and 1980s American slasher and survival cinema – films like Wes Craven's *The Last House on the Left* (1972) and Tobe Hooper's *The Texas Chainsaw Massacre* (1974). And for its first two acts *Tension* remains a lean, mean, and exceptionally brutal stalk n' slash, cat and mouse-style thriller. But for many, the film's divisive third act unspools the carefully wound tension in favour of what is either brilliantly subversive or a socially irresponsible exemplar of Robert Benshoff's (1997) 'homosexual-as-monster' motif. It is not that the twist comes out of left field – it is both foreshadowed from the very first scene and consistently supported by the film's *mise-en-scène* and editing. It is just that *Tension* simply seems like a stronger film without the big reveal, partly because it calls into question everything that comes before in a way that can only be explained if we accept that the story is being told from the point of view of an unreliable narrator who cheats the audience out of a logical chain of events, and partly because it takes an empowered Final Girl and reduces her to a monstrous lesbian. Yet this may be the point all along, and *Tension*'s big reveal may not actually be intended as a surprise – allow me to explain.

High Tension begins with the battered and bruised Marie (Cécile De France) decked out in a white hospital gown and muttering the same phrase over and over: 'I won't let anyone come between us anymore.' As she has clearly survived a traumatic experience, it is

Genres:

Drama
Horror
Mystery

Cast:

Cécile De France
Maïwenn Le Besco
Philippe Nahon
Franck Khalfoun Père
Andrei Finti
Oana Pellea
Marco Claudiu Pascu
Jean-Claude de Goros

Year:

2003

unsurprising that her body language suggests she is uncomfortable. A mechanical whir interrupts her reverie, and as she glances into the lens of the video camera across from her, she groggily asks someone off-screen if it is recording. From there, the film flashes back to Marie stumbling through a forest in slow motion. We follow, mostly behind her, focusing on her now fresh wounds and listening to her harried, painful gasps for air as she struggles to stay on her feet and elude some unseen stalker. It is not until she emerges from the forest, flags down a passing car, and screams at its driver for help that we finally see her face for the first time. Marie's nightmare wakes her from her sleep in the backseat of a car that is being driven by her friend and classmate Alexia (Maïwenn Le Besco). The two are travelling to visit Alex's family at their home in the secluded French countryside. When Alex presses Marie about her nightmare she explains, 'It was me running after me.'

Have you figured out the twist yet?

Shortly after Marie's nightmare, we cut to the family farmhouse, where a dilapidated, rust-coloured truck sits hidden on a nearby muddy road. The man in the truck pleasures himself with a severed head before chucking it out the window and driving away. The head, with its long brown hair and facial features, none-too-subtly signifies Alex and the killer's (Philippe Nahon) perverted intentions for her. When Marie and Alex arrive at the farmhouse, it is not long before everyone retires for the evening. Marie takes a stroll outside; Alex goes upstairs to take a shower. Outside, Marie sits atop a creaky wooden swing and watches Alex shower through a curtain-less second-story window. After she goes back inside, Marie walks upstairs to her bedroom, puts on a pair of headphones, and begins pleasuring herself (no doubt to thoughts of Alex). At the same time, the killer's headlights illuminate the darkness outside the farmhouse. When Marie climaxes, the killer knocks on the front door, and begins to slaughter Alex's family. Marie eludes capture but is unable to prevent Alex's abduction. And this is when the film becomes a tale of survival where Marie struggles to rescue her friend and outsmart a villain who preternaturally senses her around every corner.

The third act reveals that Marie and the killer are actually warring personalities in the same psyche, which should come as little surprise to careful viewers familiar with psychoanalytic interpretations of the slasher genre – or who simply found it suspicious that Marie's opening nightmare involved her chasing herself. Since films do not typically provide non-essential narrative information, that one is a giveaway. The two personalities vie for control throughout the entire film (a statement supported by the film's editing and inspired use of light and dark to showcase which personality is dominant at any given moment in time) and while both personas inflict considerable physical harm on one another prior to the denouement, the two remain unable to permanently extinguish the other. One could interpret this as two personalities that are integral to the existence of the whole. In other words, they are unable to kill one another, because doing so would be like committing suicide. Marie's outward appearance and demeanour masks the true nature

of her lesbianism, which the narrative implies is a form of per-verted heterosexuality that is morally reprehensible and physically repulsive.

True, Marie's lesbianism masks a grimy, sexually deviant person-ality that (we can assume) vies for position in Marie's psyche and appears whenever Marie experiences unrequited love. But if we operate under the assumption that *High Tension* is trying to mimic the American slasher film, its ending is not necessarily surprising or offensive. Rather, it is giving American audiences an unfiltered look at what a lot of their films have been showing them since the 1980s – namely, that American slasher films have always been governed by Puritanical conservatism that has, at least in part, demonized lesbianism and homosexuality. In this way, then, Aja has created the quintessential American slasher film that wears its politics on its sleeve instead of hiding them behind monstrous make-up or a mask.

Will Gartside

Them

Ils

Studio/Distributor:
Eskwad

Directors:
David Moreau
Xavier Palud

Producer:
Richard Grandpierre

Screenwriters:
David Moreau
Xavier Palud

Cinematographer:
Axel Cosnefroy

Composer:
René-Marc Bini

Editor:
Nicolas Sarkissian

Synopsis

Clémentine, a French schoolteacher working in Bucharest, lives in a secluded house with Lucas. One night, someone breaks into their house, and after a series of cat-and-mouse chases, a group of children push Lucas to his death, and capture and kill Clémentine. Before she dies, one child asks 'Why won't you play with us?'

Critique

Despite its setting in Bucharest, Romania and its nocturnal aes-thetic, *Them* is not a typical vampire film. It is not about Dracula, or haunted castles, or long-lost loves, but rather children – malign, malignant children. As a paedophobic tract, *Them* is up there with William Golding's *Lord of the Flies* (1954) and John Wyndham's *The Midwich Cuckoos* (1957) (later filmed as *Village of the Damned* [Wolf Rilla, 1960; John Carpenter, 1995]), as well as modern horrors like *Eden Lake* (James Watkins, 2008) and *Das Weisse Band/The White Ribbon* (Michael Haneke, 2009). In short, the kids definitely are not alright. Clementine (Olivia Bonamy) has recently taken a job teaching French at a local school, but struggles to communi-cate in Romanian and complains to her boyfriend Lucas (Michaël Cohen) that her students are troublesome and ill-disciplined. One night, deep in the forest, in their isolated house on the outskirts of the city, Clementine and Lucas are awoken by barely glimpsed intruders who turn the television set on and off, cut telephone and power lines, and force the couple to barricade themselves in

Ils, Eskwad, Studio Canal.

Duration:

77 minutes

Genres:

Horror
Thriller

Cast:

Olivia Bonamy
Michaël Cohen

Year:

2006

their bedroom. The minimalism of the film's visual style, its grainy cinematography, its faces and sudden movements emerging out of shadows, coupled with the relentless narrative drive of the screenplay, prevent a clear understanding of what or who 'ils' ('they') are. Only as the credits roll do we get the true extent of the intruders' motivations: a group of children in their early teens terrorized the couple because '*they* wouldn't play with us'.

At a brisk 77 minutes, the film incorporates traditional genre elements of the horror film, such as the pre-credit sequence involving a mother, a daughter, a stranded car and a rain storm, the deliberately ponderous exposition, and the rhythmic structure of chase and failure. There is also a fairy-tale feel to the film, with its forest setting and stripped-back tonal strangeness. Moreau and Palud are confident in their narrative style, for there is no rush into the obligatory frenzy, rather a slow-burning establishment of characters that deepens the coming emotional pay-offs. So, when Lucas goes down stairs to try and repair the blown fuse-box, the camera stays with him the whole time, refusing to cut back to Clementine locked in the bathroom. It is in scenes such as this, where the tension is ratcheted up to almost unbearable proportions, that *Them* also recalls the domestic threats that are a common expository element in American horror cinema (*Halloween* [John Carpenter, 1978], *When A Stranger Calls* [Fred Walton, 1979], *A Nightmare on Elm Street* [Wes Craven, 1984]), as well as recent French works like Dominik Moll's *Harry, un ami qui vous veut du bien/With a Friend Like Harry...* (2000) and *Lemming* (2005), and *Caché/Hidden*

(Michael Haneke, 2005). Broadly speaking, these scenarios are politically charged and refute the notion of the home-as-fortress. The *mise-en-scène* evokes the permeability of domestic space, notably in an early scene when Clementine's eye is nearly gauged by an intruder's screwdriver as she peers through a keyhole.

This early instance of domestic rupture pushes *Them* towards an allegorical reading: that the struggle between the French couple and Romanian intruders plays out current geo-political and cultural tensions at the heart of the European Union project. Themes of alienation (at the start of the film Clementine tells a colleague how difficult the cultural adjustment is for her) and annihilation (by the end, the couple are murdered) exploit real French anxieties about the growth of the European Union and critique the benefits of integration and freedom of movement. Indeed, France has maintained a careful balancing act in the EU: on the one pro-integrationist and pro-federalizing; on the other, highly nationalistic and deeply sceptical towards the accession of former Eastern Bloc countries and ex-Soviet satellite states.

Moreau and Palud deploy the invasion of domestic space to riff on French fears about a threatened cultural identity. Lucas is a novelist (and thus a symbol of cultural hegemony), while Clémentine's job is to educate Romanian children (using a French dictation exercise to keep them quiet). Yet cultural superiority through linguistic dominance is destabilized once the couple's home is transgressed by children communicating via coughs, clicks and sibilances. *Them* allegorically suggests that France's apparently benevolent 'cultural mission' within the new EU will be undermined. Indeed, the Romania in *Them* is configured as a highly negative space and a clear example of the failure of integration: Lucas and Clementine's home is dilapidated, telephones do not work, and the police do not respond to their calls. Moreover, as a consequence of former president Nicolae Ceausescu's conservative political agenda and his banning of birth control and abortion to increase Romania's population, the film depicts a disenfranchised underclass of homeless children prone to attacking the privileged and wealthy. These homeless children represent not just a mass of immigrants who threaten to destabilize the French labour market, but also a wider cultural and social mass primed to invade French borders and challenge its dominant culture.

Keen viewers will note that the children wear hooded tracksuit tops and use football rattles to communicate. Both of these symbols – the hoodie and the football hooligan – represent common stereotypes of the clash between disaffected youths and the middle classes that in turn is seen as emblematic of contemporary Europe's social problems. Ultimately, the film plays out like a flipside version of *The Blair Witch Project* (Daniel Myrick and Eduardo Sánchez, 1999), with its brooding sense of something ominous and evil lurking in the shadows depicted with an almost documentary-style reverence. On the back of the film's success, Moreau and Palud were snapped up by Hollywood to direct *The Eye* (2008) with Jessica Alba. Domestic invasion scenarios, regardless of language or geography, are one of modern horrors more harrowing sub-

genres, and, as *Them* makes clear, becomes even more unsettling when children are the perpetrators rather than the innocents.

Ben McCann

The Devil's Hand

La Main du diable

Studio/Distributor:
Continental Films

Director:
Maurice Tourneur

Producer:
Maurice Tourneur

Screenwriter:
Jean-Paul le Chanois (based on the poem 'La Main enchantée' [1832] by Gérard de Nerval)

Cinematographer:
Armand Thirard

Composer:
Roger Dumas

Editor:
Christian Gaudin

Duration:
78 minutes

Genres:
Fantasy
Horror

Cast:
Pierre Fresnay
Josseline Gaël
Noël Roquevert
Pierre Palau (aka Palau)

Year:
1943

Synopsis

Late at night in a remote mountaintop inn, a desperate young man, Roland Brissot, stumbles in and recounts his life story. In flashback, Roland, a failed painter, makes a pact to buy a severed hand, a talisman that grants its bearer all they desire. Roland duly becomes a successful artist, rich and celebrated, while his fickle girlfriend, Irène, finally agrees to marry him. But Roland has struck a Faustian bargain, as the Devil begins to stalk his every move…

Critique

Released in April 1943 with the world at war, *The Devil's Hand* is a triumph *maudit* in the late-phase career of Maurice Tourneur. Professionally trained in painting, sculpting and theatre, Tourneur's move into cinema, in 1913, aged 40, saw him hired by Éclair, based first at Paris and then in Fort Lee, New Jersey. A series of acclaimed Hollywood films followed, in which Tourneur's formalist style – the high-angle, deep-staged bank robbery scene of *Alias Jimmy Valentine* (1915) being a noted highlight – made his reputation as a leading world film artist. Frustrated by Hollywood's increasingly corporate production model, however, Tourneur returned to France, where during the 1930s and 1940s he became a reliably inventive senior director-for-hire, making well-regarded films like *Accusée, levez-vous!/Accused, Stand Up!* (1930; Pathé-Natan's first sound feature), *Justin de Marseille* (1935) and *Volpone* (1941).

A contemporary of Clouzot's equally scabrous *Le Corbeau/ The Raven* (1943), *The Devil's Hand* was one of five films Tourneur made for Continental Films, the Nazi-run production company set up in occupied Paris by Alfred Greven. The producer of 30 films between 1941 and 1944, Continental Films employed a stable of significant film-makers (Clouzot, Tourneur, Christian-Jaque, Henri Decoin, André Cayette) and major stars (Fresnay, Fernandel, Danielle Darrieux, Albert Préjean). Among the many bitter ironies of the Occupation is that not only did French cinema become centrally organized for the first time during this period, but also that Continental Films embodied this new commercial efficiency. It became, indeed, a microcosm of classical French film, turning out rustic comedies like the Fernandel vehicle *Simplet* (1942), three Georges Simenon-Maigret policiers (*Picpus* [1943], *Cécile est morte/Cecile Is Dead* [1944] and *Les Caves du Majestic/Majestic Hotel Cellars* [released belatedly in 1945]), period films (notably Tourneur's *Mam'zelle Bonaparte/Miss Bonaparte* [1942] and Christian-Jaque's

La Symphonie fantastique [1942]), and more provocative social dramas like *Le Corbeau* and Tourneur's *Le Val d'enfer/Valley of Hell* (1943). As Evelyn Ehrlich argues in *Cinema of Paradox: French Filmmaking Under the German Occupation* (1985), Continental Films was an industrial oasis of sorts, with rare cinematic resources (especially film stock) freely available and creative license reasonably encouraged. Amazingly, Jean-Paul le Chanois, *The Devil's Hand*'s scriptwriter, was a clandestine Jew working under a pseudonym – a fact that was apparently known to Greven, who strategically prized his company's assets above the Nazi ideology.

Although occupied France produced a broad, albeit heavily censored range of cinema, it is its more allegorical films that have always attracted the most scrutiny. Certain Continental films, in retrospect, really do seem like the symbolic self-flagellations of a defeated proud nation. A good case in point is *Valley of Hell* – Tourneur's venomous companion piece to *The Devil's Hand*, which follows a rural family torn apart by the arrival of Ginette Leclerc, whose insatiable appetites lead her to betray her husband, demand the exile of her elderly parents-in-law, then contemptuously sell off the homestead's traditional French furniture. War is never mentioned, of course, but the background imagery of the town destroying itself with explosive strip mining makes Tourneur's social diagnoses all the more pungently clear.

Even alongside *Le Corbeau* and *Valley of Hell*, though, *The Devil's Hand* may be the richest, most insidious example of this type of Occupation cinema. It is poetically abstract but iconically French, stylistically virtuoso but claustrophobic, emotionally involving but cold as black ice. The Faust legend neatly dismantles the Vichy mantra of family-work-country, all of which bedrocks crumble into dust. As the tormented dreamer brought low, Pierre Fresnay is brilliant in the central role, dishevelled and hapless before he acquires his new left hand, accomplished but despairing when the cost of his new status is revealed. Next to Fresnay (and much of the film's second half is a virtual two-hander) the veteran character actor Pierre Palau is just as unnerving and just as chameleonic as Roland's nemesis, the Devil. (Palau easily matches Jules Berry's famously slick performance, also playing the Devil, in Marcel Carné's Occupation-era period drama, *Les Visiteurs du soir/ The Devil's Envoys* [1942].) At first Palau's Devil is an ingratiating sycophant when Roland makes it big; he then morphs into a petty (Vichy-ist) bureaucrat, totting up the painter's debt – which doubles every day, as we see in one memorably demented animated aside – with bland relish; before finally revealing his true colours as a vicious, implacable sadist.

Throughout, Tourneur's *mise-en-scène* is highly evocative of a man losing his mind, deserted by anything familiar, as the Devil invades the everyday. The influence of German Expressionism looms large, with periodic chiaroscuro eruptions: in the doom-laden framing mountainside inn scenes, and an eye-catching series of night-time tracking shots, as Roland returns to his artist's garret after buying the hand, jumping at shadows, not yet aware that his life has changed course. Virtually every plot point, in fact, warrants

La Main du diable, Continental Films.

a grotesque flourish, like when, at the peak of his fame, Roland finds an elaborate funeral wreath signed over to him, while the Devil's mocking laughter echoes down the street. As with Leclerc's roles in both *Le Corbeau* and *Valley of Hell*, the brittle faithlessness of a central woman, here played by Josseline Gaël, is yet another indictment of a world where all that glitters is not gold. But charges of misogyny seem beside the point when pretty much everything and everyone in *The Devil's Hand* is poison. Even at the climax, as the inn's lodgers watch Roland and the Devil fight their final duel, the crowd of ordinary French people come across, under Tourneur's exacting direction, as mesmerized bystanders, unwilling to get involved, obviously glad that Roland's violent fate is not – yet – their own. This, Tourneur seems to say, is the real horror of Occupation, that everyone is corrupted and no one can ever be redeemed. Death is as good as it gets.

Tim Palmer

Brotherhood of the Wolf

Le Pacte des loups

Studio/Distributor:

Canal+

Director:

Christophe Gans

Producers:

Richard Grandpierre
Emmanuel Gateau
Samuel Hadida

Screenwriters:

Christophe Gans
Stéphane Cabel

Cinematographer:

Dan Lausten

Composer:

Joseph LoDuca

Editors:

Xavier Loutreuil
Sébastien Prangère
David Wu

Duration:

142 minutes

Genres:

Action
Adventure
History

Cast:

Samuel LeBihan
Marc Dacascos
Vincent Cassel
Emilie Dequenne
Jérémie Renier
Monica Bellucci
Jean Yanne

Year:

2001

Synopsis

France, 1765. Word spreads about a creature known as the 'Beast of Gevaudan' terrorizing the countryside and leaving dozens of peasant corpses in its wake. Enter naturalist-adventurer Gregoire de Fronsac, back from the New World with Native American sidekick Mani. When the King hires them to track the mysterious monster, the dynamic duo meets the ruling family of the region – the Count of Morangias, his beautiful daughter Marianne and his maladjusted son Jean-Francois. Later on, as they enter the town of Gevaudan, they encounter Sylvia, head seductress/enchantress of a local brothel. As our swashbuckling heroes chase down the Beast, they find themselves in a world where human depravity and animal instinct have become inextricably linked.

Critique

January, 2001. StudioCanal's 25 million-Euro *Brotherhood of the Wolf* assaults theatres across France, trumpeted by the media as a sincere – if rather risky – attempt by a French major to mount a true Gallic variant of the Hollywood blockbuster. As one headline put it, at last French cinema was ready to 'bare its teeth' by beefing up an authentic French legend with state-of-the-art digital effects, a multi-generational list of A-list actors, and continental franchise tie-ins (the European burger joint Quick, among others, was a participant in the ad campaign). Even amidst all of this anticipation, the film still managed to surprise many critics with its playfully anachronistic but surprisingly earnest confection of gothic-horror camp, adrenaline-infused martial arts, mannered costume drama and a large, metallic wolf-monster furnished by Jim Henson's Creature Workshop. Ten years hence, the beast itself is perhaps the least convincing part of a film that remains a fascinating specimen of the aesthetic and creative energies that continue to animate popular French cinema in the early twenty-first century.

The second feature-length production by *cinéphile*-turned-director Christophe Gans, *Brotherhood of the Wolf* was in a way the crowning achievement for a hero of French fanboy culture of the 1980s and 1990s. Like many aspiring cineastes of his generation, Gans reports feeling stifled by the low-budget introversion of much of the French film-making of his youth. For this reason, he co-founded in 1983 the fanzine *Starfix*, dedicating his time to celebrating the popular film genres usually neglected by mainstream French critics as too vulgar, too popular, too American, or all three (the first issue's cover featured *Star Wars*, the second *Rambo: First Blood*). When he did move to the director's chair in the early 1990s, Gans became something of a cult icon for his first film *Crying Freeman* (1995), an adaptation of a Japanese manga, shot in Canada and also starring Marc Dacascos. Several years later, chum and former *Starfix* co-editor Stéphane Cabel tapped Gans to fully realize the potential of a screenplay he had been working on at Canal+Ecriture, the newly created screenwriting wing of Studio-

Le Pacte des loups, Studio Canal+.

Canal. Gans' one condition, apparently, for joining the production team, was that Dacscos be added in the role of Mani, an athletic, Native American sidekick for the film's protagonist, de Fronsac (Samuel LeBihan).

In many ways this 'film event' of 2001 was a rousing celebration of two age-old traditions, so often intertwined in the cinema of France – authorship and iconoclasm. For Gans' proclamations about his cinephiliac debts both established his own critical acumen and played a major role in the film's marketing stance. Even casual moviegoers could read in the press at the time that the overall tonal and generic structure of the film was indebted to Tsui Hark's *Once Upon a Time in China* (1991), that the arrival of de Fronsac and Mani in the opening sequence was an homage to Corbucci's *Django* (1966), that Bellucci's performance in the oneiric brothel set piece channelled Bava's *The Whip and the Body* (1963). Moreover, the spastic pacing of the image track itself practically reads as a series of bold authorial flourishes, as in the bravado opening sequence where a gruff voice-over proclaims over a breakneck following shot that it is time 'for this world to change'. To his credit, Gans rarely cut corners in his pursuit of his generic reclamation project. To wit, he literally imported famed editor David Wu to

France as a consultant for the film's fight scenes, insisting that his lead actors train in martial arts choreography with an expert from Hong Kong. This insistence on doing things the 'right' way, along with terrible weather conditions during the planned shoot in the countryside, pushed the film way over budget by delaying it way beyond its initial release date.

What should we make now of the energetic inconsistencies of Gans' now ten-year-old vision? Some might argue that in the end most of his antics are in the service of a renewed, synergistic pursuit of popular audiences that characterizes the cinema of today's globalized economy in France and elsewhere. Admittedly, many of the film's features dovetailed nicely with a brand of venture capitalism that was relatively new to French film-making at the time – at least on such a large scale. StudioCanal executives openly viewed *Brotherhood of the Wolf* as their chance to rival the Hollywood giants – the film's debts to the Wachowski's *The Matrix* (1999) are rather obvious – as well as French mega-producer Luc Besson, whose 1990s films like *The Fifth Element* (1997) and *The Messenger* (1999) were to that point the clearest-cut examples of French 'blockbusters' worthy of the name and game. Perhaps what saves the film in the end, though, from being 'only' a popular product, is its ingenuous embrace of all of this madness. With a slightly more jaded view of its own machinations, *Brotherhood of the Wolf* could have been frightfully overwrought – the work of a media head whose pent-up energy spilled screen-ward in the delirium of a sky-high budget (this is certainly case of *Vidocq* [Pitof], another digitized film from the same year that is, by comparison, a rather soulless exercise). Yet as we re-watch the film's most enduring images – bullet-time action sequences of two masked tri-corn hat avengers battling clown-faced peasants in the rain; fastidiously-decorated, dialogue-filled, costume-drama stage pieces in the mansion of the Marquis; trance-like tracking shots of Mani's painted body stalking the Beast in verdant darkness – it is increasingly difficult not to admire the sheer vim and vigour of this self-proclaimed 'hybrid' generic vision of France's cinematic past and future.

Charlie Michael

Les Diaboliques

Studio/Distributor:

Filmsonor

Director:

Henri-Georges Clouzot

Synopsis

At a boarding school near Paris, Michel, a cruel headmaster, mistreats his wife, Christine, as well as his mistress, Nicole. Christine and Nicole lure Michel to Niort, where they spike his drink and then drown him in the bathtub. After they dump his body in the school's swimming pool, disturbing evidence emerges that Michel may still be alive. A retired detective investigates, and, as he draws closer to the truth, Christine's heart condition worsens.

Producer:

Henri-Georges Clouzot

Scriptwriters:

Henri-Georges Clouzot
Jérôme Geronimi
René Masson
Frédéric Grendel

Cinematographer:

Armand Thirard

Art Director:

Léon Barsacq

Composer:

Georges Van Parys

Editor:

Madeleine Gug

Duration:

117 minutes

Cast:

Simone Signoret
Véra Clouzot
Paul Meurisse
Charles Vanel

Genre:

Horror

Year:

1955

Critique:

Les Diaboliques is celebrated above all for its twist ending. Clouzot deftly manipulates our knowledge of the film's events, generating first excruciating suspense when we fear that Nicole and Christine will be caught and then a great shock when the conspiracy between the headmaster and his mistress is revealed. Only upon a second viewing can one fully appreciate Clouzot's use of restricted narration and off-screen space. Many have compared Clouzot to Hitchcock, and with good reason: both directors favoured stories of black humour, duplicity and psychological realism; both were known to plan every detail of their films in advance; and both exerted tight control over their actors. The two film-makers were linked even more closely, however. Hitchcock attempted to buy the rights to the novel from which *Les Diaboliques* was adapted, Boileau and Narcejac's 1952 *Celle qui n'était plus/The Woman Who Was No More*, but he was too late; Clouzot beat him to it. The same thing happened with Clouzot's 1953 *Le Salaire de la peur/Wages of Sin*; Hitchcock wanted the novel, but Clouzot was there first. *Les Diaboliques* was clearly a source of inspiration to Hitchcock in the making of *Psycho*, another horror film in which a sympathetic female protagonist is killed off in the tawdry setting of a bathroom.

Les Diaboliques is notable for its style as well as its suspenseful narrative. Art director Léon Barsacq, who worked on Carné's *Les Enfants du paradis/Children of Paradise* (1945), creates here a series of highly detailed, oppressive sets that effectively evoke the grim school and Nicole's cluttered apartment in Niort. Shot partly in the studio, the film also employs memorable locations: an abandoned chateau near Paris was used for the school; an actual morgue, dry-cleaning shop, and hotel were enlisted for the scenes shot in Paris. Veteran cinematographer Armand Thirard skillfully employs low-key lighting, long takes, and depth staging at moments of high drama. Simone Signoret, admired for her strong performances in *Manèges* (Yves Allégret, 1950) and *Casque d'or* (Jacques Becker, 1952) is another strength of the film. Her powerful physical presence and her crisp vocal delivery contrast nicely with Véra Clouzot's fragile, faint-hearted Christine. Charles Vanel's subtle performance as the cagey detective is notable, as is Paul Meurisse's brutal headmaster. The soundtrack is sparse, but effective, particularly in the famous scene near the end in which mysterious sounds draw Christine out of her bedroom and down the dark hallways of the school. The sound design for the scene in which Michel forces Christine to consume rotting fish is enhanced by the isolation of Michel's voice on the soundtrack as he shouts 'Swallow!'

Les Diaboliques did well at the French box office; it was one of the top twenty films of the year, coming in behind *Lady and the Tramp* (Clyde Geronimi, 1955) and *20,000 Leagues Under the Sea* (Richard Fleischer, 1954) but ahead of *On the Waterfront* (Elia Kazan, 1954) and *To Catch a Thief* (Alfred Hitchcock, 1955). And yet, François Truffaut attacked Clouzot in the pages of *Cahiers du Cinéma*, lumping him with René Clément and René Clair, and

dubbing them the 'untouchables' for their big budgets and insider status (Truffaut 1955: 18). André Bazin, for his part, predicted that *Les Diaboliques* would probably be classed among Clouzot's 'minor' films, but nevertheless thought it was Clouzot's 'most perfect' film. He liked Clouzot's stripped down, suspenseful plot and drew attention to the performance of Charles Vanel as the inspector (Bazin 1955: 42). The film's reception in the United States was no less impressive; it earned over $1 million and accomplished a rare thing for a foreign film: it was so popular that it moved from the art house cinemas, where most foreign films were shown, regardless of genre or style, to mainstream theatres and drive-ins. According to *Life* magazine, a woman in New York 'fainted in the audience, was revived in the lounge, and insisted on going right back to witness the devilish climax' (cited in Balio: 112).

Clouzot is celebrated today for his suspenseful and stylish thrillers, but his career has suffered its ups and downs. He worked in Berlin's UFA studios in the early 1930s, but contracted tuberculosis back in Paris and therefore did not direct his first feature, *L'Assassin Habite au 21/The Murdered Lives at Number 21*, until 1942. At the Liberation, Clouzot was sanctioned for having run the screenplay division of a German production company during the Occupation and for having directed *Le Corbeau/The Raven* (1943), a film considered collaborationist by some. After a two-year ban from the film industry, Clouzot made a spectacular comeback with *Quai des Orfèvres* (1947) and *Le Salaire de la peur/Wages of Fear* (1953). His career suffered again as a result of illness and the rise of the New Wave; ultimately, he directed only ten feature films. Clouzot is nevertheless treasured as an expert chronicler of the dark side of French culture: sexual jealousy, infidelity, and complex machination pervade his films. In a 1995 poll published in *Positif* listing the 'best thrillers', no director's name appears more often than that of Clouzot. He has come to our attention once again thanks to Serge Bromberg's *L'enfer d'Henri-Georges Clouzot/Inferno* (2008), an experimental documentary about the troubled production of Clouzot's unfinished 1964 film starring Serge Reggiani and Romy Schneider, *L'enfer*.

Kelley Conway

References

Bazin, André (1955) 'Le Style c'est le genre', *Cahiers du Cinéma*, 43, January.
Balio, Tino (2010) *The Foreign Film Renaissance on American Screens, 1946–1973*, Madison: University of Wisconsin Press.
Truffaut, François (1955) 'Clouzot au travail', *Cahiers du Cinéma*, 43, January.

Trouble Every Day, CLT-UFA, Rezo Films.

Trouble Every Day

Studios/Distributors:

Arte

Direcwtor:

Claire Denis

Producer:

Georges Benayoun

Screenwriters:

Jean-Pol Fargeau
Claire Denis

Synopsis

Coré lures a truck driver out of his vehicle and kills him. Shane and June fly into Paris on their honeymoon. Shane has memories or hallucinations of bodies soaked in blood. Coré's husband Léo, an African-French physician, locks her into their home before leaving for his office. Shane and June check into their hotel. Shane takes a long look at Christelle, a chambermaid; later he masturbates instead of making love to his wife. Shane visits a medical laboratory in search of Léo, saying he is interested in Léo's research.

Critique

Critic and theorist André Bazin drew a famous distinction between 'directors who put their faith in the image and those who put their faith in reality'. Taken literally, this is something of a false choice, and the films of Claire Denis could be Exhibit A in the argu-

Cinematographer:

Agnès Godard

Art Director:

Étienne Rohde

Production Designer:

Arnaud de Moléron

Costume Designer:

Judy Shrewsbury

Composer:

Tindersticks

Editor:

Nelly Quettier

Duration:

101 minutes

Genres:

Horror

Vampire/Cannibal film

Melodrama

Cast:

Vincent Gallo

Tricia Vessey

Béatrice Dalle

Alex Descas

Florence Loiret-Caille

Nicolas Duvauchelle

José Garcia

Hélène Lapiower

Aurore Clément

Marilu Marini

Year:

2001

ment against it. In her finest works, such as *Beau travail* (1999) and *Vendredi soir/Friday Night* (2002), image *is* reality, just as a Georges Méliès trick movie like *Le Voyage dans la lune/A Trip to the Moon* (1902) is at once an obvious fiction and a documentary of actors, entertainment styles, theatrical techniques, and filming practices at the turn of the twentieth century. Denis' radical and disturbing *Trouble Every Day* resembles a darksome remake of a Méliès fantasy – not in its frequently horrific content, of course, but in the way the camera transforms an array of patently synthetic raw materials into the stuff of visions, phantasms, and incursions of the impossible into ordinary life.

The film's power comes largely from its effectiveness at creating category confusions, blurring the boundaries that normally separate reality and fantasy, conscious and unconscious, science and insanity. One scene commences with a biologist matter-of-factly slicing a human brain into sections, as if the mind were meat. Other laboratory shots are decked out with mechanical gizmos, spooky colours, and lurid-looking fluids – images that are simultaneously as mundane as a lab-work checklist, as outlandish as a fever dream. There is no telling where what most of us call the *real* shades into what psychoanalysts call the *Real*, the irrational desire that cannot be integrated into the symbolic reality we depend on to sustain our fragile psyches. Uncanny forces surge through every aspect of the story, which steadfastly refuses to add up.

Trouble Every Day makes a degree of narrative sense, to be sure. Shane (Vincent Gallo), who works for a multinational pharmaceutical company, met Léo (Alex Descas) and Coré (Béatrice Dalle) at their 'bioprospection' camp in Africa, where he and Coré contracted (or discovered they had already contracted) a bizarre malady that drives them to feast on human blood and flesh. Léo's link to this ghastly syndrome becomes clear when Shane checks him out on the Internet and finds a web page hailing the young scientist for a 'brilliant article published in the Revue of the Association of Neuroscientists', promising new breakthroughs in the understanding of 'nervous diseases, pain, mental diseases and problems of libido'.

That brief précis, seen in a fuzzy image on a computer screen, is our strongest clue to the content of the film's weird science and the objectives of the film itself. Libido, pain, and afflictions of the nerves and mind are a volatile combination of research areas, and the fundamental subject of *Trouble Every Day* is horror of the body and its works, be they sexual, emotional, intellectual, or spiritual in nature. Denis' preferred method for conveying this horror is to reify, mutilate, corrupt, and humiliate the pictorial body as drastically as the medium allows. She does this with low-tech special effects – mesmeric close-ups, scary make-up, murky lighting designs, oceans of artificial blood – that make the camera seem complicit with the skin-crawling degradations it dwells on so obsessively. Contagion is the movie's chief interest and also its modus operandi, burrowing under the viewer's skin to depths few conventional horror films manage to reach.

The film's most chilling moment is, paradoxically, one of the

most understated. Shane has terminated Coré's career as an anthropophagous killer, which is good; but he has also raped and murdered Christelle (Florence Loiret-Caille), which is hideous and depraved. Which side of his personality will endure into the future? The final scene finds him in the shower, inviting us to think he might be symbolically scrubbing off his moral stain. Stepping out of the shower stall, he tells innocent, ignorant June (Tricia Vessey) that the honeymoon is over and they should now return home. This holds promise: Shane could possibly be a new man in every sense.

But streaks of blood linger on the shower wall, and we are reminded that in modern horror – think of Brian De Palma's *Dressed to Kill* (1980) and Joseph Ruben's *The Stepfather* (1987), for just two examples – stigmata of the soul are not easily washed away. The contagion, we realize, will continue unabated. Denis' film, however, will not spread its dark, dead vision into sequels or imitations. Its morbidity is too authentic, its anxiety too infectious for moviegoers to tolerate more of the same. It is a singularity, and experiencing it too often is a recipe for trouble. Every day.

David Sterritt

RECOMME
READING

Abel, Richard (1984) *French Cinema: The First Wave, 1915–1929*, Princeton: Princeton University Press.

Abel, Richard (1988) *French Film Theory and Criticism, 1907–1937*, 2 vols., Princeton: Princeton University Press.

Abel, Richard (1994) *The Ciné Goes to Town: French Cinema, 1896–1914*, Berkeley: University of California Press.

Andrew, Dudley (1995) *Mists of Regret: Culture and Sensibility in Classic French Film*, Princeton: Princeton University Press.

Armes, Roy (1985) *French Cinema*, New York: Oxford University Press.

Audé, Françoise (2002) *Cinéma d'elles 1981–2001*, Lausanne: L'Age d'Homme.

Austin, Guy (2003) *Stars in Modern French Film*, London: Arnold.

Austin, Guy (2008) *Contemporary French Cinema: An Introduction*, 2nd edn, Manchester, UK: Manchester University Press.

Austin, James F (2004) 'Digitizing Frenchness in 2001: On a "Historic" Moment in the French Cinema', *French Cultural Studies*, 15: 3, pp. 281–99.

Baecque, Antoine de (1998) *La Nouvelle vague – Portrait d'une jeunesse*, Paris: Flammarion.

Baecque, Antoine de (2005) *La Cinéphilie. Invention d'un regard, histoire d'une culture 1944–1968*, Paris: Hachette.

Bandy, Mary Lea (ed.) (1983) *Rediscovering French Film*, New York: MOMA.

Bassan, Raphael (1989) 'Trois néobaroques français', *Révue du cinéma*, 449, pp. 44–50.

Beugnet, Martine (2007) *Cinema and Sensation: French Film and the Art of Transgression*, Edinburgh: Edinburgh University Press.

Billard, Pierre (1995) *L'age classique du cinema français: Du cinéma parlant à la Nouvelle Vague*, Paris: Flammarion.

Bloom, Peter J (2008) *French Colonial Documentary: Mythologies of Humanitarianism*, Minneapolis: University of Minnesota Press.

Bonnell, René (1978) *Le cinema exploité*, Paris: Seuil.

Bonnell, René (2005) *La vingt-cinquième image: Economie de l'audiovisuel*, Paris: Gallimard.

Bordwell, David (1980) *French Impressionist Cinema: Film Culture, Film Theory and Film Style*, New York: Arno Press.

Buchsbaum, Jonathan (1988) *Cinema Engagé: Film in the Popular Front*, Urbana: University of Illinois Press.

Buchsbaum, Jonathan (2005) 'After GATT: Has The Revival of French Cinema Ended?', *French Politics, Culture and Society*, 23, pp. 34–54.

Buchsbaum, Jonathan (2006) '"The Cultural Exception is Dead". Long Live Cultural Diversity!: French Cinema and the New Resistance', *Framework*, 47: 1,

NDED

pp. 5–21.

Conway, Kelley (2004) *Chanteuse in the City: The Realist Singer in French Film*, Berkeley: University of California Press.

Conway, Kelley (2008) 'The New Wave in the Museum: Varda, Godard, and the Multi-Media Installation', *Contemporary French Civilization*, 32: 2, pp. 195–217.

Creton, Laurent (1995) *Cinéma et marché*, Paris: Armand Colin.

Creton, Laurent (1999) *Cinéma et l'argent*, Paris: Nathan.

Creton, Laurent (2005) *Économie du cinéma: Perspectives stratégiques*, Paris: Armand Collin.

Creton, Laurent (ed.) (2002) *Le Cinéma à l'épreuve du système télévisuel*, Paris: CNRS Editions.

Crisp, Colin (1997) *The Classic French Cinema: 1930–1960*, Bloomington: Indiana University Press.

Crisp, Colin (2002) *Genre, Myth, and Convention in the French Cinema 1929–1939*, Bloomington: Indiana University Press.

Crofts, Stephen (1993) 'Reconceptualizing National Cinema/s', *Quarterly Review of Film and Video*, 14: 3, pp. 46–57.

Danan, Martine (2006) 'National and Post-National French Cinema', in P Willeman and V Vitali (eds.), *Theorising National Cinema*, London: BFI Publications, pp. 172–85.

Dyer, Richard and Vincendeau, Ginette (eds.) (1992) *Popular European Cinema*, London: Routledge.

Ehrlich, Evelyn (1985) *Cinema of Paradox: French Filmmaking Under the German Occupation*, New York: Columbia University Press.

Ezra, Elizabeth and Harris, Sue (2000) *France in Focus: Film and National Identity*, New York: Berg.

Farchy, Joëlle (2004) *L'Industrie du cinema*, Paris: Presses Universitaires de France.

Flitterman-Lewis, Sandy (1990) *To Desire Differently: Feminism and the French Cinema*, Urbana: University of Illinois Press.

Forbes, Jill and Kelly, Michael (eds.) (1996) *French Cultural Studies: An Introduction*, Oxford: Oxford University Press.

Frodon, Jean-Michel (1995) *L'age moderne du cinema français: De la nouvelle vague à nos jours*, Paris: Flammarion.

Gimello-Mesplomb, Frédéric (2003) 'Le Prix de la qualité: L'État et le cinéma français (1960–1965)', *Politix*, 16: 61, pp. 97–115.

Gimello-Mesplomb, Frédéric (2006) 'The Economy of 1950s Popular French Cinema', *Studies in French Cinema*, 6: 2, pp. 141–50.

Graham, Peter and Vincendeau, Ginette (eds.) (2009) *The French New Wave: Critical Landmarks*, London: BFI.

Greene, Naomi (1999) *Landscapes of Loss: The National Past in Postwar French Cinema*, NJ: Princeton University Press.

Hayes, Graeme and O'Shaugnessy, Martin (2005) 'French Cinema: Globalization, Representation and Resistance', *French Politics, Culture and Society*, 23: 3, pp. 1–23.

Hayes, Graeme and O'Shaugnessy, Martin (2005) *Cinéma et Engagement*, Paris: L'Harmattan.

Hayward, Susan (2005) *French National Cinema*, 2nd edn, New York: Routledge.

Hayward, Susan and Vincendeau, Ginette (eds.) (2000) *French Film: Texts and Contexts*, 2nd edn, New York: Routledge.

Higbee, Will and Hwee Lim, Song (2011) 'Concepts of transnational cinema: Towards a critical transnationalism in film studies', *Transnational Cinema*, 1: 1, pp. 7–21.

Higson, Andrew (1989) 'The Concept of National Cinema', *Screen*, 30: 4, pp. 36–47.

Hillier, Jim (ed.) (1985) *Cahiers du Cinéma: The 1950's: Neo-Realism, Hollywod, New Wave*, Cambridge: Harvard University Press.

Hillier, Jim (ed.) (1986) *Cahiers du Cinéma: 1960–1968: New Wave, New Cinema, Reevaluating Hollywood*, Cambridge: Harvard University Press.

Ince, Kate (2008) 'From Minor to "Major" Cinema? Women's and Feminist Cinema in France in the 2000s', *Australian Journal of French Studies*, XLV: 3, pp. 277–88.

Jäckel, Anne (2000), 'The Inter/Nationalism of French Film Policy', *Modern & Contemporary France*, 15: 1, pp. 21–36.

Jeancolas, Jean-Pierre (1979) *Le cinema des Français: La Ve république, 1958–1978*, Paris: Stock.

Lanzoni, Rémi Fournier (2002) *French Cinema From its Beginnings to the Present*, New York: Continuum.

Levine, Alison J Murray (2008) 'Mapping *Beur* Cinema in the New Millennium', *Journal of Film and Video*, 60: 3/4, pp. 42–59.

Levine, Alison J Murray (2011) *Framing the Nation: Documentary Film in Interwar France*, NY: Continuum.

Marie, Michel (2003) *The French New Wave: An Artistic School* (trans. Richard Neupert), London: Blackwell Publishing.

Mazdon, Lucy (2000) *Encore Hollywood: Remaking French Cinema*, London: BFI.

Mazdon, Lucy (ed.) (2001) *France on Film: Reflections on Popular French Cinema*, London: Wallflower.

Michael, Charlie (2005) 'French National Cinema and the Martial Arts Blockbuster', *French Politics, Culture & Society*, 23: 3, pp. 55–74.

Moine, Raphaelle (2005) *Le cinema français face aux genres*, Paris: Publications de l'association française de recherches sur l'histoire du cinema.

Neupert, Richard (2006) *A History of the French New Wave Cinema*, 2nd edn, Madison: University of Wisconsin Press.

Neupert, Richard (2011) *French Animation History*, New York: Wiley-Blackwell.

O'Shaughnessy, Martin (2007) *The New Face of Political Cinema: Commitment in French Film Since 1995*, London: Berghahn.

Palmer, Tim (2007) 'An Amateur of Quality: Postwar French Cinema and Jean-Pierre Melville's *Le Silence de la mer*', *Journal of Film and Video*, 59: 4, pp. 3–19.

Palmer, Tim (2008) 'Paris, City of Shadows: French Crime Cinema Before the New Wave', *New Review of Film and Television Studies*, 6: 2, pp. 113–31.

Palmer, Tim (2011) *Brutal Intimacy: Analyzing Contemporary French Cinema*, Middletown, CT: Wesleyan University Press.

Powrie, Phil (1997) *French Cinema in the 1980s: Nostalgia and the Crisis of Masculinity*, NY: Oxford University Press.

Powrie, Phil (2005) 'Unfamiliar Places: "Heterospection" and Recent French Film on Children', *Screen*, 46: 3, pp. 341–52.

Powrie, Phil (ed.) (2000) *French Cinema in the 1990s: Continuity and Difference*, Oxford: Oxford University Press.

Powrie, Phil (ed.) (2006) *The Cinema of France*, London: Wallflower Press.

Powrie, Phil and Reader, Keith (2002) *French Cinema: A Student's Guide*, London: Arnold.

Prédal, Réné (2008) *Le Cinéma français depuis 2000: Une renouvellement incessant*, Paris: Nathan.

Sellier, Genviève (2008) *Masculine Singular: French New Wave Cinema* (trans. Kristin Ross), Durham, NC: Duke University Press.

Smith, Alison (2005) *French Cinema of the 1970s: The Echoes of May*, Manchester: Manchester University Press.

Tarr, Carrie (2005) *Reframing Difference: Beur and Banlieue Filmmaking in France*, Manchester: Manchester University Press.

Tarr, Carrie and Rollet, Brigitte (2001) *Cinema and the Second Sex: Women's Filmmaking in France in the 1980s and 1990s*, New York: Continuum.

Temple, Michael and Witt, Michael (eds.) (2004) *The French Cinema Book*, London: BFI.

Vanderschelden, Isabelle (2007) 'Strategies for a 'Transnational'/French Popular Cinema', *Modern & Contemporary France*, 15: 1, pp. 37–50.

Vanderschelden, Isabelle (2009) 'The "*Cinéma du Milieu*" is Falling Down: New Challenges for Auteur and Independent French Cinema in the 2000s', *Studies in French Cinema*, 9: 3, pp. 243–57.

Vecchiali, Paul (2010) *L'Encinéclopédie, Volume 1: Cinéastes français des années 1930 A-K*, Paris: Éditions de l'Oeil.

Vecchiali, Paul (2010) *L'Encinéclopédie, Volume 2: Cinéastes français des années 1930 L-Z*, Paris: Éditions de l'Oeil.

Vincendeau, Ginette (1987) 'Women's Cinema, Film Theory, and Feminism in France', *Screen*, 28: 4, pp. 4–18.

Vincendeau, Ginette (1996) *The Companion to French Cinema*, London: BFI.

Vincendeau, Ginette (2000) *Stars and Stardom in French Cinema*, New York: Continuum.

Waldron, Darren and Vanderschelden, Isabelle (eds.) (2007) *France at the Flicks: Trends in Contemporary French Popular Cinema*, Cambridge: Cambridge Scholars Publishing.

Williams, Alan (1992) *Republic of Images: A History of French Filmmaking*, Cambridge: Harvard University Press.

Wilson, Emma (2000) *French Cinema Since 1950: Personal Histories*, London: Rowman & Littlefield.

Wilson, Emma (2005) '*État présent*: Contemporary French Women Filmmakers', *French Studies*, LIX: 2, pp. 217–23.

FRENCH CINEMA ONLINE

Association for Studies in French Cinema
http://www.surrey.ac.uk/fahs/research/sfc/
The website for the professional organization founded by Professors Susan Hayward and Phil Powrie (and which publishes *Studies in French Cinema*). It provides information on their annual conference, as well as various academic prizes, books, and PhD theses related to French film.

Bibliothèque du film
http://www.bifi.fr/public/index.php
In French. The library and archive's website, detailing collections and services available to French film scholars. In addition to a searchable catalogue, there are links to virtual resources and exhibits, including: 'Le scénario du *Silence de la mer* de Jean-Pierre Melville', 'Story-board de cinéma', and 'Un dessin de Méliès pour *L'Homme à la tête en caoutchouc*', among others.

Cahiers du Cinéma
http://www.cahiersducinema.com/-Extraits-English-Version-.html
The famous film journal makes available select articles translated into English.

Centre National du Cinéma et de l'Image Animée (CNC)
http://www.cnc.fr/web/en
An organization of the Ministry of Culture and Communication, the CNC regularly publishes extensive and vital data sets related to the French film industry, including theatre admissions as well as film distribution and exports.

Cinémathèque Française
http://www.cinematheque.fr/
In French. The website for the institution founded by Henri Langlois; it includes information on upcoming events and activities related to their film screenings and museum space.

DVDFR.com

http://www.dvdfr.com
In French. An easily navigable website for non-French users, which indicates, importantly, whether French DVD releases have English subtitles.

Le Film Français
http://www.lefilmfrancais.com/
In French. The French equivalent of *Variety*, the film trade's main publication.

Film Studies for Free | French New Wave
http://filmstudiesforfree.blogspot.com/search/label/French%20New%20Wave
An amazing online repository and directory for open-access film studies publications (books, articles, etc.); this particular link limits to posts with the tag 'French New Wave'.

Films de France
http://filmsdefrance.com/homepage_eng.html
A wealth of information on the history of French film, allowing access by decade, genre, and notable directors and/or actors.

French Culture
http://www.frenchculture.org/
'The Official Website of the Cultural Services of the French Embassy in the US.' This website highlights current film-related events, publications and festivals.

French New Wave | The Criterion Collection
http://www.criterion.com/explore/4-french-new-wave
A 'theme' page assembled by the Criterion Collection, featuring links to all the French New Wave films in their catalogue, which, in turn, link to many of the essays and ancillary texts included in their DVD inserts.

Première Magazine
http://www.premiere.fr/
In French. A vibrant website for the French magazine *Première*, which is published in print monthly. It provides full-text access to news, biographies and reviews, and features photos and video clips.

Stars of French Film
http://www.frenchfilmstars.dept.shef.ac.uk/home.html
A project supervised by Dr Guy Austin from the Department of French at the University of Sheffield. The website features a searchable database, indexing publications ranging from *Cinémonde* to *Positif*, as well as biographies and filmographies of French film stars.

uniFrance
http://en.unifrance.org/
The website for the organization 'in charge of promoting French cinema throughout the world', it provides statistics for films in theatrical release and broadcast on television generally and specifically by select regions. In addition, the website features a searchable industry database with entries for film actors and professionals noting, importantly, agents.

TEST YOUR KNOWLEDGE

Questions

1. Mathieu Kassovitz, who plays Nino Quincampoix in *Amélie*, is also famous for directing this 1995 film starring Vincent Cassel.
2. Which actress starred in *Point of No Return*, a remake of Luc Besson's *Nikita*?
3. In Jean Cocteau's *Orpheus*, to achieve the shot of Orphée putting his hands through glass, Cocteau used a vat of what liquid element?
4. According to Agnès Varda's *Salut les cubains*, the main island of Cuba, for men, is shaped like a cigar; however, what is it shaped like for women?
5. Robert Desnos not only wrote the original poem that this film is based on but also had a small walk-on role in the film.
6. This director of *Un Chien Andalou* also begins the film in an uncredited role as the man responsible for slicing the woman's eyeball with a razor.
7. The mask that Edith Scob (Christiane Génessier) wears in *Eyes Without a Face* supposedly inspired the mask worn by this figure in John Carpenter's *Halloween* slasher series.
8. Before his death at a tragic young age and following *Zero for Conduct*, Jean Vigo directed this 1934 film starring Dita Parlo.
9. Rejecting the use of stars, Robert Bresson famously coined this term to refer to actors.
10. Which grizzled star has a double role in the policier *Between Eleven and Midnight*?
11. In contemporary Hollywood a $100 million domestic gross typically defines a film as a blockbuster and major box-office success. What criterion defines blockbuster status for a film in France?
12. Which star is notably associated with Poetic Realist films?
13. Which iconic film-maker was Agnès Varda married to between 1962 and 1990?
14. This film-maker, director of *Of Gods and Men*, headed Céline Sciamma's

graduation board at La Fémis.

15. This star pair, real-life spouses, have appeared together in films such as *The Apartment*, *Brotherhood of the Wolf*, *Irreversible* and *Secret Agents*.

16. Marguerite Duras' *Nathalie Granger* features this well-known actor as a beleaguered washing machine salesman.

17. Before attaining international acclaim for her role as Edith Piaf in *La vie en rose*, Marion Cotillard attained fame in France for her role in this trilogy of action films.

18. Which film, Céline Sciamma's debut feature, was nominated for a Best First Film César?

19. Actress Claude Perron plays characters who have the same job in both *Amélie* and *Locked Out*. What is that job?

20. During the summer of 1993, this film competed with *Jurassic Park* at the French box office, spurring newspaper headlines like 'Cola vs Zola'.

Answers
1. *Hate*
2. Bridget Fonda
3. Mercury
4. A crocodile
5. *The Starfish*
6. Luis Buñuel
7. Michael Myers
8. *L'Atalante*
9. 'Modèles' (Models)
10. Louis Jouvet
11. Receiving a million paid admissions at the box office, becoming a so-called millionaire.
12. Jean Gabin
13. Jacques Demy
14. Xavier Beauvois
15. Monica Bellucci and Vincent Cassel.
16. Gérard Depardieu
17. The *Taxi* franchise.
18. *Water Lilies*
19. Worker in a sex shop.
20. *Germinal*

NOTES ON CONTRIBUTORS

The Editors

Tim Palmer is Associate Professor of Film Studies at the University of North Carolina Wilmington and the author of *Brutal Intimacy: Analyzing Contemporary French Cinema* (2011). His research has been published in many journals including *Cinema Journal*, *Journal of Film and Video*, *Studies in French Cinema*, *New Review of Film and Television Studies* and the *French Review*. He is also co-founder and co-Editor-in-Chief of *Film Matters*, the first peer-reviewed film journal for undergraduates, published quarterly by Intellect. His next book will be a monograph on *Irréversible/Irreversible* (2002) for Palgrave Macmillan.

Charlie Michael is Visiting Assistant Professor of French in the Department of Modern Languages & Literatures at the University of Miami. His work has appeared in *The Velvet Light Trap* and *French Politics, Culture & Society*, and he has forthcoming articles in *SubStance: A Review of Theory and Literary Criticism* and *The Blackwell Companion to Contemporary French Cinema*. He is currently at work on a book-length manuscript entitled 'French Blockbusters: Context, Culture, Controversy.'

Framing Essayists

Colin Burnett is Assistant Professor in the Program in Film and Media Studies at Washington University in St Louis. He is currently working on a book manuscript, titled *The Making of Robert Bresson: Authorship and Cinephilia in Postwar France*. He has written on the concept of film style in *New Review of Film and Television Studies* (2008) and *Arnheim for Film and Media Studies* (2010), on Bresson in the 1930s in *Robert Bresson (Revised)* (2012), and the dynamics of authorial intentionality in *The Blackwell Companion to Media Authorship* (2012).

Margaret C. Flinn is Assistant Professor in the Department of French and Italian and in the Program in Film Studies at The Ohio State University. Her book on documentary and realist film of the 1930s, *The Social Architecture of French Cinema, 1929–39*, is forthcoming from Liverpool University Press. Her articles on documentary have appeared in journals such as *Yale French Studies*, *Contemporary French and Francophone Studies: Sites* and *Studies in French Cinema*. Her next book length project will address the rising value of French documentary film/media and of commodified heritage as indices of a national cinema in transition.

Paul Douglas Grant is a PhD candidate at New York University and is the translator of Serge Daney's *Postcards from the Cinema* (2007). He is a frequent contributor to *Film International* and *Senses of Cinema* and is currently working on a dissertation on 1970s French militant cinema, as well as translations of both Jean-Louis Schefer's *The Ordinary Man of Cinema* and Jean Barrot's *Le Mouvement communiste*.

Anne Jackel is a former visiting research fellow at the University of the West of England, Bristol. Her recent publications include numerous book chapters and journal articles on cinematographic co-productions, European cinemas and film policy. She is also the author of *European Film Industries* (BFI, 2003).

François Massonnat teaches French language, literature, and film at Villanova University and is finishing his doctoral dissertation on contemporary French crime cinema at the University of Pennsylvania. His research focuses on questions of authorship and performance in the films of such directors as Alain Corneau, Jacques Audiard and Guillaume Nicloux. His work has appeared in *Contemporary French Civilization*, *French Forum* and *The French Review*.

Ben McCann is Senior Lecturer in French Studies at the University of Adelaide. He is the co-editor of *Michael Haneke: Europe Utopia* (Wallflower, 2011) and is currently writing a book on French director Julien Duvivier.

Marc Saint-Cyr studied cinema and history at the University of Toronto. A staff writer for *J-Film Pow-Wow*, he has also contributed to the first and second volumes of the *Directory of World Cinema: Japan* and *World Film Locations: Tokyo* from Intellect, as well as such publications as *CineAction*, *Midnight Eye*, *Row Three*, *Senses of Cinema*, *Toronto Film Scene* and the *VCinema Podcast and Blog*. He holds a special interest in Asian and European cinemas.

Essayists

Dr Zelie Asava is a lecturer in Film Studies at University College Dublin, and IADT. Her research publications focus on the intersection between race, gender and sexuality in French, Irish, African and American cinema.

Adam Bingham teaches Film Studies at Edge Hill University in Lancashire, England and writes regularly for *CineAction*, *Cineaste*, *Asian Cinema* and other journals. He is the editor of the WCD book on Eastern European Cinema from Intellect and the author of an upcoming monograph on the Japanese director Yoshida Yoshishige.

Vincent Bohlinger is Associate Professor of Film Studies in the Department of English at Rhode Island College. His research primarily concerns film history and film theory, and he is currently working on a book about Soviet film style between montage and socialist realism.

Brett Bowles is Associate Professor of French Studies at the State University of New York, Albany. His research focuses on the social and political dimensions of French cinema since the 1930s.

Kelley Conway is Associate Professor of Film in the Department of Communication Arts at the University of Wisconsin-Madison. She is the author of *Chanteuse in the City: The Realist Singer in French Film* (University of California Press, 2004) and essays on Jean Renoir, Brigitte Bardot, Agnès Varda, and multimedia installations.

Jonathan Driskell wrote his PhD thesis on 'Female Cinematic Stardom in 1930s French Film'. He now lectures in Film and Television Studies at Monash University Sunway Campus (Malaysia) and is the author of a forthcoming book on Marcel Carné, which is to be published by Manchester University Press.

Audrey Evrard completed her PhD in French Studies at the University of Illinois at Urbana-Champaign and is now Assistant Professor of French at Drew University. She specializes in French documentary cinema and video-making. In her research, she focuses most specifically on the articulation of subjectivity and political activism in the recent engagement of French film-makers with globalization. She is the author of an article on Luc and Gédéon Naudet's 2002 documentary film *9/11* in *Contemporary French Civilization* (29: 2, 2005).

Tom Fallows is a writer and infrequent film-maker based in Stoke-on-Trent. After studying Film Journalism with the BFI in London, he went on to co-author a biography on zombie king George A. Romero for Pocket Essentials and continues to contribute to numerous film blogs around the globe, including the Rondo-nominated Classic-Horror. Tom is currently working on the short film *Charlie on the Streets*, a film about homelessness and Charlie Chaplin.

Sarah Forgacs is a doctoral candidate and Graduate Teaching Assistant in the department of Film Studies at King's College London, where she is writing a thesis entitled: 'Filming in the feminine: Varda, Denis, Breillat and Ozon' which examines the writings of the French feminist philosopher Hélène Cixous in relation to the work of these four directors. Her wider research interests include intersections between film and philosophy, cinema and the senses, and feminist approaches to film.

Alain Gabon is currently Associate Professor of French at Virginia Wesleyan College in Virginia Beach, VA, where he directs the French program. He has BA, MA, and PhD degrees in English Literature and French Studies from several French and American universities including the University of Burgundy, France, and the University of Iowa. He publishes and lectures widely throughout the United States and Europe on contemporary France including literature, film, and more recently European Islam.

Will Gartside is a third year Communication doctoral student at the University of Illinois at Chicago (UIC). He is a fan and producer of cinema in the horror genre. His research interests include examining the production and consumption of violence as a form of entertainment.

Mary Harrod is currently writing a PhD thesis on the rise of romantic comedy in contemporary French cinema at King's College, London. Her interests span European and Hollywood cinema, with a particular focus on popular modes, including language, stardom and representational politics, as well as different strategies of engagement and the relationship between aesthetics and ideology. She has published in the journals *Screen* and *Studies in French Cinema* (forthcoming).

Kierran Horner lives in London where he works, writes, and is researching a doctorate on the films of Agnès Varda, Chris Marker and Alain Resnais, at King's College, University of London.

Jonah Horwitz is a PhD candidate in Communication Arts at the University of Wisconsin-Madison. For his doctoral dissertation, he is studying the poetics of American live television anthology drama and the role of the 'television generation' in feature film-making of the 1950s and early 1960s. He has been a member of the Collegium Sacilense at the Giornate del Cinema Muto, and developed a website on live television drama for the Wisconsin Center for Film and Theater Research.

Brigitte E. Humbert is Associate Professor of French at Middlebury College. She has published a book on the various film adaptations of *Les Liaisons dangereuses* and written many articles on French films, including *Le retour de Martin Guerre/The Return of Martin Guerre* (1982), *La reine Margot/Queen Margot* (1994), *Ridicule* (1996), *Outremer/ Overseas* (1990), *Indochine* (1992), *Paris* (2008), *3 hommes et un couffin/Three Men and a Cradle* (1985) and *Lucie Aubrac* (1997).

Mariana Johnson is Assistant Professor in the department of Film Studies at the University of North Carolina-Wilmington.

Oscar Jubis is a PhD candidate in Film Studies at the University of Miami. He is the author of 'Lucrecia Martel: The Salta Trilogy' and a regular contributor to *Film International*.

Juan Carlos Kase is Assistant Professor of Film Studies at the University of North Carolina Wilmington. His ongoing research concerns the overlapping aesthetic, historical, and political registers of experimental cinema, documentary, art history, performance, and popular music within American and global culture.

Colleen Kennedy-Karpat holds a PhD in French from Rutgers University and teaches film and culture studies in the department of Communication and Design at Bilkent University. She is currently preparing a book manuscript about exoticism in French narrative cinema of the 1930s, and researching French right-wing films and film-makers of the interwar years.

Gary M. Kramer is a contributing writer to the alternative newspapers *Gay City News* (NY), *Philadelphia Gay News*, *The Philadelphia City Paper*, *San Francisco Bay Times*, *Out Front Colorado* and *Frontiers/In Los Angeles*; the websites *Salon*, *Slant*, *indieWire* and aroundphilly.com. He also contributes to the journal *Film International*. Kramer is the author of *Independent Queer Cinema: Reviews and Interviews* (2006), and the co-editor (with Beatriz Urraca) of *Directory of World Cinema: Argentina*.

Alison J. Murray Levine is Associate Professor of French at the University of Virginia. She has published a book, *Framing the Nation: Documentary Film in Interwar France* (Continuum, 2010) as well as articles and book chapters on contemporary French and francophone cinema, film history, colonial history, colonial memory, and colonial tourism.

Mike Miley teaches Literature and Film Studies at Flintridge Preparatory School in La Cañada, CA. He holds a BA in English Writing from Loyola University New Orleans and an MFA in Directing from the American Film Institute Conservatory. His criticism has appeared in *Bright Lights Film Journal*, *Film International*, *Moving Image Source*, *The New Orleans Review*, and *Scope*.

Richard Neupert teaches at the University of Georgia where he is the Wheatley Professor of the Arts and Josiah Meigs Distinguished Teaching Professor in Film Studies. His books include *French Animation History* and *A History of the French New Wave Cinema*.

Liza Palmer is Review Section Editor of *Film International* and Co-Editor-in-Chief of *Film Matters*. Her current work on avant-garde film is supported by an American Library Association Carnegie-Whitney grant.

David Petterson is Assistant Professor of French at the University of Pittsburgh. He writes about the politics of popular culture in interwar French literature and cinema and he has published articles on Malraux and Renoir.

Phillip Roberts is completing a PhD at the Cardiff Centre for Critical Theory in cinema and the politics of control. His recent work includes contributions to the Korea edition of the *Directory of World Cinema* and *Schizoanalysis and Visual Culture*, a special issue volume for Deleuze Studies.

Zachariah Rush is a prize-winning poet, essayist, film-maker and film critic, having regularly contributed to *Film International* and several volumes of Intellect's *Directory of World Cinema* and *World Film Locations* series. He is completing a book on dialectical dramaturgy to be published by McFarland and is currently adapting Albert Camus' novel *L'étranger* into a libretto for Gallimard, Paris.

Bradley Schauer is Assistant Professor in the School of Theatre, Film, and Television at the University of Arizona. His research interests include the contemporary media industries, classical Hollywood cinema, and exploitation film. His work has appeared in journals such as *The Velvet Light Trap*, *The New Review of Film & Television Studies*, and the *Quarterly Review of Film & Video*. He is currently preparing a manuscript entitled 'Science Fiction and the Exploitation Tradition in Hollywood'.

Aparna Sharma is a documentary film-maker and theorist. She is presently working in India's northeastern region where she is documenting the Kamakhya Temple and researching early and contemporary Assamese cinema. She has previously written on Indo-Pak ties through documentary and the representation of gender. At UCLA's Department of World Arts and Cultures she teaches video practice combining film theory with cultural theory and visual ethnography.

Christopher Sieving is Assistant Professor in the Department of Theatre and Film Studies at the University of Georgia. He is the author of *Soul Searching: Black-Themed Cinema from the March on Washington to the Rise of Blaxploitation* (Wesleyan University Press, 2011), a social and industrial history of African American-themed film-making from 1963 to 1970.

David Sterritt is Chair of the National Society of Film Critics, Film Professor at Columbia University and the Maryland Institute College of Art, Professor Emeritus at Long Island University, co-Chair of the Columbia University Seminar on Cinema and Interdisciplinary Interpretation, film critic for *Tikkun*, and chief book critic of *Film Quarterly*. His books include *The Films of Alfred Hitchcock*, *The Films of Jean-Luc Godard: Seeing the Invisible*, *Guiltless Pleasures: A David Sterritt Film Reader*, and *Mad to Be Saved: The Beats, the '50s, and Film*. His writing has appeared in *Cahiers du Cinéma*, the *New York*

Times, Journal of American History, Journal of French and Francophone Philosophy, Hitchcock Annual, The Journal of Aesthetics and Art Criticism, and many other publications as well as numerous edited collections. He is a former member of the 'New York Film Festival' selection committee and was film critic for *The Christian Science Monitor* for decades.

Brian Wilson has written for a number of film journals, including *Film International, Quarterly Review of Film and Video, CineAction*, and *Senses of Cinema*. His chapter on the dialogue of Howard Hawks will appear in the forthcoming *Film Dialogue* anthology published by Wallflower/Columbia University Press.

FILMOGRAPHY